THE
TENNIS COURT

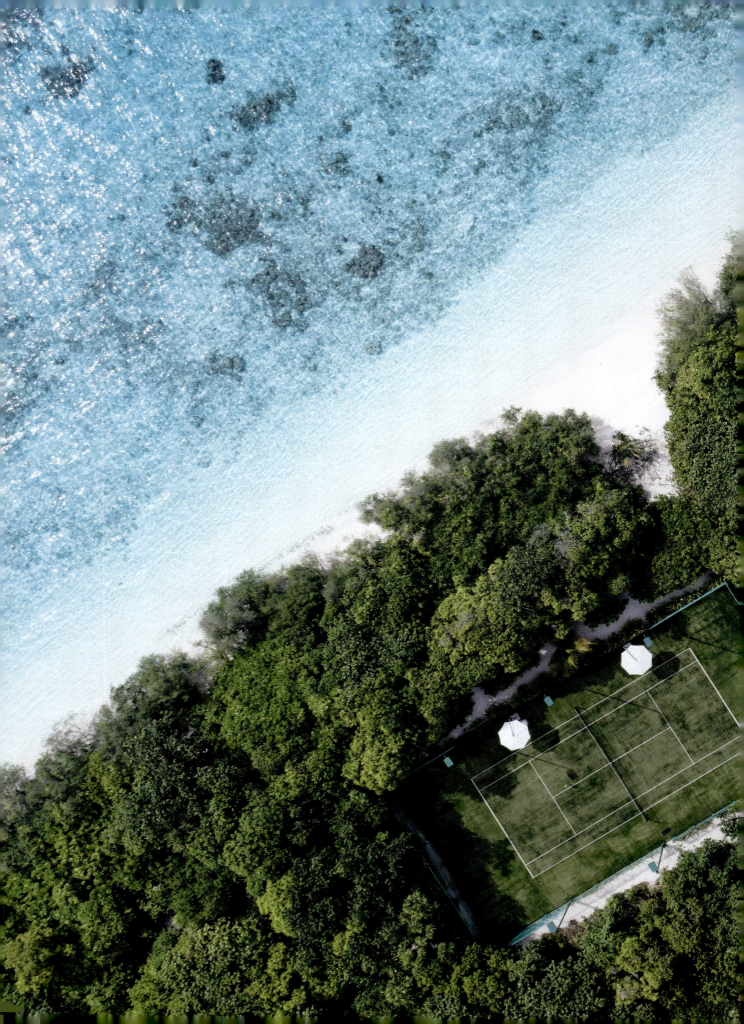

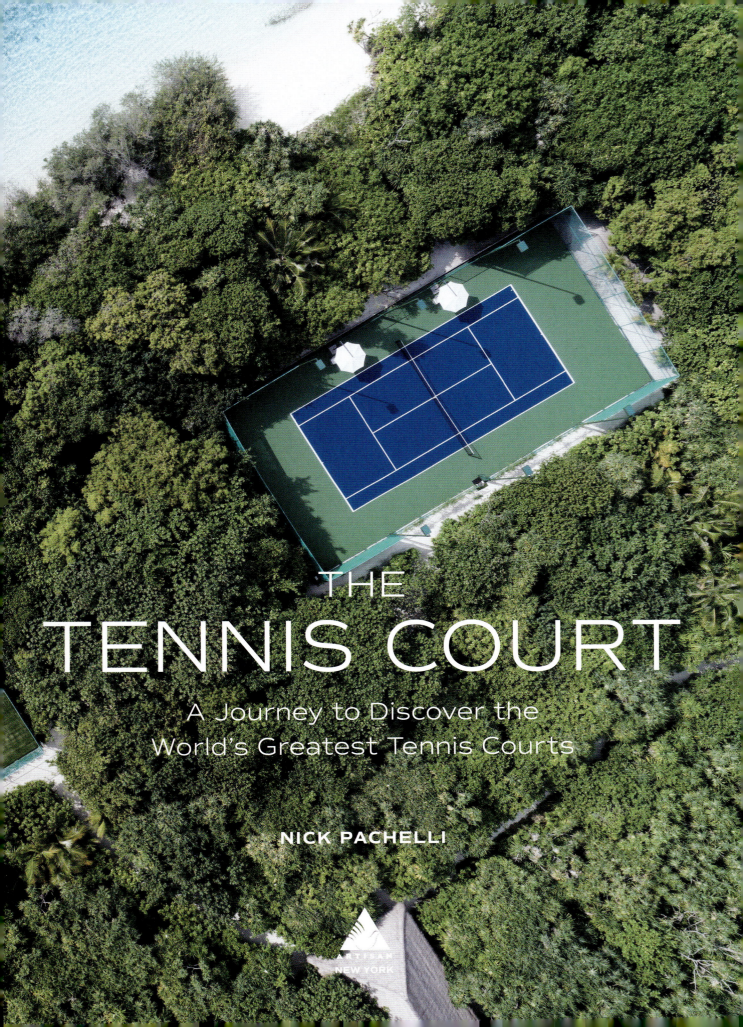

THE TENNIS COURT

A Journey to Discover the World's Greatest Tennis Courts

NICK PACHELLI

Copyright © 2024 by Nick Pachelli
Photographs copyright © 2024 by Nick Pachelli, except as indicated on page 335.

Hachette Book Group supports the right to free expression and the value of copyright. The purpose of copyright is to encourage writers and artists to produce the creative works that enrich our culture.

The scanning, uploading, and distribution of this book without permission is a theft of the author's intellectual property. If you would like permission to use material from the book (other than for review purposes), please contact permissions@hbgusa.com. Thank you for your support of the author's rights.

Library of Congress Cataloging-in-Publication Data is on file.
ISBN 978-1-64829-335-1

Design by Suet Chong

Artisan books may be purchased in bulk for business, educational, or promotional use. For information, please contact your local bookseller or the Hachette Book Group Special Markets Department at special.markets@hbgusa.com.

The publisher is not responsible for websites (or their content) that are not owned by the publisher.

The Hachette Speakers Bureau provides a wide range of authors for speaking events. To find out more, go to hachettespeakersbureau.com or email HachetteSpeakers@hbgusa.com.

Published by Artisan,
an imprint of Workman Publishing,
a division of Hachette Book Group, Inc.
1290 Avenue of the Americas
New York, NY 10104
artisanbooks.com

The Artisan name and logo are registered trademarks of Hachette Book Group, Inc.

Printed in China on responsibly sourced paper.

10 9 8 7 6 5 4 3

To Louise,
who never missed a match

Contents

Introduction		8
01	LOVE	13
02	READY, PLAY	61
03	NO MAN'S LAND	123
04	WILD CARD	177
05	DRILL, GRIND, REST, REPEAT.	219
06	CHANGE OF PACE	285
Afterword		332
Acknowledgments		333
Index		334
Photo Credits		335

INTRODUCTION

In the span of two years, I crisscrossed more than 250 cities and towns in search of the greatest tennis courts, which is to say, I chased tennis experiences in every form I could think of. It started off much like any journalistic assignment. I called people, hundreds in every pocket of the world, and asked, "Where's your favorite tennis court, and when should I go?" Then I set out with racquets, notepads, cameras, a drone, and a few cans of balls. I visited over a thousand tennis grounds on every tennis-playing continent, rallied on over two dozen surfaces, and watched every type of player, from newcomers to pros to 90-year-olds playing barefoot.

 I played at the "elite" institutions, rallied on Rod Laver and Arthur Ashe stadiums, and spent time with newer clubs and tennis communities that aspire to a more egalitarian tennis world. I explored the heavyweights such as the All England Lawn Tennis Club while also seeking out the hidden jewels—from a remote New Zealand valley to the Venice Canals. I chatted with strangers in tennis stadiums large and small, from center courts at all four Grand Slam locations to a pink stadium in Morocco.

 Everyone I met on or around the courts, even if we had no common language, reminded me of one thing over and over: These homes of tennis matter in innumerable ways to one of the most diverse and wide-reaching global communities in all of sports.

I've been shaped by tennis courts since 1995, when I was a ball kid for my parents. Every weekend, I'd sit slouched against the net, trying to notice the spin on the ball as it flew past, usually

unimpressed by their level of play. I'd slide my fingertips along the rough green-and-red hard court. As with all courts in the dry, windy high desert of Albuquerque, New Mexico, cracks in the surface spread quickly along the net line and edges. Whenever my parents played, I picked off a tiny piece of the surface to take home. The habit stuck for the next 30-some years.

I was a tennis-obsessed junior, a lefty with a half-decent kick serve, with aspirations to play for America's top tennis colleges. At clinics around the city, at tennis camps and academies throughout the West and in Florida, and at every tournament I played, I'd take pieces of courts home in my overstuffed mess of a bag. A handful of dirt from a clay court in Palm Springs, an already chipped-off piece of white line from a hard court in Phoenix. (I'd just lost to a kid who cheated masterfully, and because I knew those balls were on the line, I took the line home with me.)

After my first time playing on grass, I accidentally pulled a chunk of soil out of the plot, and then I threw the wet clump in my bag before anyone could see. Even when I served my time as a ball kid at professional tournaments alongside my friends, who, same as me, were all oddly game to get hit by 120-mile-per-hour serves, I'd pocket edge pieces of the courts. During those years, as I reached a top-20 ranking in the Southwest US in singles and doubles, I loved looking at those bits of courts. Once, in high school, when a local reporter came to write an article about my doubles partner and me playing two undefeated seasons, he noted that I put a palm to the surface of the court at every changeover. He described me in his article as "prickly" and wrote that I "needled" my partner to victory, which was a fair assessment.

There was never any real reason for taking bits of courts home with me. Call it a nervous tic from playing a mentally swirly individual sport. Every physical and emotional pole is felt on a tennis court. All those years, I yelled, cheered, cramped, tore, vomited, and cried regularly on courts. I still cramp and cry on courts, just less often.

It wasn't a straight trajectory from playing junior tennis on courts around the US to a global tennis pursuit. There was a blip of collegiate tennis, some burnout and injury, and a couple of years when I didn't play and only watched the Slams.

My work led me into journalism, and while I reported and photographed for glossy magazines and newspapers, I folded in tennis to reconnect with the sport. Engaging with tennis through a new lens felt natural and invigorating. When I worked at the Slams or other pro tournaments, I chatted with professionals, coaches, trainers, umpires, and others who saw the depths of the sport's theater and its impact on its massive fan base. Also, of course, when

the *New York Times* or other publications sent me to Los Angeles, New York, Paris, Havana, and elsewhere, I always found myself sneaking on-court to play or sit and listen.

As a competitor-turned-outsider-turned-journalist, I noticed new details of the game. Reading the words of Grace Lichtenstein, Christopher Clarey, David Foster Wallace, barefoot grass player Bud Collins, and Louisa Thomas refined everything I understood about tennis. When I watched, I became more curious about how and when players embraced the crowd, or why they'd mix their pace and spin on the ball at seemingly inopportune moments. I also found myself hearing the differences in the *pop* of the ball off players' strings, the acoustics of an empty and full stadium, and the textured sounds of movement on clay, grass, or hard courts. When I played, too, particularly when I competed, the cruelties and minute victories of the game came into focus. So did some insights about most anything else going on in my life. Louisa Thomas once wrote in the *New Yorker* that sports are "always a fun-house mirror of the wider world." Double goes for tennis, regardless of whether we're casually watching, just starting out, or playing every day.

Many might say a court is just an empty space, which is true. Seventy-eight feet (23.8 m) long and 27 feet (8.2 m) wide, 36 feet (11 m) for doubles, with a net 3 feet (91 cm) high at the center. Eleven lines to draw if you want to make your own—two baselines, two singles lines, two doubles lines, two service lines, two center marks, and a center service line.

Most courts fall into three families. Grass courts are cheeky, unpredictable, and fast. Clay courts are slow, sticky, messy canvases. Hard courts are unforgiving screechy slabs. One could easily make a map detailing which regions of the world tend to fall in with each respective family, and the people you'll find there are die-hard enthusiasts. Add elements of space, wind, acoustics, sight lines, shadows, humidity, and air density, and you have a court's unique persona (see page 178).

Technically speaking, anything can be considered for the surface of a tennis court. The materials need only allow for a good enough bounce for play, and the international governing body of tennis can pay you a visit and approve it or send you back to the drawing board. I've not yet mixed my own rogue materials to make my own court, but will one day soon.

Outside of the three main surfaces, some true marvels exist, like the golden sand courts in southern Spain, the crushed-shell courts in the Philippines, or the clay court made of termite mounds in Kenya. (See pages 208, 184, 58.)

During the past two years, I spent countless hours staring at courts from every angle. While David Foster Wallace likened courts to cardboard cartons when seen from above, I see them more like dams nestled into their surroundings, with all that turbulent movement roiling within.

There are roughly half a million tennis courts in the world. The aim of this book is to profile and celebrate an array of the most cherished and unique, whether beloved for their surfaces, people, history, or something else altogether. And while I took the majority of the photos in the book, I'm proud to say that for the places I haven't yet traveled to, but have every intention of visiting, such as the courts in Pakistan and Cameroon, the photographers are all either tennis players themselves or deep thinkers about the game. Each section keeps to a theme: courts that are true sites of Love (page 13), courts where we eagerly await the words Ready, Play (page 61), courts found in distant No Man's Land (page 123), oddball courts often seen as Wild Cards (page 177), courts where the most committed Drill, Grind, Rest, Repeat (page 219), and courts both old and new that embrace a Change of Pace (page 285).

At every single one of these places, stories and emotional connections abound; we, as viewers and players, share them through tennis. I hope you'll venture into these pages game for the journey. And trust me, this book only scratches the surface. •

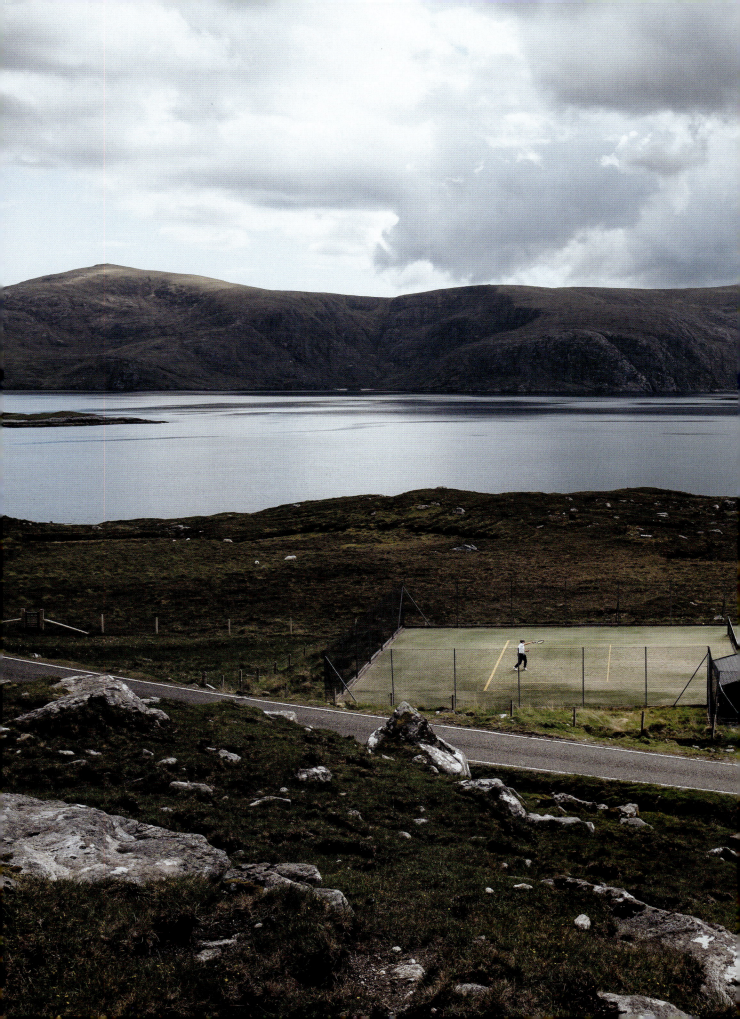

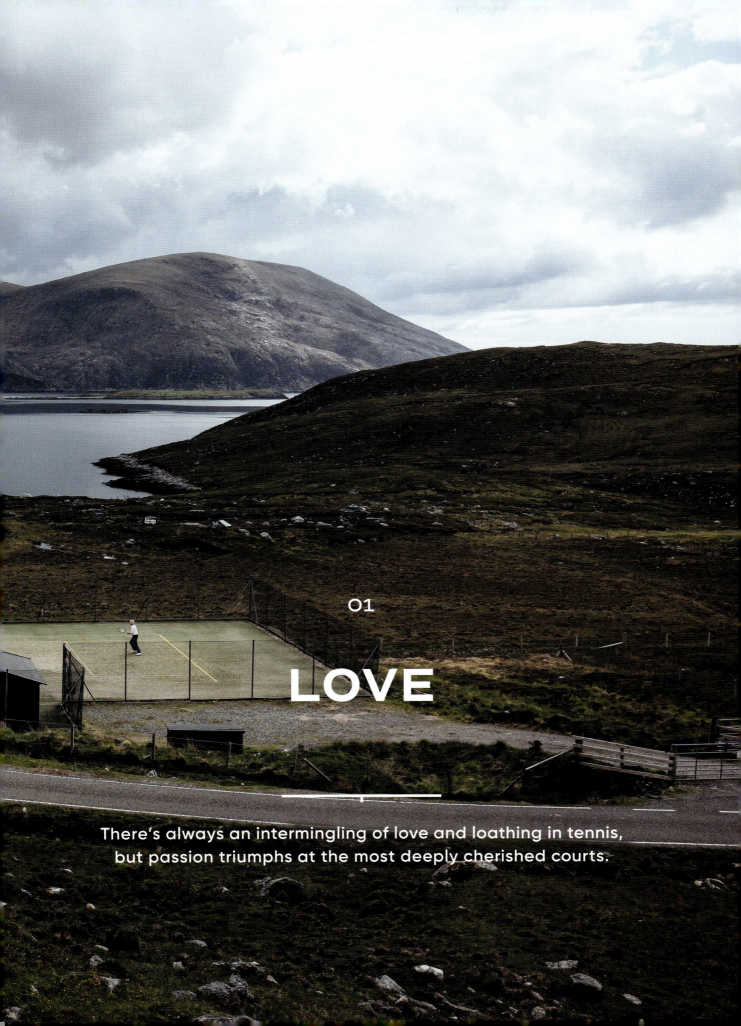

01

LOVE

There's always an intermingling of love and loathing in tennis, but passion triumphs at the most deeply cherished courts.

Once, I met a woman waiting outside some public courts in Melbourne. A portrait photographer by day, she liked to watch tennis online at night. She was about to play the sport for the first time in her life.

She waited outside the clubhouse. It had long green shutters and yellow paint peeling off the old wood. We shared a bench covered in cobwebs and morning dew. She squinted at her racquet, carefully picking at the strings. I asked her if I could sit in on her first lesson, and she agreed. She apologized for what might come.

Her coach that day looked the same as most coaches—harsh tan lines, toned calves, bulky sunglasses, flowy hat. He gave her the rundown, versions of which all players have heard. *Grip the handle of the racquet this way. This is a stroke, like this, and this is how your feet and your legs, hips, torso, and shoulders should interact as one fluid chain as you swing. And your point of contact should hopefully be somewhere you can see.*

"Oh, you hit yourself. No worries," said the coach. He grabbed the basket and drop-fed from his hand. She swung and struck a few balls that went somewhere.

No one can remember the first tennis ball they hit. Or where it went. Some of us might remember the hand-me-down racquet and used balls. Or new everything. And the court where we played on our first days. There were probably, too, some lingering thoughts about the vibes of the game—wellness, or status and celebrity, or style.

The coach paused and briefly explained to the woman what the lines on the court mean. She waved him off and asked to keep swinging. She was already overwhelmed—one has never had more ricocheting, garbled words in their head than while learning to play tennis.

"Sorry," she said.

Swing. Hit.

"Sorry."

(Challenge: Try to get through a hit without saying *sorry*.)

At some point, the coach stopped the swinging and shouted something over the net about her wrist and her hips. She was frazzled and hot, and her fingers must've been tingling by the way she was wringing her left hand.

The session went on for about 45 minutes. She was simply awful. Even as far as beguiling and frustrating first days go, it was painful to witness, like each errant shot was daring the next to go bigger. Throughout, the woman grinned, swung, cursed, swung, hit herself, cursed again, and smiled at the same time. This went on at about 30-second intervals. She was entranced.

At the end, the coach with the toned calves told her that her best tennis was yet to come. And that she'd find ways to calm down, clear her head, and "play a bit more off your instincts." The coach was right. The most popular how-to writing on tennis tells us to empty the mind and just do what comes instinctually. Avoid overthinking. Play freely. It's cruel and annoying, but true.

Before she left for the day, a man wearing a knee brace and an elbow brace waved to her through the fence.

"It's a lifelong sport," he said. She nodded, then turned to me and caught me rolling my eyes. "Not true?" she asked. I admitted that I agree, but also pointed to the poor guy on Court 4 whose back had seized up 20 minutes earlier. He hobbled through every rally with a grimace.

For many, the feelings of our first days tend toward the poles, either full of hope and excitement or simple loathing. Both were true for the photographer that day in Melbourne. And both are fine.

I was curious whether she kept up with the game, so I spoke with her months later and asked how her tennis was going. "I'm addicted," she said. She talked about her strokes—*backhand, garbage; serve, wild*. She had about 15 minutes' worth of gripes about the grunt of someone who often plays on the court next to hers, but also said she'll never switch courts. I asked her what it's like having tennis in her life now, and she paused, then said she was surprised by how the game was mirroring most everything else in her life, like her work, also a solitary preoccupation. Arriving on court is just like going out to a remote location to shoot photographs with just one lens, she said, and she's trying to drown out all the other noise and get better at just one thing for that day.

She said tennis was also reflecting things about herself in ways she didn't expect. She needed to take more time to embrace glee, after a well-struck shot (*finally!*) and in life. She also found she needed better pathways to temper longer-lasting feelings of frustration, wherever they might come from.

Tennis stays in the woman's life as a friend and an enemy, at times a constant companion, at times an off-and-on hookup. The place in Melbourne where she fell in love with the game has become a source of nostalgia, as well as a reminder. As so many tennis grounds are wont to do, the courts foster an opportunity to bring introspection to our largely unreflective lives.

We can use it to see truths within our temperament, problem-solving, anger, and bliss. Our tennis, over time, mimics how we digest timeworn themes like longing, triumph, and loss. And maybe changes in the tennis can begin to dictate the life. When on-court, though, the game will never cease to be riddled with the same fraught confusion we met on our first days, and the space between introspection and frustration need not be reconciled but rather revisited at the start of every session. Tennis will always captivate and pick away at us. •

TENIS CLUB ARGENTINO

Buenos Aires, Argentina

Every month, four truckloads of clay, formally known as *polvo de ladrillo*, get dropped off in Buenos Aires's leafy Palermo neighborhood. All the dusty red powder, mostly made of pulverized red brick or shale, is kept in giant metal vats and eventually carted out by wheelbarrow and spread across these meticulously maintained courts.

These are the clay courts of dreams, tracing their roots back to 1913, one of the richest tapestries of clay-court history in this hemisphere. They're certainly the most unanimously adored plots of clay in the country, thanks to a staff of over a dozen groundskeepers, several of whom have worked here most their adult lives.

The ties to the clay and to the club are unwavering. Gustavo Viacava, known as Gusy, a longtime TCA coach, has taught on Court 15 every day for nine hours a day since the 1980s. He's seen Argentine professionals and Davis Cup coaches develop here since they were juniors. Most regulars favor Court 9, directly in front of the Tudor-style clubhouse, and they'll book their time on that court long in advance. Foreign ambassadors and the families of tennis legends come here to play alongside the professionals who often train here. There's also an adherence to the original touches that endeared the Argentine and foreign tennis communities to the club in its early days. In the locker rooms there is still a sign that directs the match winners (*ganadores*) to one set of showers and losers to another.

The club is only a 15-minute walk from Buenos Aires Lawn Tennis Club, an institutional cornerstone of the Buenos Aires tennis corridor, a three-mile (4.8 km) stretch of nonstop clay courts wedged between the city airport and the city's most iconic parks. There's Deportes Nacionales, Racket Club (formerly Vilas Tennis Club), SportClub Obras, CeNARD, and Club Ciudad de Buenos Aires. Even the police headquarters, also on Libertador Avenue, has three clay courts. All are neighbors, party to a continually replenished dust bowl over 100 years old.

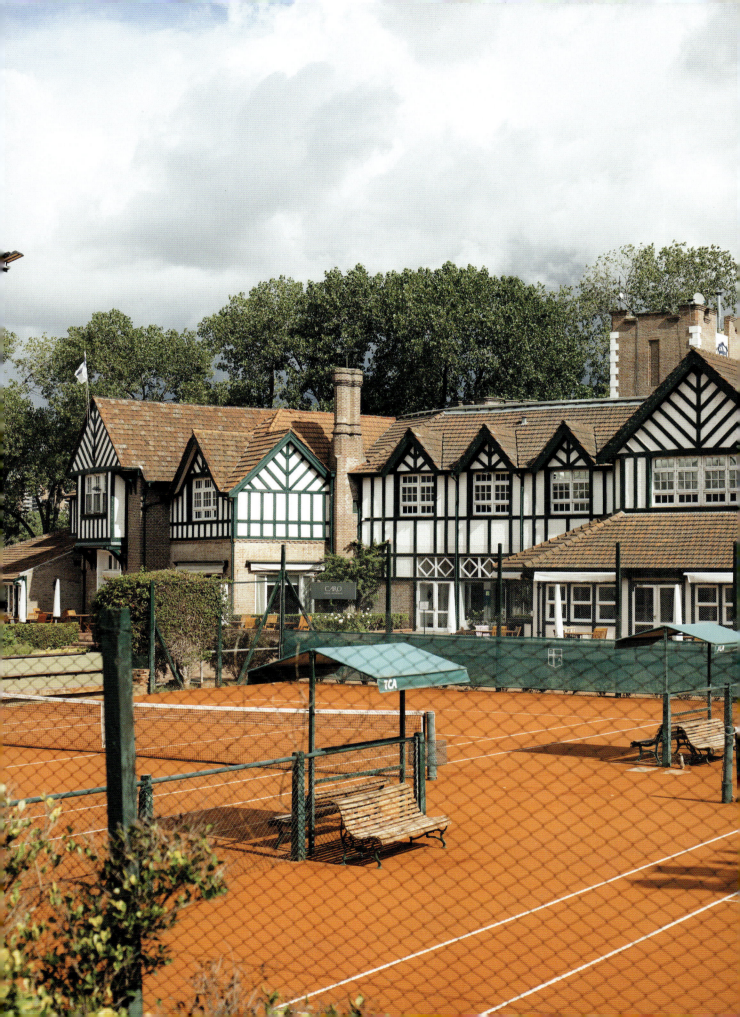

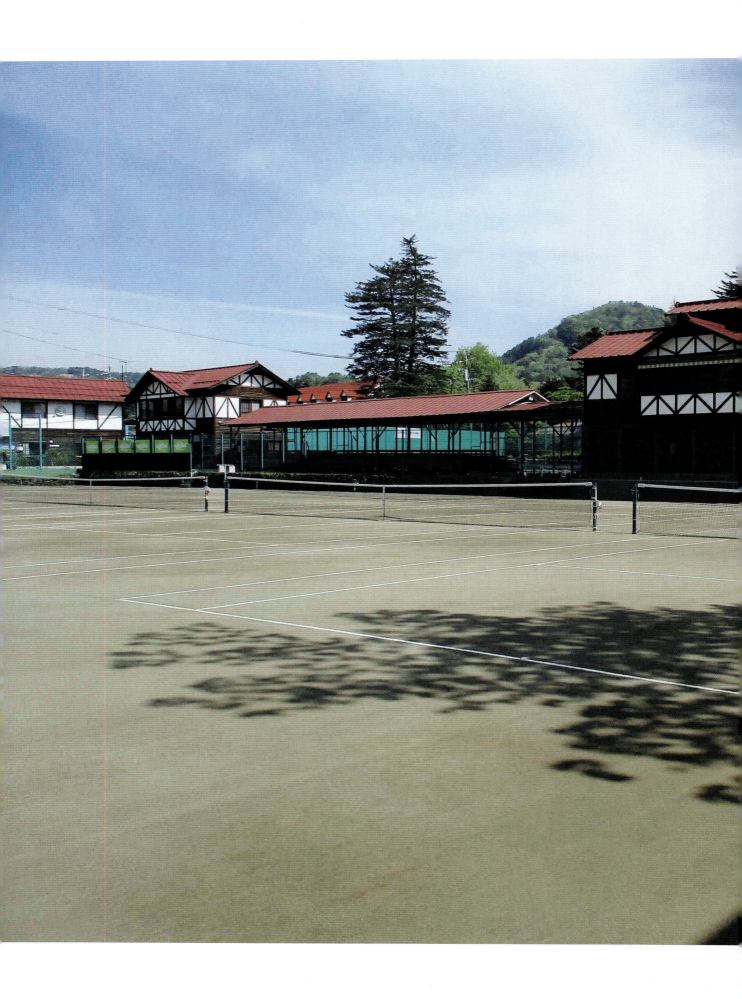

KARUIZAWA TENNIS COURTS

Karuizawa, Japan

It was a typical hot August day in Nagano Prefecture. At the local courts tucked behind the tall forest, the clay had been brushed off the lines and everyone present had brought their own wooden racquets. Most were on holiday, trading Tokyo heat and noise for the quiet respite of Karuizawa. All arrived to be randomly paired up for the weekly drop-in doubles play.

On one of the courts, a mixed doubles match unfolded. Everyone on-court had only just met that day, gathering there to exercise and commune over this exciting pastime that was gaining popularity around Japan. It was a leisurely round of play but still competitive—each side analyzing the other's serves, the assuredness of their volleys and overheads, the shape of their slices, their temperament on changeovers.

But this was also a fateful match. On one side of the net that August day in 1957 was 23-year-old Crown Prince Akihito, future emperor of Japan. And on the other was the woman who would become his partner, 22-year-old Michiko Shōda, a well-off "commoner" with a degree in English literature. It's been reported, but never verified, that the future empress's team won the match, the first of many to come. The two began playing together regularly, mostly at the Tokyo Lawn Tennis Club (page 292), and married two years later.

The tucked-away courts in Karuizawa still host new doubles pairs on the 13 Japanese clay courts just northeast of town center. Not too long ago, the former emperor and empress visited the courts and rallied on the same court where they met—different racquets, same surface.

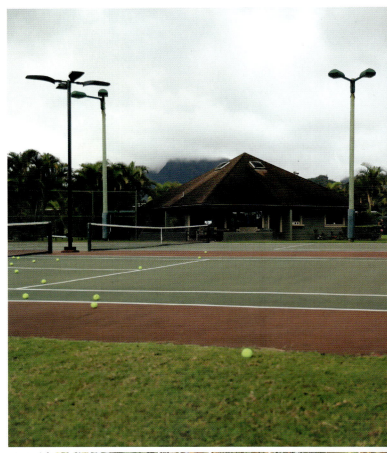

KAILUA RACQUET CLUB

Kailua, Hawai'i, USA

Some regulars at this member-owned club still miss the turn on Oneawa Street. It looks like someone's private driveway. The smell of plumeria in bloom drifts through the air. The only sounds are from a dog or a rooster, or a distant echo from the valleys of the Ko'olau Mountains.

Nine hard courts, each with the same dark-red-and-green surface, are interspersed around the Kailua grounds. The windward side of O'ahu was largely undeveloped in the 1930s, when the founders bought the land in the dense flora and dug deep into the marshy soil to build one tennis court, a sand volleyball pit, and a pool.

These days, the club comes alive in the evenings, especially on Tuesdays and Fridays for drop-in doubles matches. (These happen to be the two days of the week when the on-site bar serves drinks until the end of play.)

The club also holds the truest mark of a local, community-owned club: Bruce the cat can almost always be found sunbathing outside the clubhouse by Court 7.

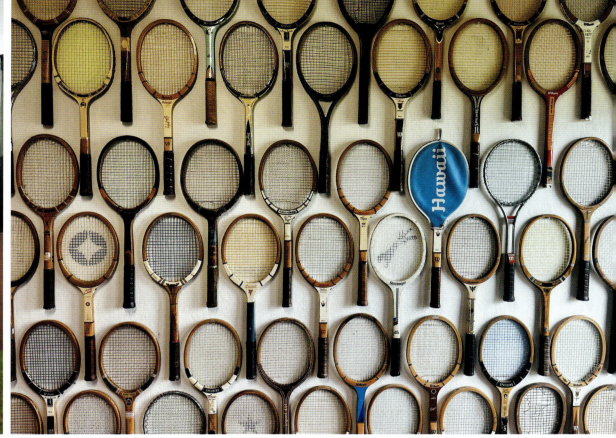

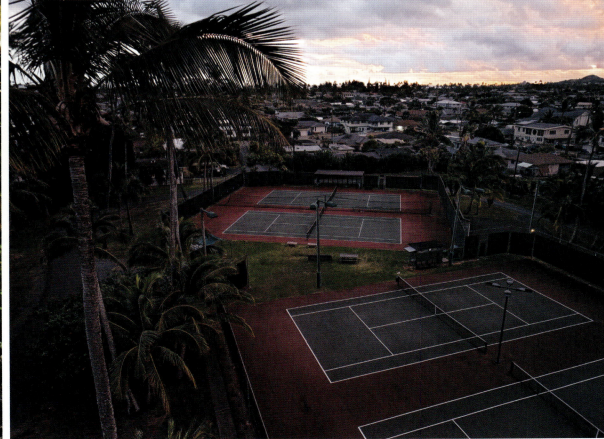

LUANCO TENNIS CLUB

Luanco, Spain

It started as a summer gathering among a group of friends. In the 1970s, on the remote Asturian coast of northern Spain, two brothers and their friends with a fondness for tennis got together on the dark sands of Luanco, wooden racquets in hand, and made their own stage.

On La Ribera beach, they drew lines in the sand, found a net and wood posts, and hosted their own round-robin tournament. The sand was firm, close enough to clay, and the ball bounced fine. The friends later wanted the tournament to resemble the Davis Cup, so they gathered four teams of two, all newcomers to the sport from Luanco and the neighboring town of Candás. They even got a referee to officiate.

Soon, the town took notice and crowds formed on the stone walls above the beach to watch. Metal plates replaced ropes and hand-drawn lines, a practice that continues today in the Torneo Tenis Playa Luanco, now a professional exhibition event that has become something of an Asturian sensation.

The Luanco Tennis Club was formed just to sustain this celebration of local tennis. Playing on the coastline, this pop-up 2,000-seat stadium court floods every 12 hours when the tide comes in. Kids swim in the pool that forms. When the tide goes out, the sand firms, the metallic plates for lines fit neatly together, and the town returns to the court ready for play, even if it's the middle of the night. The community admits that they do not relocate sand to make the court perfectly level—there are slight inclines to the muddy court because, keeping to tradition, it's created by the sea.

All the greats of Spanish tennis have made the trip to Luanco to play on the beach: Manolo Santana, Sergio Casal, David Ferrer, Pablo Carreño Busta, Feliciano López, Carlos Moyá, and others.

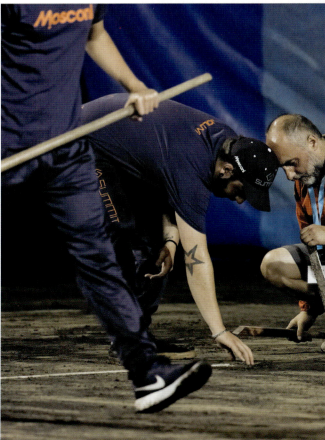

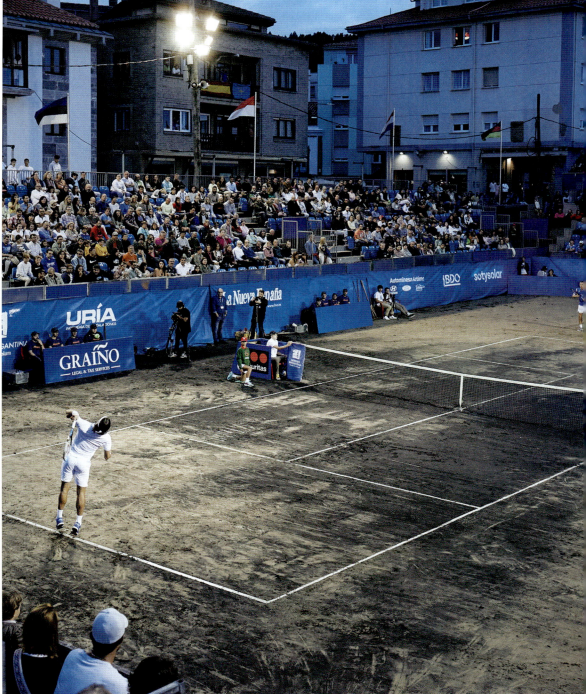

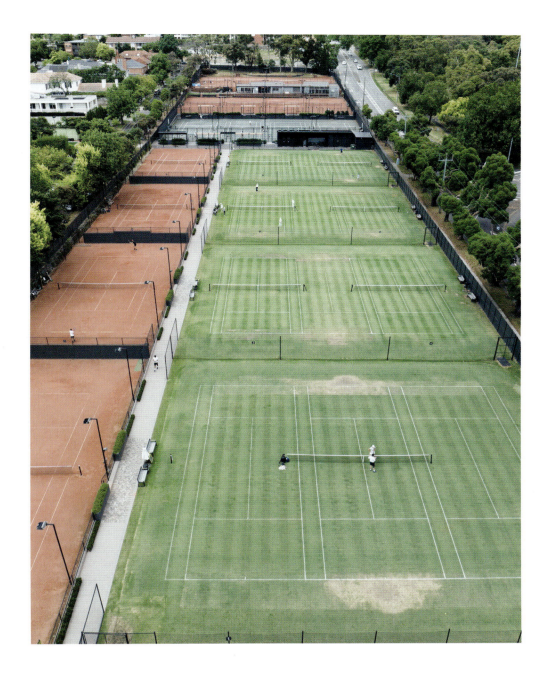

ROYAL SOUTH YARRA LAWN TENNIS CLUB

Melbourne, Australia

As far as historic clubs go, Royal South Yarra exudes community and neighborly rapport more than most. Juniors in the development program under veteran coach John McCurdy, who worked with Lleyton Hewitt, grind out ground strokes on the clay and Har-Tru (see page 322) courts alongside longtime members and guests enjoying a hit on the grass. One such member often playing doubles with friends is Judy Dalton, one of the Original 9, the female players who formed their own tour and laid the foundation for professional women's tennis as we know it today.

With around 4,500 members, it's the third-largest club in Australia. Many pros stop here to train, and visitors write to the club to request a stay at the on-site apartments. In the clubhouse, the entryway doubles as a museum full of shadow boxes honoring Neale Fraser, Margaret Court, and others who honed their games on these very courts.

HITS BEHIND THE PIAZZA

Italy

Bustling tennis tribes kick up clay in the backyards of the Spanish Steps and the Vatican in Rome, and Piazza Michelangelo in Florence, all landmarks with community courts within striking distance. Local hitters chafe against the congestion of getting here, but would never choose to play anywhere else than their nondescript tennis havens. They've been coming here to play just as their grandparents and parents did, often at the exact same times of day. One family will tell you to always listen for the sounds of racquets striking balls whenever you're getting lost between the piazzas.

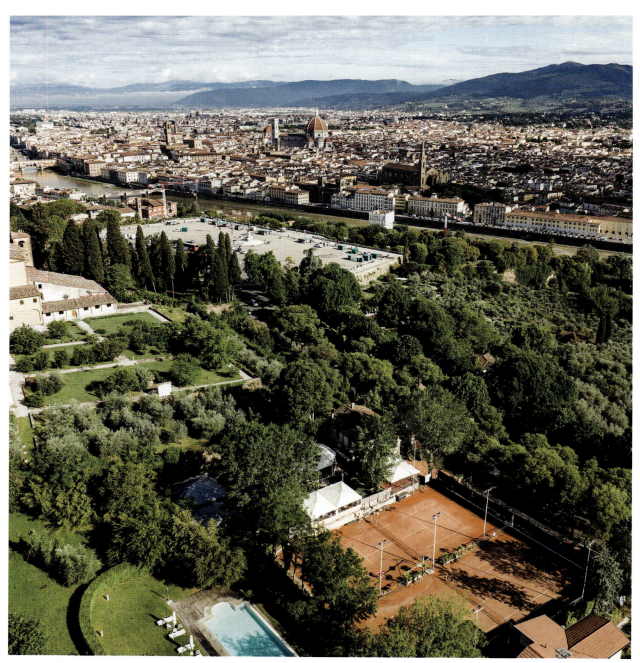

TENNIS MICHELANGELO

Florence, Italy

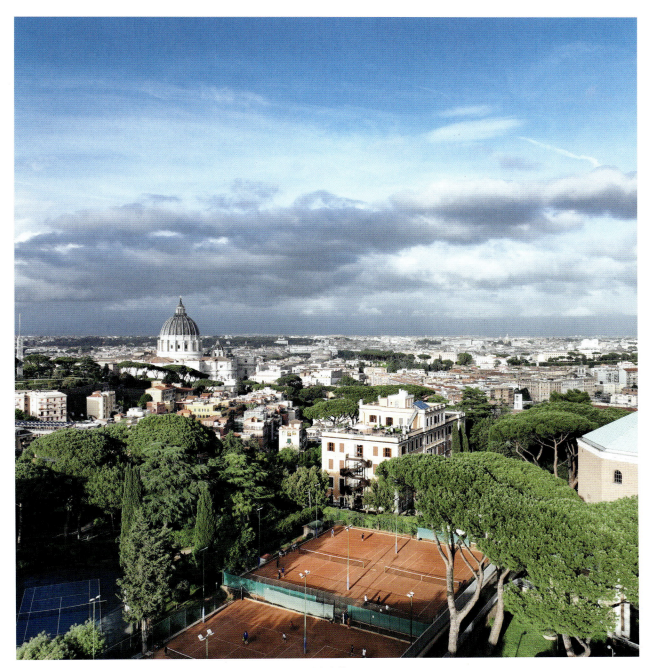

CIRCOLO SPORTIVO TENNIS EMILIA DE VIALAR

Rome, Italy

GEZIRA SPORTING CLUB

Cairo, Egypt

The 30 clay courts at Gezira embody the tennis residence. The players, coaches, and guests fringe around Court 1 and talk tennis as part of their daily and nightly routines. Long into the evenings, once the heat subsides, it's not uncommon to see a coach wandering about and encountering their students, asking when their next hit is and what they're working on. But it goes much deeper than that. Here there's a dedication to understanding the sport beyond its physicality, like how to focus through the terrain of a four-hour match, keep yourself in your head and control your thoughts, and not be overwhelmed by the aloneness. At least that's how the chatter on the patio overlooking Court 1 goes.

Play ramps up on the clay courts at Gezira around mid-September every year. There's little play in summer, as the only tolerable hours to play are early mornings and late nights.

The sporting club at large sits in the center of Zamalek Island and boasts having reached more than 40,000 families, both Egyptian and foreign, since opening in 1882. It's not uncommon to see a grandparent rallying with their grandchild on the training courts. But the most prized hitting partners here might be the ball kids, all of whom come from lower-income families in Cairo, and who are some of the most astute players and analysts. Observing the sport for hours every day yields some shrewd tennis minds, able to critique the carve of strokes or serves with ease. If you're out playing, and they know you well, they'll comment on your swing. "You're a little rusty today," or "You need to calm down." Most of them go on to be hitting partners and coaches.

Gezira hosts the Pharaoh's Cup, an international event for top juniors from around the continent and Europe, and hopes here run high that as the sport continues to grow, more professional tour events will arrive in North Africa. In early 2024, the Davis Cup returned to Egypt and took place on the famed Gezira Center Court.

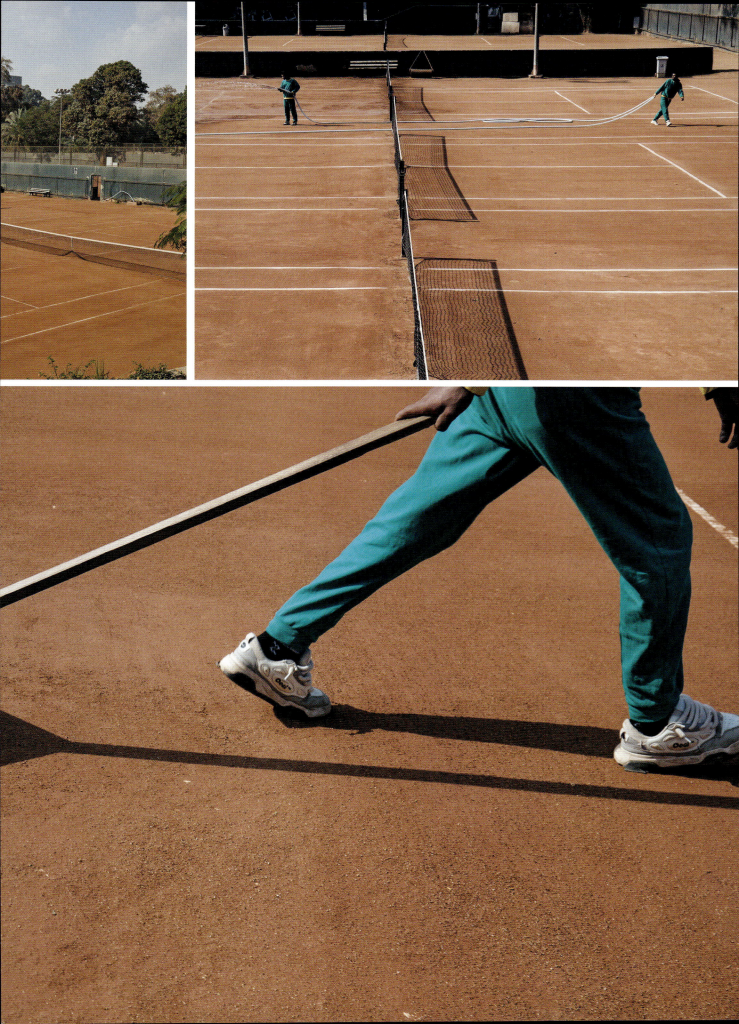

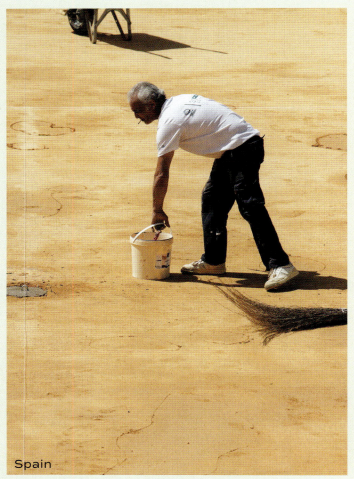

Spain

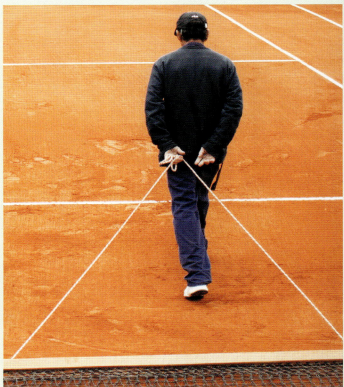

Argentina

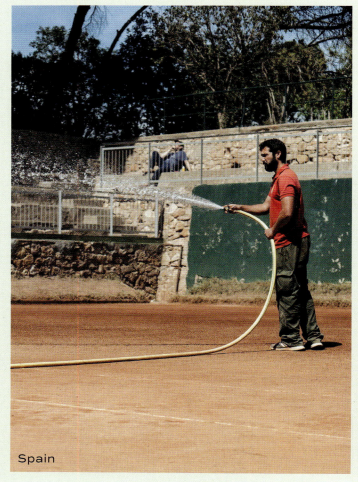

Spain

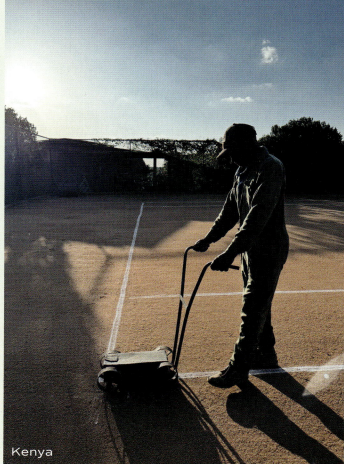

Kenya

The Keepers of a Court's Secrets

No matter the surface, the individuals who maintain tennis courts worldwide harbor a special connection to the court. Funnily enough, most of them don't play or follow tennis. The groundstaff at Wimbledon is quicker to banter about Premier League football than the upcoming edition of the Championships. Same goes for the groundstaff of the golden sand courts in Sevilla, Spain (but they riff on LaLiga), or the courts in Pune, India (cricket). They do all share a lingua franca of precision and perfectionism. The size of the granules must be uniform. The grass must be firm but not too firm. The lines of the hard court mustn't have a blip of errant paint. They're poignantly infatuated with details in service of a game they don't engage with. Only they will truly know the courts with all their imperfections and quirks.

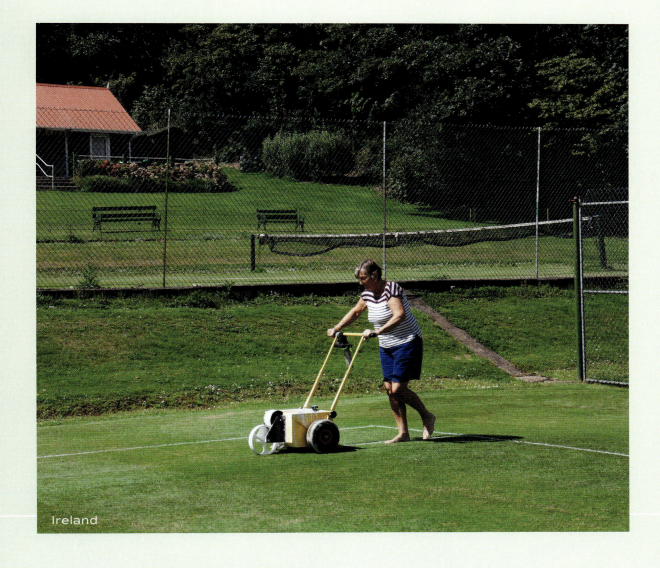

Ireland

TENNIS CLUB SAN STIN

Venice, Italy

A member of the tiny Tennis Club San Stin, a very well-kept secret, tells a story about how they came to find the club.

They had heard rumors about a tucked-away single outdoor clay court in central Venice. "*Segreto, segreto*," one person said. The court was talked about as if it were a front for something sinister. They set to walking, getting lost among the canals, hoping they'd hear the sound of a ball being struck. One day, while crossing from Campo San Polo and Campo San Giacomo dell'Orio, they heard the pop of cans opening, probably a coach refilling a basket. They looked up and noticed that above a 15-foot (4.6 m) wall was an even higher fence shrouded in vines. It'd be several years and many friends-of-friends connections before they joined San Stin and became one of only a couple dozen people who hit on this court.

There's no logo or sign other than a mailbox engraved with TENNIS to hint that there's a court above the canals and damp walkways. The court switched hands many times through the early twentieth century, often going unused as a backyard ornament for whichever high-ranking Venetian society member owned the attached villa. In the early 1960s, some friends who used to meet at the court, having convinced the owner to let them play, heard the villa had been sold, leaving the fate of the court in jeopardy. They quickly procured a city decree to designate the court as a historic site and establish themselves as a club, at first called Circolo Amici del Tennis, with a logo of a cat for reasons unknown. Several iterations later, the group settled on San Stin, with a simpler logo. The clay in city-center Venice is among the wettest, stickiest clay one can find with a ball bounce that, when translated, one member called a "sludgy bounce."

Although tennis players around Venice likely won't become members, or even be able to see the court, people still look for it. As with anything, there are always breadcrumbs: If you see a local dog out for a walk with its owner pick up an errant tennis ball, you're probably near what is easily among the best-kept, most beloved tennis secrets.

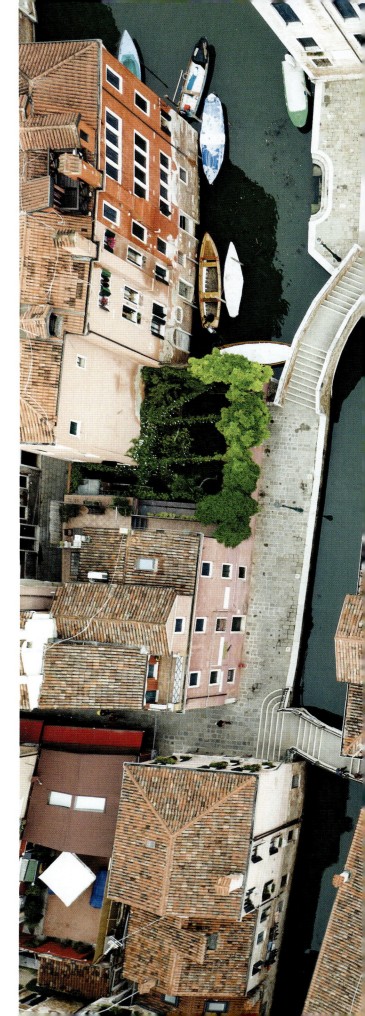

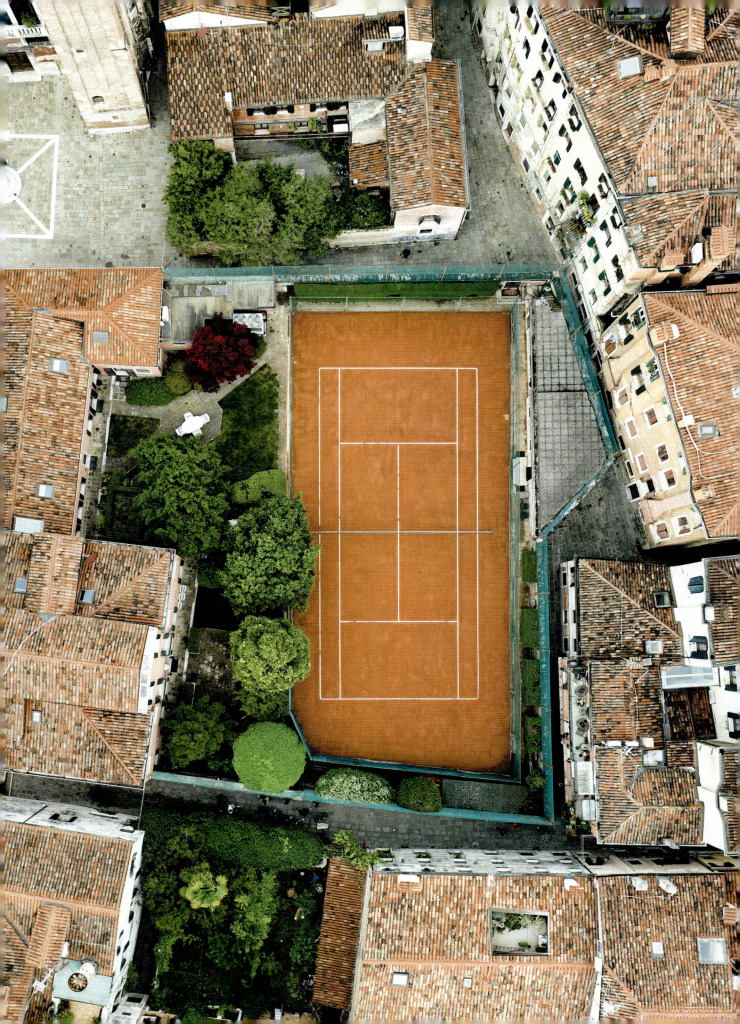

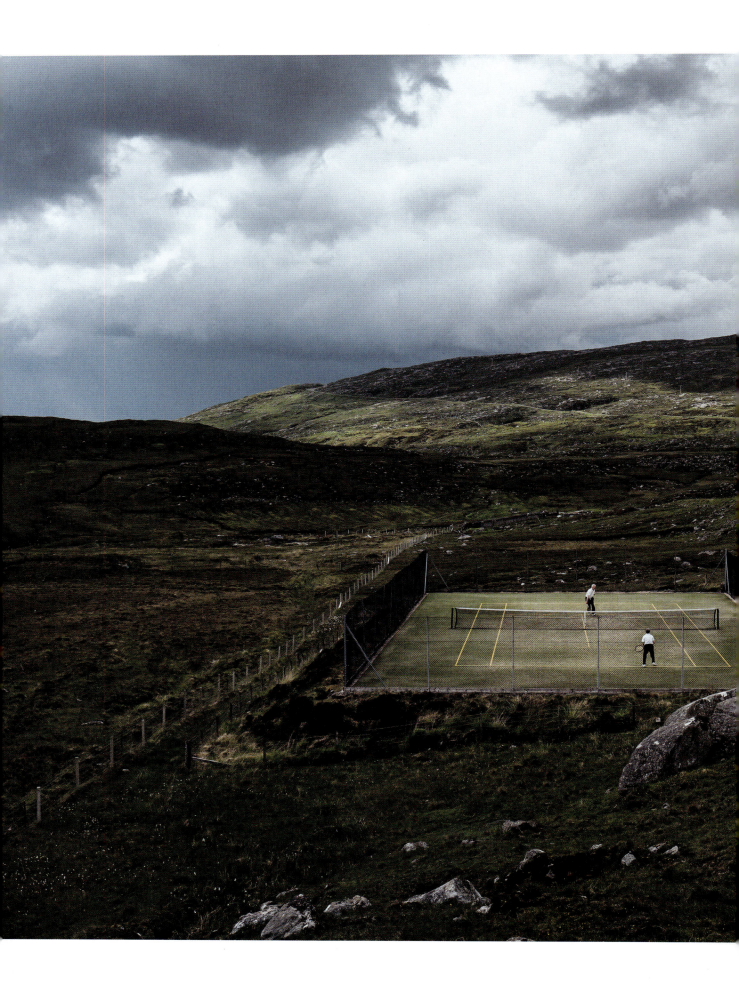

BUNABHAINNEADAR TENNIS COURT

Isle of Harris, Scotland, UK

Mike and Peggy Briggs envisioned their court at the base of Uisgneabhal Mor, more of a large hill than a mountain, on Scotland's western Isle of Harris. It's close enough to the seaside to hear the sounds of the waves but far enough to be protected from the northern winds. Having relocated to the isle from southern England where they had played tennis often, the couple wanted a place for the community to play. Previously, kids used fishing line for nets across an unpaved road. The local estate sold them the land for a single pound, and four years later, after much crowdfunding, letter writing, and drilling into the stone, the turf court was finished.

Today, a ferry ride and a lengthy road trip to Bunabhainneadar end at a roadside sign that reads "Available for hire every day of the year except Sundays." It is perhaps the world's most resilient court, enduring the worst of the lonely North Atlantic winters. All is restored during the idyllic Scottish summer.

ARGIDEEN VALE LAWN TENNIS & CROQUET CLUB

County Cork, Ireland

What do you do when your tennis is in need of a new phase of life? Maybe you imagine yourself taking long changeovers, unconcerned with chasing form or scores. Or maybe you're retiring from play and just want to watch in peace. Many in Ireland dream of starting their new eras at Argideen, an all-grass club in the vales of western Ireland.

A community of families keeps and protects these rural grounds, and a married couple has tended to and played on these six pristinely maintained grass courts for 18 years. On these plots, the 83-year-old father plays five sets of tennis on a Saturday with his 81-year-old wife, while their daughter and son-in-law play on the next court over. A longtime member needles the younger players, taunting them after a missed volley. The most prized event of the season is a doubles tournament where everyone draws the name of their partner from a hat and takes the time to commend the groundstaff. The rest of Ireland ventures here for annual tournaments like the West Cork Open.

The courts are only open for play three days a week, and the remaining days allow the grass to rest and recover. (The regulars here remark that such a model would serve many players well; time off is just as important as time on.)

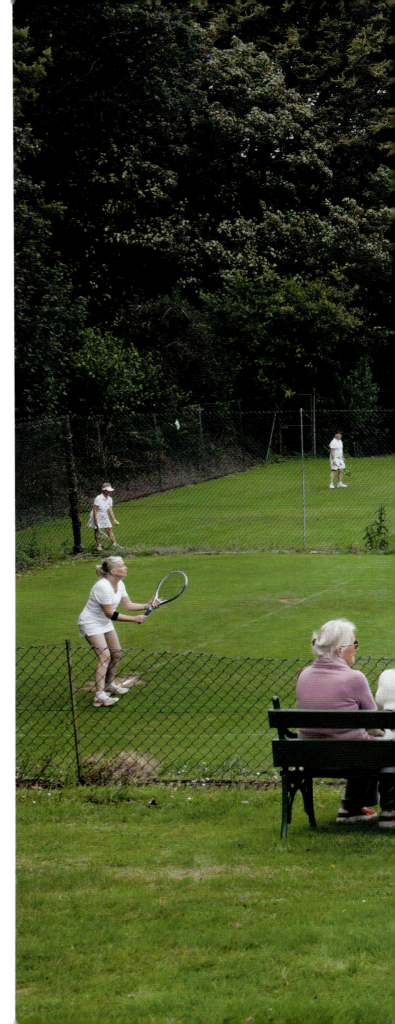

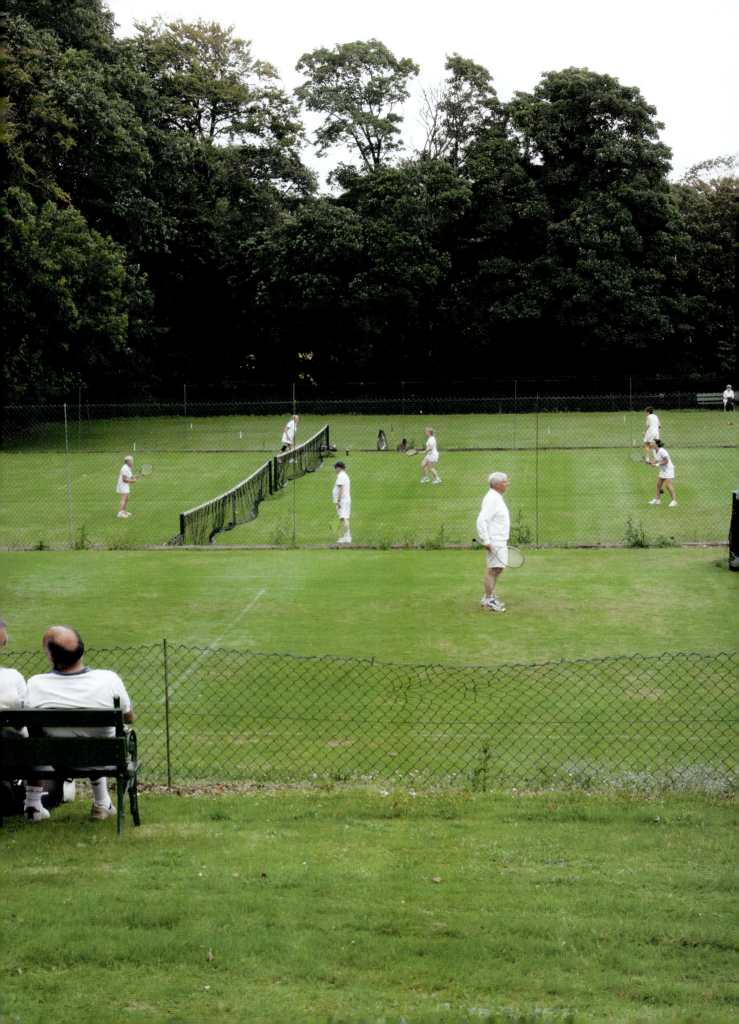

DANSK TENNIS CLUB
Copenhagen, Denmark

When 24-year-old Leif Rovsing arrived in Stockholm for the Olympics in the summer of 1912, he was already a champion. He'd won multiple national doubles titles in his home country of Denmark and had played both singles and doubles at Wimbledon. Leif had something of a reputation for being a hothead, and wrote in his journals about emphatically refuting line calls during matches (line calls were as hotly contested in 1912 as they are today). That summer, he arrived at the Olympics and played several matches. Some contests were held on what was one of the most beautiful courts he'd ever seen, the indoor court at Tennispaviljongen, Sweden's tennis cathedral, on a wood surface. Leif didn't win a medal at the Games, but still returned to Denmark as an idol for many who were infatuated with this relatively new sport.

Leif's idol status changed dramatically just five years later, when he was investigated by the sporting community on suspicion of being gay. Under the guise of protecting youths from exploitation, the sporting establishment banned him from tennis competition. A tumultuous time followed, during which Leif, not denying his sexuality, argued for himself in local Danish courthouses that he should be able to play. He had minimal success: He was able to play briefly when the ban period ended, but only one or two clubs in Denmark would invite him; others sought a more permanent ban, which was renewed in 1923 and cemented in 1928.

Amid the turmoil, Leif took a large inheritance he'd received from his deceased father and built his own wood-floored indoor court in Hellerup, a northern suburb of Copenhagen. He called it the Dansk Tennis Club.

While the exterior of the hall was meant to resemble the shape of a central train station, Leif pulled influence for the interior from what he liked about design and his deep knowledge of tennis, drawing inspiration from the best parts of indoor courts he'd played on in London, Stockholm, and elsewhere. He knew overhead lighting overly complicated play, so he made a rectangular structure with a cantilevered wooden roof and placed windows high along the long edges of the court, creating one of the first side-lit indoor courts ever made. He hung large pieces of white fabric perpendicular to the windows, like sails, to diffuse and refract the light.

The inside of the club was an atlas unto Leif himself, a refuge built around love and acceptance, for Leif and anyone else seeking a space to express themselves freely in tennis and in life. Leif savored the art of Egypt and the expressiveness of Bali, both places he traveled to in his thirties. Paintings reminiscent of his time exploring other continents cover the walls.

Leif's club on Rygårds Alle still stands today, although it's a hard court, no longer wood. All the paintings are maintained by the National Museum of Denmark. It's one of few courts around the world that is a true product of a single person's life. Leif chose to build a monument to the sport in the midst of a lonely battle against its national institutions. In this cavernous hall, it's easy to reflect on the ways tennis has been exclusionary, obstinate, and unkind to many over generations. But this is really a space to consider and have gratitude for the people like Leif who seek to move tennis forward.

People who frequent Leif's club sometimes say that the white sails by the windows can hold your dreams. They can hover there and be kept warm in the light.

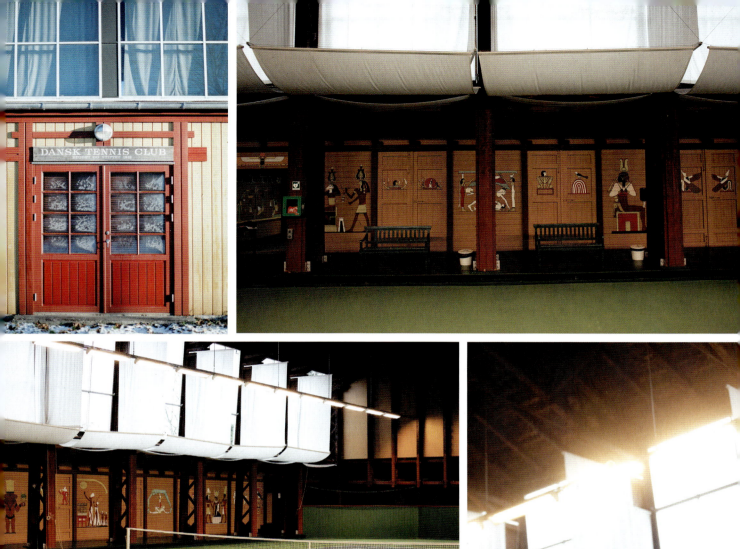
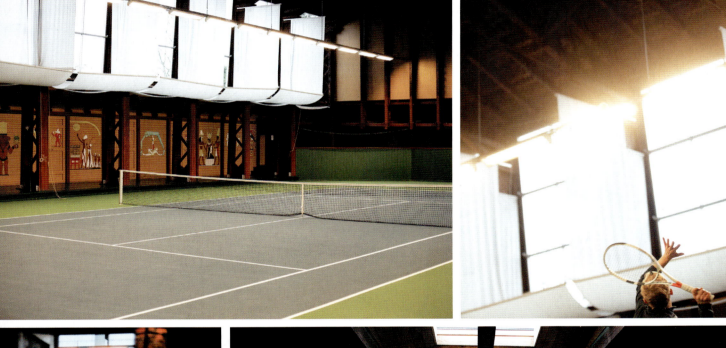

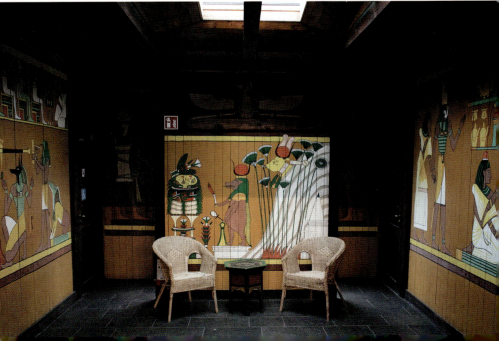

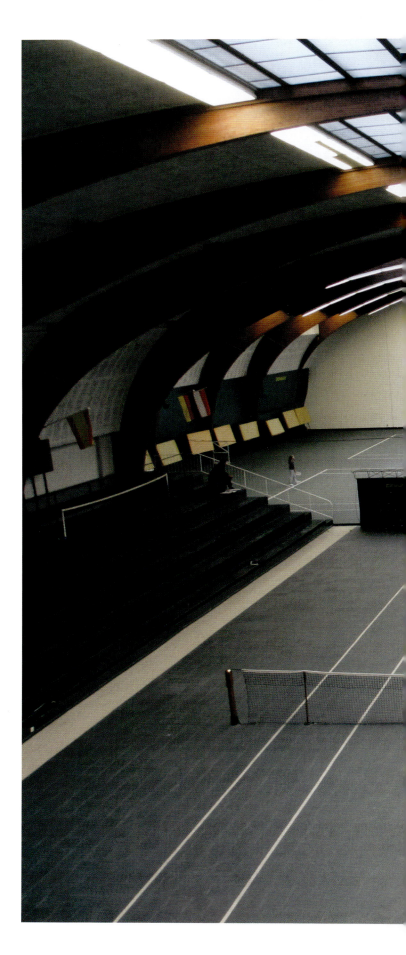

TENNIS CLUB DE BELGIQUE

Brussels, Belgium

There's a place that can act like a salve for those disillusioned with their tennis, or disenchanted with their tennis generation, or maybe just disillusioned with the world. Behind door number 26 off bustling Avenue Louise in central Brussels, an elliptical roof covers a home for true tennis enthusiasts and egalitarians. Founded in 1954, the club was the first indoor tennis space in Belgium. It mimicked the surface of the storied indoor hard courts of Sweden, and quickly drew in tennis's biggest names. The current owner has set up shop to embody a tennis-as-cinema sensibility, and the place should feel like a 1950s theater when you enter and watch a match. The overhead windows point a natural spotlight directly on the 1,000-seat center court, leaving spectators in a hushed dark.

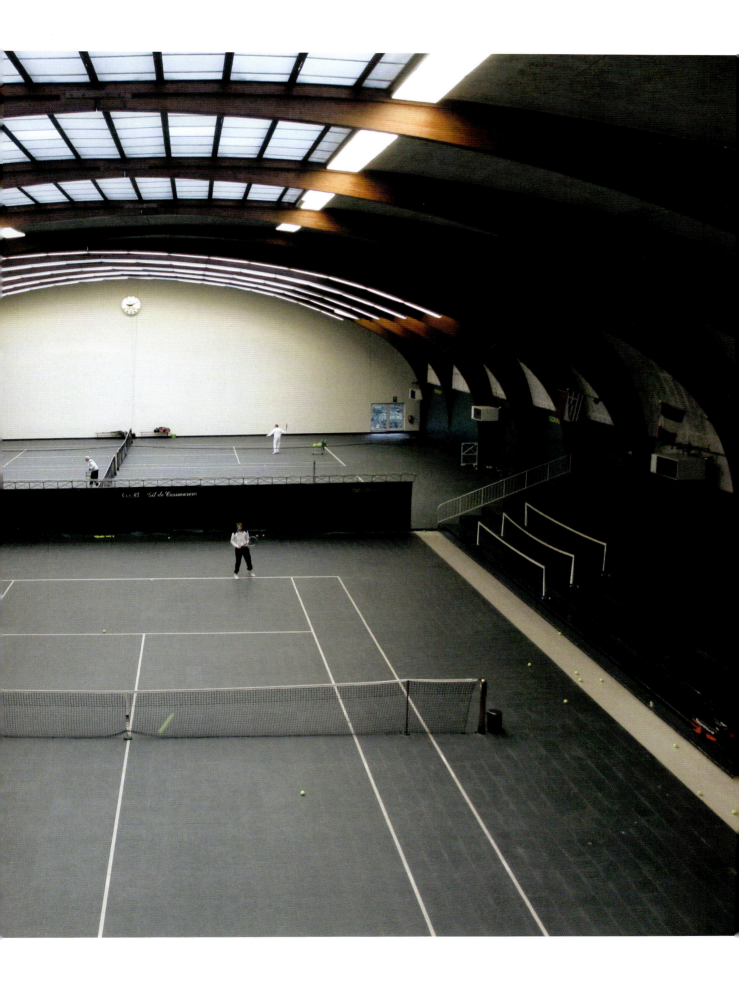

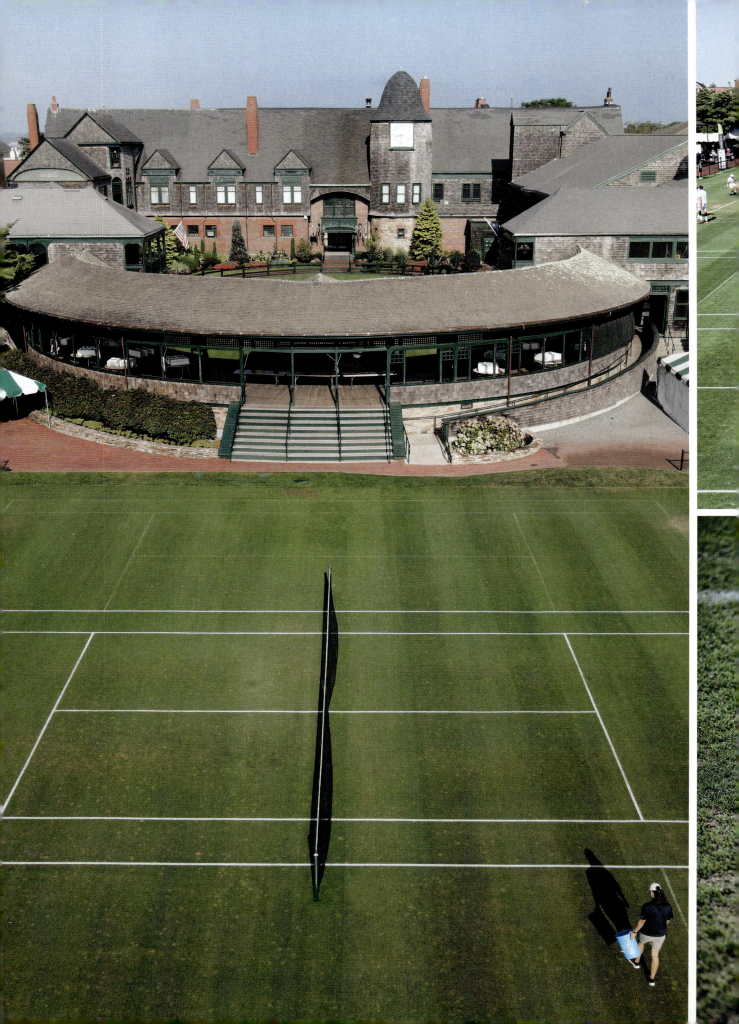

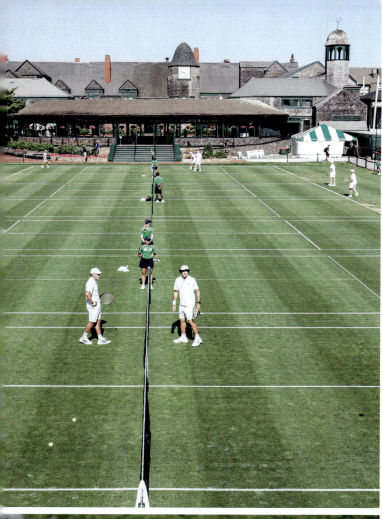

INTERNATIONAL TENNIS HALL OF FAME

Newport, Rhode Island, USA

Before the US Open went to Forest Hills, and later Flushing Meadows, it was held here on the manicured lawns of the Newport Casino. These storybook grounds only grew in prominence when a local sportsman established a shrine to tennis at the casino in 1954, which would eventually become the International Tennis Hall of Fame.

Now with a wider array of courts, including indoor hard courts, the grass remains the centerpiece with its all-white dress code. Many players and fans make the pilgrimage here for the museum, a way of transporting themselves back to nineteenth-century Wimbledon and every decade of tennis that unfolded thereafter, in every corner of the world. What's more, anyone can come play here.

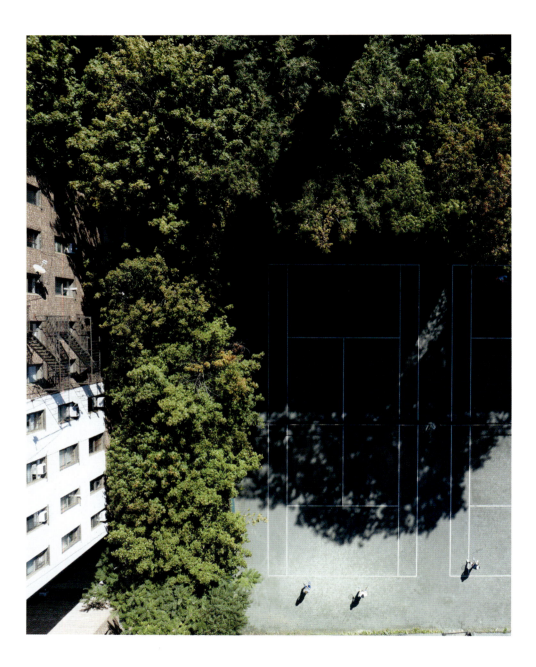

KNICKERBOCKER FIELD CLUB

Brooklyn, New York, USA

Deep in the heart of Flatbush, Brooklyn, five courts hide behind apartment complexes on the corner of Tennis Court and East 18th Street. The heritage of the Knick, as members call it, goes back to 1889. No club has seen its urban surroundings transform quite like here. Throughout its 130 years, the club has managed to sustain a veranda-style clubhouse (which burned down in the 1980s and was later rebuilt) with generations of Brooklynites old and new hitting together on the Har-Tru courts until dusk. Music streams out the windows of the apartments overhead, and one of the city's busiest subway lines rumbles by behind the trees. Amid it all, the Knick maintains an aura of easy community tennis rife with neighborly rivalries, especially among its elder members. The member-owned club is open to anyone who submits an application to join—the waiting list, however, is just about seven years long.

The commitment to these courts runs so deep that a member who passed away in 2022 had their ashes spread out on Court 4, their most treasured place.

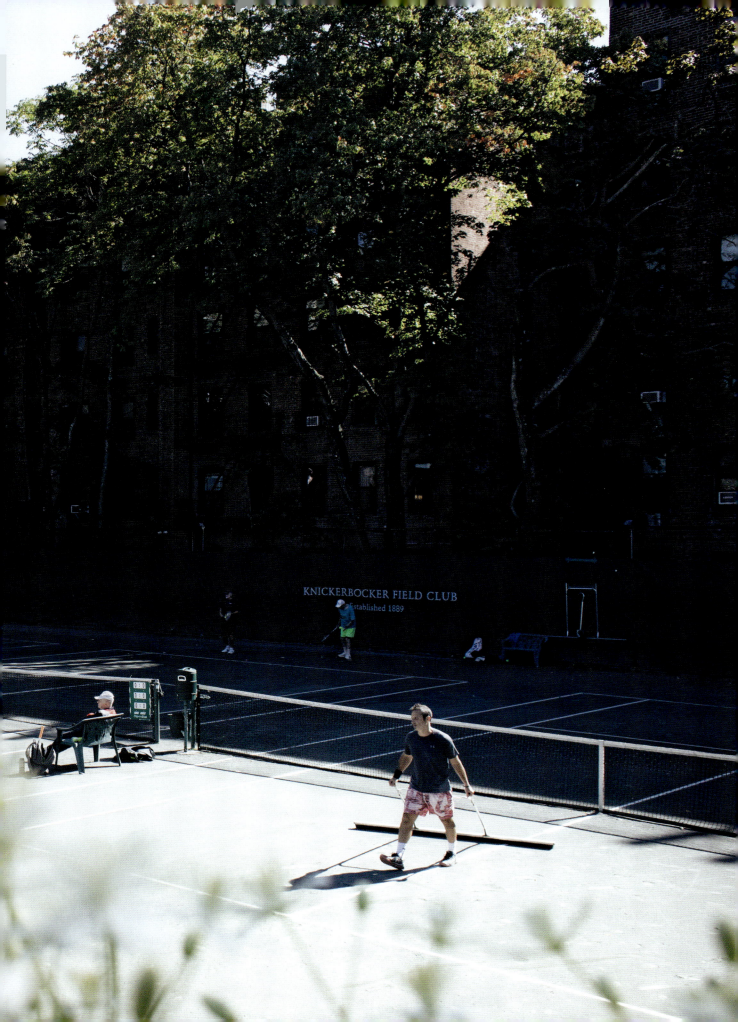

ALL IOWA LAWN TENNIS CLUB

Charles City, Iowa, USA

The drive from any major city to the All Iowa Lawn Tennis Club gives one several hours of passing cornfields and cattle farms and plenty of opportunity for daydreaming. Some of the pleasure around this grass court in the middle of America is in the very anticipation of it—the image of the court beyond the white picket fence, the vibrant green with crisply painted lines surrounded by farmland. The moment arrives and the armchair fantasy materializes.

The place is no longer a secret. Newspapers, magazines, and TV crews have all made the trip to Charles City to meet Mark Kuhn (pictured top left and opposite), the Iowa corn and soybean farmer and Wimbledon grass aficionado who made a now sacred grass court in the middle of the Great Plains.

Kuhn has been fascinated with grass-court tennis since he first heard Wimbledon radio commentary as a boy. The obsession blossomed over the years, and he finished the court dressings for the first time in 2002. Kuhn has traveled to Wimbledon a handful of times, and has even convinced the staff at SW19 to let him be an honorary court attendant leading up to the tournament—hanging the nets, painting the lines, monitoring the irrigation, squinting at the height of the blades of grass. The groundstaff at Wimbledon all know Mark. Many of them also know that his court in Iowa continues on year after year in memory of Kuhn's son, whom he lost in 2016. It's one of those rarefied places where one family's entire history, their triumphs and losses, merge with a passion shared with the world.

Today, Kuhn hosts a junior tournament every year where Iowa players compete against kids from surrounding states—the Alex J. Kuhn Memorial Invitational, named for his son. The green-and-purple insignia appear all around Kuhn's backyard while the Union Jack flaps in the wind. The court is available to anyone willing to make the trip, particularly those who believe that tennis, and sharing tennis, has the power to heal us.

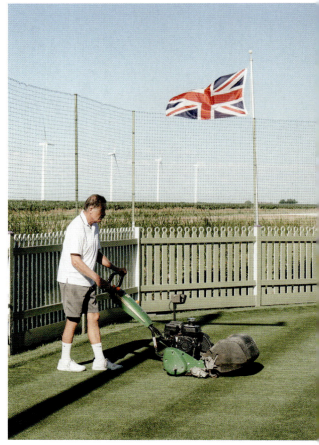

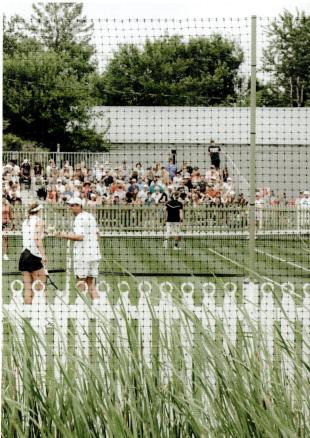

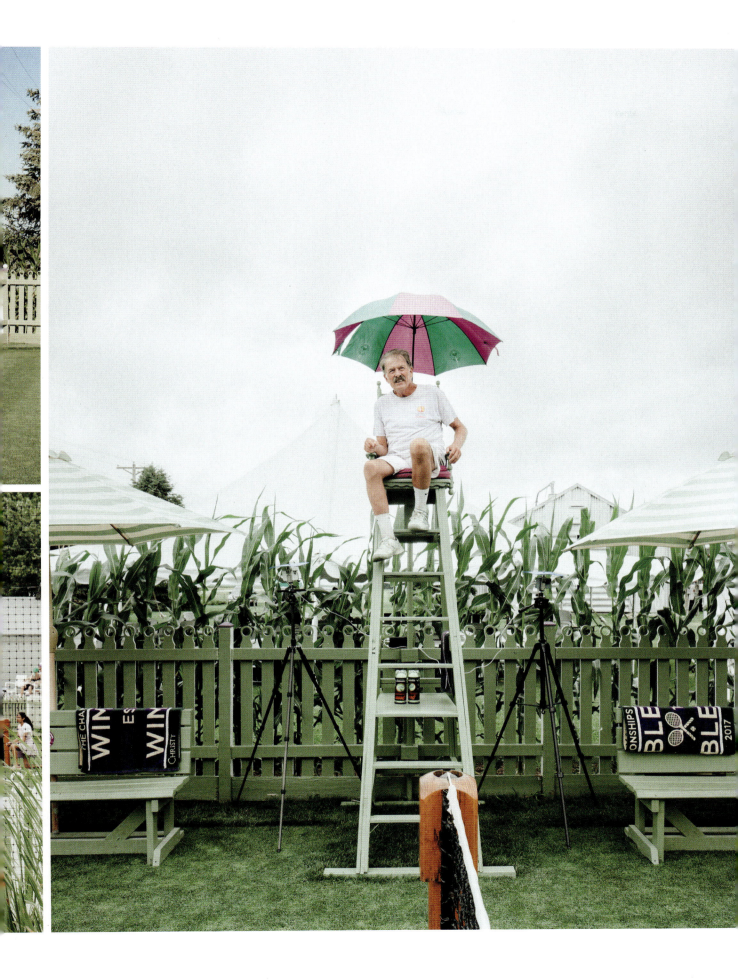

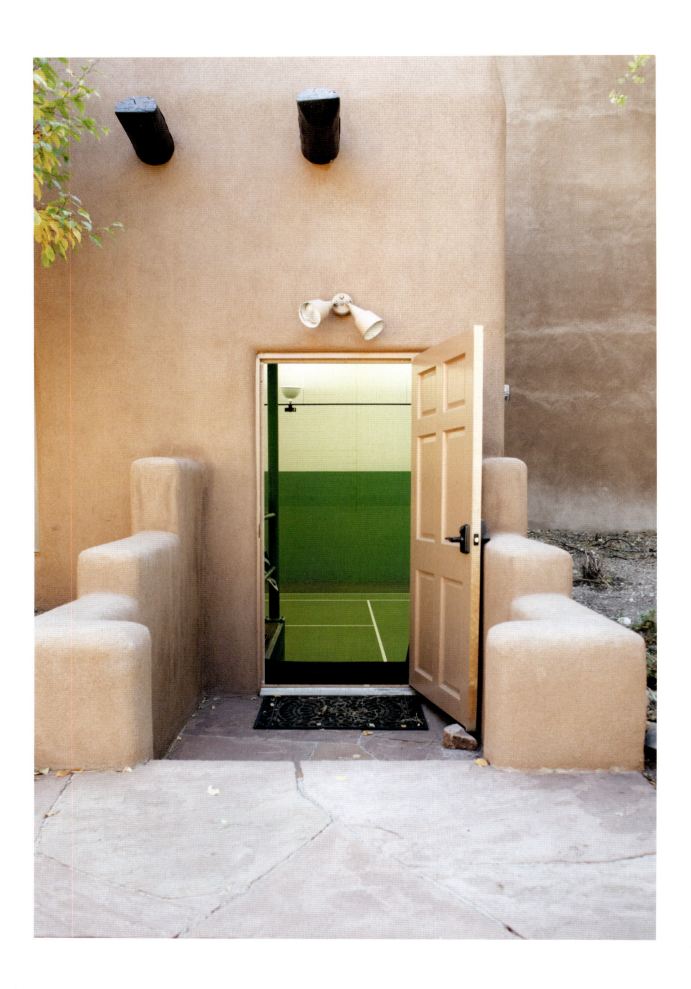

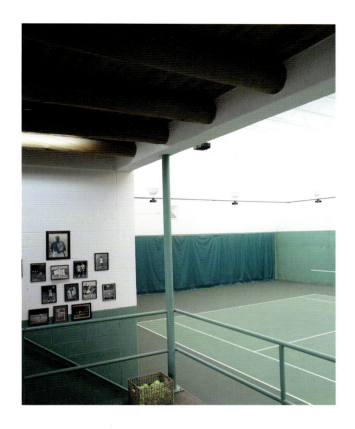

HELDMAN HOUSE

Santa Fe, New Mexico, USA

For those who don't recognize the name, take what Billie Jean King says about Gladys Heldman: "Without Gladys, there wouldn't be women's professional tennis."

Since the 1950s, Gladys Heldman has impacted every corner of tennis. She started *World Tennis Magazine*. She cocreated and secured the financing for the Virginia Slims Circuit, the first professional women's tour, which led to the creation of the Women's Tennis Association (WTA) several years later. She was also a player herself. She won the Texas State Championships and competed in early rounds of both Wimbledon and the US National Championships.

Gladys picked up tennis at the age of 23 and, along with her husband, Julius "Jules" Heldman, frequented the Berkeley Tennis Club, one of the original homes of tennis in California. Most everyone to emerge as a tennis great and changemaker of this era passed through Berkeley Tennis Club, along with Los Angeles Tennis Club. King, Casals, Kramer, Riggs, and so many others had some of their first contests with rivals on these hard courts.

Heldman set up the first WTA headquarters in San Francisco and continued to be a leading, if not the foremost, figurehead of tennis up until she and her husband retired. She was inducted into the Tennis Hall of Fame in 1979. Of course, Gladys and Jules kept on playing tennis in their retirement years. They created a hidden haven for tennis legends and thinkers to come play and talk about the future of the game. They built an indoor court, underground, at their home in Santa Fe, New Mexico, in 1982.

The list of greats who stopped in Santa Fe to visit the Heldmans rivals most any historic club's peg board: Rod Laver and Billie Jean King, for example. Gladys also welcomed any Santa Fe residents who wanted to play. There was just one rule: Everyone had to bring a brand-new pair of tennis shoes, never worn before, to play on this hard court. No shoes that had touched the ground outside the adobe structure could go on-court at Gladys's tennis hall. People continued to come visit until Gladys and Julius passed away in the early 2000s.

Tucked away behind pine and aspen trees in the backyard of the same historic Santa Fe home, the court remains in use today. Local coaches give lessons here, and the current owner coordinates visits upon request, with some favoritism for tennis lovers who reside in the Land of Enchantment.

LIBBEY PARK

Ojai, California, USA

About 80 miles (129 km) northwest of Los Angeles, there's a quaint, unimposing park where sycamore and eucalyptus trees shade two sets of hard courts with forest-green bleachers on all sides. This is Ojai, a town of only about 8,000 with a quirky, calming wilderness aura about it.

Here in Libbey Park, the courts play host to what might be the town's, if not the country's, greatest tennis treasure: an annual tournament simply called The Ojai.

Held every April, The Ojai has been played on these courts since 1896. It is, by most accounts, the world's oldest tennis tournament continually held in its original location. Ask almost any elite player who grew up in California, or in the western US at large, and they'll likely tell you The Ojai holds a special place in their personal tennis history. Pete Sampras, from Palos Verdes, California, played The Ojai twice as a junior in the early 1980s. Lindsay Davenport, also from Palos Verdes, took home the girls' 16s trophy in 1990. Today, elite college players on the cusp of going pro rarely miss this event.

For many years, The Ojai was a long-standing amateur tournament, but it's since expanded and now has 26 divisions with more than 1,300 players and $25,000 in prize money for the Open divisions.

Still, it's really all about the charm at these storied small-town courts. During the event, guests and players are still served fresh orange juice or tea in the tea tent. Of course, the event could never get through hundreds of matches with so few courts. In the early rounds, Ojai residents with private courts open up their backyards for competition. For a week every year, Ojai is a pure tennis town.

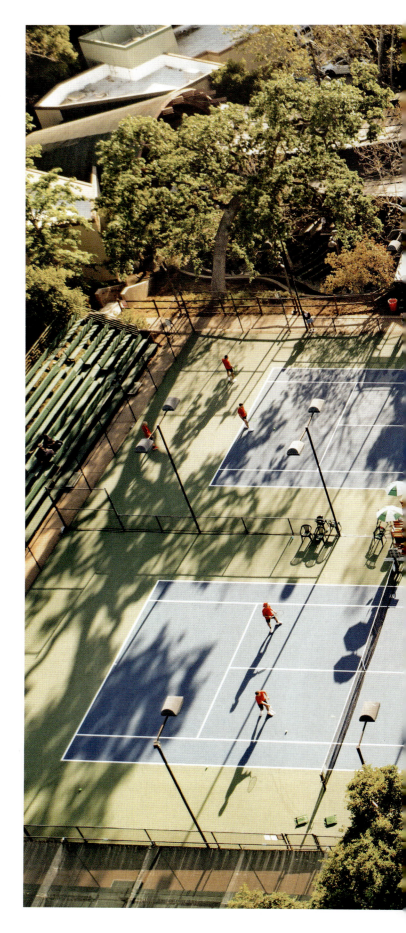

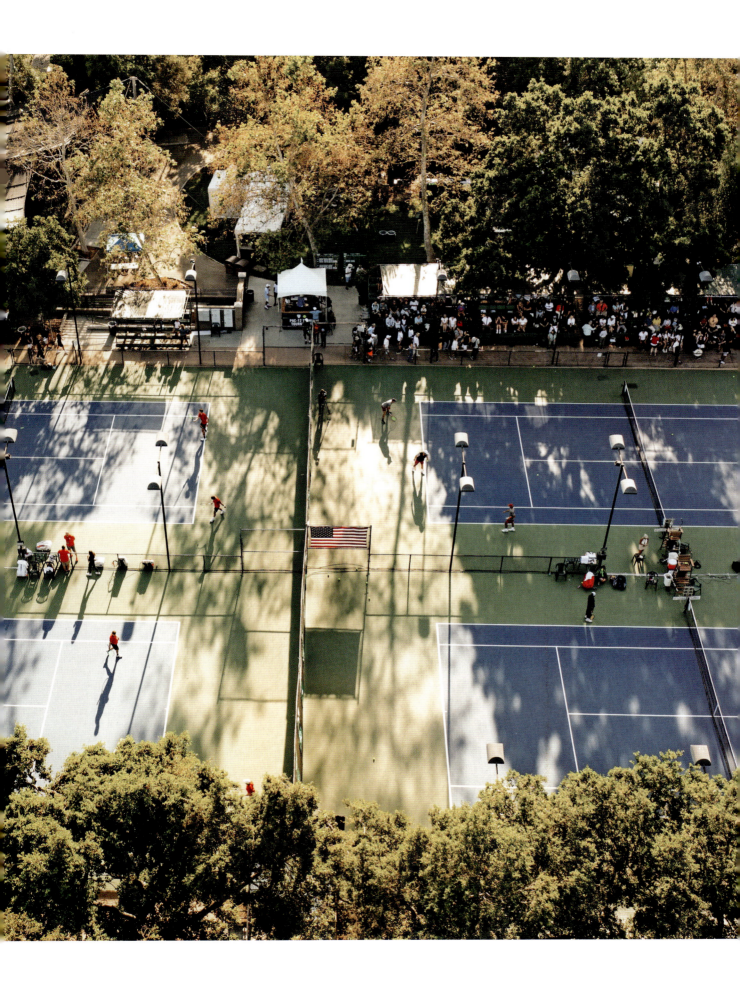

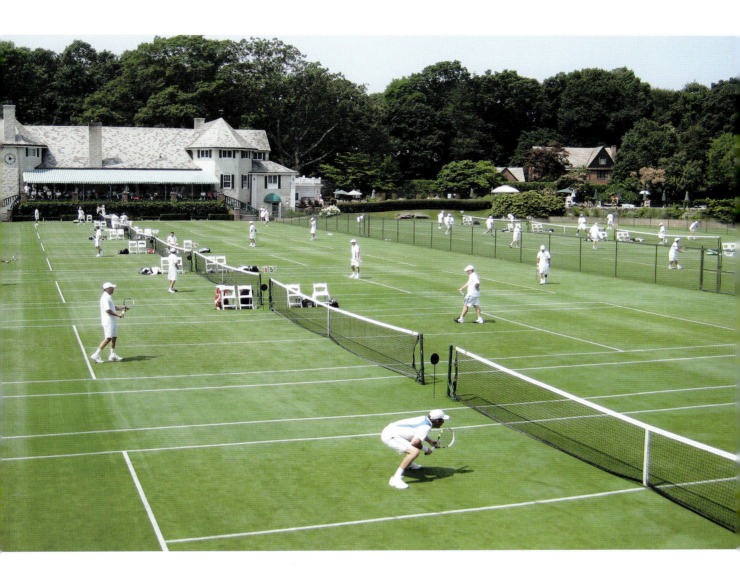

LONGWOOD CRICKET CLUB

Boston, Massachusetts, USA

It can be easy to be cynical about grass-court tennis. It is the most inaccessible, guarded surface, fawned over by commentators who recount stories of their own time on the cushiony plots. Still, playing on grass can be a transformative experience, particularly at Longwood.

The rarity and uniqueness of grass for the average racquet holder demands that you let go of your past, forget the feeling of the surface you're accustomed to having beneath your feet. You also need to release your preconceptions and re-embrace your basic nature of standing on bare land. That insight might be why a subset of players at Longwood play barefoot all season long, a practice popularized by former member and noted barefoot player, journalist Bud Collins. Assuming you can tolerate this, your doubt and indecision on the lawns will disappear for a moment, and while you might feel clumsy, it might also be freeing.

There are few places in the world where one can have such experiences on grass. In truth, it helps if there's a long stretch of courts, some expanse where you can place yourself far away from any high-nosed smarminess, something tennis hasn't quite done away with.

Longwood is one such free-flowing, inviting tennis institution, which started with cricketers turned tennis players and keeps its grass traditions alive today. This starts with their test plots, several courts set aside just for experimenting with grass varieties. Barefoot play on these plots is highly encouraged.

Today, Longwood stages what some would call the family tennis championships. The United States Tennis Association (USTA) hosts national championships for the men's ages 85–90 division, as well as the national championships for mother-daughter, father-son, father-daughter, and grandparent-grandchild doubles. There's no guarantee that playing with immediate family members will be a freeing experience, but the grass might help.

LOVE | 53

KOOYONG LAWN TENNIS CLUB

Melbourne, Australia

At the "spiritual home of Australian tennis," there are more nostalgic stories passed down through generations than at perhaps any other club in the world. Now with over 8,600 members, Kooyong might as well be the International Tennis Hall of Fame's headquarters in the Southern Hemisphere.

The club formerly hosted what we now know as the Australian Open for much of the 1970s and '80s. The tournament switched locations around the country many times before settling at Melbourne Park. At Kooyong today, the 26 grass courts (some of which have been there since the 1920s), 22 Australian clay courts, and 3 hard courts can all be seen from the clubhouse, which has been expanded to the tune of seven figures, with renovations that maintain some of the original touches. Shrines to the likes of Evonne Goolagong, Pat Cash, Rod Laver, Ken Rosewall, and others dot the lobby in a living museum.

The most illustrious arbiter of stories at Kooyong is Cedric Mason. Formerly a touring player, Tasmania-born Mason has had an evolving role at Kooyong as coach, tennis manager, grounds purveyor, historian, and overall tennis magnate since the '80s. Day to day, he can be found either hitting on-court, perusing the grounds, analyzing the strokes of kids and adults, or finding small imperfections in the grass and discussing them with the grounds team.

Mason and other Kooyong mainstays all congregate every year for the Kooyong Classic, an exhibition tournament held the week before the Australian Open. The Classic pulls some of the game's biggest names to compete on the magnetic-blue hard courts.

A less attended but equally invigorating tournament takes place when the juniors take over the grass courts for an event named after none other than Mason. Top juniors from Kooyong and Royal South Yarra Lawn Tennis Club, another historic tennis landmark of Victoria, battle it out on the grass at both clubs. Mason played and coached at both clubs over the years, and is a true emeritus historian of Aussie tennis.

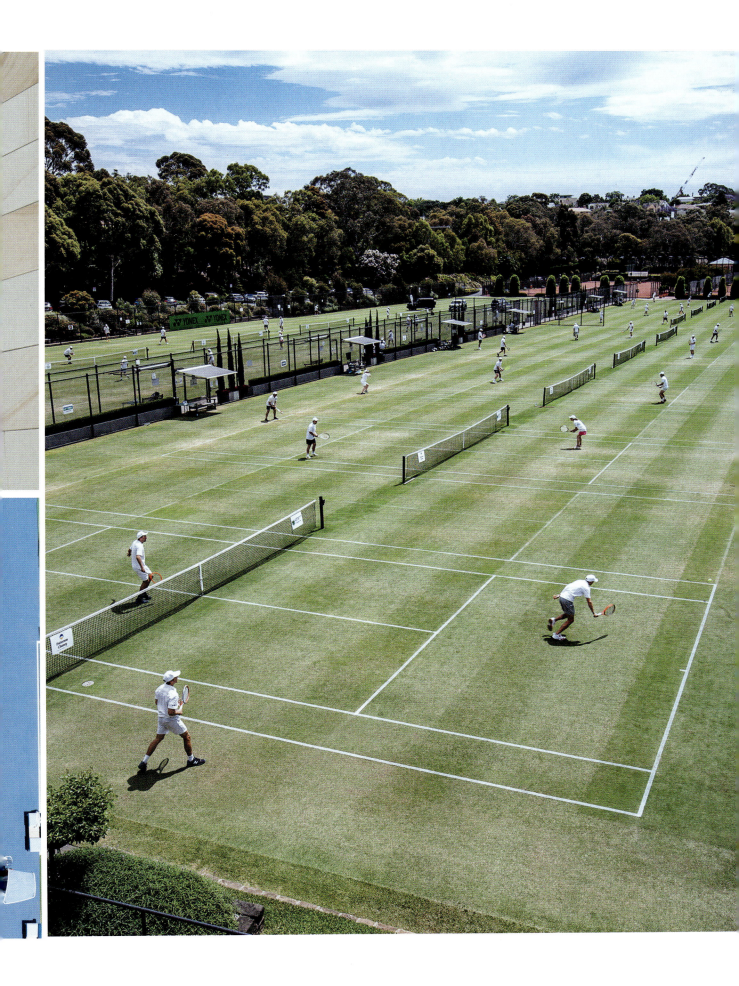

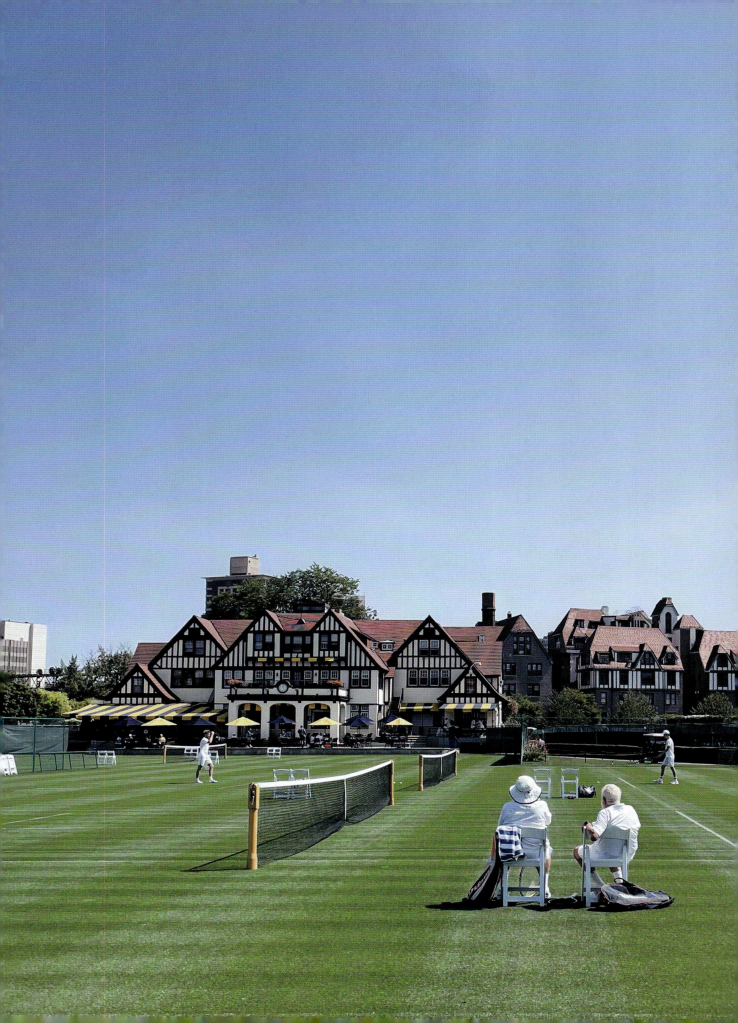

WEST SIDE TENNIS CLUB

Forest Hills, New York, USA

There's no space long enough to list the seminal moments of the stadium court at Forest Hills. Now more than 100 years old, it was the predominant home of the US Open from 1915 to 1977, through every iteration of amateur and Open-era tennis, before the tournament moved to the marshlands of Flushing Meadows. Most often on grass when it was held here, the US Open was also played on green clay for three iterations in the 1970s. Some might remember this as the golden age of elite tournaments, when fans had the run of the place and could storm the court after a match. These days, the stadium, now a hard court, hosts more concerts than tennis matches.

West Side Tennis Club, the entity that owns and operates the Tudor clubhouse and grounds, traces a meandering history through much of New York City. What started near Central Park in 1892, with two dirt courts and 13 members, moved uptown, once to 117th Street and then to 238th Street, before settling in leafy Forest Hills and becoming an almost mythic tennis home. And while it has the oldest tennis stadium in America, it does not contend for the oldest club in the country. That title is sometimes debated by tennis history detectives at the Tennis Collectors of America. Some say the oldest is New Orleans Lawn Tennis Club. Others say Seabright Lawn Tennis & Cricket Club in New Jersey holds that title.

The crown jewel at modern-day Forest Hills is the grass lawn that sprawls out from the clubhouse. It's always perfect, void of imperfections, never worn out, unlike most other grass-court institutions toward the middle or end of a summer. The groundstaff at West Side shifts the location of the courts weekly, moving the lines and the net posts to let sections of the lawn rest and rejuvenate. Doing this makes the grass some of the most uniform and durable year after year. Current and past pros and all their affiliated sponsors flock here for events every year before and during US Open action. Favorite courts are the ones farthest from the clubhouse. There's no real sound of the ball bounce on grass, so it can help if there's little outside noise aside from the Long Island Rail Road puttering out of the city.

LAIKIPIA COURT

Lolldaiga Hills, Kenya

In the shadow of Mount Kenya, at about 7,000 feet (2,134 m) above sea level, a single court sits at a mom-and-pop tented safari camp. It might look like a clay court, but it's a little more involved than that.

Moon and Ed Hough, the owners of the camp called the Safari Series, built the court in 2023. Having long loved tennis and in need of a house project, they thought a court from scratch seemed like a suitable option. They looked online and found a late-1800s guide for building makeshift tennis courts in the Australian Outback. They didn't have standard clay on hand, but they had plentiful termite mounds. They mixed the clay from the mounds into their own dirt to cover the court and then used an old oil drum to level the surface. On top of the sandy mixture, Ed sprinkled crushed salts (usually used for cows) to wick away moisture and dry the court quickly when it rains.

Now, their whole family and guests to the camp enjoy playing on the world's only termite-mound tennis court. As Moon Hough says, the court plays quite well as long as you don't get distracted by a passing elephant.

02

READY, PLAY

The tennis stadium, like any theater,
is about much more than just the game.

What do we think about when we're watching tennis in stadiums? The minutiae of play? The wider theater and sport? Or something else? This answer can vary wildly and might fall along regional and generational lines. Regardless, engaging in such conversation with rabid tennis consumers fulfills a spectator's life.

 In a stadium in Argentina, I sat with several fans who were infatuated with the movements of a young Spanish player named Carlos. It was all they could talk about—in Spanish, with long extended vowels. For them, the player is an artist with a racquet, and tennis is a tradition of mimesis. Months later, in Germany, I encountered some fans in an amphitheater-style stadium who were fixated on the angle of a player's ankles and legs, what remarkable mobility she possessed. In the southeastern United States, fans debated the merits of green clay. Later, in Tokyo, muted chatter centered on the acoustics of the stadium and the squeak of the shoes on the hard court. Could one close their eyes and hear which player was moving with greater intensity?

 I'd posit that nowadays the most curious and engaged fans congregate at stadiums *beyond* the homes of the four Grand Slam tournaments. Not to knock the Grand Slams. They feature the most magnificent courts and grandest matches-as-festivals the world over. (This section begins with my favorite of the four.) But in a coliseum in Tokyo or center court in Charleston, Berlin, or Buenos Aires, you can engage with the sport most thoroughly and also build an appreciation for where regional communities come to cherish it. These halls are the more understated, less feverishly swarming, and less celebrity- and sponsor-driven places to consider why we love and pay to watch tennis.

On a blistering and humid day in Rome, I sat near some fans with opposing allegiances. They were Italian, speaking Italian; the players were also Italian. Know this: There's no better seat than next to an Italian tennis fanatic with fierce loyalty to a player. The bickering was going nowhere as play began. The two fans, a husband and wife, analyzed the play with cursory remarks. More pressing though, as the match wore on and the score tightened, they closely monitored the shifting emotions of *their* players. What could their expressions, especially following a mistake, tell them? "He's furious. . . . He can't control anger even after he hits a winner. . . . He's going through a lot." They guessed at not simply each player's mood but their nature. (Here is where player and spectators meet around the restless mind.) Until the end of the match, they traveled through the depths of frustration, hesitation, cautious optimism, triumph, and failure with their allies.

I asked one of them about a post-match interview their favorite player had done the day prior. "Only here," she said, scoffing. Then she reiterated that she only pays attention to her favorite player live or occasionally watches a match on TV. I find this often among fans at these smaller tour events, the ones local tennis communities shape their whole year around attending. Perhaps they're onto something: that the stadium court reveals the player. While professionals can be like a soundboard of clichés and platitudes in press conferences about their time on court, these fans realize we can only glimpse the player's truest self when they're battling on their own half of the 78-foot island. •

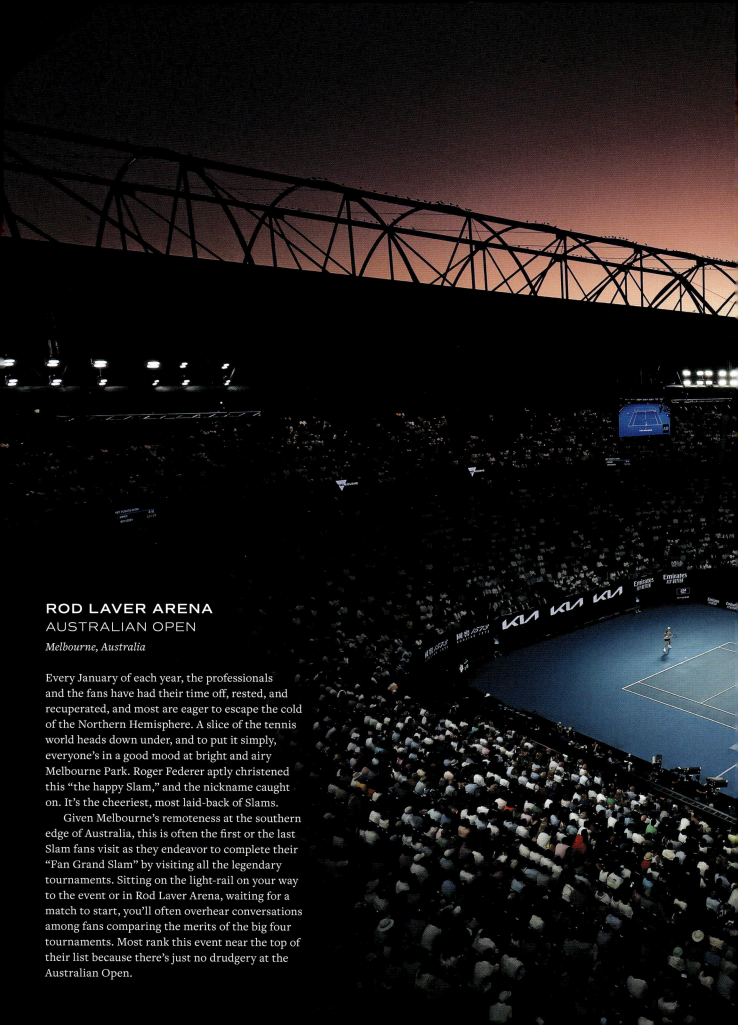

ROD LAVER ARENA
AUSTRALIAN OPEN
Melbourne, Australia

Every January of each year, the professionals and the fans have had their time off, rested, and recuperated, and most are eager to escape the cold of the Northern Hemisphere. A slice of the tennis world heads down under, and to put it simply, everyone's in a good mood at bright and airy Melbourne Park. Roger Federer aptly christened this "the happy Slam," and the nickname caught on. It's the cheeriest, most laid-back of Slams.

Given Melbourne's remoteness at the southern edge of Australia, this is often the first or the last Slam fans visit as they endeavor to complete their "Fan Grand Slam" by visiting all the legendary tournaments. Sitting on the light-rail on your way to the event or in Rod Laver Arena, waiting for a match to start, you'll often overhear conversations among fans comparing the merits of the big four tournaments. Most rank this event near the top of their list because there's just no drudgery at the Australian Open.

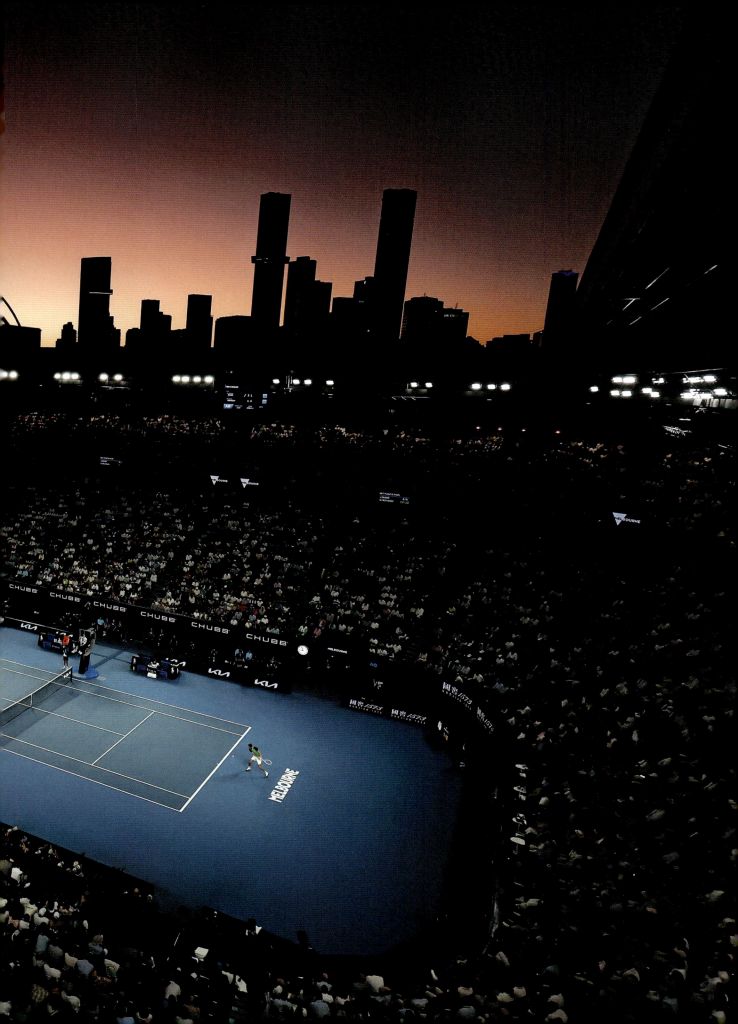

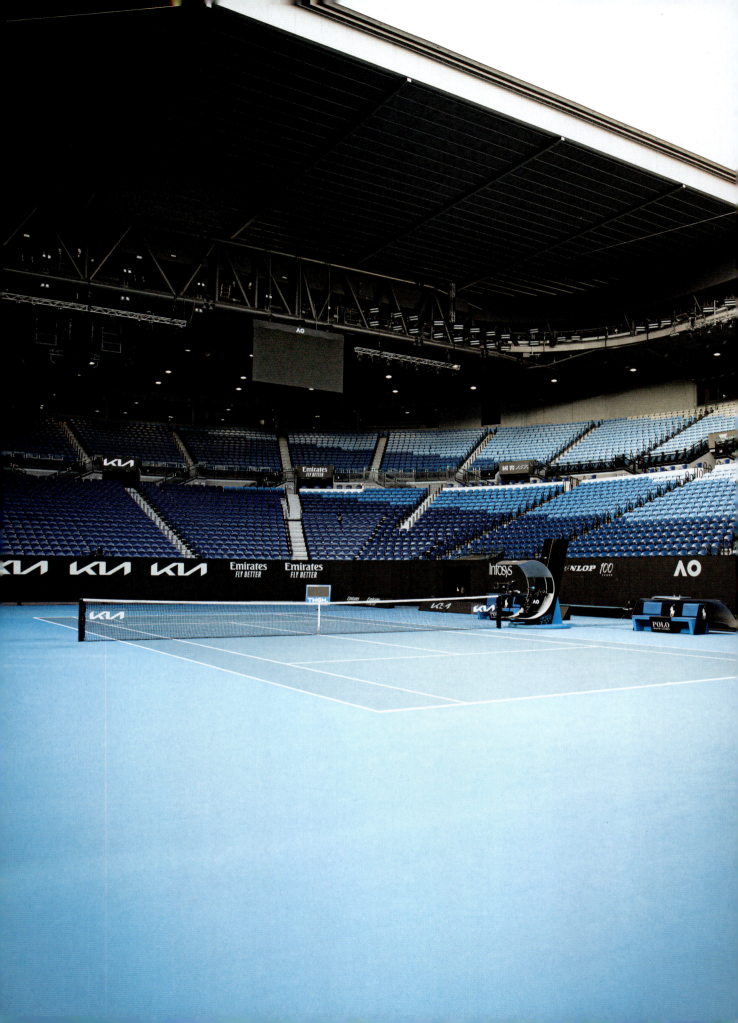

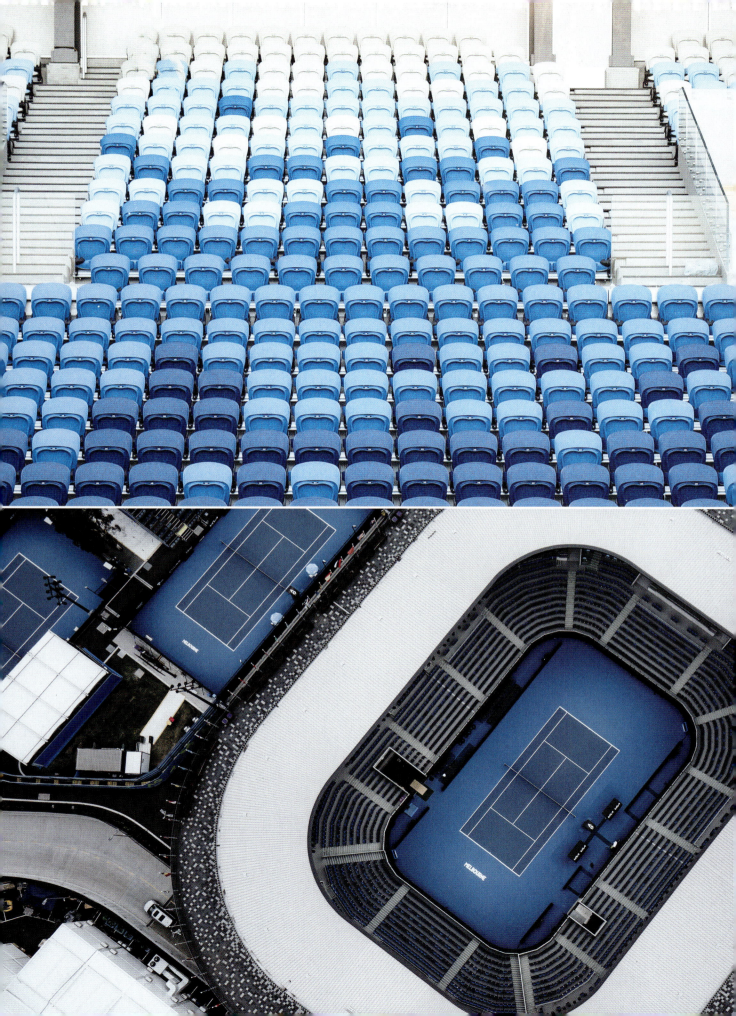

KIA ARENA
AUSTRALIAN OPEN
Melbourne, Australia

This local crowd favorite seats 5,000 fans and is the largest general admission stadium at Melbourne Park. Like a great bullfighting ring of tennis, the arena consistently produces an intimate, festival-like atmosphere that can be heard from all over the grounds.

As with Laver Arena, the stands are colored like a fresco of cascading blue tiles. You'll notice a swirl when sitting here looking around the oval. Many a local Melburnian (pronounced *melb-UN-ian*) claim it's the best stadium to watch Australian nationals compete. Unlike the other Slam venues, Melbourne Park serves as the headquarters of the national federation, through which all the young upstarts have to pass at some point early in their careers. Playing on Kia shapes up as an honored homecoming for Aussie players. And Australian fans are particularly mad for sports in general, so the combination elevates the tension and passion. Just ask anyone who witnessed the 2021 title-winning run of Nick Kyrgios and Thanasi Kokkinakis in the men's doubles. They played most of their matches on this court.

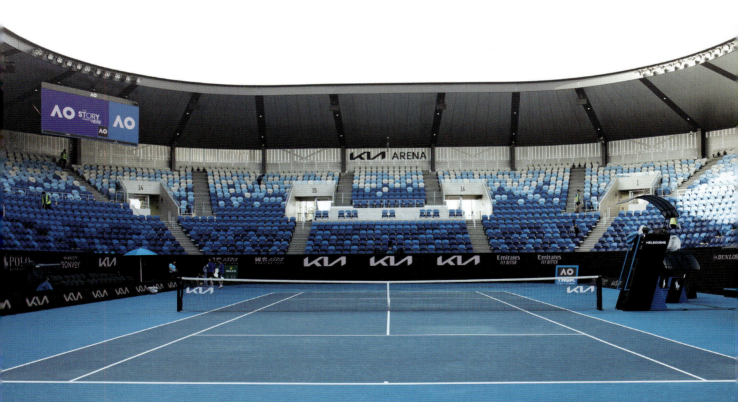

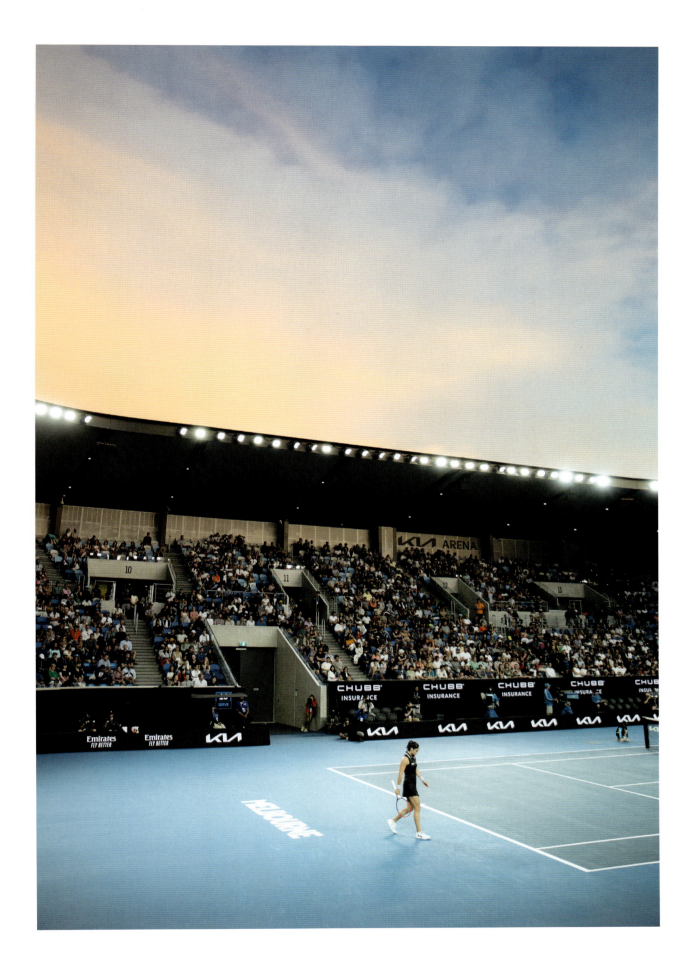

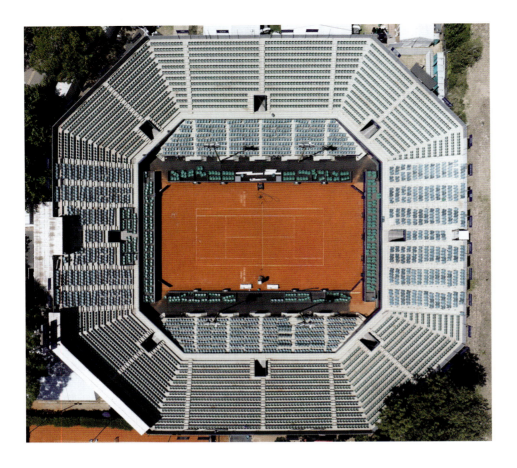

BUENOS AIRES LAWN TENNIS CLUB

Buenos Aires, Argentina

Every weekend in February is a finals weekend somewhere along the Golden Swing, a lineup of annual professional tournaments held across South America. All the tournaments are played on red clay, some of the most vibrant in the world. It looks more like bright muddy paprika. The most historic and lively place to witness the Golden Swing is in Buenos Aires at the Argentina Open, or as it was previously called, the Campeonato del Río de la Plata.

The tournament is held at the Buenos Aires Lawn Tennis Club (BALTC), which dates back to 1892 and is the long-standing home of South America's largest tennis stadium, Court Central Guillermo Vilas. To Argentines, BALTC is "la Catedral del Tenis," and spectators in this roughly 5,500-seat venue can get close enough to watch the dust spray as players slide across the surface, cracking and pushing around the clay, which gets leveled out and smoothed over on every changeover. You can't help but watch the groundstaff brush off the lines and draw a mesmerizing pattern on the court using repurposed nets as a sort of Zamboni for the clay.

Watching here requires joining in chants and echoing whistles. It's where soccer fandom fuses with tennis obsession—and the Argentines have a deep love affair with tennis. It largely started with Guillermo Vilas's success in the 1970s and '80s. Vilas played iconic matches against Ivan Lendl, Björn Borg, John McEnroe, and others, all on this very court. The sport continued to grow across the country, buoyed by Gabriela Sabatini's titles in the '90s (and her ongoing efforts to expand the sport locally) and by the men's national team's first Davis Cup victory in 2016.

INDIAN WELLS TENNIS GARDEN

Indian Wells, California, USA

In tennis's largest stadiums, it can be difficult for spectators to concentrate on the match, or for players to feel the game. Chatter rumbles in the upper decks and swirls downward. You might argue that tennis was never meant to be played in giant spaces. But there's something about the main stage in Indian Wells, California, home of the "fifth Grand Slam," as many call it, that eases all qualms about the supersized tennis stadium. It's a place where everything—the mood, the weather, especially at twilight—tells you that you're exactly where you want to be.

Opened in 2000, Indian Wells Tennis Garden occupies 54 acres (23 ha) in the Coachella Valley with the heat-blurred lines of mountain ranges skipping along the horizon and cacti dotting the landscape. The event doubled down on its desert oasis presentation in 2009 when the tournament was purchased for a reported $100 million. The prize money shot up, the celebrity chefs arrived, and, some argue, Indian Wells officially outdid the US Open. (But it's not a competition.)

Most people who keep the Women's Tennis Association (WTA) and the Association of Tennis Players (ATP) tours running—umpires, coaches, journalists, players—will admit that West is best. The Garden has its mix of Los Angeles glitz—there's a Nobu inside Stadium 2—and Palm Springs artsiness and quirkiness. At the center of tennis heaven is the 16,100-seat stadium that functions like a sand-dusted sundial for the nearly 500,000 fans who attend every year.

The size is about as large as a tennis stadium can get while still giving every spectator a sense of the action. The best time to settle into Stadium 1 is in the evenings, when shadows pass and the heat subsides. Find yourself watching one of these night matches, and you might have a tennis-as-religion experience. From the upper decks you can gaze at the dark expanse of the sky above. Then look down and watch the match in something like slow motion. It's a house of art.

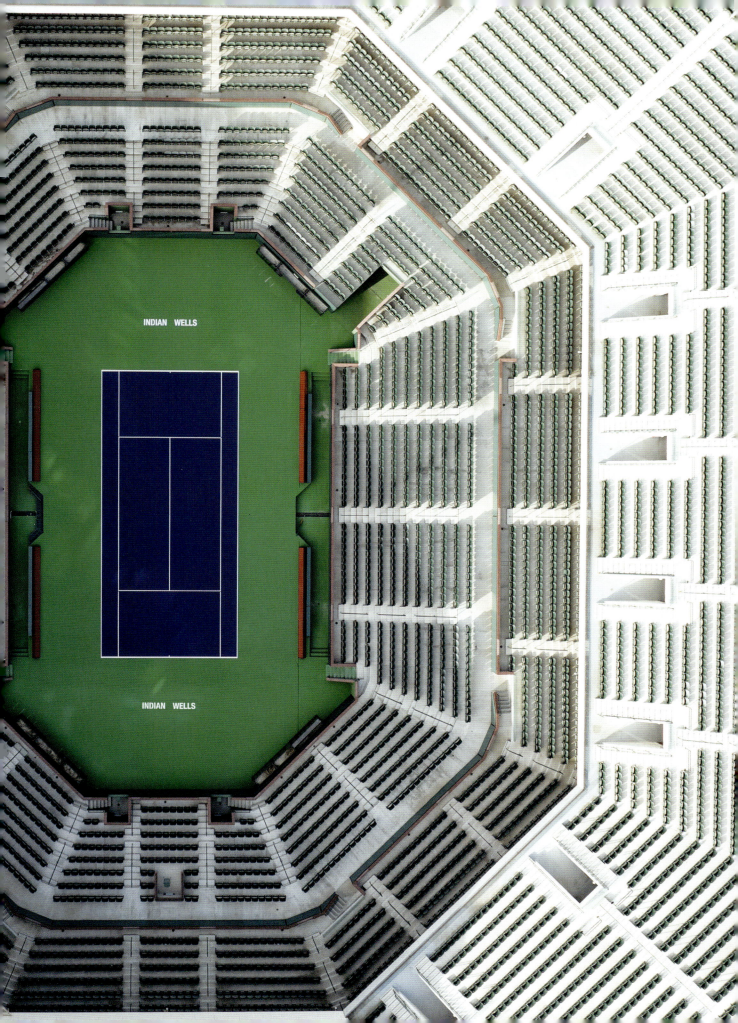

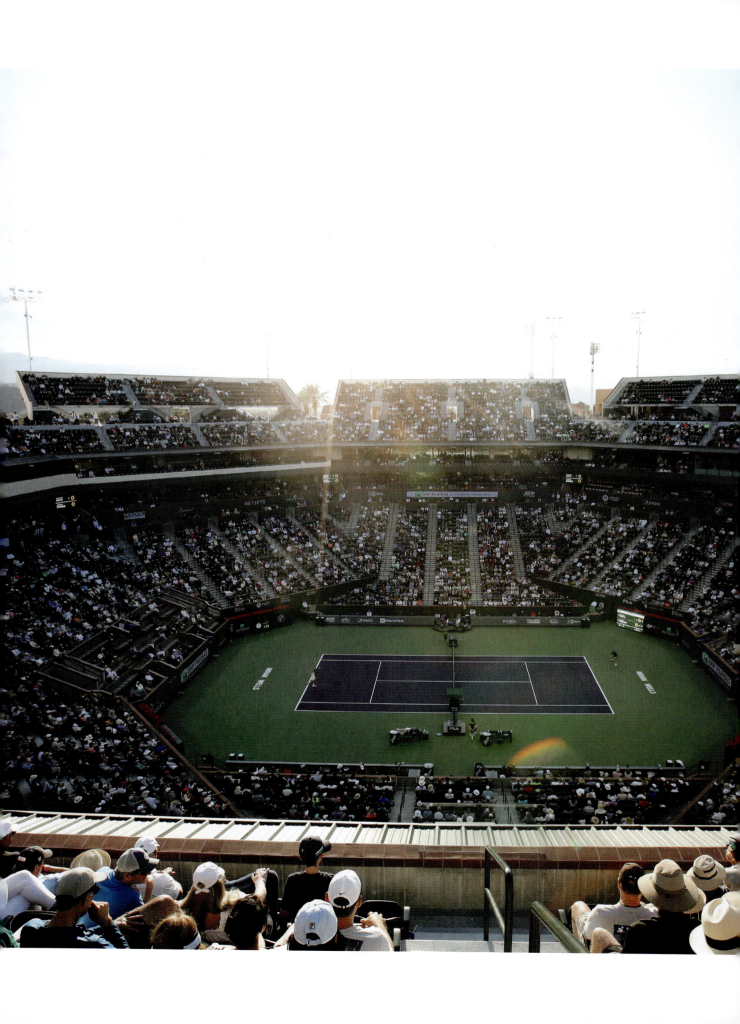

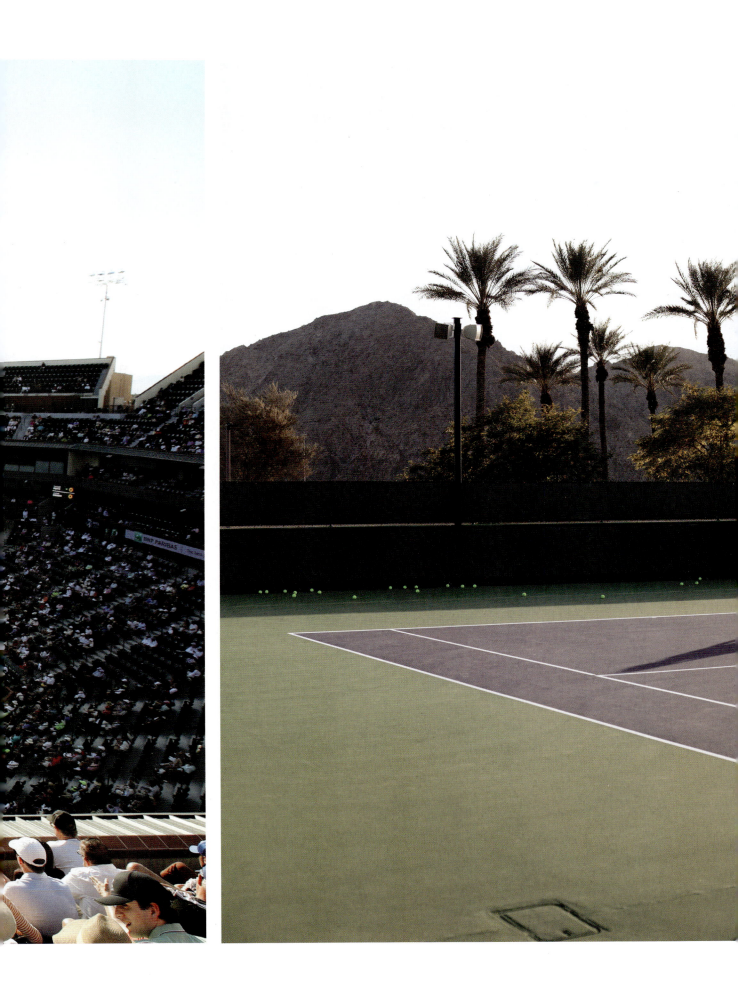

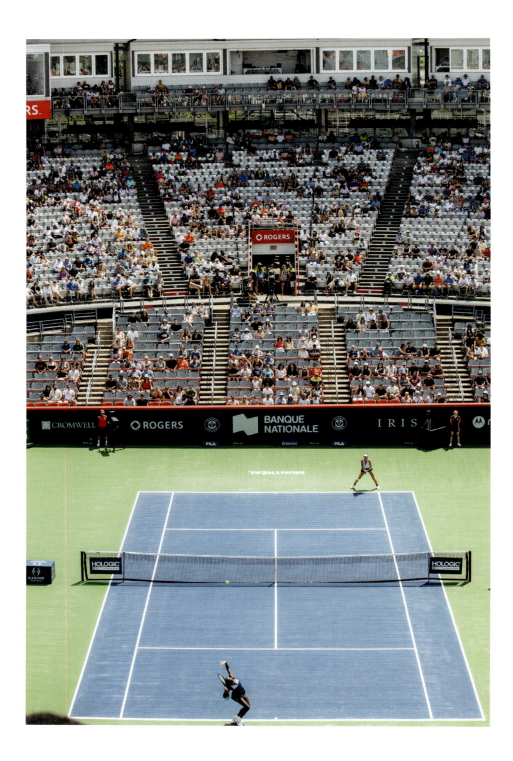

STADE IGA

Montreal, Quebec, Canada

Not unlike the oval Grandstand at the US Open or the stadium in Forest Hills, any seat in the horseshoe southern side of the Canadian Open arena offers a perfectly clean sight line to the match. On the edge of Parc Jarry (Jarry Park), one of Montreal's largest green spaces, the arena's bowl is a remnant of the days when the stadium was dedicated to baseball and was home to the Montreal Expos. Sitting in the bowl at Stade IGA (IGA Stadium) can feel like a classic tennis viewing experience that most contemporary tennis architecture has forgone.

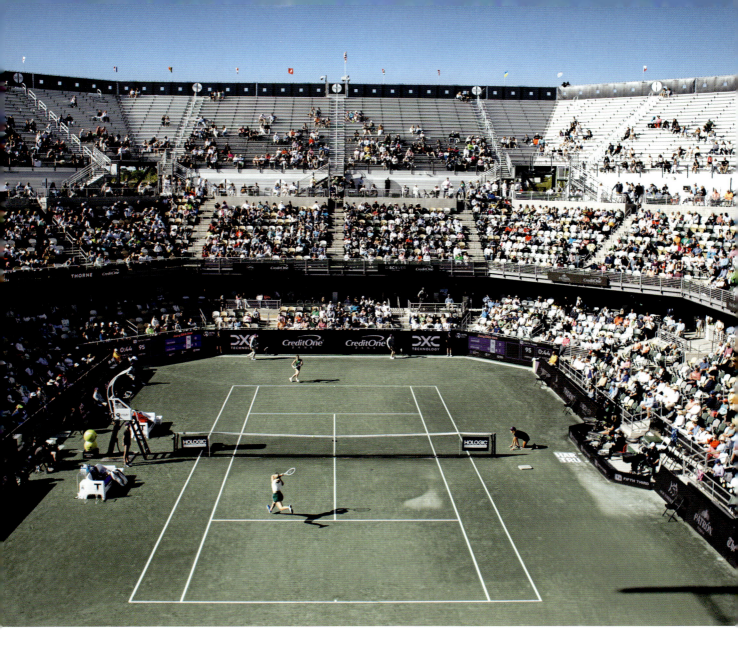

CHARLESTON OPEN AT LTP TENNIS DANIEL ISLAND

Charleston, South Carolina, USA

Before professional tennis heads to Europe every season, a lesser-known, defiant-feeling tournament takes place in South Carolina's Lowcountry. The women's tour makes a visit to Daniel Island every year for the only premier-level tournament held on green clay. For those from the eastern United States who play every day on the Har-Tru surface, this may be the most relatable professional tennis event to watch.

There's a tradition of keeping this place a secret. Many of the year-to-year visitors to the event are perfectly fine letting the bulk of the American tennis audience focus their attention on Indian Wells and Miami, while they keep quiet about how enchanting the tennis viewing (and playing, when the stadium isn't being used for the professional tournament) on the Wando River can be. Players pick these grounds above most others, too: The Charleston Open received the WTA 500 Tournament of the Year Award in 2022 and 2023, an honor voted on by players.

As the players sprint and slide on the grayish-green clay, one might wonder how the courts stay damp without the regular hosing you see at red clay courts worldwide. The courts are irrigated from below with pipes running ¼ mile (0.4 km) deep under every court. Most annual attendees flock to Althea Gibson Club Court to get up close to the clay. (Gibson, whose victory at the French Open in 1956 made her the first person of color to win a major championship, was born about a 90-minute drive from Charleston.)

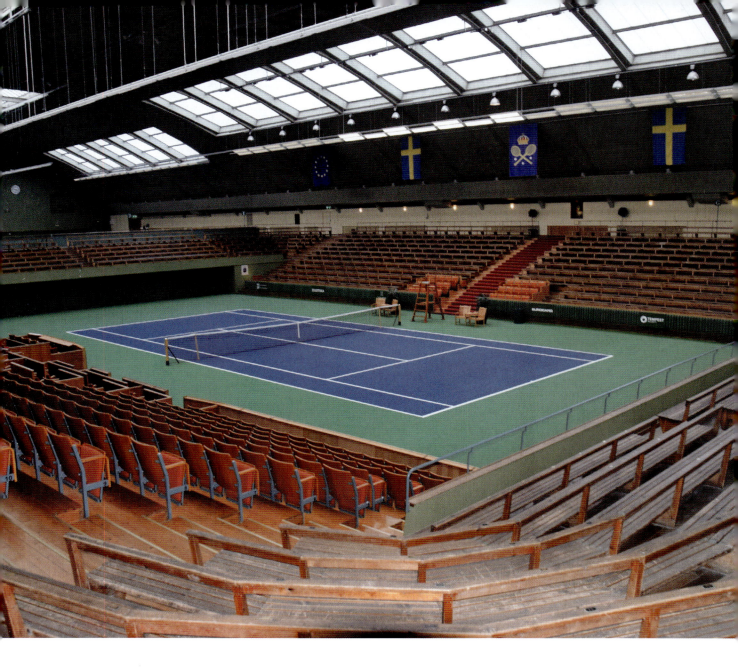

KUNGLIGA TENNISHALLEN

Stockholm, Sweden

Arriving at the finest indoor tennis court in the world, you're first reminded of the history behind this royal jewel of Stockholm. Crown Prince Gustaf—later King Gustaf V—thrust tennis into the Swedish public consciousness with the tennishallen. A tennis obsessive and avid player, he pushed for this tennis sanctuary to be finished in 1943, creating a haven and respite amid the anxieties of World War II. It'd be called Kungliga Tennishallen (KLTK), or Royal Tennis Hall.

Home to the oldest indoor tournament and the largest international sports competition in Sweden, the hard court inside KLTK today maintains its original, pointedly Swedish surroundings—minimal, functional, and symmetrical. Sitting in the spacious hall can feel more like you're ready to view an orchestra than a tennis match, and many of the fans can talk about past players (mostly Björn Borg) with the same kind of aesthetic musings as fans of opera. Some of the elder spectators can even recall the year 1980 when a rubber surface was used as a last-minute emergency alternative—Borg won the title that year.

Nowadays, talk at KLTK swarms around the younger Borg, Björn's son Leo, who trains at the club alongside much of the Swedish tennis community. The 15 indoor hard courts and five outdoor clay courts have made these grounds the tennis capital of Scandinavia.

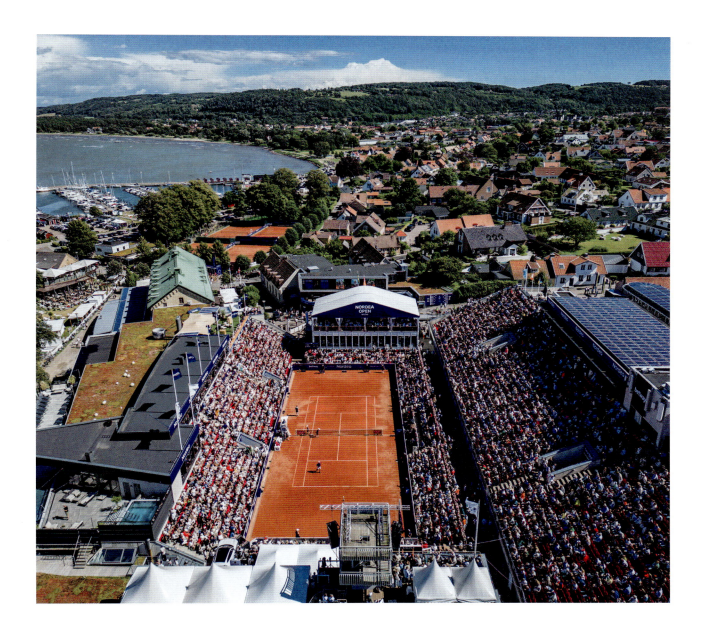

BÅSTAD TENNIS STADIUM

Båstad, Sweden

Many Swedes picture tennis and the sea exclusively when they think of Båstad in the summertime. One of the oldest competition grounds in professional tennis, the city hosts both tours every summer on the clay of the Swedish Riviera. Many call Båstad their favorite tennis hub of Sweden; its rich tennis history goes back to the early 1900s, and it is the country's largest-capacity stadium dedicated to the sport. The annual tournament has become a cultural touchstone for the whole country, a celebration of sport and life. The 4,500-seat stadium sits a short walk from the beach, and here the tennis IQ of the audience is among the highest you'll find worldwide. Players also voted this tournament as the best of its tier for 11 years straight.

The stadium court was first built in 1907 by Ludwig Nobel, nephew of Alfred Nobel, and began hosting the Swedish Open in 1948. The court was long a hard court, but now sources clay from Germany. And while the days of Björn Borg, Mats Wilander, and Stefan Edberg winning the Swedish trophies are gone, the Swedes still embrace long summer tennis days as their Danish, Norwegian, and Finnish counterparts join them by the sea.

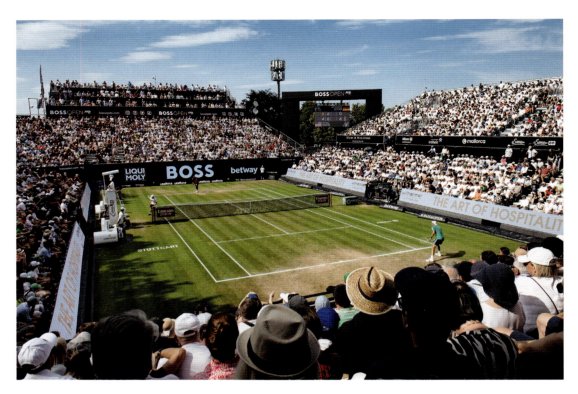

TENNISCLUB WEISSENHOF

FINDING THE LINES IN BERLIN AND STUTTGART

Germany

Every year, the small groundskeeping staffs at TENNIS CLUB ROT-WEISS and TENNISCLUB WEISSENHOF must contend with increasingly unpredictable winter and spring weather to nurture, tame, and stabilize the grass on their plots. It's never a guarantee that a grass court will be ready by the time the professional players and sponsors make their way to town. The earlier in the year a tournament, the more difficult, and anxiety-ridden, the process of getting the courts ready. Somehow, year after year, they are, owing to some of the shrewdest groundstaffs in tennis. Pro women arrive in Berlin and pro men arrive in Stuttgart, where the courts (and the local fans) are novelties. At these smaller-scale grass tournaments, you'll find the fans to be among the most intensely curious about the game. The buzzing talk in the stands centers on the erratic, fast surface and its relationship to the players. They make grass, and understanding play on the platz, a sport in itself. Nowhere else might you find so many spectators recalling a player's past fortunes on the courts and as shrewd a critique of their movement on that year's trim. Both venues emerge out of historic clubs, the 7,000-seat stadium named for Steffi Graf at Rot-Weiss and Center Court at Weissenhof, and both claim a rarity with side-by-side grass and clay courts together. One might soon emerge with an exhibition match on half-and-half courts, a mentally taxing ultimate challenge many in the tennis world would travel for.

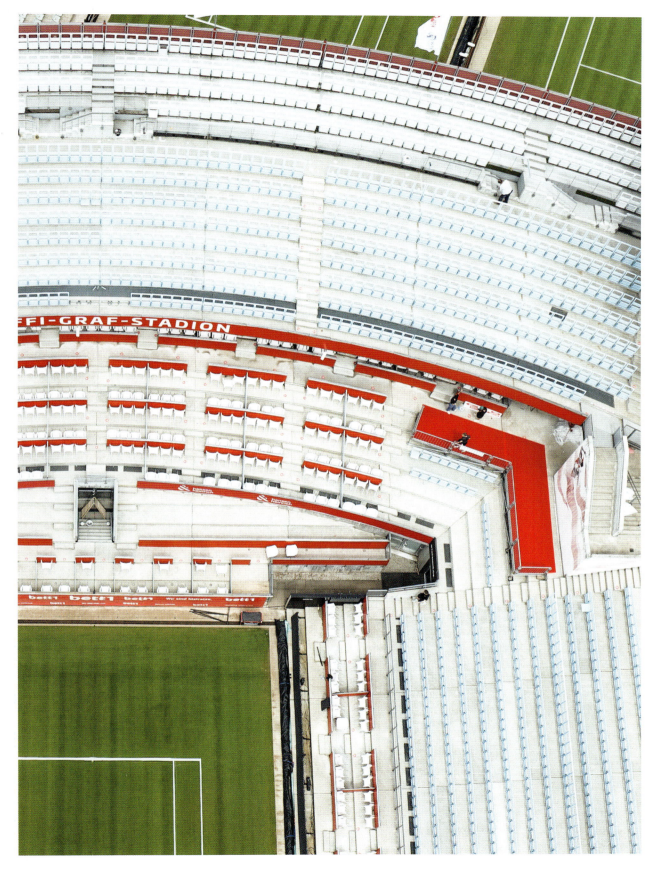

STEFFI GRAF STADIUM AT TENNIS CLUB ROT-WEISS

COURT PHILIPPE-CHATRIER
FRENCH OPEN
Paris, France

The clay of Roland-Garros takes on a different shade—bright orange, burnt red, burgundy, umber—every time you see it, depending on the mood of the sky. Going back to when the stadium was built in 1928, every spectator, player, umpire, and ball kid has had a unique relationship with the terre battue. Views on its color, how it rises and falls, and its temperament are uniquely yours.

 The title of clay whisperer has belonged to Algerian men who have dedicated their lives to the clay at Roland-Garros since 1936. The elder statesman of the surface at Roland-Garros is Malek Benyahia, an Algerian man in his early seventies. Benyahia, now retired after more than 35 years directing the work on these courts, still has an occasional emeritus-style consulting role for the French Open. When he's spoken about the surface on Court Philippe-Chatrier, he acknowledges that, yes, there's a science to what lies underneath the vibrant red-orange dirt, but still, everyone's relationship with the powdered tennis gold is different.

 A company in a suburb north of Paris has long supplied the clay in heaping plastic bags to the grounds west of central Paris. One to one is the approximate rule—1 ton of crushed brick for one court—roughly 85 tons set aside for each edition of Roland-Garros. And that's only to cover each court with a precise 0.078 inch (2 mm) of clay for players to slide on with ease. Under the clay lies about 3 inches (8 cm) of limestone, about the same amount of coal residue, and then a little over a foot (30.5 cm) of crushed gravel. With a fresh and even dousing of water, that's what we all get to marvel at every year.

 If you get a chance to engage with this finest of clay surfaces here or at another court that uses the same clay from the same provider, study its apparent rustiness but feel its velvetiness when rubbed between your hands. If you happen to slip and fall, as most do, see how it creates kaleidoscopic shapes on your clothes, feel the clay on your skin like a mask. If nothing else, make a single footprint and take a picture to carry with you. Like the players at Roland-Garros, make a clay court your own canvas—it'll tell a story in dashes, dots, swipes, and scars. Until you show up to the next freshly groomed clay court, cleansed and starting anew.

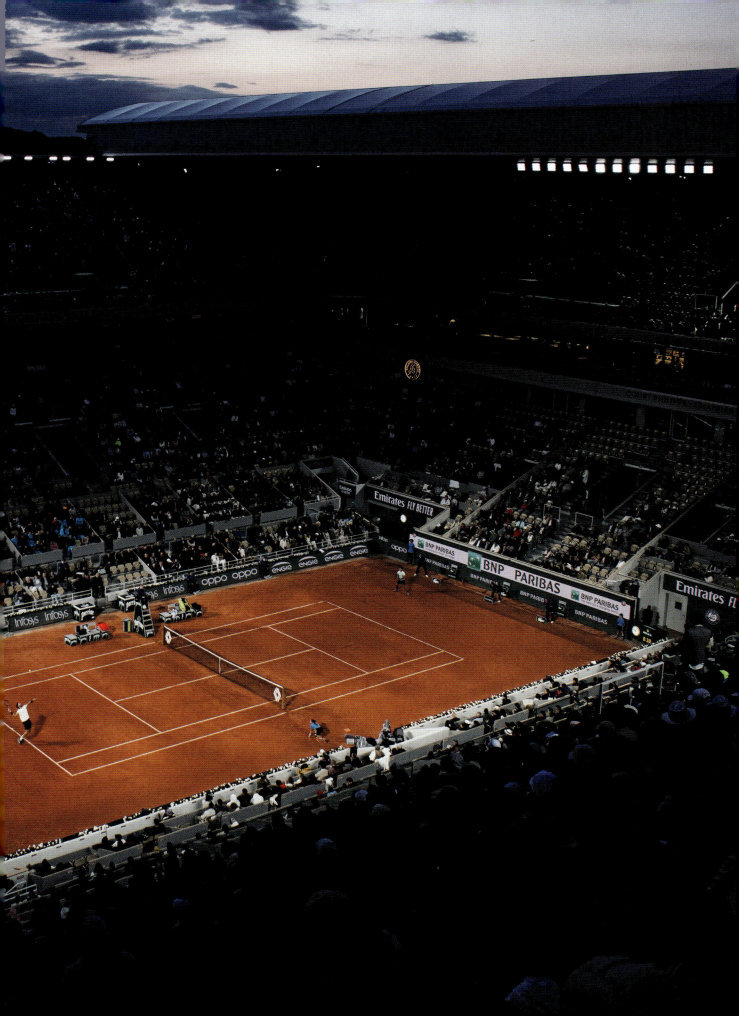

Court Philippe-Chatrier

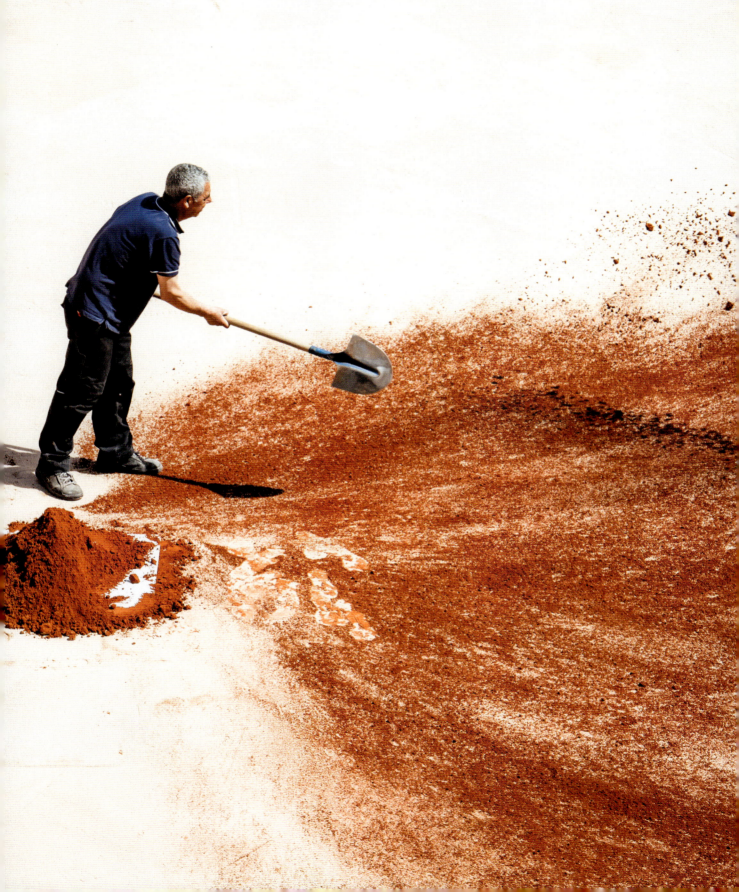

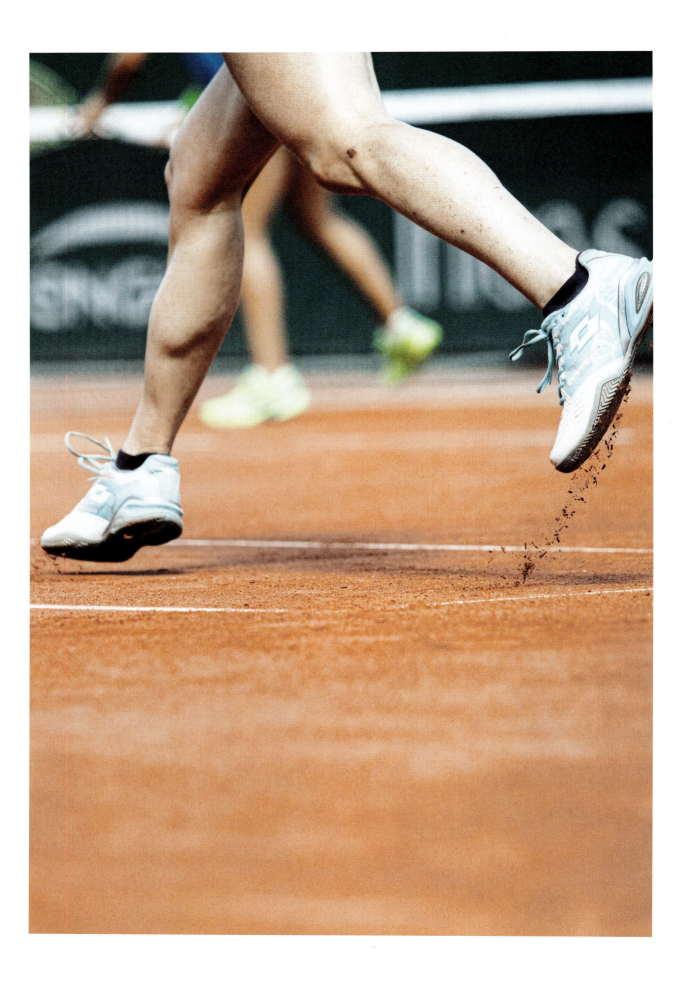

COURT SIMONNE-MATHIEU
FRENCH OPEN

Paris, France

Walk away from the busy side of the Roland-Garros grounds and into the Serres d'Auteuil botanical garden to find the Slam's third stadium, arguably the most unique at any of the Slams. Few spectators or players realize it, but if you look past the concourse level of this sunken court, you'll notice foggy, dewy glass paneling. The stadium is enclosed by four greenhouses, each with plants from Asia, Australia, Africa, and South America. (The flora is all managed by the City of Paris, not the tournament.)

When construction on the court started in 2011, the French tennis federation faced heavy protests from neighbors and environmental groups. In the end, the tournament won out with a compromise in the form of a massive wreath around the 5,000-seat stadium, named for the French women's singles champion of the 1930s, Simonne Mathieu.

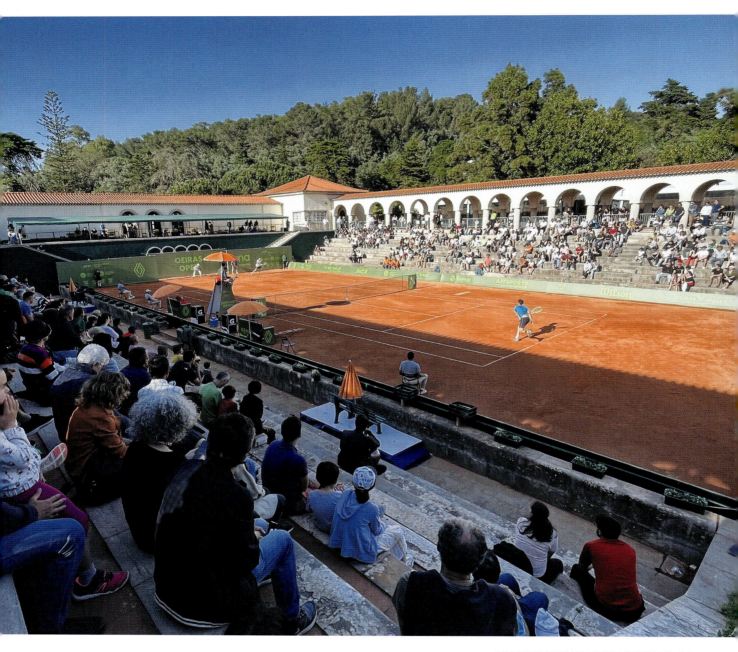

JAMOR TENNIS TRAINING CENTER

THE TINY TOURNAMENTS

Portugal and England

True tennis fans will always tell you there is more than just the marquee stops of the professional tours. In fact, a few fans of the game will choose one of the second-tier pro events over the Slams any day of the week. These events are hidden from most of the sports world and vastly underappreciated in the tennis world. Think of these as the cozy, community-centric tournaments where players battle it out in remote pockets of the world, cobbling together enough points to gain entry into the bigger events. Out here in Lisbon, Portugal; Ilkley, England; Nouméa, French Polynesia; and elsewhere, the stands are always filled with local families. There's a friendliness and eagerness in this crowd. You develop a habit of chatting up fellow tennis fans and use a shared tennis obsession to converse your way into new friendships. Barriers fall at these tiny tournaments.

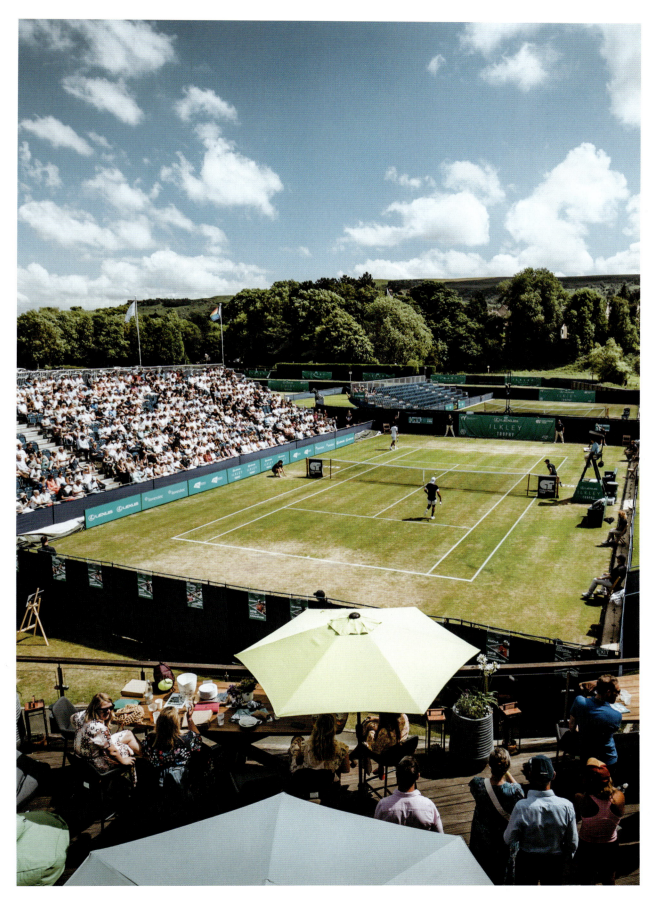

ILKLEY LAWN TENNIS CLUB

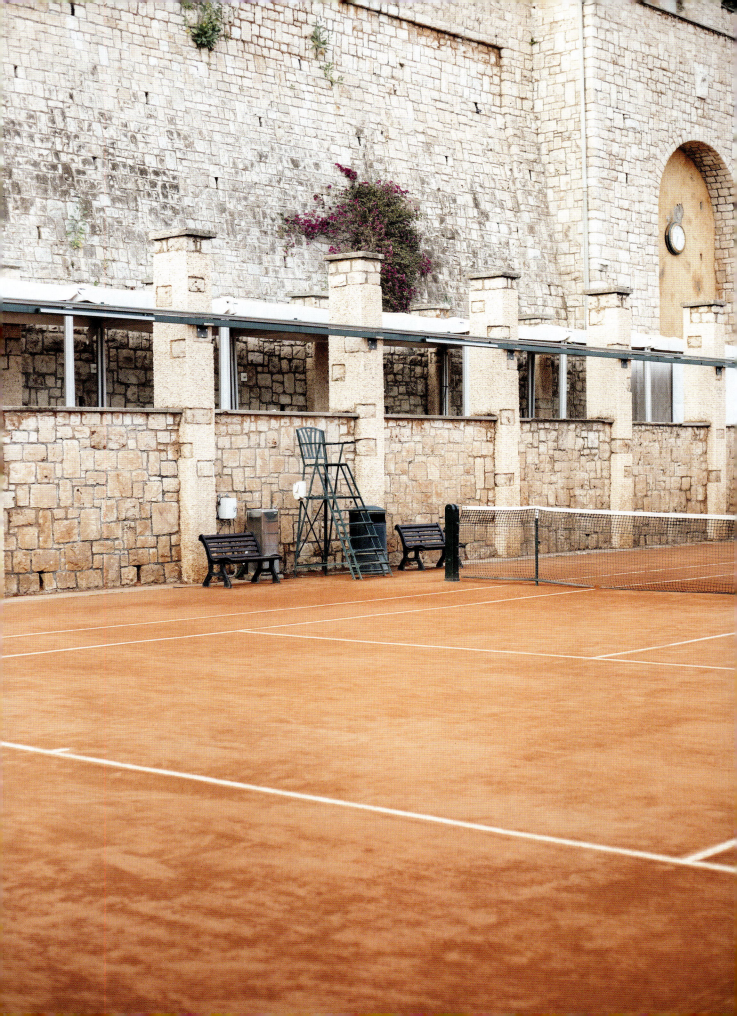

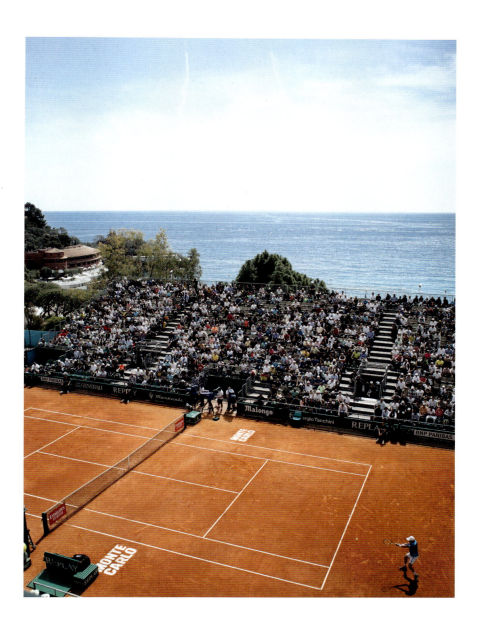

MONTE-CARLO COUNTRY CLUB

Roquebrune-Cap-Martin, France

The Monte-Carlo Country Club sprawls out on the cliffside above the ivory coast. Many recognize this as a tournament venue first. But for 11 months of the year, grassy berms surround the three center courts and peach-stuccoed art deco clubhouse. These are the courts in their truest form, Monaco's and the French Riviera's tennis gathering place since the club set up shop on the natural terraces in the late 1920s (it was originally a small club with courts atop a garage). Bits of red clay color the sidewalks that connect the gladiator-style courts above to the low courts among the meadows below.

During the professional tournament every year, the club leans into its gladiator-tennis sensibility. Fans clamor at the base of the stone cliffs to watch players on the practice courts. Narrow walkways and stairs weave above, below, and between the sounds of grunts, sliding, and roaring applause. Pull back a curtain here or there, and you'll find the bags of clay ready to be carted off to the arenas. Court Rainier III serves as center court, an almost entirely temporary stadium aside from the seating attached to the clubhouse. The nearby Court des Princes is a crowd favorite. Watching with your back to the sea starkly juxtaposes the clay and the six stone columns of the lower clubhouse. In the stands, fans marvel at tennis by the sea in a soft mix of whispered French, Italian, and Spanish.

France

England

Italy

Spain

Ball Kids

No one gets a closer view of the visceral energy exchange that goes on between the professional player and the court than the ball crew, those kids, and some adults, afforded the task of moving in concert with the players between points.

Ball kids sometimes start as young as 8 years old—Federer was a ball kid at age 12. They pride themselves on having a relaxed, unphased demeanor even as 130-mile-an-hour (209 kph) serves hurl toward them. They've come a long way. Some of the first were young men of 1920s Wimbledon (female ball kids joined at the All England Club in 1977). There's not much written on the history of the role, but we know the boys of Margaret Court's 1973 French Open final were slouched over in the corners, resting their chin on one fist as Court and Chris Evert held both service balls in their tossing hand. In 1981, at Wimbledon, ball kids broke the facade and cheered when John McEnroe beat Björn Borg (they kept their gaze down during the "You cannot be serious?" episode). More recently, as the game has progressed with faster serves and long rallies, ball persons have become void of emotion and more alert.

Laray Fowler is a ball person at the US Open who has worked more than 20 editions of the tournament, with a trophy case of moments unfathomable to the everyday tennis enthusiast. She fostered a connection with favorite player Kim Clijsters. After working each of the Belgian's matches at the 2009 Open, the two tearfully embraced following her win. Fowler went on to work both of Serena Williams's 2012 and 2013 championship matches—Serena would often wink at her before or after she played.

There's nothing like being on court.

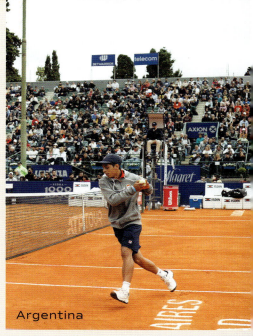

Argentina

England

USA

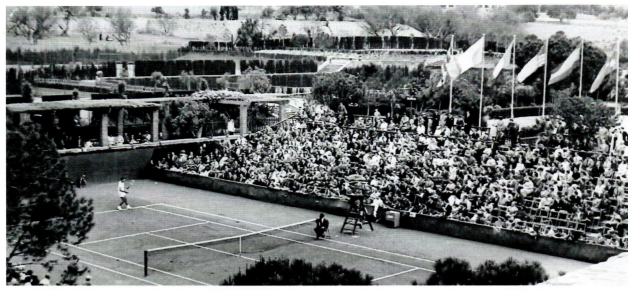

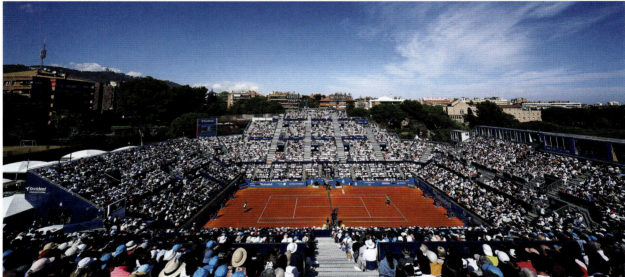

REIAL CLUB DE TENIS BARCELONA 1899

Barcelona, Spain

"The gathering place for Spanish tennis." "The talisman court." This is what you hear on the grounds of the Royal Tennis Club Barcelona. For most of the year, it's a private tennis club, the most coveted in Spain, but every April it transforms for a men's professional tournament around the Conde de Godó trophy. The place becomes almost unrecognizable as a historic club, but the members themselves keep the character alive. The ball kids at the tournament are all students in the club's tennis school, and much of the staff running the tournament is among the club's membership.

While the club changed locations several times throughout the first half of the twentieth century, it settled in the Pedralbes neighborhood of Barcelona in the 1950s. As tennis garnered popularity in Spain in the 1960s, the court became known as *la pista talismà* (the talisman court), a place where some of Spain's greatest achievements in sports were made.

Many come to the tournament every year solely to witness pure Spanish dominance. Owing largely to Rafael Nadal, the Spanish men have monopolized the trophy in Barcelona, winning most of the last 26 editions of the Barcelona Open.

Much like watching the Aussies in Melbourne Park, the passion of the Spaniards at RCT Barcelona is on full display. Many of the Spanish players have been coming to this tournament as spectators or junior players since they were kids, cheering as they would inside Barcelona's or Real Madrid's soccer stadiums.

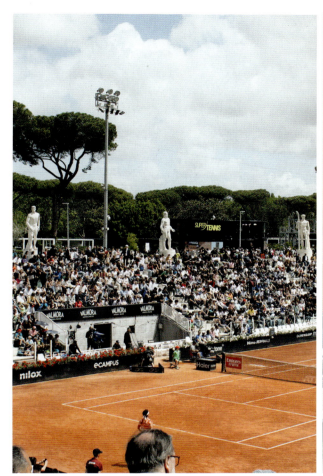
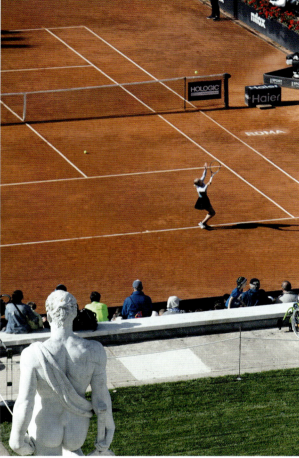

FORO ITALICO

Rome, Italy

Any match at Foro Italico combines the raucous sounds of the classic Italian fan base—whistles, shouts, chants, heckling of opponents—with the long-standing and tumultuous sporting tradition at this massive Fascist-era sports complex. Visiting on the liveliest of days, one might watch an evening match at the Rome Open, then make their way to a Roma club football night match. *Veni vidi vici, viva Roma*. At what was originally known as the Foro Mussolini, the clay courts take on more of a modern sensibility, except for Stadio Nicola Pietrangeli, the court with 18 marble statues surrounding it. At this all-public-seating stadium, often the best court to watch at the tournament, the crowds clamor into several rows of wide marble amphitheater seating to watch the clay and the players fly.

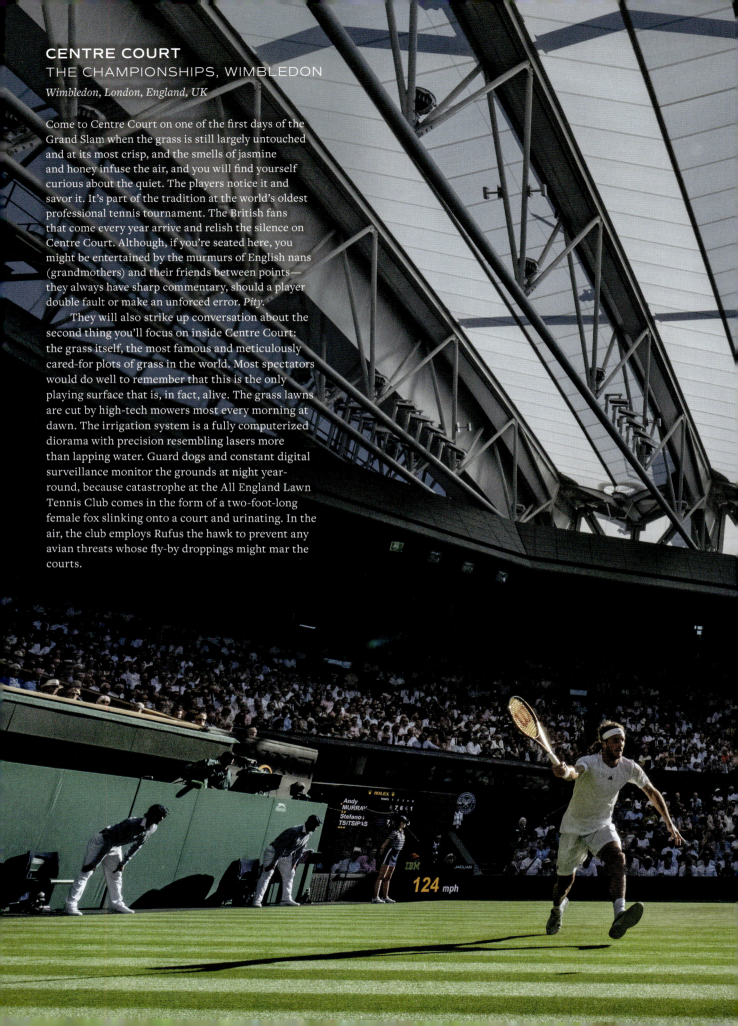

CENTRE COURT
THE CHAMPIONSHIPS, WIMBLEDON
Wimbledon, London, England, UK

Come to Centre Court on one of the first days of the Grand Slam when the grass is still largely untouched and at its most crisp, and the smells of jasmine and honey infuse the air, and you will find yourself curious about the quiet. The players notice it and savor it. It's part of the tradition at the world's oldest professional tennis tournament. The British fans that come every year arrive and relish the silence on Centre Court. Although, if you're seated here, you might be entertained by the murmurs of English nans (grandmothers) and their friends between points—they always have sharp commentary, should a player double fault or make an unforced error. *Pity*.

They will also strike up conversation about the second thing you'll focus on inside Centre Court: the grass itself, the most famous and meticulously cared-for plots of grass in the world. Most spectators would do well to remember that this is the only playing surface that is, in fact, alive. The grass lawns are cut by high-tech mowers most every morning at dawn. The irrigation system is a fully computerized diorama with precision resembling lasers more than lapping water. Guard dogs and constant digital surveillance monitor the grounds at night year-round, because catastrophe at the All England Lawn Tennis Club comes in the form of a two-foot-long female fox slinking onto a court and urinating. In the air, the club employs Rufus the hawk to prevent any avian threats whose fly-by droppings might mar the courts.

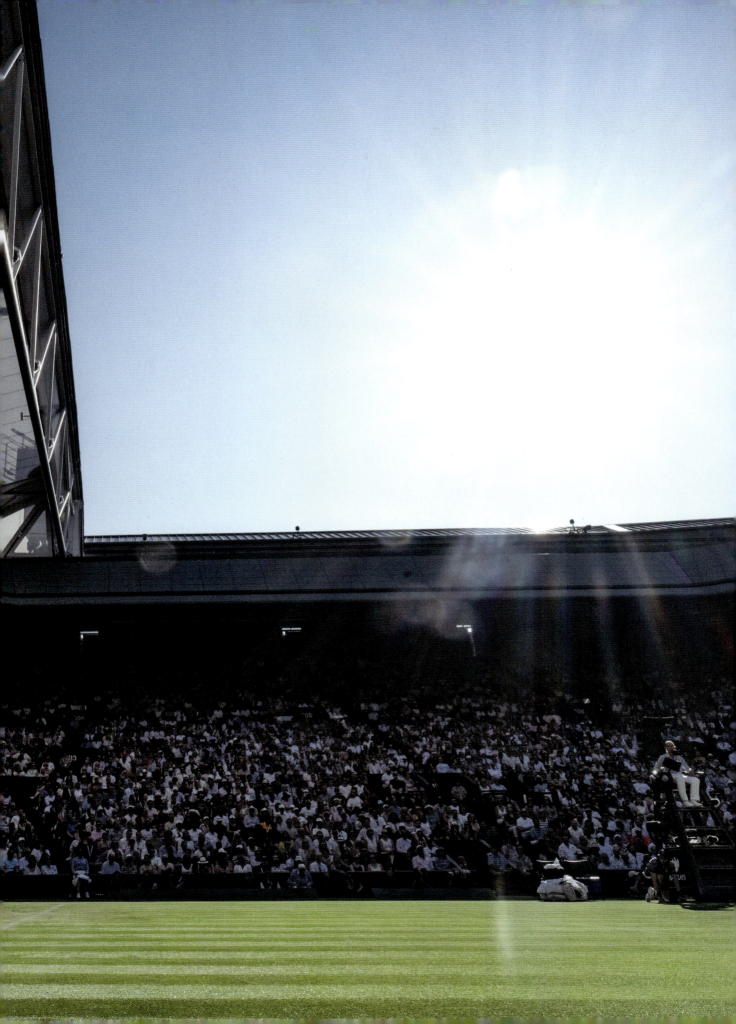

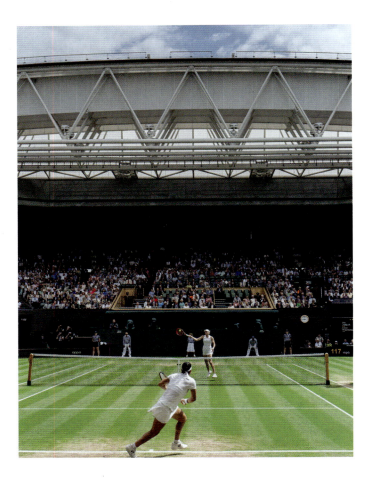

The team that manages these plots talks about the Wimbledon courts in familial terms. Each plot of grass is a member of the family, the elder courts representing the trunk from which grew many branches with their own personalities. Every family has its errant members (see Court 2). There are also literal family members among the groundstaff, with two sets of brothers on the team. These experts maintain the most cherished tennis grounds on earth, but very few of them watch, play, or savor tennis itself—one head groundskeeper aligns himself with Liverpool football first and foremost. But they all fixate on the product, keeping photos of courts from past years as reminders of their perfections (or imperfections). Walk around Centre Court before the lines are painted, and the talk is all about the greenness of the grass, whether the plot looks hungry, or whether it has been resilient this year. The lawns are massaged and primmed and wrestled into shape until the groundstaff gets a reading of around 200 gravities for the start of the tournament and 300 gravities for wheelchair tennis, the ideal resistance for the Wimbledon bounce.

The last reflections you'll hear from the Wimbledon regulars will be that of events past. What's the greatest match ever played? It's an impossible inquiry. One's preference for surface, era, style, metrics, nationality, racquets, even commentators factors in. But any true Wimbledon regular, or All England Lawn Tennis Club member, won't let you deny that since its opening in 1922, an outsize constellation of the best matches the sport has ever seen have been held at Centre Court: Cochet vs. Tilden, 1927, when 25-year-old Henri Cochet came back from being down two sets and 5–1 in the third to prevail. Budge vs. von Cramm, 1937, a five-set, brutal Davis Cup match with stakes far beyond the sport itself. Gonzales vs. Pasarell, 1969, a first-round match with a jarring score line—22–24, 1–6, 16–14, 6–3, 11–9. Borg vs. McEnroe, 1980, credit for high-stakes drama going to the fourth-set tiebreaker that took 22 minutes and 34 points to finish. Graf vs. Sabatini, 1991, Steffi Graf's first major win, with one of the tightest deciding sets of that decade. Williams vs. Davenport, 2005, with Venus clawing out a 9–7 third-set victory and defining pressure-point tennis. Nadal vs. Federer, 2008, the subject of multiple books.

The list goes on. These matches weren't all finals, but surely it's the grass, despite its changing composition over the years, that produces such seminal, grueling contests.

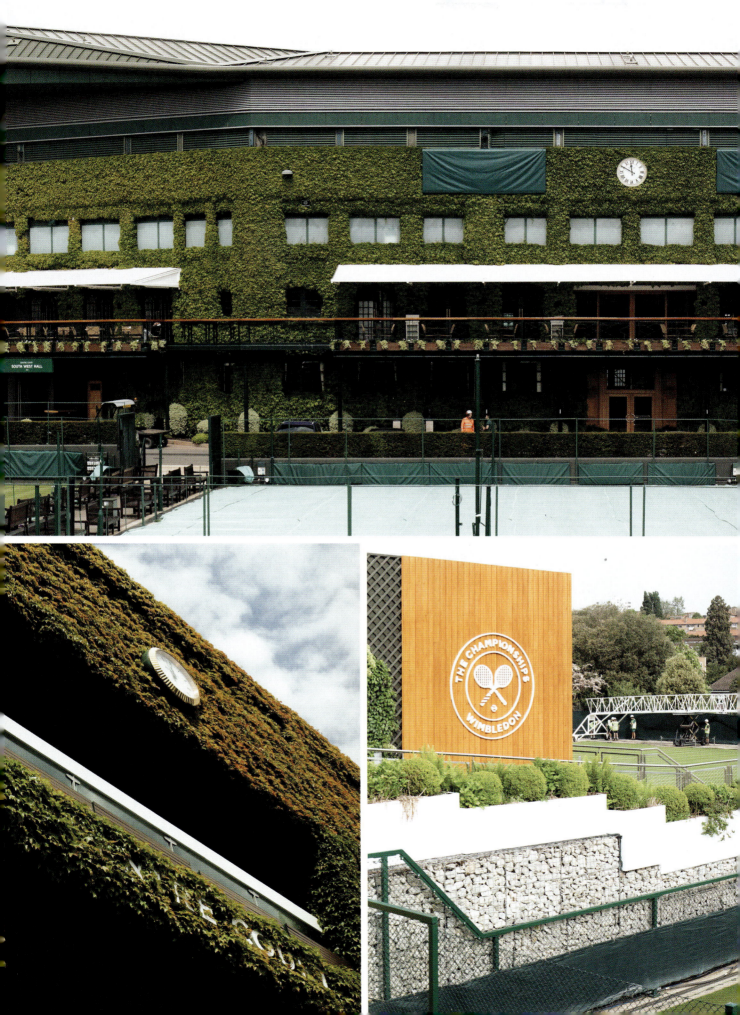

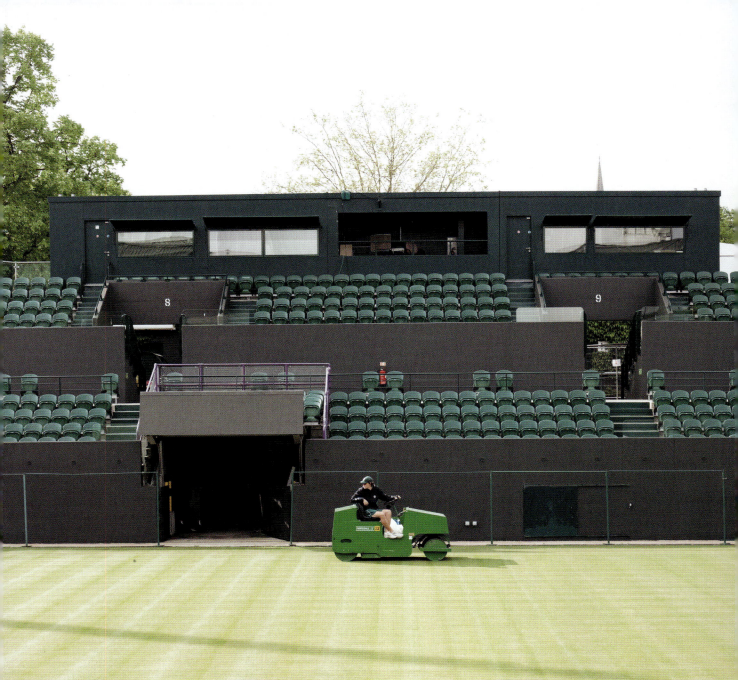

COURT 2
THE CHAMPIONSHIPS, WIMBLEDON

Wimbledon, London, England, UK

There's no bad view at Wimbledon. But Court 2, a favorite among the groundstaff, is the place to deeply appreciate the heart of the grass-court stage. Not for the individual court's aesthetics—thousands of hours go into making all the plots look exactly the same—but because it's difficult, temperamental, and unwieldy.

The surface of Court 2 is set below ground level, beneath the water table, so the soil and blades of grass stay wet longer. But the court also dries and heats faster because of the angles of light and shade in spring and summer. This cousin in the Wimbledon family requires the most parenting by far. Every week, as the team assembles for their duties, Court 2 needs checking on, whether for rolling, measuring, watering, or redirecting. It's not like Courts 5 and 6, which have optimal growing conditions with no shade issues. The groundstaff could leave managing those courts to their children. Maybe.

As you sit and watch a match on Court 2, know that this is the hardest-earned grass-court arena in the world.

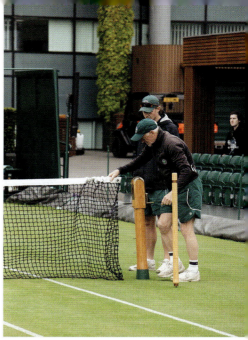

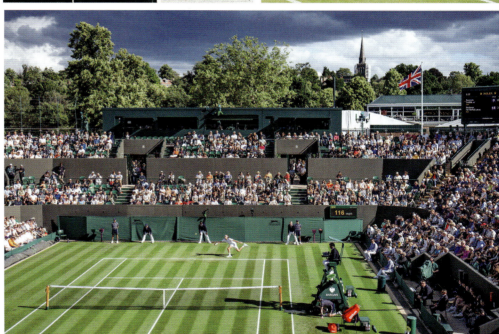
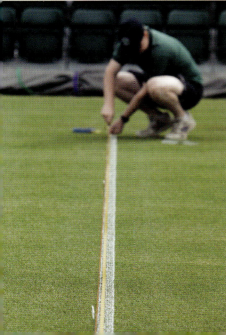

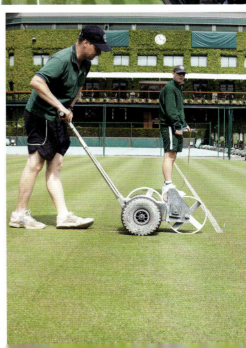

QIZHONG FOREST SPORTS CITY ARENA

Shanghai, China

One of the most iconic tennis bowls outside the Grand Slams is in southwest Shanghai and was built specifically for the men's ATP Finals in 2005. Nowadays, the site plays host every autumn to the Rolex Shanghai Masters 1000, a tournament that won the award for best ATP 1000 five times in its early history. As you sit in one of the 14,000 blue-and-red seats, here's one of the few moments in tennis where you'd actually want rain to fall over the oval so they close the roof. With its eight petals, each weighing more than two tons, this retractable marvel was designed by Japanese architects to unfurl like a magnolia blossom, the official flower of Shanghai. It makes one think all the Grand Slams should be required to stylize their retractable roofs after a nationally recognized floral treasure.

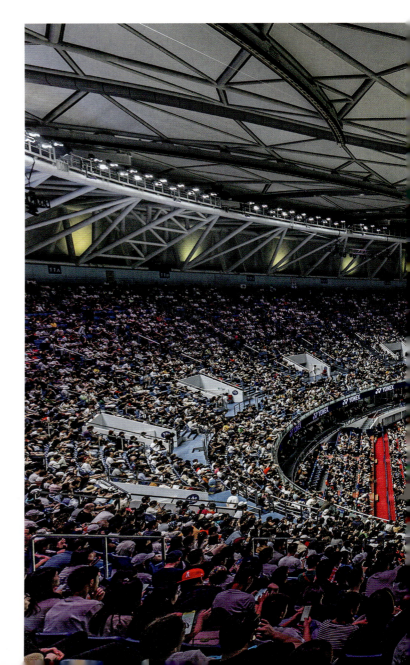

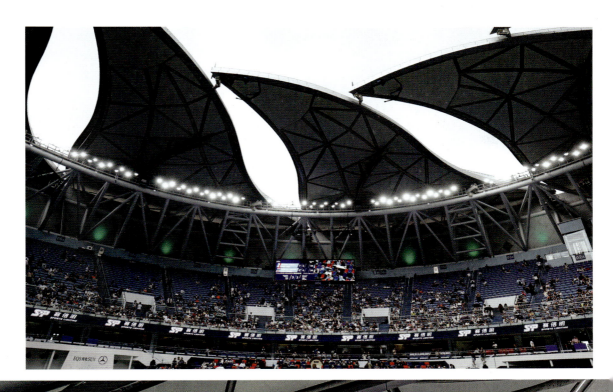
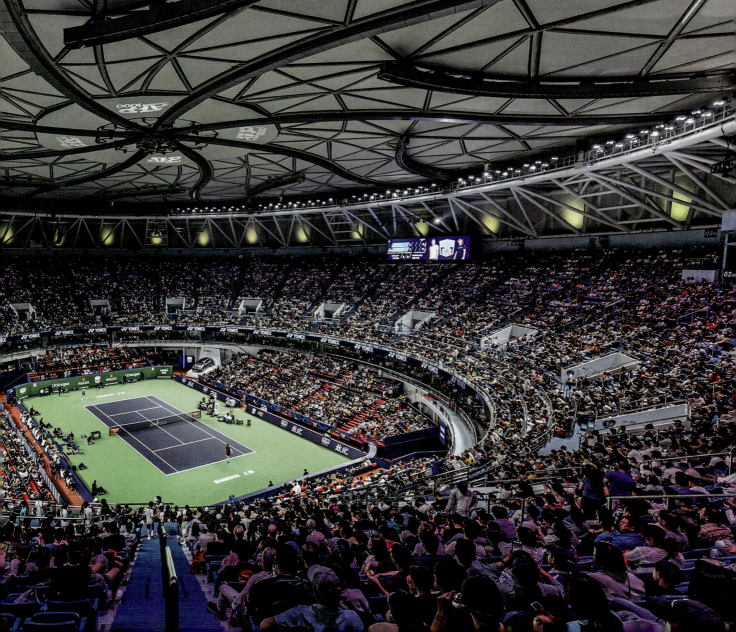

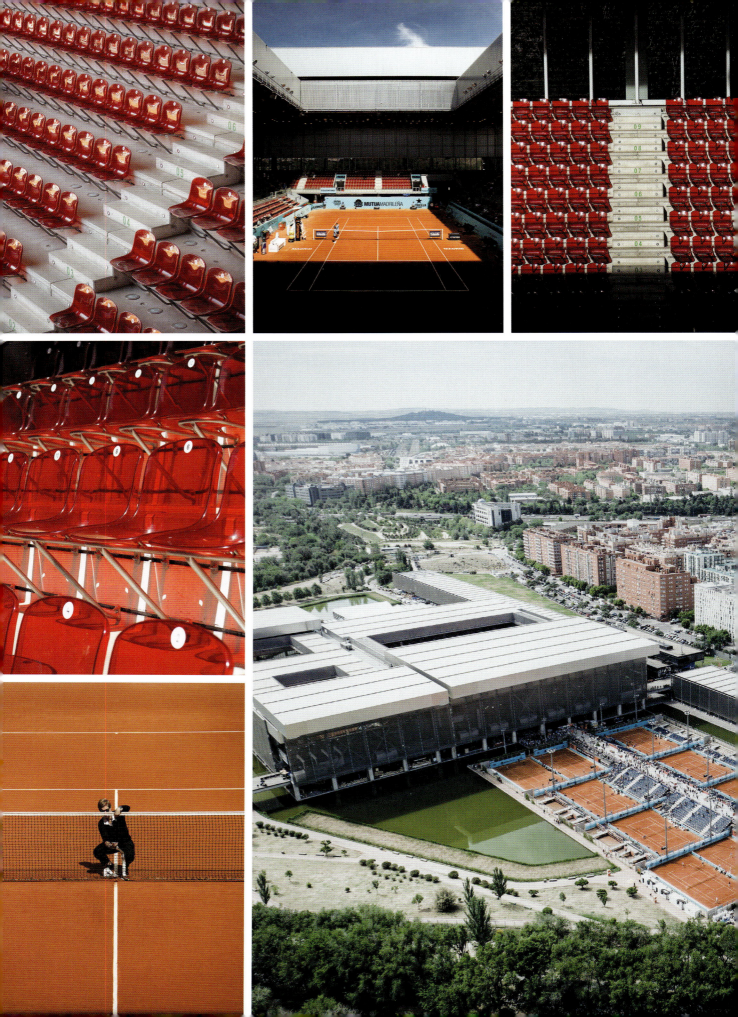

LA CAJA MÁGICA

Madrid, Spain

Enter La Caja Mágica, Spain's modern clay cathedral, and forget everything you've understood about what a tennis venue can be. Of course the tennis here is played on picturesque orange-red Spanish clay. But the clay at La Caja Mágica appears brighter, more vibrant. The gargantuan structure's slated steel roof reflects blinding and dazzling light around the courts.

The postmodern Caja Mágica, home to the Madrid Open since 2009, sits above an artificial lake nestled into the suburbs south of Madrid, and while it's difficult to truly appreciate once you enter, this open-air apparatus contains three stadiums within its porous metal exterior. Court Manolo Santana, the crown jewel, has two siblings, Court Arantxa Sánchez Vicario and Court 3 (no namesake yet). French architect Dominique Perrault fashioned the steel curtains that surround the facility to recall a lantern. In the stands and on the concourses, the venue feels a bit like a spaceship, as if all the spectators and players have lifted off the lake and are floating in orbit while the match carries on. Even the seats, all a striking translucent pomegranate color, evoke a futuristic feel. Call it whimsy as you take in the stark contrast of concrete and steel blocks against the red clay sheen.

Watching the tennis during the Madrid Open, puffs of cotton drift whimsically in the air from the surrounding cottonwood trees on the far sides of the lake. The sounds of play here, too, overpower almost all others in tennis, especially inside the smallest stadium, Court 3, where well-struck serves and forehands echo explosively. To appreciate the action that takes place on the courts outside the box, take the extended walk to the nearby lookout at Cerro Coyote, where from off the grounds you can see Madrid to the north and the box to the south.

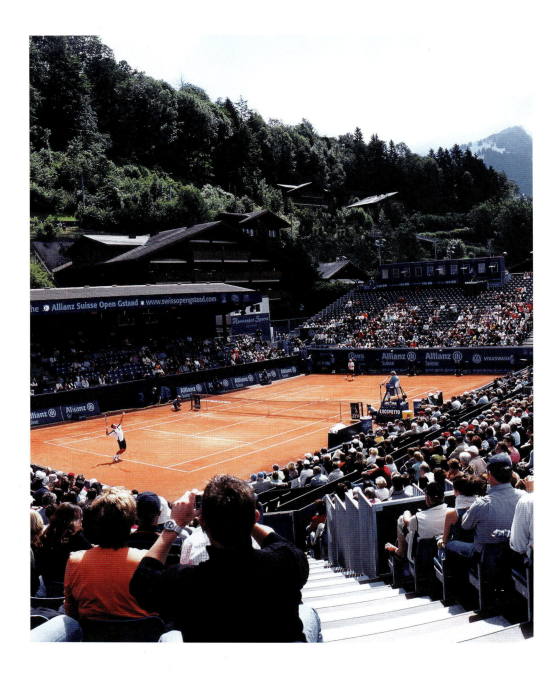

ROY EMERSON ARENA

Gstaad, Switzerland

When the grass-court season ends and it's not quite America's turn to host the professionals on their screechy, ruthless hard courts, some pro players take jaunts back to clay in two tournaments on trophy courts everyone in the tennis world would do well to visit. First, in the southwest Swiss town of Gstaad, Roy Emerson Arena holds about 4,500 spectators in this crisp, deep-blue-colored nest at the base of the Alps. The energy here can feel like a glitzy exaltation. All the scores of the very short grass season have been settled, and the predominantly European-born pros are back on their home surface in front of a predominantly Swiss and French crowd. Most spectators are annual visitors and recreational players themselves and not short on sharp-witted commentary. There's also apparel representing Swiss-born Roger Federer everywhere. In 2003, after Federer won his first Wimbledon, the tournament presented him with a brown cow wearing a crown of yellow roses and sunflowers to celebrate. No word on whether Federer kept the cow.

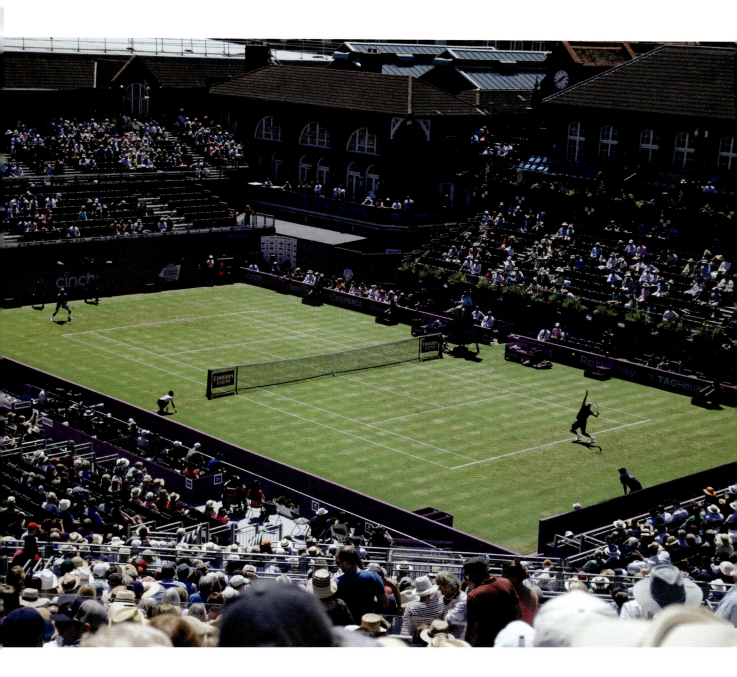

THE QUEEN'S CLUB

London, England, UK

When the French Open ends, not all the pro players yearn to feel the slick finish of damp grass under their shoes. Some would rather go golfing than train and compete on grass. But the grass-court tournaments carry an austere and prestigious transition for fans. And perhaps the most notable and storied grounds on which to witness this change of surface are at the Queen's Club.

Named after Queen Victoria, the club's first patron, the 28 courts at the private club in West Kensington get converted to accommodate a 9,000-seat pop-up stadium every June. The grass here is as finely maintained as the lawns 4 miles (6.4 km) away in Wimbledon.

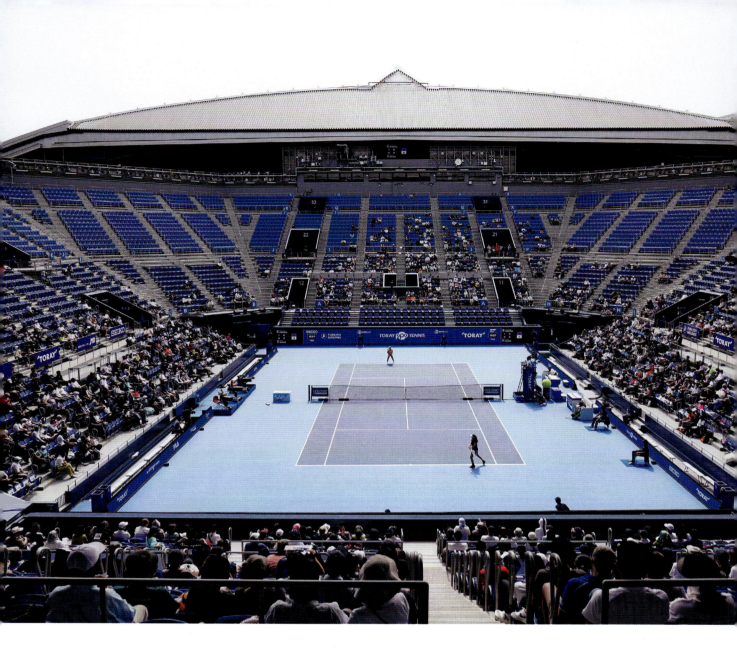

ARIAKE COLISEUM

Tokyo, Japan

Nearly 50 hard courts sprawl out across the leafy Ariake Tennis Forest Park, Japan's tennis headquarters, with the Ariake Coliseum as its centerpiece. Toward the end of the professional season every October, the site hosts the Tokyo Open for both the women's and men's tours.

The 10,000-seat arena has one of the game's oldest retractable roofs, dating back to the early 1990s, long before Wimbledon or Arthur Ashe Stadium became convertible caverns themselves. The great debate in praise of, or lambasting, roofs on tennis stadiums really started in the Pacific. Rod Laver Arena, in 1988, and Ariake Coliseum shortly thereafter were the first major tennis stadiums to have the giant railroad-track-style enclosures. The roofs made the thumping sounds of balls striking more forceful—in Ariake, the echo and sharpness of the sound feel even more acute than in Melbourne. Tennis tradition demands the game be played among the natural elements. Still, there's an added drama and intensity to watching indoor tennis, and though Ariake with its roof closed is one of the quietest venues, its acoustics are the most emphatic.

CABO SPORTS COMPLEX

Los Cabos, Mexico

As professional tennis tournaments have leaned into stark color schemes, courts that pop on TV, and a generally bright, crisp-edged appeal, this new venue in western Mexico has opted to enmesh itself in its natural surroundings instead. There's a mystique to the courts at the newly constructed complex, which hosts the professional men every summer. The small stadiums do what few venues can authentically achieve: seamlessly fit the courts and the seating into the landscape. Here it's in the arid desert of Baja California. The stadium known as the Crater sits below ground level, with only native plants in the surrounding terrain. Raw stone is used for the venue's seating, as well as the court's perimeter. It feels like the future: Any prospective tennis sites would do well to adhere to the textures, colors, and elements of their natural surroundings.

BOURBON BEANS DOME
Kobe, Japan

Very few sporting facilities, especially tennis grounds, integrate into their natural surroundings. Unless courts are placed in a natural checkerboard, similar to a cornfield, blurring boundaries isn't tennis's strong suit. Indoor facilities have long been eyesores, and the tennis bubbles, or domes, popularized in the 1970s are not the most aesthetically pleasing or player-friendly blobs to behold.

The Bourbon Beans Dome in southern Japan provides something of an antidote. This nine-court facility is ingeniously enmeshed into the green Kobe hillside and creates a bold tennis galactica scene within. Renowned Osaka architect Shuhei Endo built the dome in 2005 using spiraling steel to encase the place like a shell or legume. Endo likely wasn't thinking of how satisfying the sound of a well-struck serve can be in indoor tennis, but here is the ultimate indoor tennis orchestra for players. There's nowhere one would rather go to crack a flat serve or maybe slap a forehand just for the sound and echo.

For the Hyōgo prefecture, Bourbon Beans Dome is part of a wider sports complex and, more important, acts as an emergency relief center (the complex was built following the Kobe earthquake of 1995, which killed thousands of people in the cities Miki and Kobe). Ten sites dot the landscape, with the 174,000-square-foot (16,165 sq m) tennis dome as the most inspired. Three enormous oval skylights keep the place well lit, and the upper walls are essentially windows with beams deflecting and leveling any glare. From above, it looks like giant tennis balls got squished into the earth. Four courts flank the center court on either side, with 1,500 seats available for the Challenger Tour pro tournament held here during the indoor season. What's more, tickets for the event are donation-only, with all the money going to a regional disaster fund.

The pro tours make their way to Asia every year after the US Open, and tennis is growing fastest in Japan and South Korea. A swing through Japan starting with the Japan Open may be a fan's or player's top priority. From the Tokyo Open, you can spend a week or two hitting courts around Tokyo, then take the three-hour bullet train to Osaka to visit Bourbon Beans Dome for the tournament here.

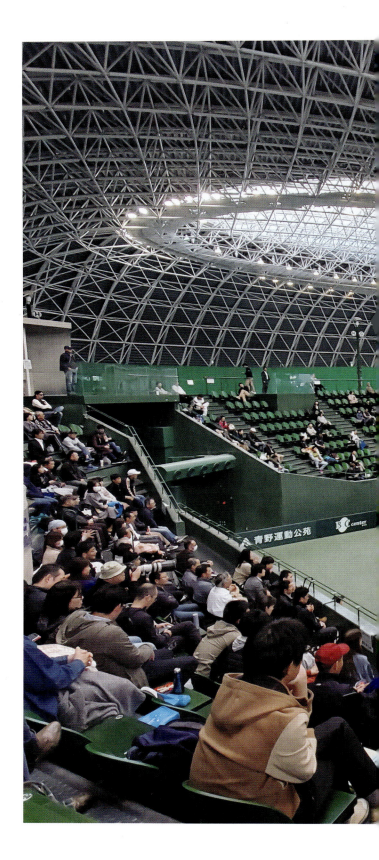

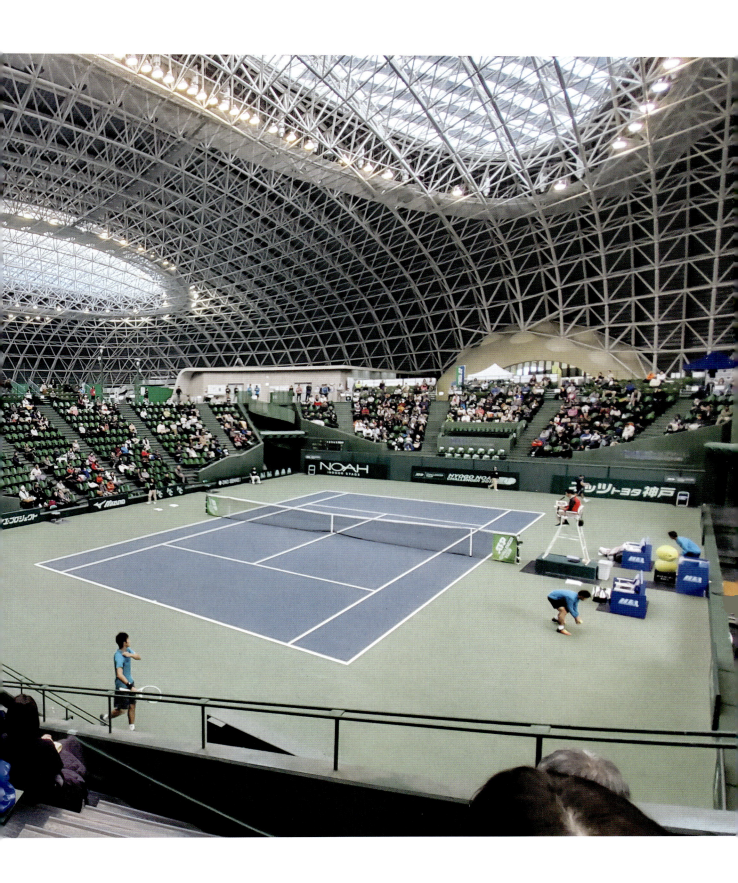

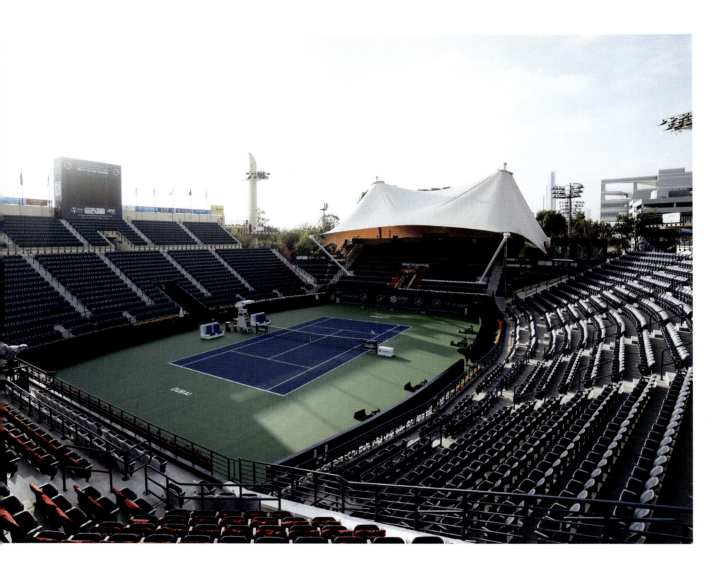

DUBAI DUTY FREE TENNIS CENTRE
Dubai, United Arab Emirates

Many will remember the Dubai court in the sky. Constructed on a helipad for a Federer-Agassi photo op in 2005, the court was temporary, and the helipad remains just a helipad atop a seven-star hotel. But from that perch—or as you're arriving to Dubai by plane—you can see how tennis has grown in Dubai, now home to dozens of public facilities and even more private clubs and hotel courts to play on.

It would have been easy to assume the Emirati would build the site of the Dubai Open with as much if not more extravagance—a tennis tournament in the sky with an Emirates airplane coasting around on a loop for the length of the tournament.

But the Dubai Duty Free Tennis Centre, home of the Dubai Open, is a bit of an anomaly. Cobblestone walkways string around a modest row of restaurants and bars in an area dubbed the Irish Village, which stays open year-round. The stadium could've been made to match the opulence and extravagance of the Burj Khalifa, the Dubai Frame, or the entire Jumeirah, but it stayed peculiar, an Emirati mismatch. Some visitors to the tournament and locals alike have come to revel in this, as maybe tennis, too, is a practice of being at odds with your counterpart and your surroundings.

Over in the capital city, however, the court at Zayed Sports City, home of the pro tournament in Abu Dhabi, has the glittery, neon-sheened courts that you'd expect of the Emirati.

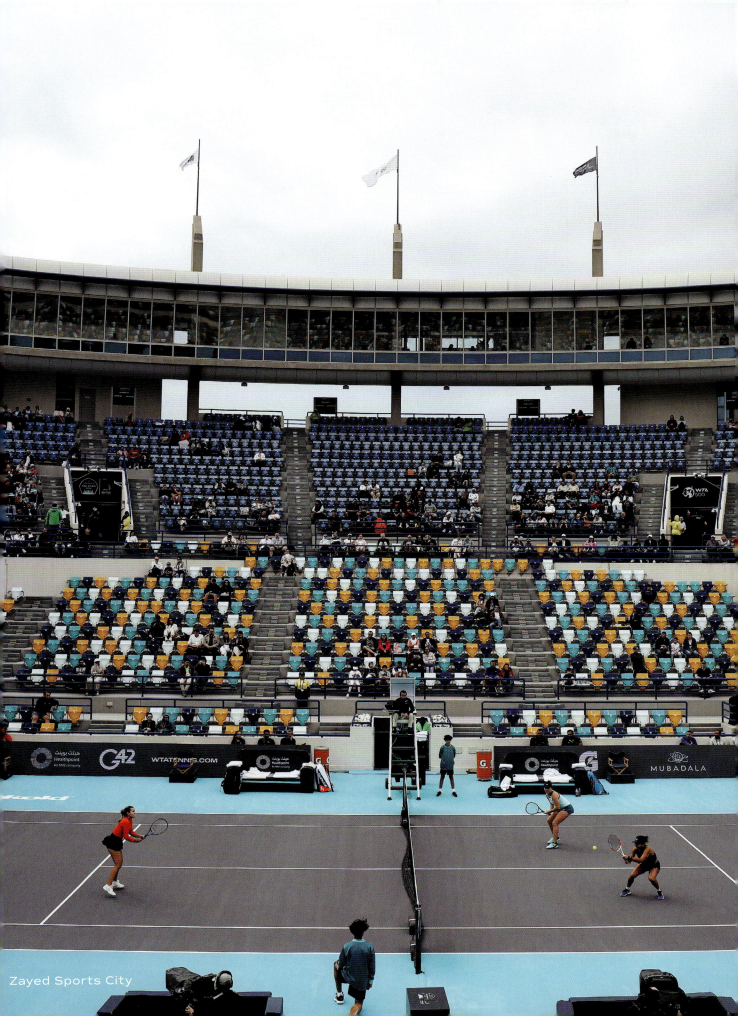

ARTHUR ASHE STADIUM, GRANDSTAND & COURT 17
US OPEN

Flushing, New York, USA

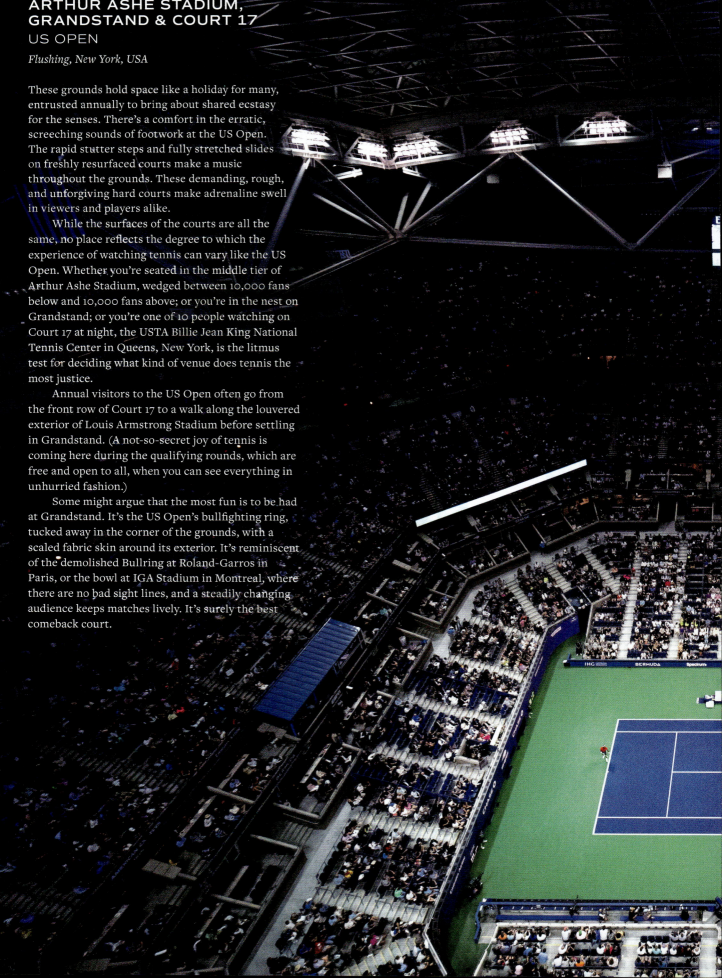

These grounds hold space like a holiday for many, entrusted annually to bring about shared ecstasy for the senses. There's a comfort in the erratic, screeching sounds of footwork at the US Open. The rapid stutter steps and fully stretched slides on freshly resurfaced courts make a music throughout the grounds. These demanding, rough, and unforgiving hard courts make adrenaline swell in viewers and players alike.

While the surfaces of the courts are all the same, no place reflects the degree to which the experience of watching tennis can vary like the US Open. Whether you're seated in the middle tier of Arthur Ashe Stadium, wedged between 10,000 fans below and 10,000 fans above; or you're in the nest on Grandstand; or you're one of 10 people watching on Court 17 at night, the USTA Billie Jean King National Tennis Center in Queens, New York, is the litmus test for deciding what kind of venue does tennis the most justice.

Annual visitors to the US Open often go from the front row of Court 17 to a walk along the louvered exterior of Louis Armstrong Stadium before settling in Grandstand. (A not-so-secret joy of tennis is coming here during the qualifying rounds, which are free and open to all, when you can see everything in unhurried fashion.)

Some might argue that the most fun is to be had at Grandstand. It's the US Open's bullfighting ring, tucked away in the corner of the grounds, with a scaled fabric skin around its exterior. It's reminiscent of the demolished Bullring at Roland-Garros in Paris, or the bowl at IGA Stadium in Montreal, where there are no bad sight lines, and a steadily changing audience keeps matches lively. It's surely the best comeback court.

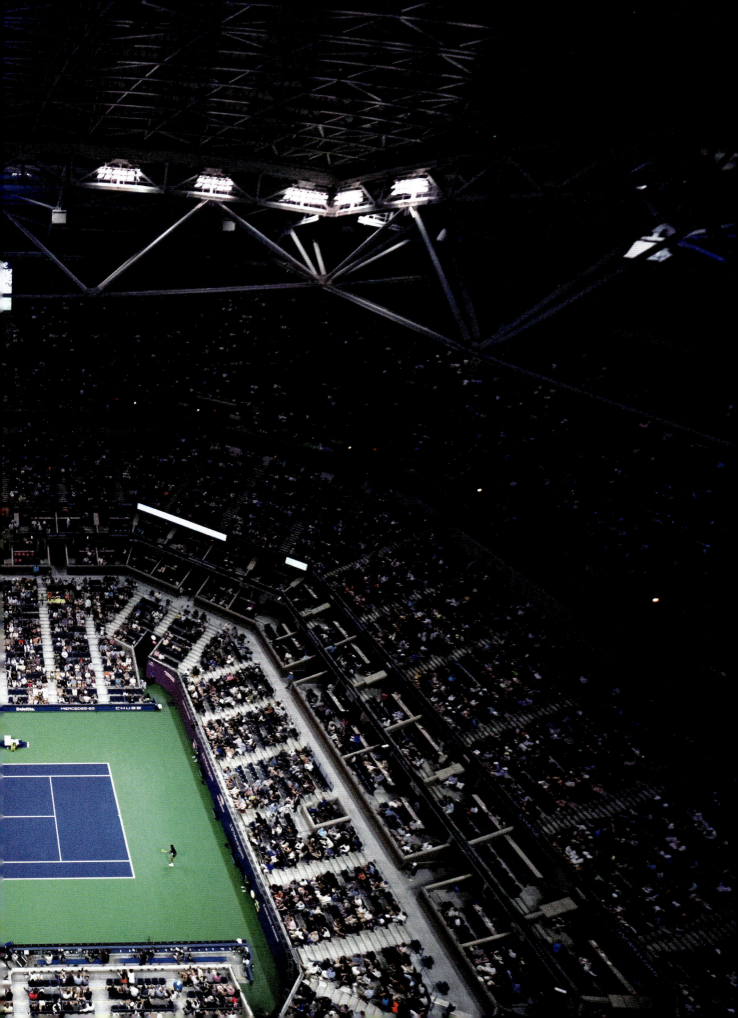

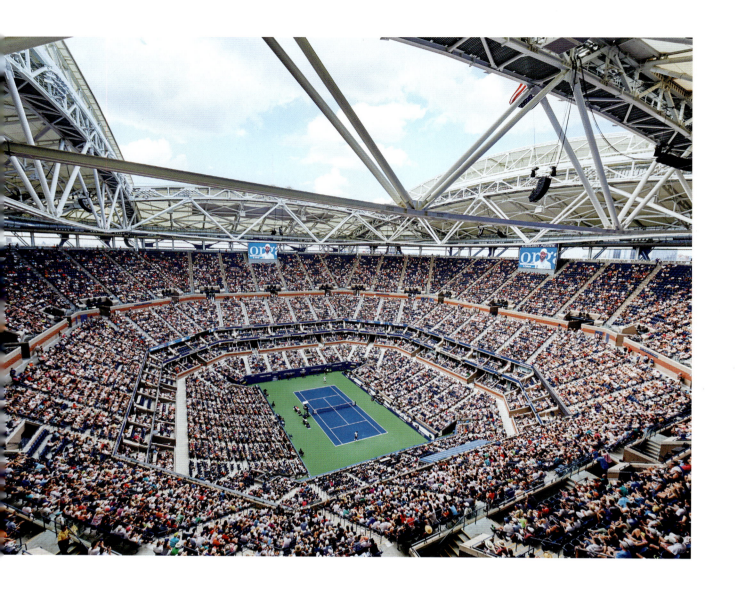

Then you enter Arthur Ashe Stadium and all its glorious, loosely controlled chaos. The atmosphere is intoxicating, at times because a fair portion of the audience is, in fact, intoxicated.

This isn't Gstaad. It's New York City.

It's loud, the loudest since it was built in 1997, and everyone experiences it together, taking from the cacophony a dose of love or disdain. Regardless, this place makes you feel the experience of watching tennis deeply, even if you're sitting in the top row of the upper decks, 120 feet (36.5 m) above the court.

Sometimes, on the faces of newcomers, players, or spectators, you can see the surprise at how talk from the upper decks runs down toward the court in layers of echoey chatter, especially when the 5,000-ton (4,540 mt) roof is closed. The sound of the ball striking ricochets and cascades. When the crowd screams mid-point, you—and the players—often can't hear a line call. That's what makes the court great, or a punishment—it's the only venue in tennis where in high-pressure moments, you'll see players covering their ears as the noise swells before big points.

It's a reminder that in most sports, chaotic noise is encouraged. It all keeps Ashe the vast outlier of tennis arenas, something to behold no matter how you feel about it. Few can name a more drunk-on-tennis feeling than watching a match on Arthur Ashe that runs deep into the night, 2 or 3 a.m., when the crowd has thinned, there's been an improbable comeback, and you've stuck it out with a community of equally tired but still giddy and hyped tennis fans, new and old, inside tennis's largest hall.

The tour has been going on all year, and it's the final Grand Slam stop. It's only fitting that we'd play all night.

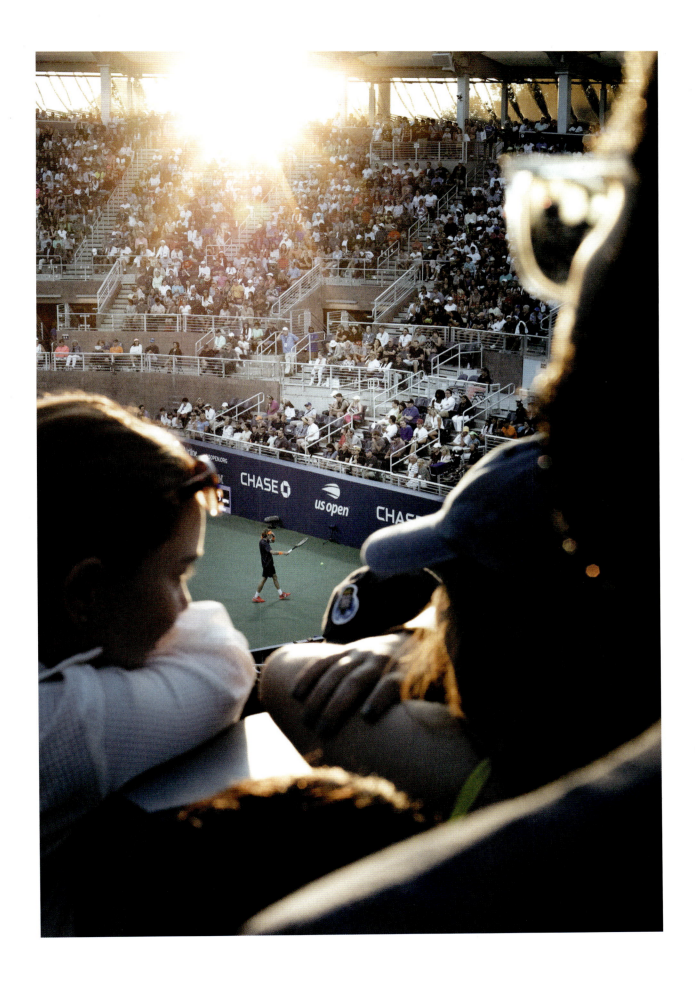

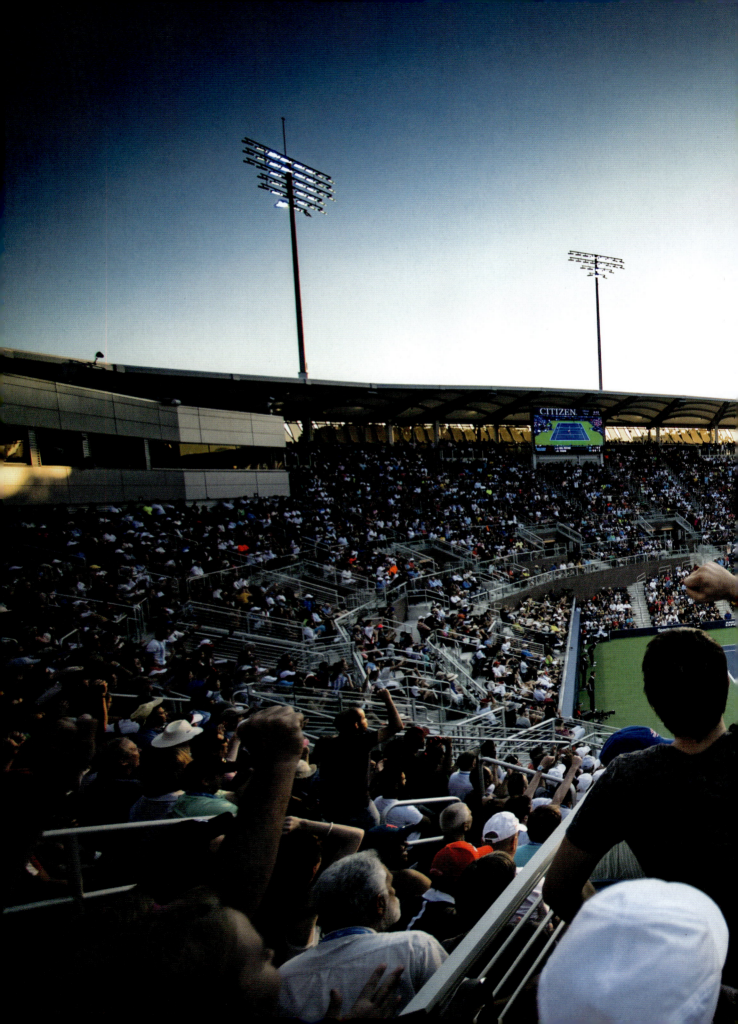

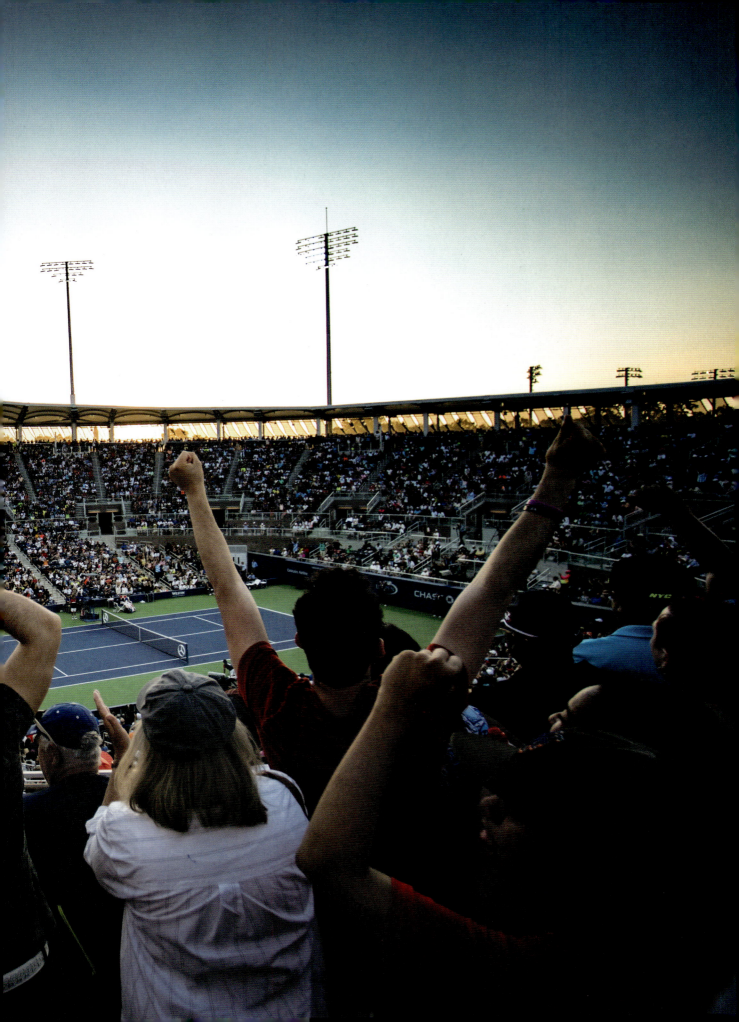

ROYAL TENNIS CLUB DE MARRAKECH
Marrakech, Morocco

Sunshine drenches this clay center court year-round in the heart of the pink city. That, and the winds of the Western Sahara, keep the surface of these Marrakech courts chalky and smooth. Dust is everywhere, part of the fabric of the nets and windscreens, and forms a light film on the balls and the baskets. Every time you start a rally here, it's with a satisfying puff of orange powder. All the clay is brought in from the riverbanks of Safi, what many call the City of Clay, providing clay to all the courts from Casablanca to Mohammedia to Marrakech.

The club, situated in the Gueliz district, is the oldest in Morocco, and the 3,000-seat stadium abides by the Marrakech color mandate—a palette of gentle peach pastels and burnt oranges—for its seats, awnings, and boxes. Built between 1925 and 1929 by a French architect, it's so aesthetically cohesive that on the hotter, dusty days, it's easy for the structure, court surface, and sky to blur together. The only time locals and visitors can't play here is during the Grand Prix Hassan II, the annual professional tournament (and the only ATP tour-level event staged in Africa). Most of the 900-odd members here at the Royal Tennis Club de Marrakech structure their year around attending the tournament.

If you come here to play on one of the 10 clay courts, longtime club president Abdelaziz Tifnouti reminds you and all other visitors to bring your own cans of balls.

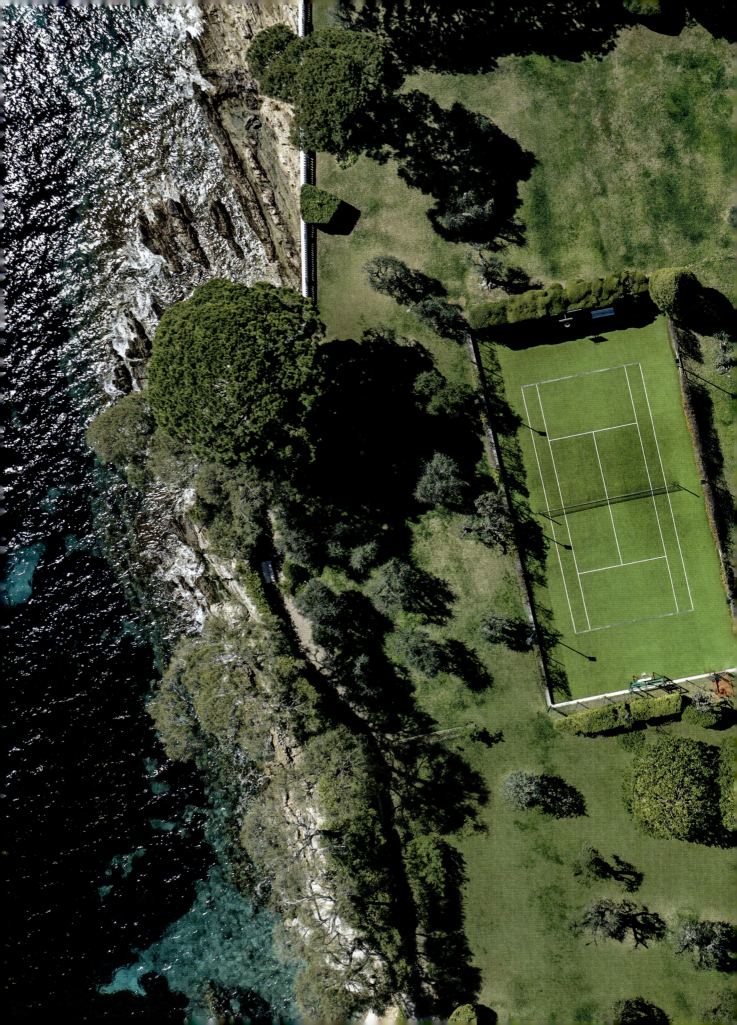

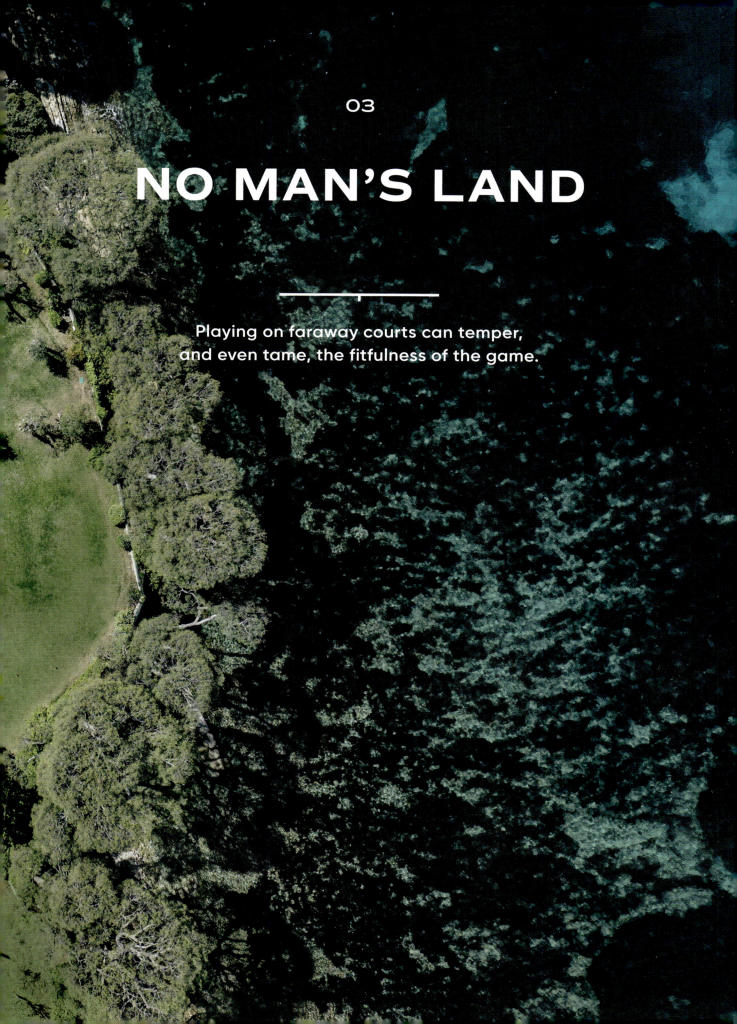

NO MAN'S LAND

03

Playing on faraway courts can temper,
and even tame, the fitfulness of the game.

Anyone who's watched or played tennis knows how much hyperawareness surrounds the game. There's the amplified array of thoughts and feelings we harbor about score, space, balance, energy, pliability, or lack thereof. Then there's the fixation on expectations and limitations. I'm often thinking about the limitations of my left shoulder and my staccato, not graceful, footwork. The mind wanders amid all the details. Then there's what actually happens.

 The greats, the most mindful players, overcome this by tuning in to only what serves them. But for most, playing tennis can very often feel like spinning through a series of rushed departures. Rage comes like an effervescent gas that swells in the air. You're momentarily unable to differentiate the downward spiral of your on-court performance from the rest of your life. The forehand going awry aligns with the missed shots of your romantic pursuits. We aren't meant to be so vastly overwhelmed while alone. But we do it willingly.

 While we can get frustrated anywhere we play, remote courts have the potential to be grounding, or at least distracting enough to let our cares fall away and calm the rhythm of the game. Set out for a court far from anything—towns, people, man-made sounds—and time softens, games feel less hurried and even melodic. While seconds pass slowly in the moments before we play, transitions ease on such courts. Perhaps the large distance between you and literally anyone else, or any other routine or demands, makes the tennis mind here feel less hurried.

 As these places arrest us, whether wittingly or not, our play can become looser, silk-like—even if we have nowhere near the flexibility to swing *that* freely. •

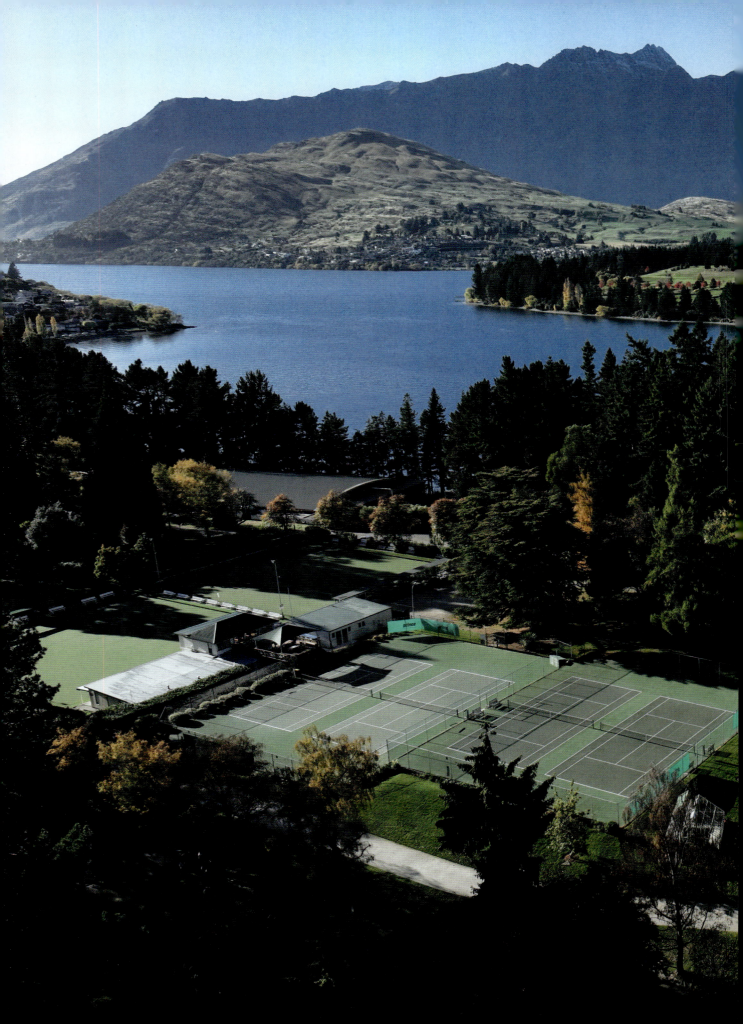

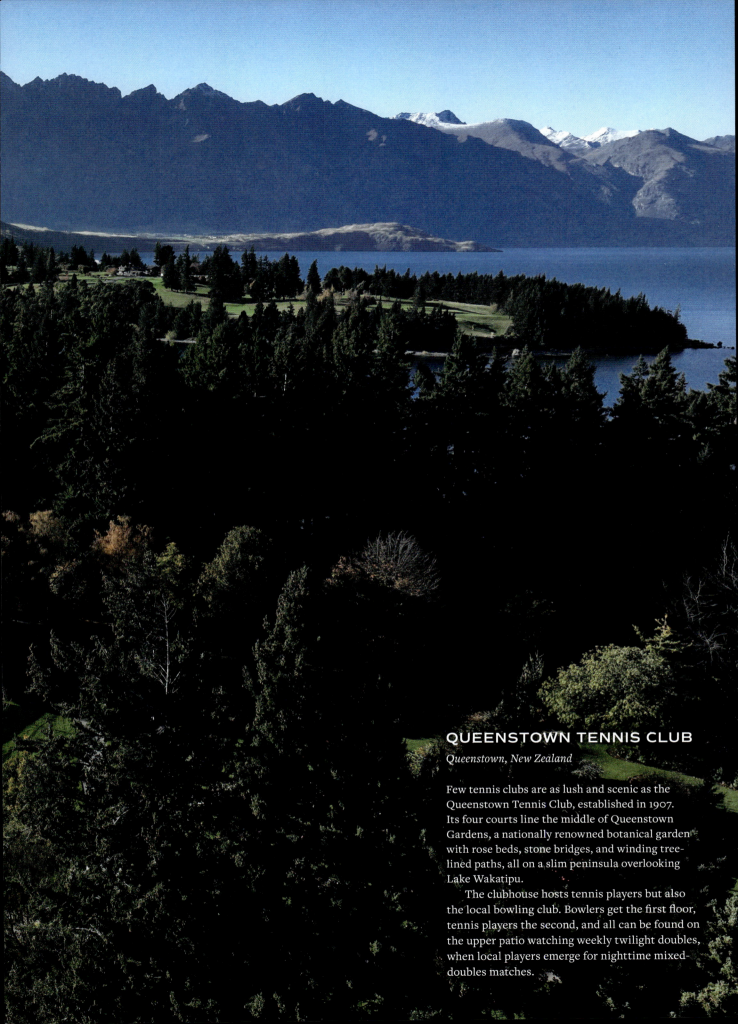

QUEENSTOWN TENNIS CLUB
Queenstown, New Zealand

Few tennis clubs are as lush and scenic as the Queenstown Tennis Club, established in 1907. Its four courts line the middle of Queenstown Gardens, a nationally renowned botanical garden with rose beds, stone bridges, and winding tree-lined paths, all on a slim peninsula overlooking Lake Wakatipu.

The clubhouse hosts tennis players but also the local bowling club. Bowlers get the first floor, tennis players the second, and all can be found on the upper patio watching weekly twilight doubles, when local players emerge for nighttime mixed-doubles matches.

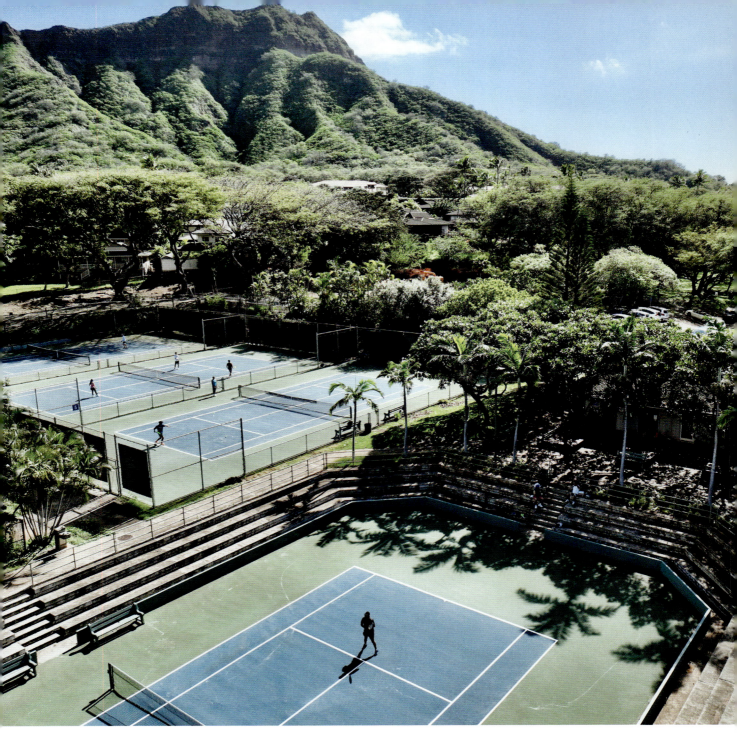

DIAMOND HEAD TENNIS CENTER

O'AHU'S WINDING TENNIS TRAIL

USA

Whether you're on the windward or leeward side or along the North Shore, meandering O'ahu for tennis offers an apt reflection of the island itself. The hard courts see fairly constant use any time of day, any time of year, and all sit near some of Hawai'i's most striking natural landmarks.

Kapi'olani Regional Park's DIAMOND HEAD TENNIS CENTER is one of the busiest spots on the island located just south of Waikiki, and sits in the shadow of Diamond Head crater every afternoon. Farther east, a quieter scene plays out at Koko Head District Park at the base of Koko Head crater. And if one really shanks a ball over the fence at SUNSET BEACH PARK on the North Shore, it'll land on the beach of one of the island's most famed surfing spots, the Banzai Pipeline.

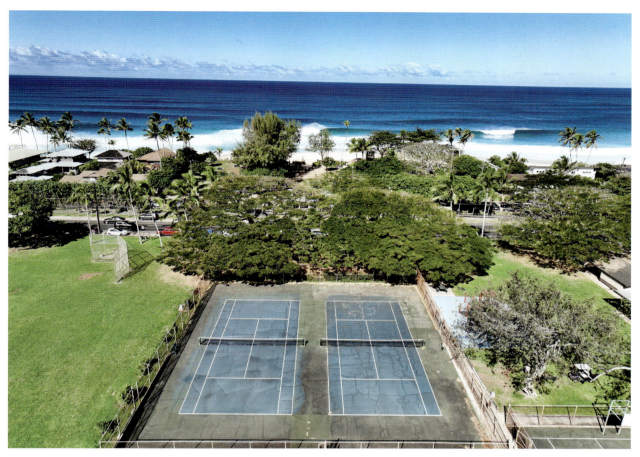

SUNSET BEACH PARK

TURTLE BAY

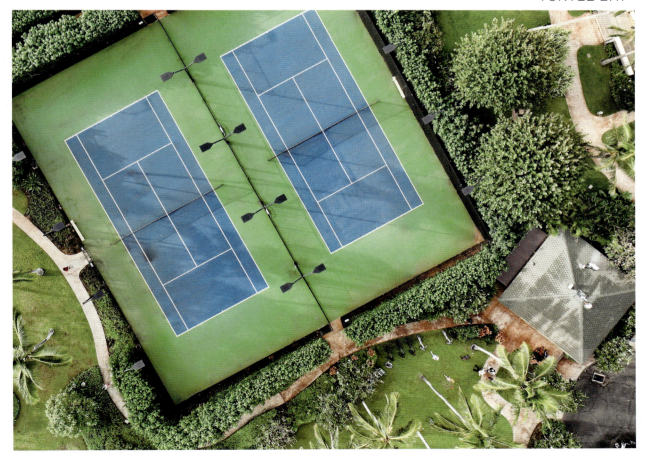

THE COURTS

Borrego Springs, California, USA

In 2018, designers Leah Goren and Adil Dara stumbled upon the 1970s-built Anza Borrego tennis center while on a cross-country road trip. The courts needed some love, and it just so happened that the place was up for sale. On these four courts they saw what could be: a pastel-y convergence of art, design, and community tennis.

The surrounding town in the Santa Rosa Mountains still has no stoplights, only local stores, and now it can boast a cohort of committed tennis enthusiasts who congregate at 286 Palm Canyon Drive every season starting in October. You can find everything from converted trailers for rent to Pop Art to zany tournaments out here.

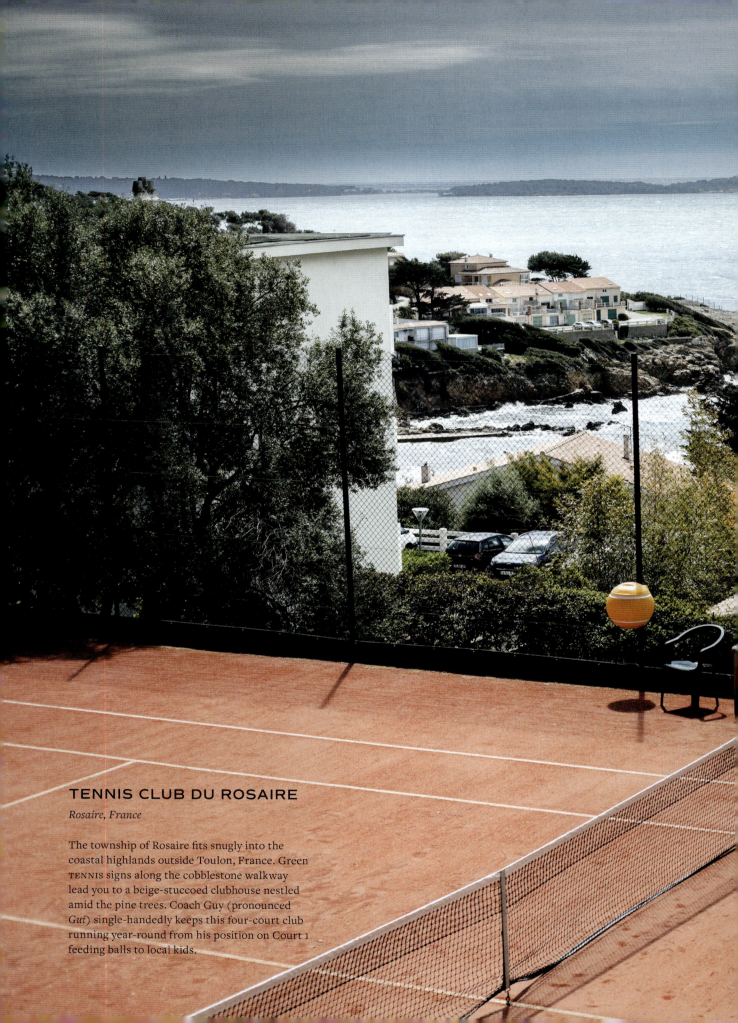

TENNIS CLUB DU ROSAIRE

Rosaire, France

The township of Rosaire fits snugly into the coastal highlands outside Toulon, France. Green TENNIS signs along the cobblestone walkway lead you to a beige-stuccoed clubhouse nestled amid the pine trees. Coach Guy (pronounced *Gui*) single-handedly keeps this four-court club running year-round from his position on Court 1 feeding balls to local kids.

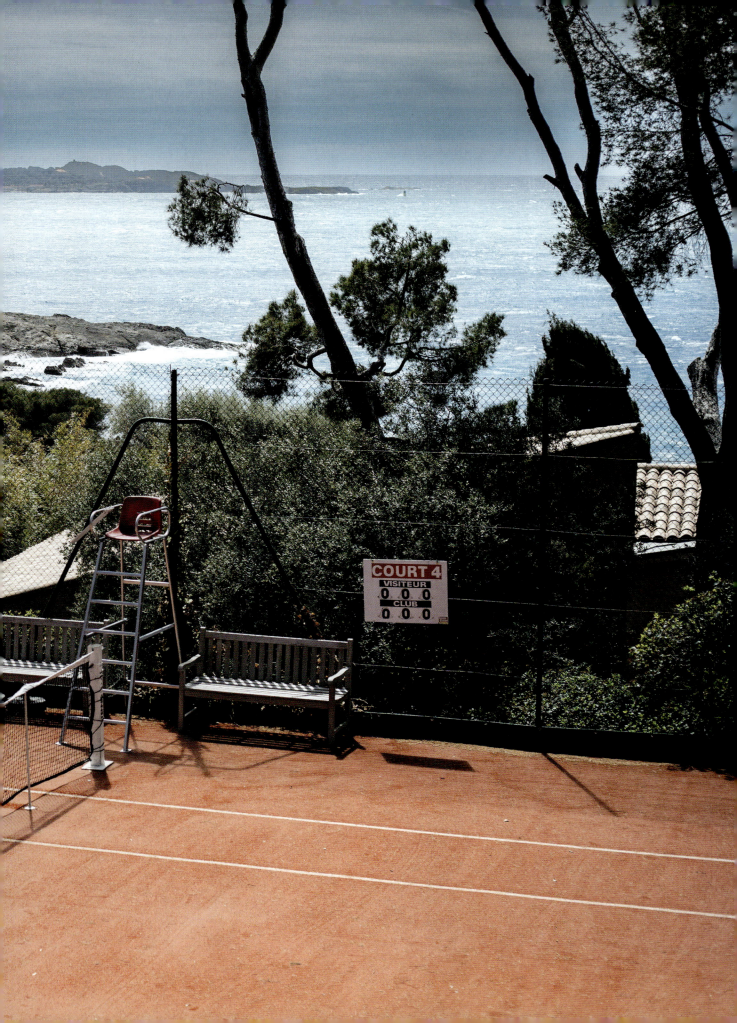

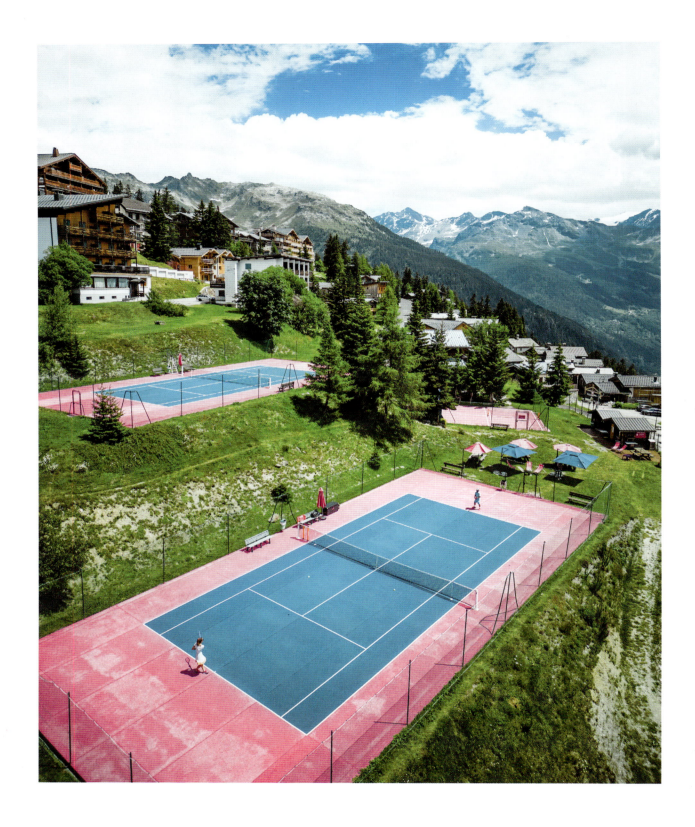

TENNIS LA ROSIÈRE

La Rosière, Montvalezan, France

At a little over 6,000 feet (1,829 m) in altitude, it's easy to lose your footing in the French Alps. The regular summer visitors suggest you bring your own cans of off-color tennis balls—maybe white or a custom black even, something to contrast with the unmistakably bright colors of the courts.

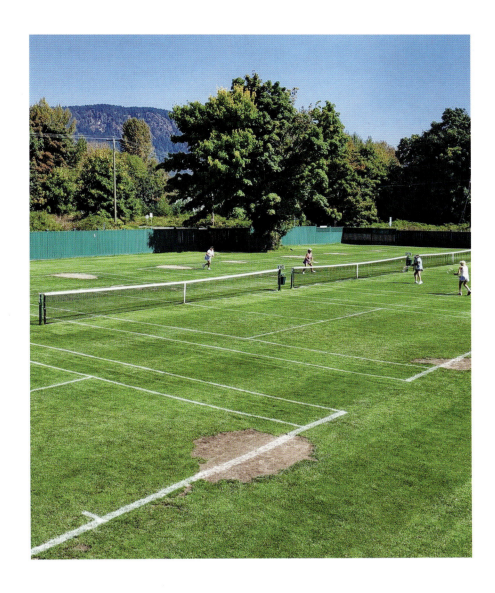

SOUTH COWICHAN LAWN TENNIS CLUB

Duncan, British Columbia, Canada

Canada ought to be more widely recognized for their grass courts, owing in part to Cowichan Lawn, the most commanding small club of western Canada. Out here on bucolic Vancouver Island, a party emerges, like an annual seaside summer camp, centered around the seven grass and two hard courts. The wooden sign at the entrance reads "Circa 1887," marking the year when English settlers played on two grass plots on their dairy farm. Play at the present location commenced not long after in 1907. Several tournaments take place here every summer as the volunteer-run club promotes grass-court tennis to the tennis communities of Victoria, Vancouver, and Greater British Columbia. One main difference of playing here: If someone from the community wants to watch your match, they'll join you on-court and sit in chairs set up about ten paces behind the baseline. No fear of an errant serve hitting them. Tennis is best watched up close.

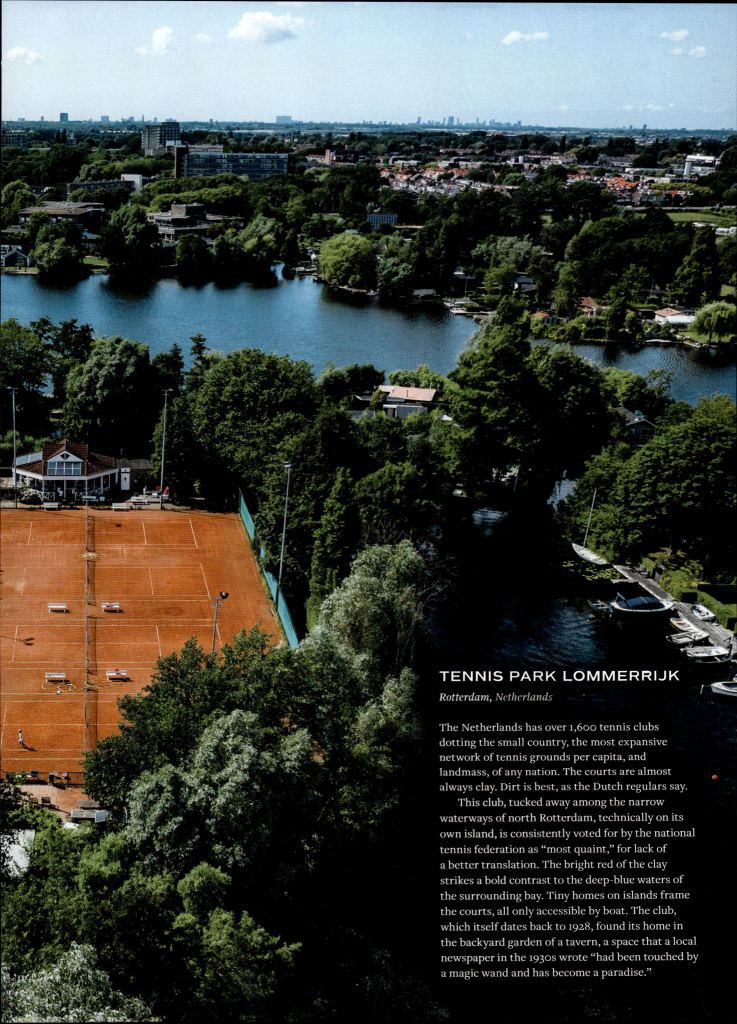

TENNIS PARK LOMMERRIJK

Rotterdam, Netherlands

The Netherlands has over 1,600 tennis clubs dotting the small country, the most expansive network of tennis grounds per capita, and landmass, of any nation. The courts are almost always clay. Dirt is best, as the Dutch regulars say.

This club, tucked away among the narrow waterways of north Rotterdam, technically on its own island, is consistently voted for by the national tennis federation as "most quaint," for lack of a better translation. The bright red of the clay strikes a bold contrast to the deep-blue waters of the surrounding bay. Tiny homes on islands frame the courts, all only accessible by boat. The club, which itself dates back to 1928, found its home in the backyard garden of a tavern, a space that a local newspaper in the 1930s wrote "had been touched by a magic wand and has become a paradise."

CLUB CAMPESTRE DE CALI

Cali, Colombia

"We need dust," you'll hear yelled (in Spanish) across the 20-acre (8 ha) estate. You'll hear it as *polvo*, or *tierra*, here in western Colombia and across the South American continent. The 31 clay courts at Campestre get a daily misting from the trees shedding a layer of dew, the result of nearly constant drizzle in the region. Fresh water means more dust, more bags of crushed-brick-and-sand mixture carted out on-court to fill in the little streams that have formed from baseline to baseline.

The club was formed in the 1930s and has since been the main host of most national and international events held outside Bogotá, including the Pan American Games in the 1970s. Over the years, Cali has produced some of Colombia's best-ranked professionals, and today, the national tennis community still looks to Cali and the juniors that flock to Campestre for the next crop of great players, particularly doubles players. They love their doubles here in the salsa capital of Colombia, maintaining a national emphasis on paired dynamism.

Everyone at Campestre walks around with damp shoes and socks powdered with an orange blush, the mark of clay court pride. During play, they pause often before serving, usually to wait for a bird to stop squawking. The club sits in the middle of one of Cali's green sanctuaries, with more than 150 types of protected birds. Many a bird-watcher weaving through the park will catch a glimpse of the rallies on the courts.

COUNTRYSIDE PURSUITS

United Kingdom

Some in the tennis communities of the United Kingdom venture out on long, winding pursuits often with very little thought for the destination. There's a propensity among them for savoring what happens during the hours of empty single-lane roads and expanses, and holding a kernel of promise on the other end. Several small groups of friends in and around London take this love for the endeavor and set out once every summer to a single court, often picked at random, in a far-off, sparsely populated corner of the UK. They might find courts on the way; they might not. The endearing quality to it is the simplicity.

CROMLIX

A hard court painted Wimbledon colors, this court and property are owned by Andy Murray, who grew up nearby in Dunblane, Scotland. You can often find one of the foremost coaches in tennis, Judy Murray, Andy's mom, hosting clinics for local schools on the court.

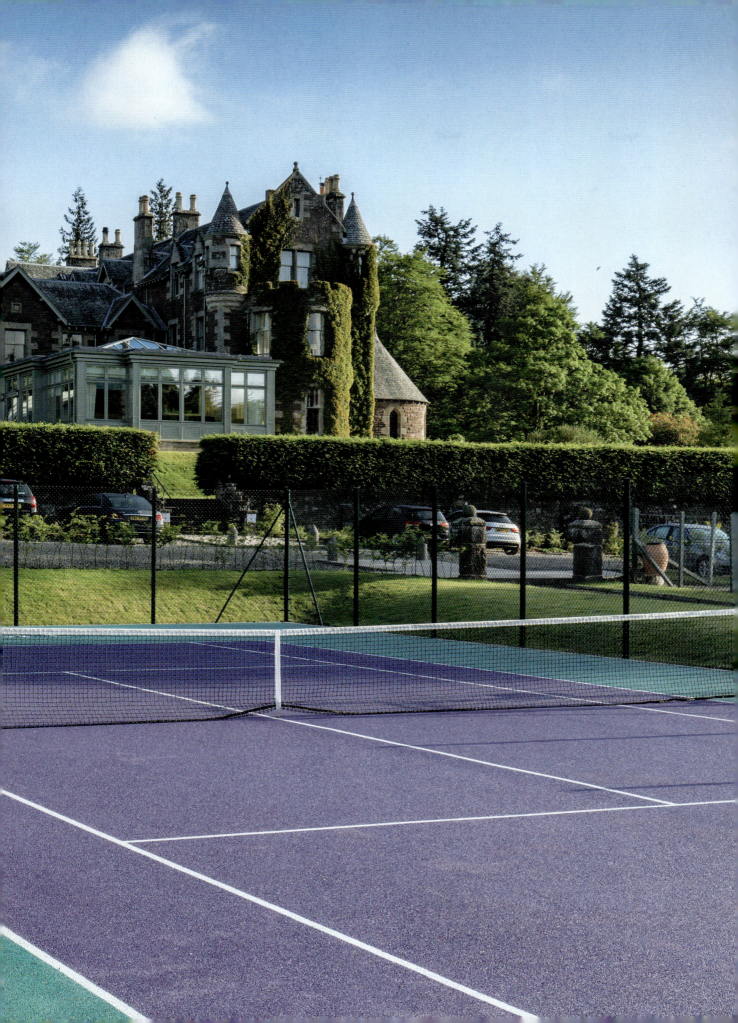

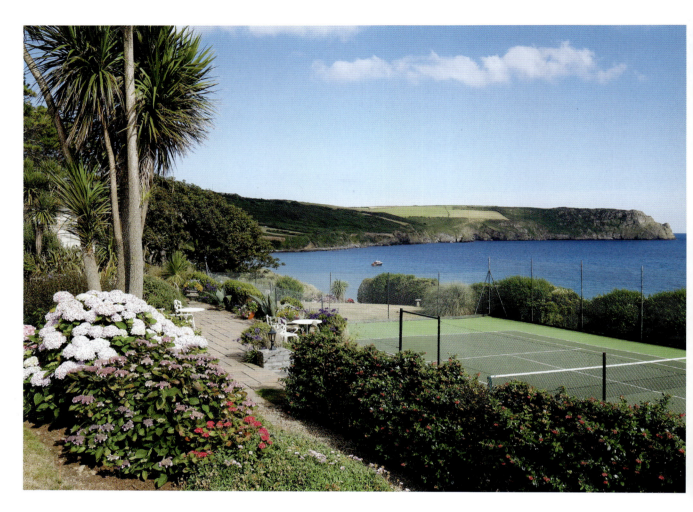

THE NARE HOTEL

Cornwall, on the southwestern UK peninsula, boasts a litany of courts often hidden at the base of hills near the sea.

BURGH ISLAND

This island off the coast of Devon is accessible only during low tide, and you can get here with your racquets by sea tractor. The turf court and the island itself spark images of Agatha Christie, who made the island her own writing and tennis-playing refuge. Tennis appeared often in Christie's works—doubles matches, tennis parties, a tennis instructor who ended up being the murderer . . .

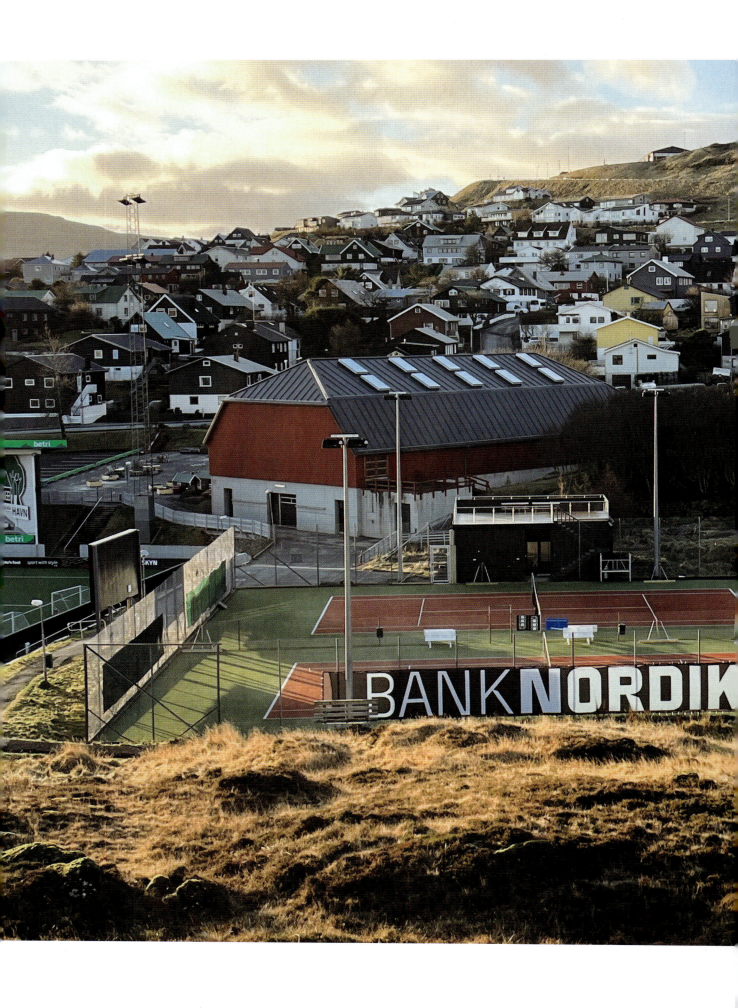

HAVNAR TENNISFELAG

Tórshavn, Faroe Islands

The Faroe Islands, high in the North Atlantic, are quite content to not host travelers, at least not en masse. They shut the country down to tourism every spring to help preserve natural areas and repair hiking routes. In this small Danish outpost made of 18 volcanic islands, there are two tennis courts on the high hillside of the capital city. Whether you play outside or in, there might not be a better place to be reminded to respect the natural world upon which these courts are laid.

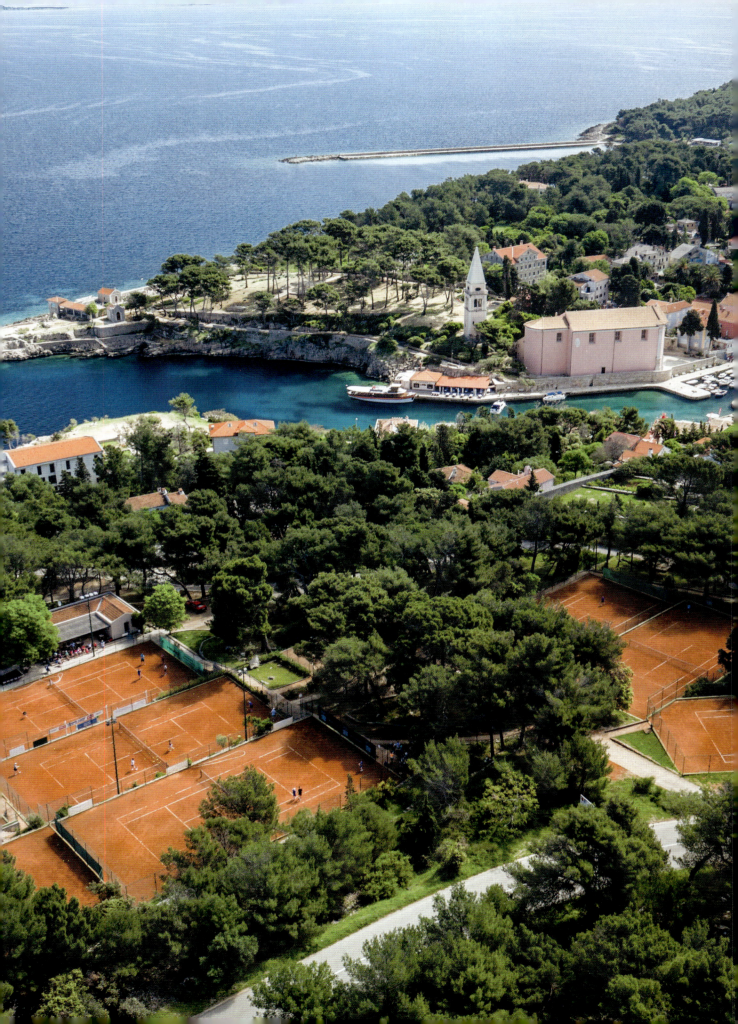

LJUBICIC TENNIS ACADEMY

Lošinj, Croatia

At one of the most remote tennis academies in the world, the commitment starts with getting there. From Zagreb, drive about two hours to the Valbiska ferry, putter across the bay, and land on the island of Cres. Then head south until you reach the Osor bridge. Cross it. Finally, you're on Lošinj. Then keep going until you reach the southernmost part of the island. Only then, when the road ends and the pine forest clears, do you see the stark white buildings with roofs the same color as the clay courts. The terraced courts anchored by stone walls took some grunt work and finessing to build on the rocky and steep Adriatic coastline.

Playing here under the guidance of retired professional and Roger Federer's former coach Ivan Ljubičić, you might be asked to take a break and go smell the flowers. They're serious. The forestry around the academy counts more than 1,000 plant varieties, almost all of them indigenous. Bring some sparsely picked blooms back on-court with you for some nuanced aromatherapy between games. The Dalmatian Coast to the south remains the great lure for most travelers, but here the north is just as luxurious for that rare Croatian seaside court time.

SPORTCHALET MÜRREN

Mürren, Switzerland

In spring and early summer, as the glaciers drop their snowpack, natural waterfalls form in every mountain crevice of the Swiss Alps. Notably for players, wildflowers bloom around every clay court. Thousands make the journey to storybook Mürren every year, but most might not even notice the four cliffside clay courts. They are, quite literally, on the cliff's edge. The town is only accessible by gondola or high-elevation train. If your ball flies over the fence, your only hope of getting it back is if a paraglider catches it. Otherwise, that ball has about a 2,500-foot (762 m) descent to the valley floor.

Some call this a classic love court, but in a platonic-soulmate kind of way. Coming here, you ought to ask at the check-in desk if they know of anyone else in town to hit with. Often tennis soulmates are found serendipitously on these grounds, a spark that lights many future tennis trips.

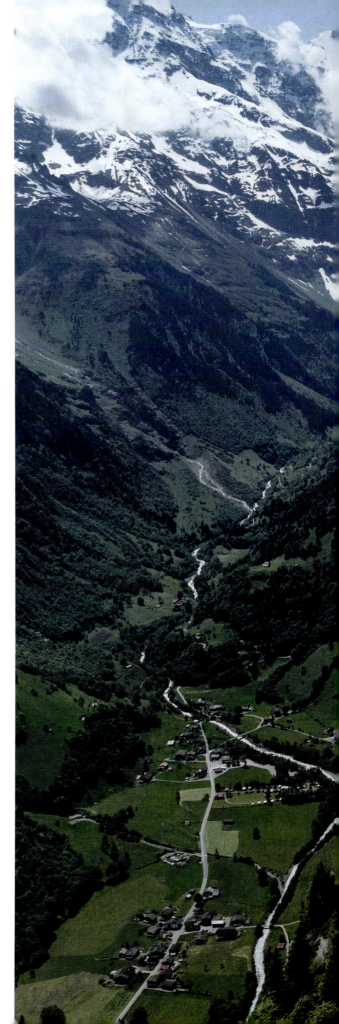

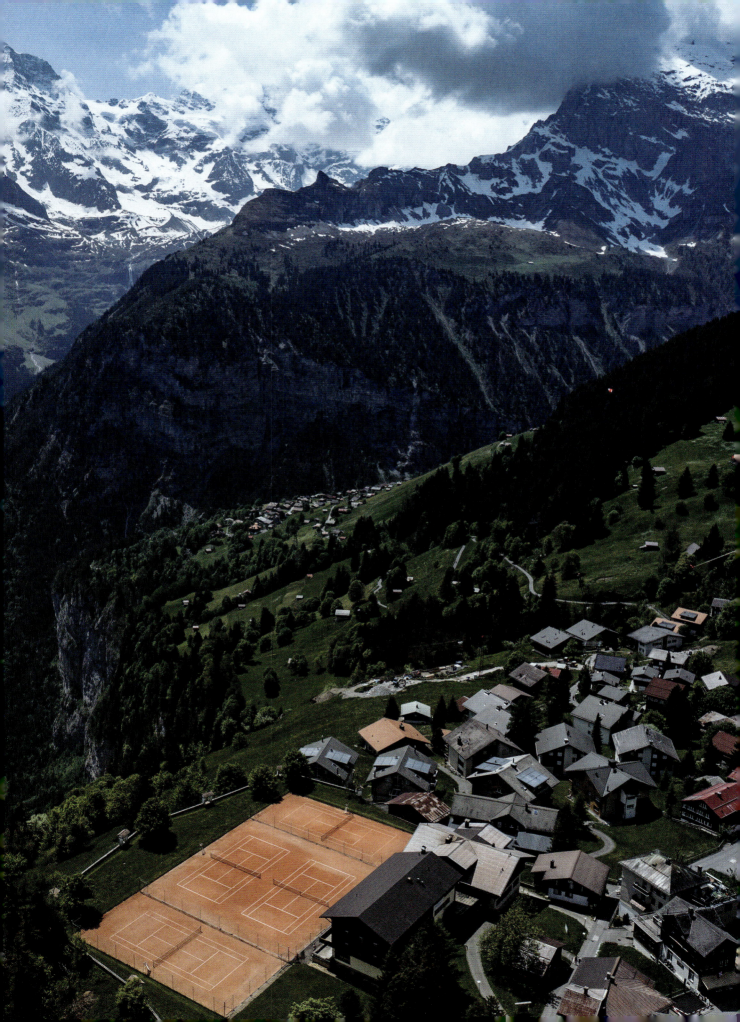

THE GRAND SEASIDE COURTS

France and Italy

Waterfront clay courts are staples for the French and Italians. Most of these courts have been here for more than 50 years, their properties beginning as small houses or inns, the clubhouses as mere storage sheds. Arrays of fruit trees and manicured hedges border one side of the clay's base, while the other side is usually misted by the lake or sea.

Finding these places, especially alongside any regular to these grounds with well-worn treads on their shoes, is a journey through tennis's easiest beauty. The avid players will end their sessions with clay stains on the backside of their shorts, a mark of commitment to the grit of clay.

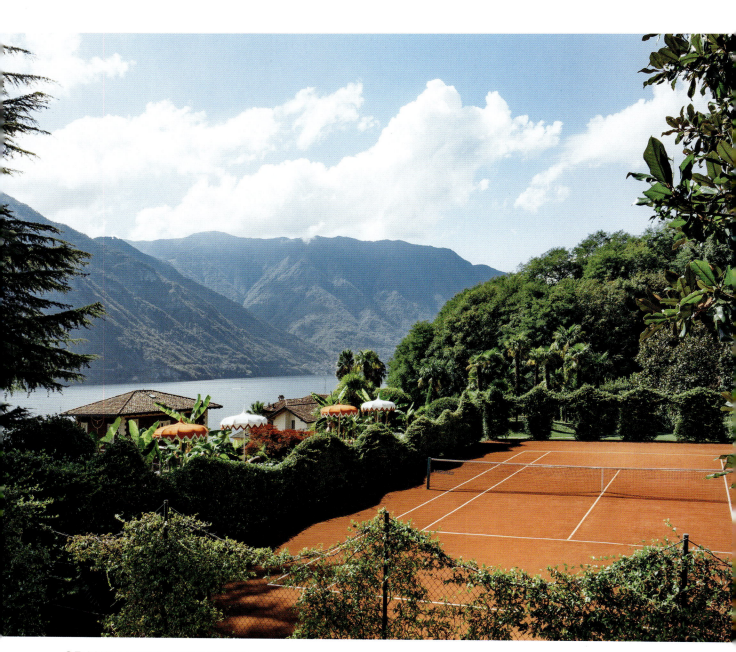

GRAND HOTEL TREMEZZO

Lake Como, Italy

TENNIS CLUB MALCESINE

Malcesine, Italy

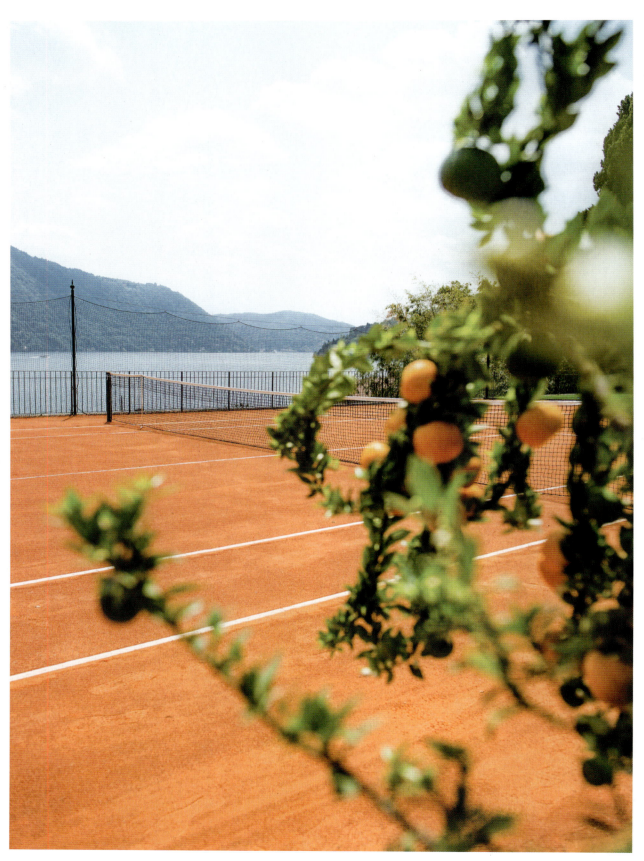

PASSALACQUA

Lake Como, Italy

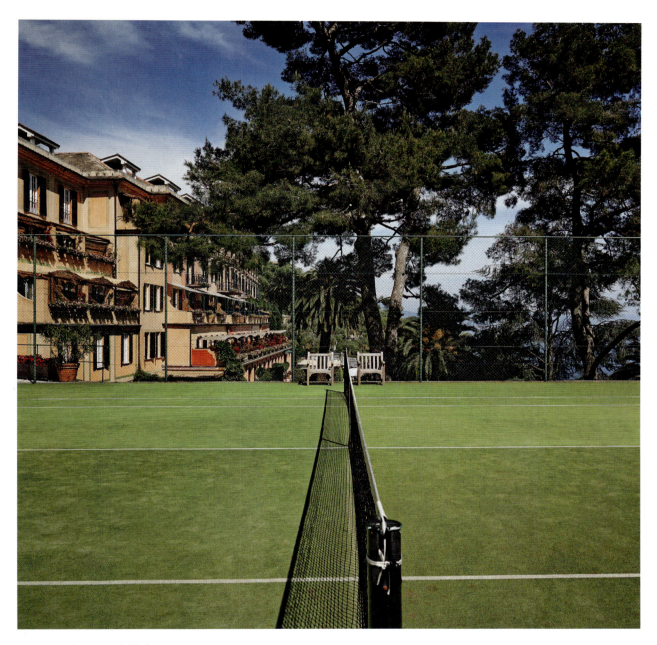

HOTEL SPLENDIDO

Portofino, Italy

Not all the courts by the sea are clay. Tennis time begins in the morning here, when the sunlight creeps across the court and glistens on the Gulf of Tigullio just outside Genoa.

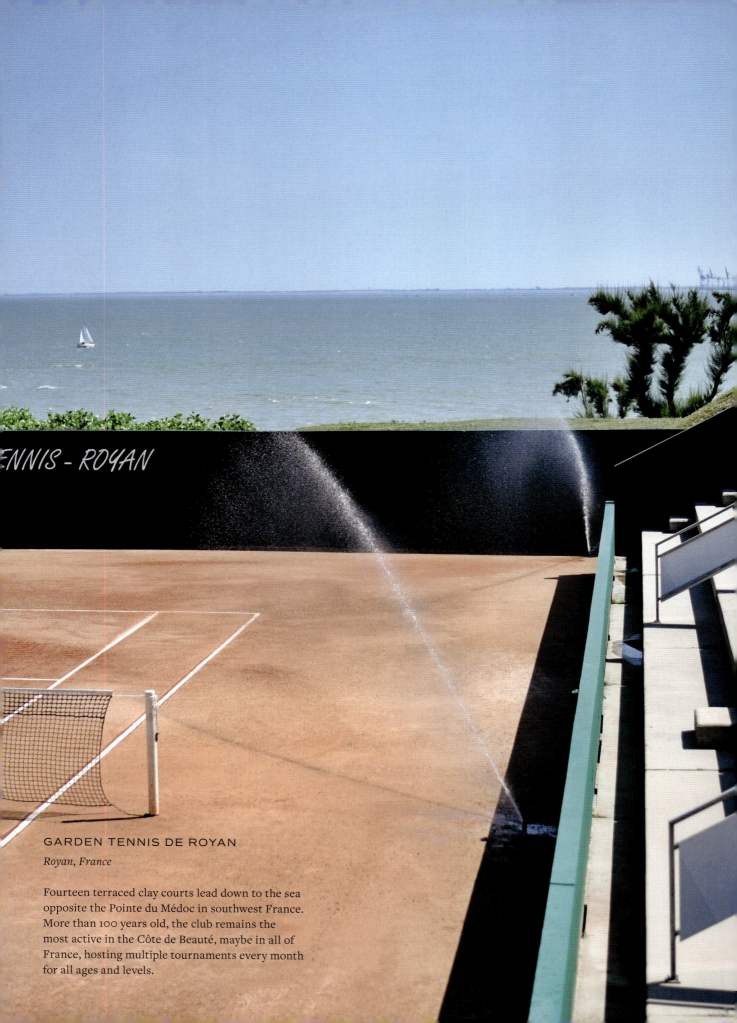

GARDEN TENNIS DE ROYAN

Royan, France

Fourteen terraced clay courts lead down to the sea opposite the Pointe du Médoc in southwest France. More than 100 years old, the club remains the most active in the Côte de Beauté, maybe in all of France, hosting multiple tournaments every month for all ages and levels.

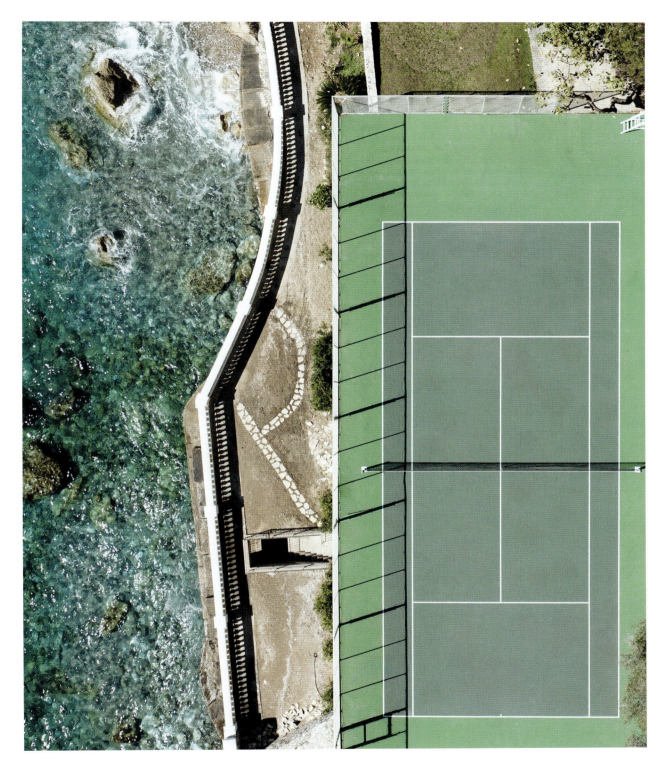

LE CAP ESTEL

Èze, France

A slightly more unusual tennis-and-beach venture sits on the water of the Côte d'Azur at the hotel Cap Estel. From the edge of the court itself, you can descend down the stone steps straight into the Mediterranean Sea, wet your hat or shirt, and start a set anew.

HOTEL DU CAP-EDEN-ROC

Antibes, France

Five pristinely maintained clay courts lie under some pines in the property's lower gardens.

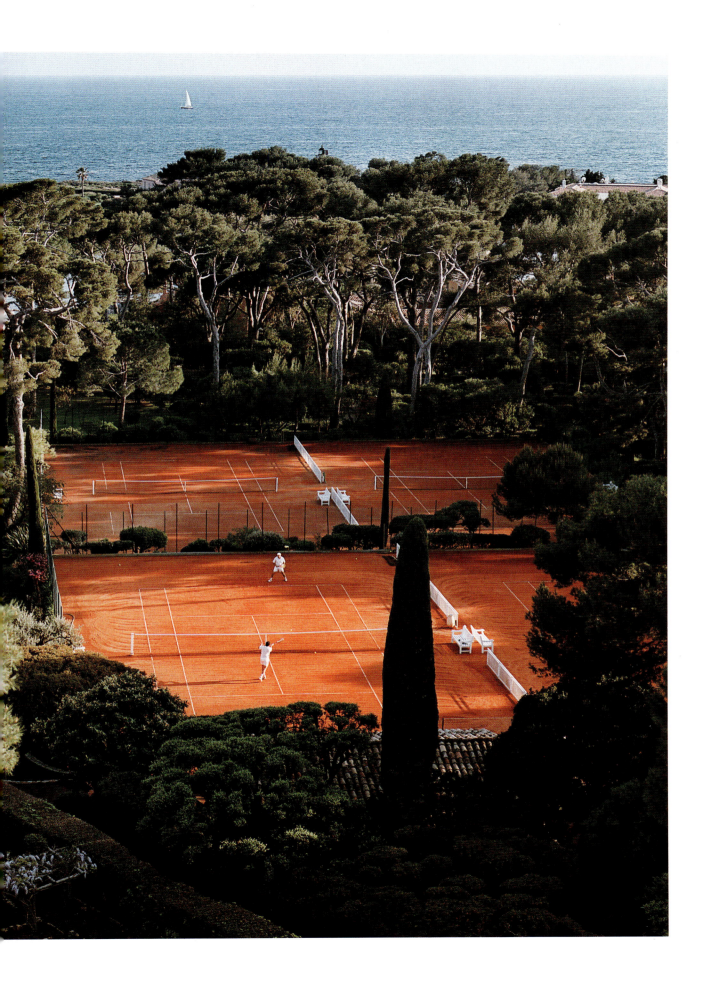

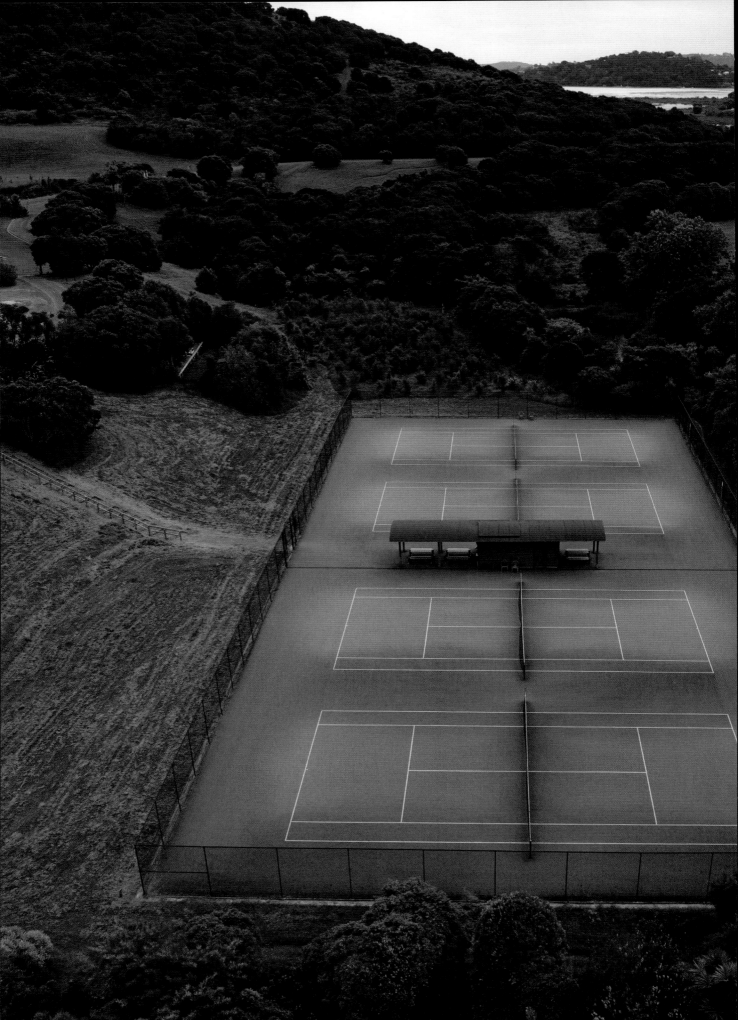

WAIHEKE TENNIS CLUB

Waiheke Island, New Zealand

It takes an extra level of commitment to arrive at Waiheke's four courts. Likely a flight, then a ferry, then a car or bus, and then a walk. Parrots and fantail birds that nest around the nearby Rangihoua Creek await on the turf courts. It's just you, your hitting partner, and the hillside vineyards. The only marker of the club: the words *Waiheke Tennis* carved into the benches and letter box outside the storage closet.

 Constructed in 2001, the club has about 80 members on this island of around 8,000 people. Every November, Waiheke hosts Le Tour de Tennis, a roaming tournament played on courts around the island, culminating in finals played on the club courts. The tournament, which raises funds for local healthcare workers, draws Auckland players and even some from New Zealand's South Island every year.

FOREVER OPEN ON THE IBERIAN COAST

Spain and Portugal

Tepid play and high winds run through the coastlines of the Iberian Peninsula. Courts like these possess a gentler daily rhythm than most, providing more time to think about one's game, whatever benefit or detriment such thinking may bring.

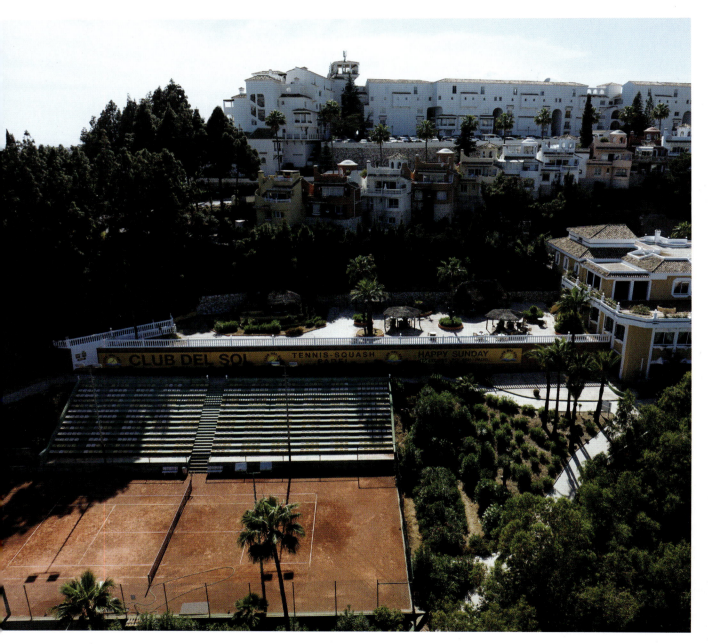

CLUB DEL SOL

Calahonda, Spain

A club that's never closed. The longtime owner of Club del Sol boasts that it has been open for tennis every day—holidays, COVID-19 pandemic, and all—for the past 22 years. And it will stay open as long as people with racquets keep showing up and sipping espressos while waiting for their court time.

REAL CLUB DE TENIS DE SAN SEBASTIÁN

San Sebastián, Spain

The historic club is open to anyone on the west side of secluded San Sebastián on Spain's northern coast. Many will find their way here to relax with some cava at the club's Wimbledon bar after a hike to see the sculptures that make up *El Peine del Viento* (Comb of the Wind).

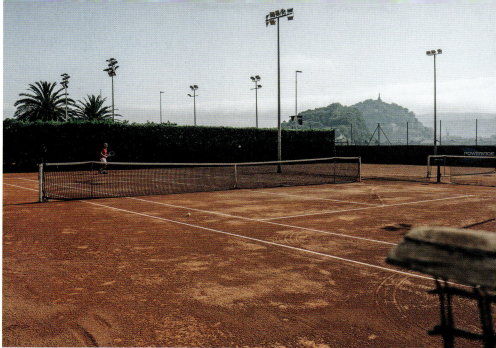

QUINTA DA MARINHA RACKET CLUB

Cascais, Portugal

Here and on other Spanish and Portuguese clay courts, the shed keeps the clay down and the wind at bay. The open-air structures are icons of southern Europe, each their own dust palace.

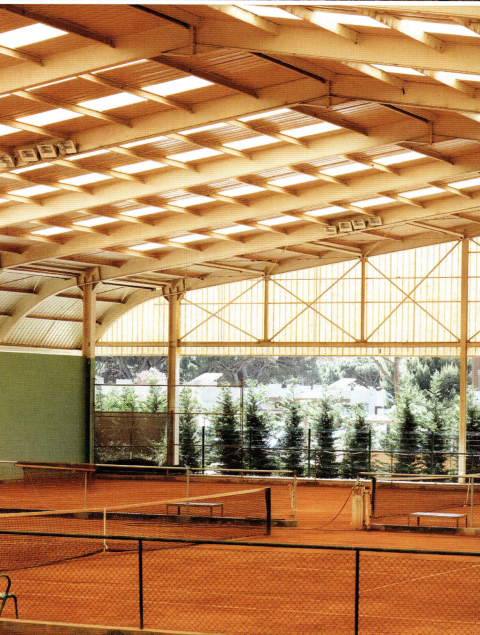

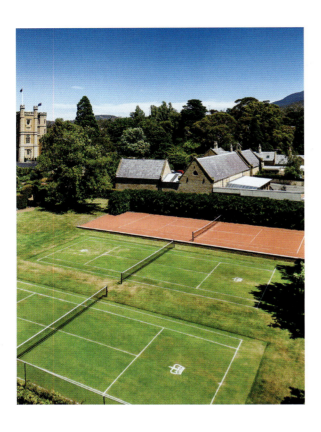

GOVERNMENT HOUSE

Hobart, Tasmania

Perhaps the only political address in the world to open their grounds to the public for tennis is in Hobart, Tasmania. Every year, from October to March, the greenkeeper at the official residence of the Tasmania governor etches the governor's seal into the grass and clay near the baselines, and players from Hobart and greater Australia come to play here among the bluebells and wisteria blooms.

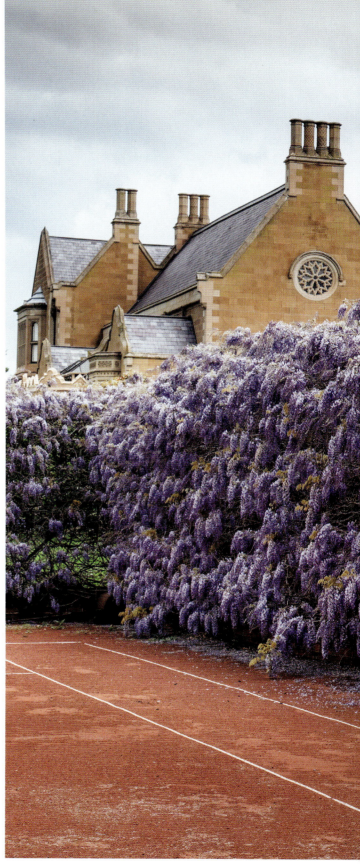

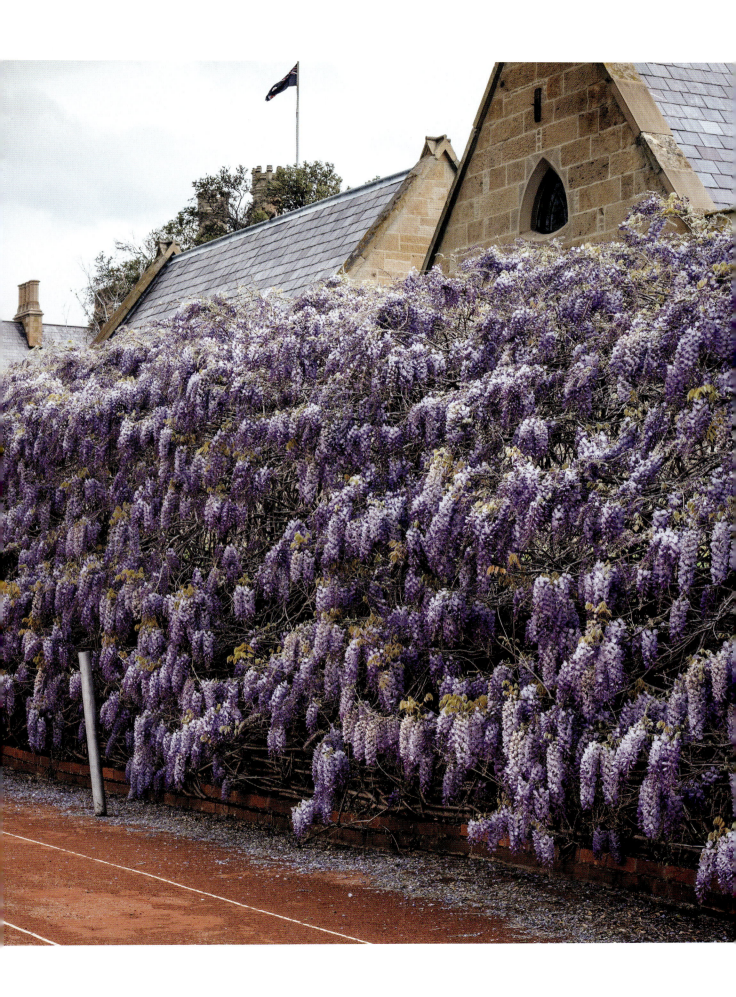

WODONGA TENNIS CENTRE

Wodonga, Australia

While the number of grass courts in Australia might be decreasing, the country still maintains more than 170 sites. Recall that it was not until 1988 that the Australian Open switched from playing on grass to hard courts. Now a marvel for Aussie grass-court enthusiasts sits in remote Wodonga, three hours north of Melbourne: 30 grass courts, where the grass is what they call a common couch, the stuff that grows naturally in the area. All the plots are watched over by their in-house grass curator, Shayne Ried, who has been at Wodonga since 1995. He's taken only two breaks while on the job, one of which he spent working at Wimbledon. You can find him studying the courts during the Australian Junior Grasscourt Championships held every January.

OLIVE FARM TENIS KULÜBÜ

Datça, Turkey

Before there were courts, there were only olive groves. But now the clay courts and the olive trees are watered in one fell swoop by the players and groundstaff alike. Out on the Datça Peninsula, a 50-mile (80 km) rustic idyll in southwest Turkey, the Turkish property owners took up the olive farm about 20 years ago, added courts and a small guesthouse, and created a quiet clay-court retreat. You're near the Greek islands of Rhodes and Kos when you're here, and you're reminded of it, as the uplands surrounding the courts smell of thyme and pine for all the playable months of the year.

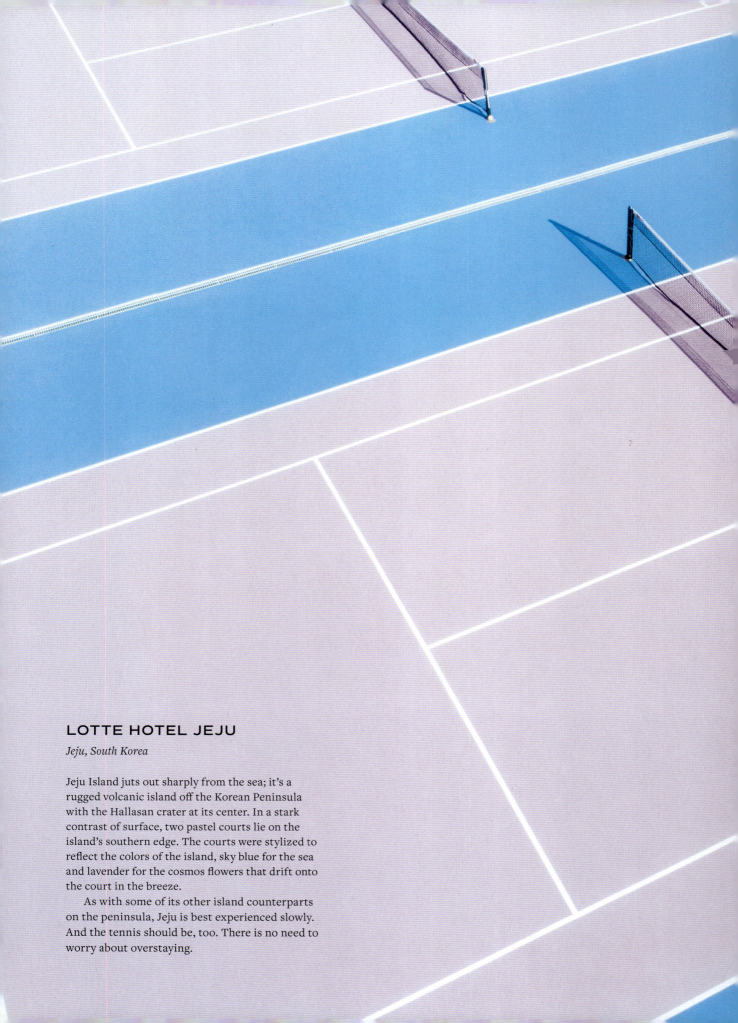

LOTTE HOTEL JEJU

Jeju, South Korea

Jeju Island juts out sharply from the sea; it's a rugged volcanic island off the Korean Peninsula with the Hallasan crater at its center. In a stark contrast of surface, two pastel courts lie on the island's southern edge. The courts were stylized to reflect the colors of the island, sky blue for the sea and lavender for the cosmos flowers that drift onto the court in the breeze.

As with some of its other island counterparts on the peninsula, Jeju is best experienced slowly. And the tennis should be, too. There is no need to worry about overstaying.

ISLAND SOLACE

The Maldives

The Maldives is made up of 26 ring-shaped atolls, 1,190 islands in total. There's no official count, but around 100 courts are scattered throughout these palms. Resorts run the game. You could fill an entire season traversing the islands' sandbars and lagoons, dropping in at the hidden courts. In the professional offseason (a blip in late November and early December), many players will plant themselves here. It's become known as a place of opulence, convalescence, and swimsuit Instagram posts. It's also a place premised on solitude. Most of the courts are tucked away in the dense palm forests.

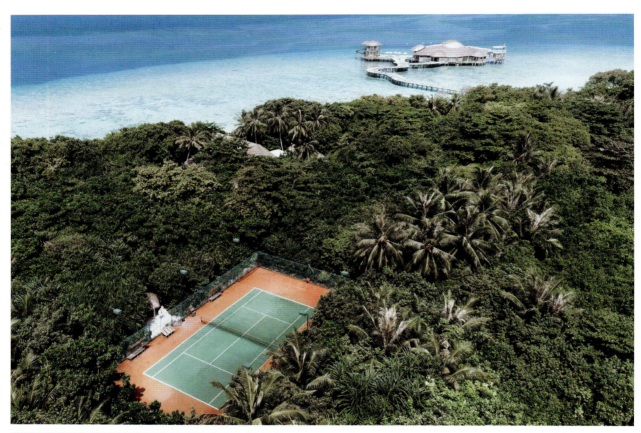

SONEVA FUSHI

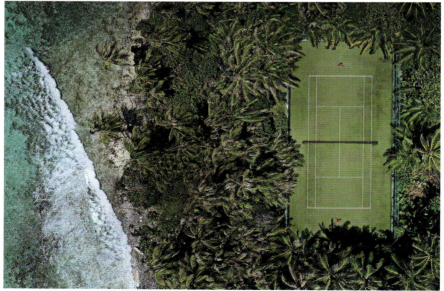

NIYAMA PRIVATE ISLANDS
MALDIVES

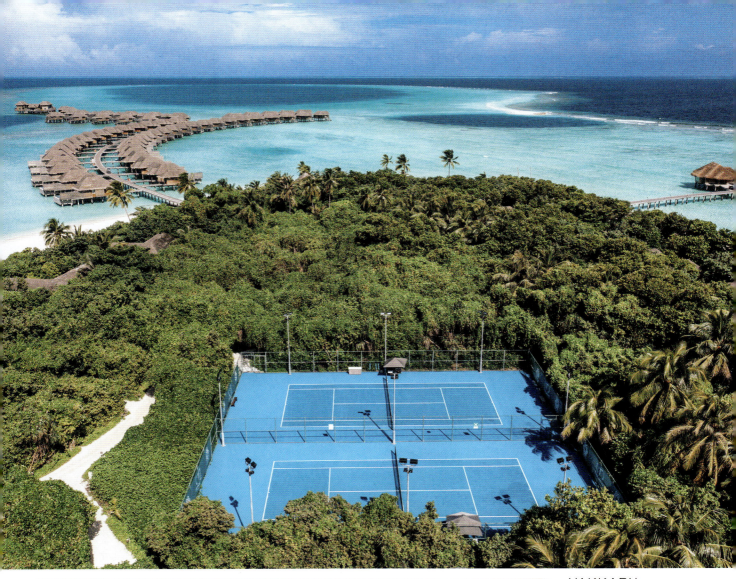

VAKKARU

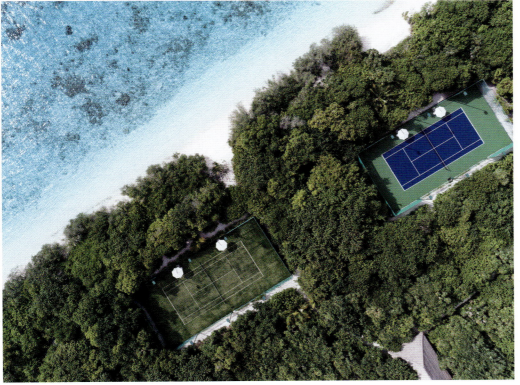

CHEVAL BLANC

WILDFLOWER HALL

Shimla, India

Everything in the Himalayas centers around being outside in the thin air. At over 8,000 feet (2,438 m), surrounded by cedar trees, few would think to rally between treks in Himachal Pradesh, but maybe they should. The turquoise-blue court, part of resort property outside Shimla, is a tiled hard-plastic surface, not meant for competitive play but rather for some tranquil exchanges. You'll lose some balls over the low Himachal stone walls.

PUDDLE-JUMPING BETWEEN SETS

The Caribbean

Throughout much of the Caribbean, hotels own and run tennis. Even most clubs where local juniors and adults train have some sort of arrangement with a resort to use their courts. Mostly clay and hard courts dot every island from the Turks and Caicos to Tobago.

BEACHCOURT VILLA

Anguilla

In Anguilla, only one court runs up against the white sands. And thanks to an arrangement with the local tennis academy, anyone can set up a hit with players on this court or elsewhere.

CASA DE CAMPO RACQUET CENTER

La Romana, Dominican Republic

FOUR SEASONS RESORT NEVIS

Nevis, West Indies

WILD CARD

In tennis, basically any surface,
in any odd sort of quirky home, counts.

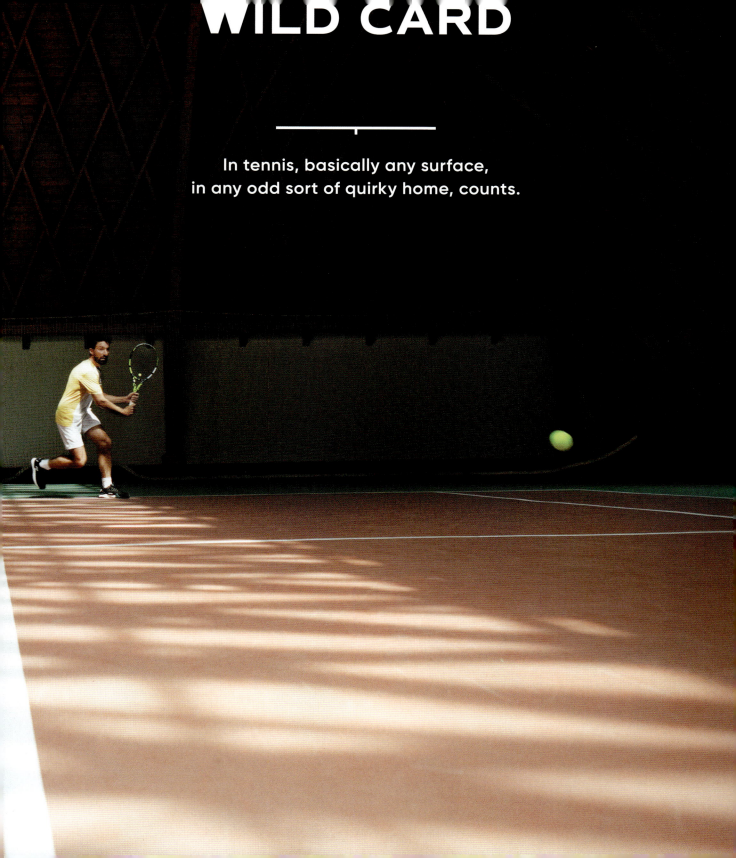

Imagine standing on a surface so sleek and shiny you can see the shape of your reflection as you step up to serve. As you bounce the ball, the sound is higher pitched than you expect. It echoes. The harsh squeak when you stutter-step into position for a forehand forebodes a strained ankle if you don't adapt. The ball zips off the glossy surface, and every point is like a rapid-fire, winner-take-all affair. You're indoors. Light is tricky, and so is keeping an eye on the yellowish-green ball.

This is playing tennis on a basketball court, but this is also a public court in Italy. And while it doesn't fit neatly into the common conception of the three main surfaces (hard, clay, and grass) or typical outdoor surroundings, it's a welcome home of the sport for the tennis community that frequents here, just like all the other surfaces and odd venues that stretch and enrich the physics and feeling of tennis in unique ways.

The International Tennis Federation (ITF) recognizes more than 180 different types of court surfaces. Some have proprietary names like Ekipflex, an acrylic hard court made in Turkey; LushCourt, made in India; and Notix Pro 15/45, a sand-filled synthetic grass made in Italy. Every surface goes through a testing and certification process. Technically, the international governing body does not bar any material from being considered for the surface of a court. It only needs to meet some benchmarks—for example, a ball must bounce on it with relative uniformity for its family of surfaces. Courts made of gravel, concrete, wood, asphalt, turf, carpet, even polyurethane (like a basketball court) have all been certified.

Understanding the differences between surfaces requires a bit of physics, specifically friction (as it relates to ball spin), momentum,

and pre- and post-bounce speed differences. These are factors the ITF studies to measure what's called a Court Pace Rating, utilizing lasers and a ball cannon to test out how a surface behaves. Note: If you want the ITF to certify your own concoction of a surface, you can easily file a request and submit a sum of money for an analyst to pay you a visit.

For about 20 years, tennis courts globally, at the pro level and the recreational level, have sought out a sort of consensus, or middling, when it comes to the surface of courts. Clay courts, traditionally slow surfaces, have often become a bit faster by tinkering with the consistency of that top layer of surface. Grass courts have been made a bit slower by changing the variety of grass so the blades grow thicker and the soil below remains drier and harder. Standardizing makes for a more stable, predictable, sellable product for a game with nebulous multitudes. If court speeds are all more similar, the professionals will face less inconsistency and perhaps not need to adapt as much as if, say, they had to play a match on a glossy court that basically demanded that players approach the net as often as possible. Short points may be more or less appealing to spectators— to each their own—but it's still the game. And as those who watch and play know, the truest parts of tennis are game plan, adaptation, and problem-solving. More surfaces as well as more types of venues, particularly indoors, mean more fun.

Something tennis spectators and players alike can celebrate, even if tacitly, is pride in the fact that their sporting love is the one with a wide variety of canvases and homes. And experiencing the quirks of them all, even if sometimes grating, is a lifelong affair. •

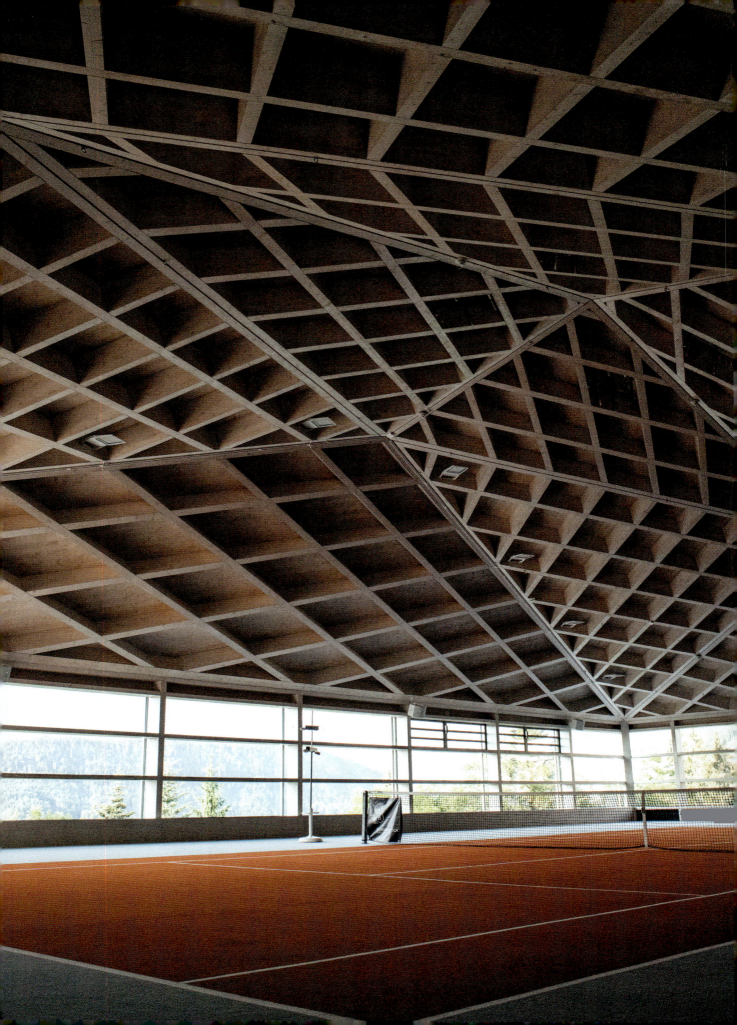

BÜRGENSTOCK RESORT

Lake Lucerne, Switzerland

The Diamond Domes, two identical courts mounted onto the cliffside near Lake Lucerne, prompt frequent conversations about sound. To be more specific, *sound value*. It's an often discussed but rarely delved into corner of the game. The sound of a well-struck tennis ball is a satiating, even invigorating, noise. The frequency is quite low, usually, which is why so many find it a pleasing note. Indoor tennis ramps up dialogues about sound, and schematics of space can make or break that staccato melody.

Start by thinking like this: Is the sound of the ball strike airy? Is it balanced and crisp? Is it congested or muddy? Is it lush? These are terms audiophiles employ frequently—tennis spectators and players, not so much. But all those thoughts of lush, crisp, uncongested sound come to the fore at the Diamond Domes.

The architecture and carpentry firms that built the domes in 2017 had to reckon with acoustics often. Their mandate at first was to evoke images of a mountain crystal emerging from the earth. Originally, the plan was to fully enclose the space with glass, but wood was deemed safer and more adaptive. The hivelike texture of the ceiling, all local spruce timber, absorbs and redistributes sound evenly throughout the space. And the surface of the courts is carpet, a finicky surface to move on, but one that muffles the sound of footwork. All you have here are crisp, even tones with every shot.

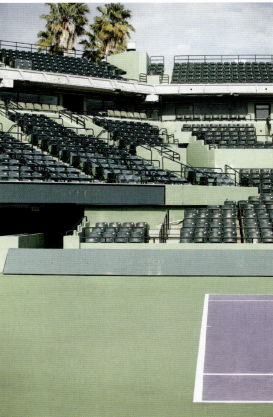

CRANDON PARK TENNIS CENTER

Key Biscayne, Florida, USA

Amid the abundance of facilities around South Florida, the most alluring and nostalgic must be the purple hard courts on Key Biscayne Island. But besides mystique and a feeling of a past home being the brand, it's also an odd, Jurassic Park–like place of loss, desertion, and uncertainty.

Crandon Park Tennis Center was home to the Miami Open from the late 1980s until the tournament set up shop at Hard Rock Stadium in 2019. The 27 courts and the 13,000-seat stadium at Crandon remain tucked away behind the tall brush. It's the relatively frequent emptiness and uncertain future that define these courts.

Hitting here is laid-back and easy with the coconut palms at your back and the occasional iguana sunbathing on the next court. (There's also a slim chance you'll come across an alligator or a crocodile. Welcome to Florida.) Anyone can play inside the lime-colored stadium where Venus and Serena Williams, Andre Agassi, and others paved their way into history. The corridors now collect dust, and plants have broken through the concrete, growing up the legs of the empty seats. Imagine what this palace could become if all the seats were taken out—maintain the court but let the arena grow wild.

One of the most exciting times to visit for tennis is during the Orange Bowl, when the world's top juniors come to South Florida every December to battle for ultimate name recognition as the next great up-and-comer. The tournament sprawls out at sites all over Miami, Crandon included. You see up close the highest-level junior tennis in the world, with the added drama of the coaches, agents, and the ever-entertaining alliances made by parents and national federations.

Most important, you see the next crop of pros first. Some past Orange Bowl winners: Evert, Borg, Federer, Sabatini, Roddick, Wozniacki, Gauff.

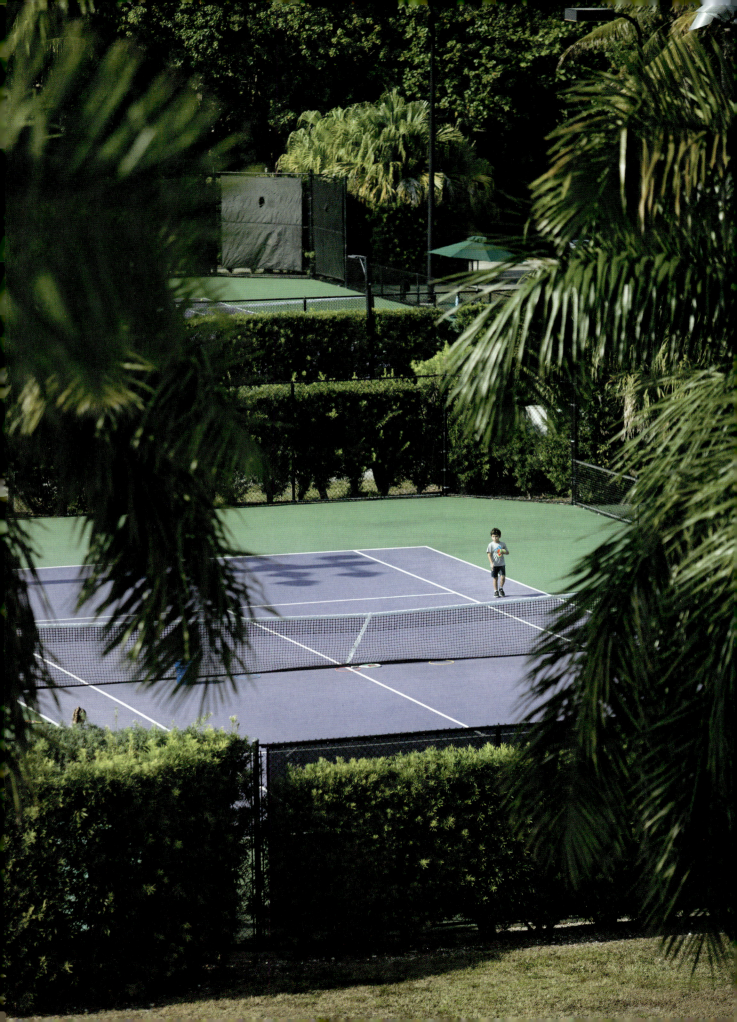

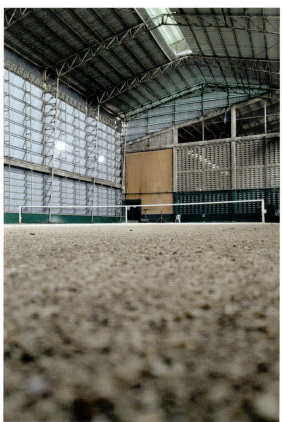
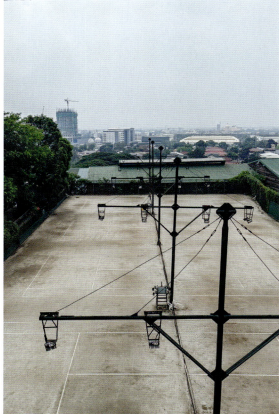

VALLE VERDE COUNTRY CLUB

Manila, Philippines

Spend enough time at tennis grounds where the courts surface need replenishing—clay, sand, or otherwise—and you'll find the corners where the raw materials are kept, usually with a wheelbarrow or some heavy machinery nearby. Spend some time in the Philippines, and you'll find sandbags full of chalky brown fragments, not clay and not exactly sand, either.

When tennis gained modest popularity in the Philippines and clay was emerging as a global surface of choice, clubs in the Philippines lacked enough brick or stone to process, crush, and surface the courts. They needed something the country already possessed in excess. The best option: shells from the beaches and seafloor of Manila Bay. Court designers crushed the discarded shells, mixed them with some sand, and shell courts were born.

To this day, at spots around Manila, Cebu, and several southern islands, crushed-up shells are raked out across the courts at the start of each morning. Of course, the color is not as appealing as the original color or design of the shells. The surface comes out a light, faded brown or sometimes black. If you sift the stuff through your fingers, you'll feel some of the sharp edges of the shell scraps.

Longtime players who have played on the surface since the 1970s opt for the shell courts at Valle Verde Country Club or Manila Polo Club.

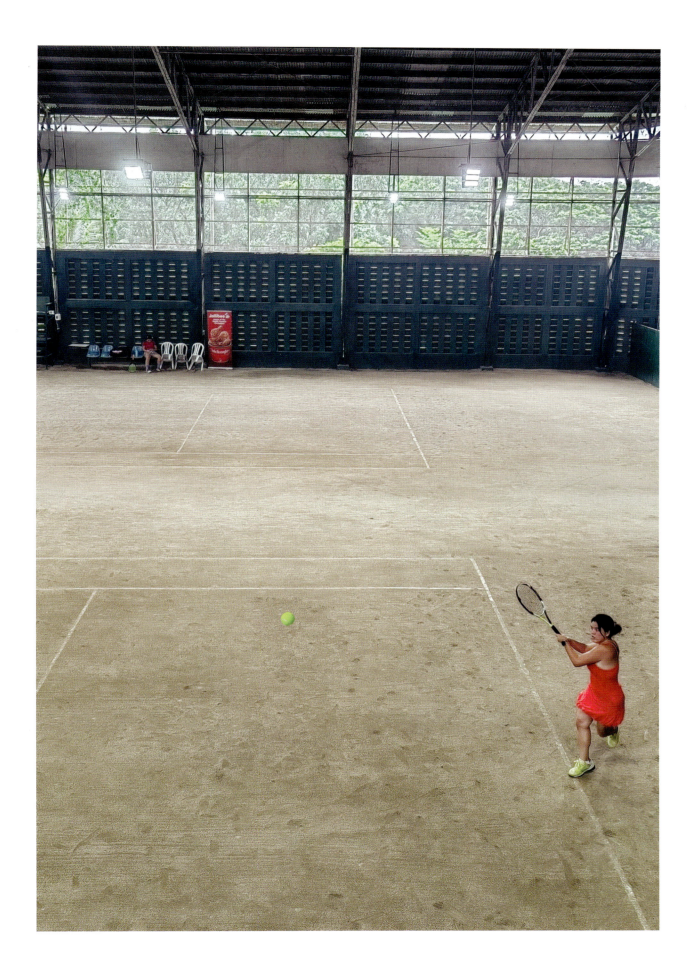

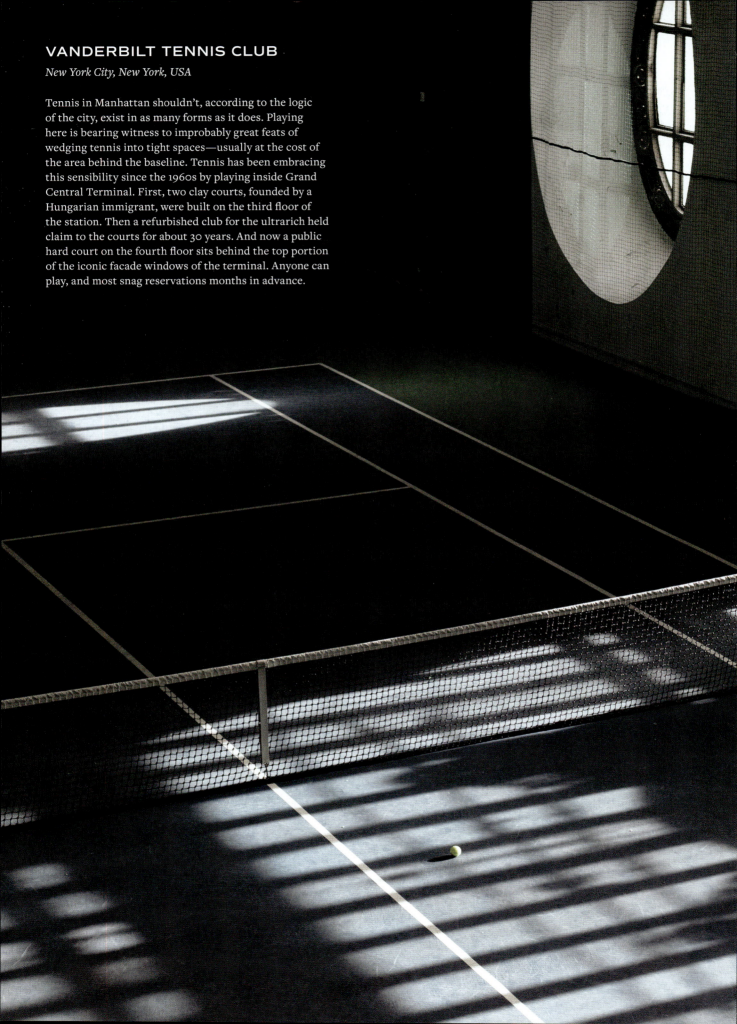

VANDERBILT TENNIS CLUB

New York City, New York, USA

Tennis in Manhattan shouldn't, according to the logic of the city, exist in as many forms as it does. Playing here is bearing witness to improbably great feats of wedging tennis into tight spaces—usually at the cost of the area behind the baseline. Tennis has been embracing this sensibility since the 1960s by playing inside Grand Central Terminal. First, two clay courts, founded by a Hungarian immigrant, were built on the third floor of the station. Then a refurbished club for the ultrarich held claim to the courts for about 30 years. And now a public hard court on the fourth floor sits behind the top portion of the iconic facade windows of the terminal. Anyone can play, and most snag reservations months in advance.

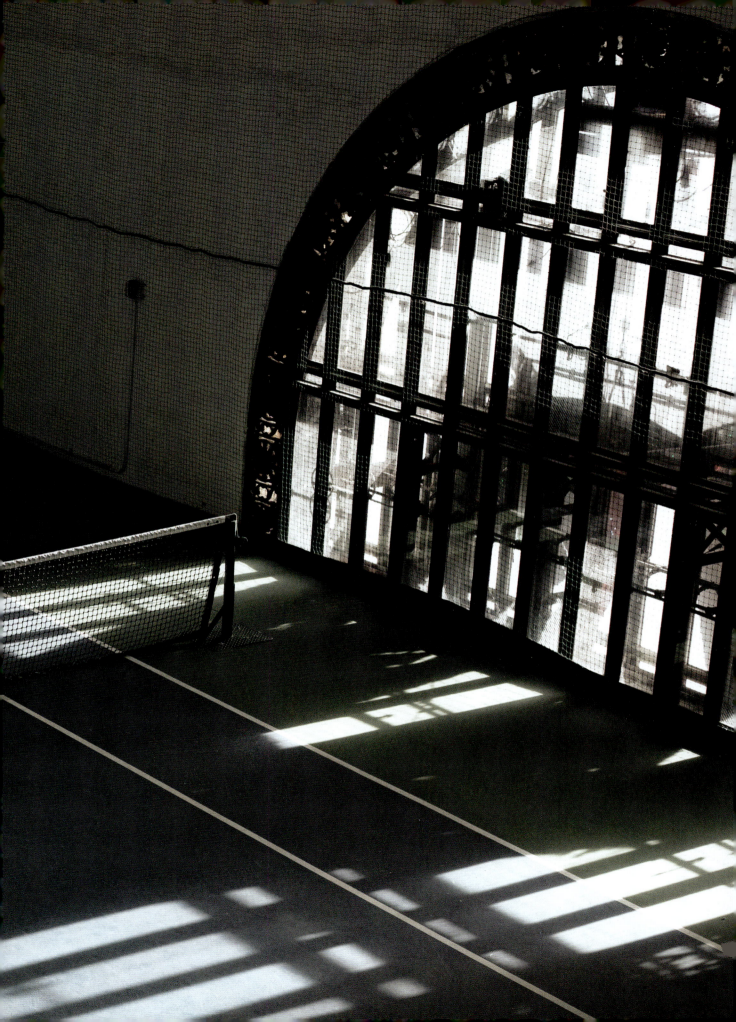

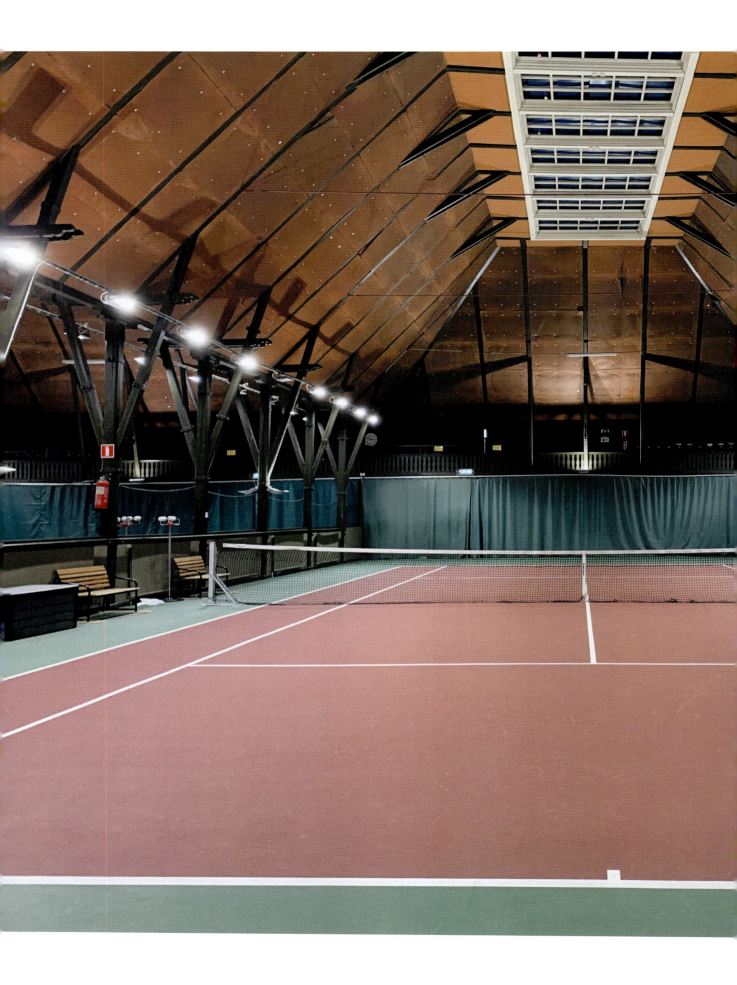

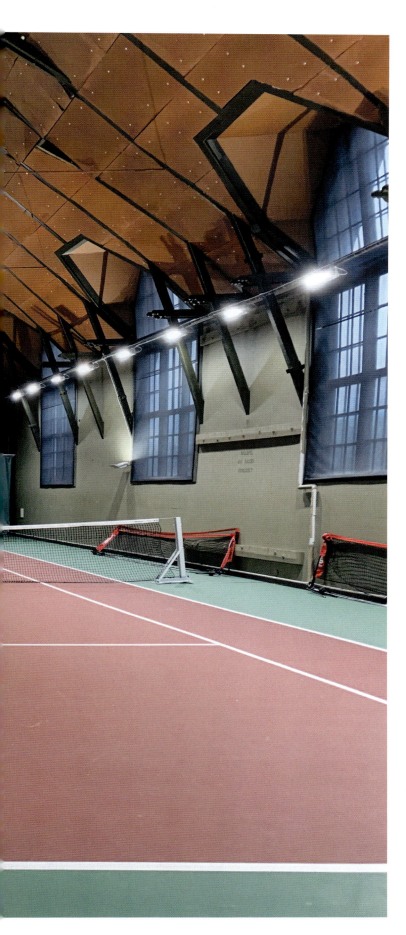

TENNISPAVILJONGEN/ C-HALLEN

Stockholm, Sweden

Ask most anyone in Swedish tennis and they'll tell you the most beautiful tennis hall in the country is just a few minutes away from the Royal Tennis Hall. And to be clear, this was the original Royal Tennis Hall before it moved locations. Everyone calls it the Tennispaviljongen (Tennis Pavilion), or C-hall. The indoor facility was built in 1896 with an architect's vision to merge tennis with a romantic cathedral, meant to mimic other structures made for the 1897 Stockholm Exhibition. The entirely wooden structure has dual skylights, a bell tower, and high-angled windows. The Stockholm 1912 Olympic Games opened with an indoor tournament in this pavilion.

 A wide-ranging community of mostly kids comes to play on the hard courts, now considered a national antique of Sweden. The sound is exactly what you'd expect from playing under a cathedral dome—thunderous and satisfying.

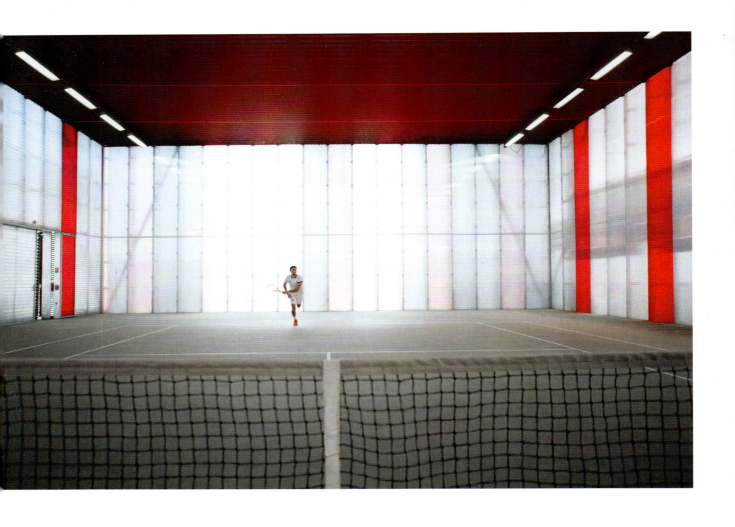

CENTRE SPORTIF JULES LADOUMÈGUE

Paris, France

One slightly incorrect pretense many have about French tennis: The French all grew up hitting only on red clay. Not exactly. And this is evidenced by the fact that the French haven't had Roland-Garros champions since Mary Pierce in 2000 and Yannick Noah in 1983. (It does prompt the inquiry: Should the Spanish host the clay Grand Slam at some point, seeing as they've produced more clay champions?) Most French tennis players, particularly in Paris, grow up on hard courts. Clay is difficult to maintain in the cold and wet months in northern France, so hard courts and other synthetic surfaces win out. Public courts abound in Paris; it's where the tennis community congregates en masse. And some places, like Centre Sportif Jules Ladoumègue, carry that artsy sensibility around the plateau of courts that you might expect. The alternating red and faint white are meant to resemble piano keys, nodding to the Cité de la Musique (City of Music) across the boulevard.

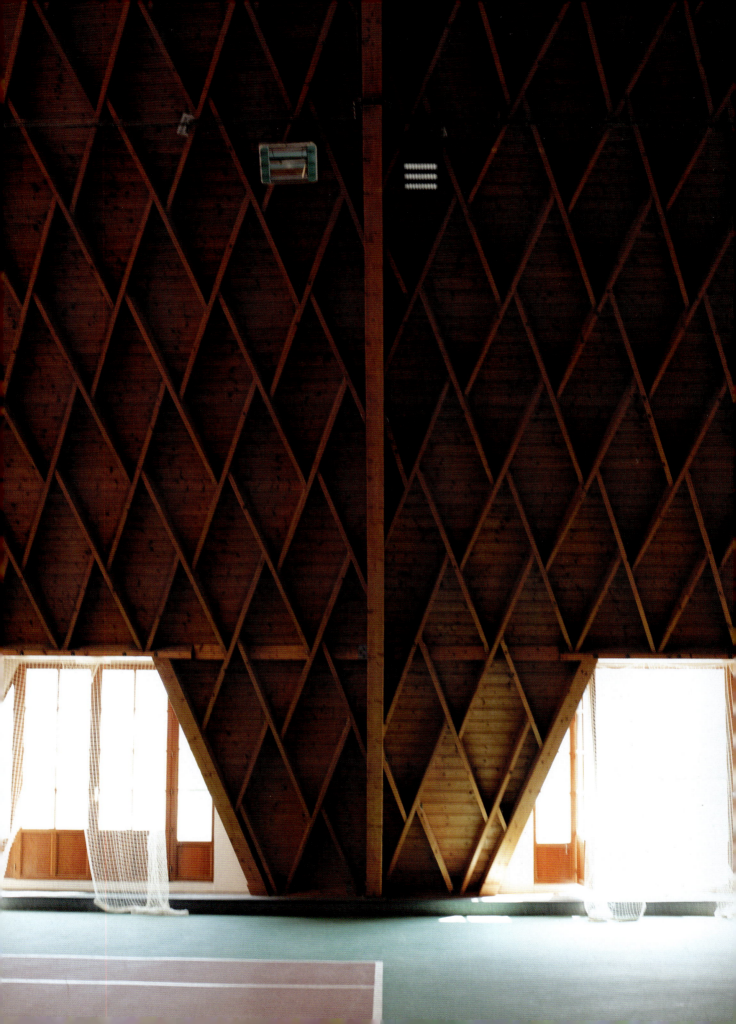

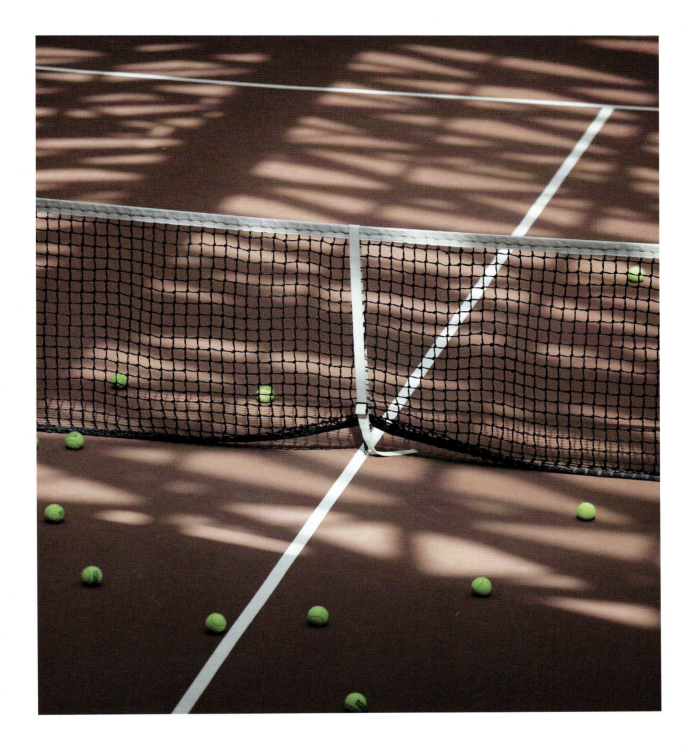

TENNIS DE LA CAVALERIE

Paris, France

Rarely do courts get elevated to the top floors of buildings. But Tennis de la Cavalerie has long found refuge on the seventh floor of a nondescript building in Paris's 15th arrondissement. Everything here is wood—the tiny corridor clubhouse, the locker rooms, the latticework roof, which took over 1,400 pieces to craft about 25 years ago. The hard-court surface plays fast, and the triangles of the structure blur as you play. The club maintains a small membership so as to not overuse the honeycomb court. Increasingly, Parisians more intrigued by the acoustics of tennis than the play itself have requested to come watch some matches here from the patio overlooking the Eiffel Tower.

LA MAMOUNIA

Marrakech, Morocco

The mythic stories of these gardens go back to the eighteenth century, when a young prince inherited this estate and turned it into an Eden inside the old city walls. The tradition of maintaining the gardens of La Mamounia carries on, and now the morning sounds of birds in the olive and palm trees mingle with the sounds of well-struck serves and sliding across the Moroccan clay. People who come here to play are always surprised by the infusion of scents on-court, a mix of jacaranda, rose, periwinkle, and bougainvillea.

Austria

Come-Down Corner

A wooden bench, a plastic chair on Centre Court at Wimbledon, a metal couch at the US Open, or a dusty towel laid on the ground are the forgotten centerpieces of the courts. If these areas where we sit on changeovers were part of the tennis lexicon, they'd be called something like the come-down corner.

They house all tennis outpourings, small or large, gleeful or fitful or both. Anyone who's played the sport has had their fair share of moments here. When players arrive at the bench or chair, they've let go of the racquet when it probably felt heavier than a mallet. They sit and feel a pressure release from somewhere around the ankles. Either it's time to go again, or it's time to leave. Until the next.

Pakistan

Austria

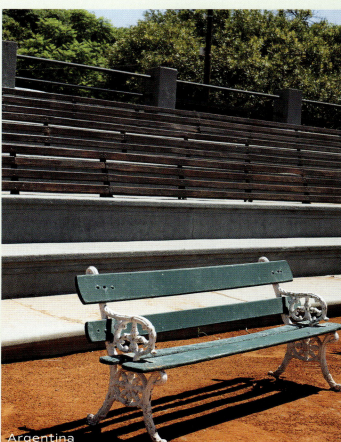

Argentina

USA

Cameroon

Austria

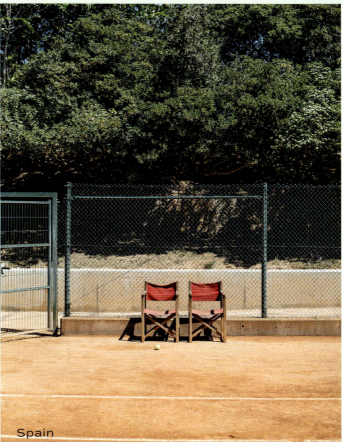
Spain

USA

Spain

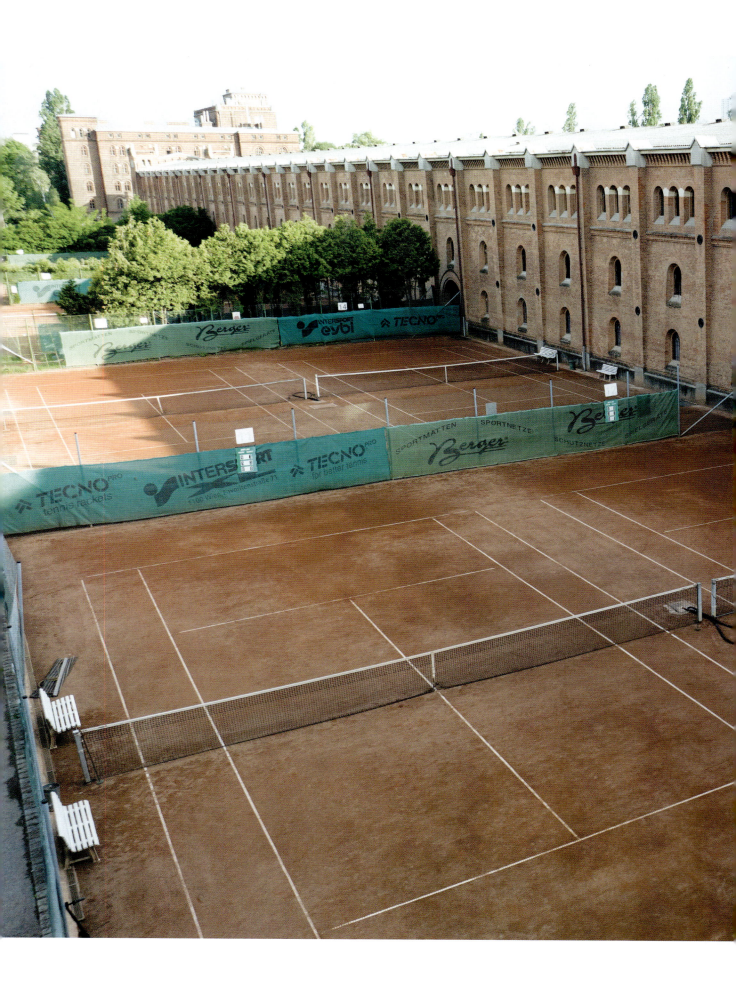

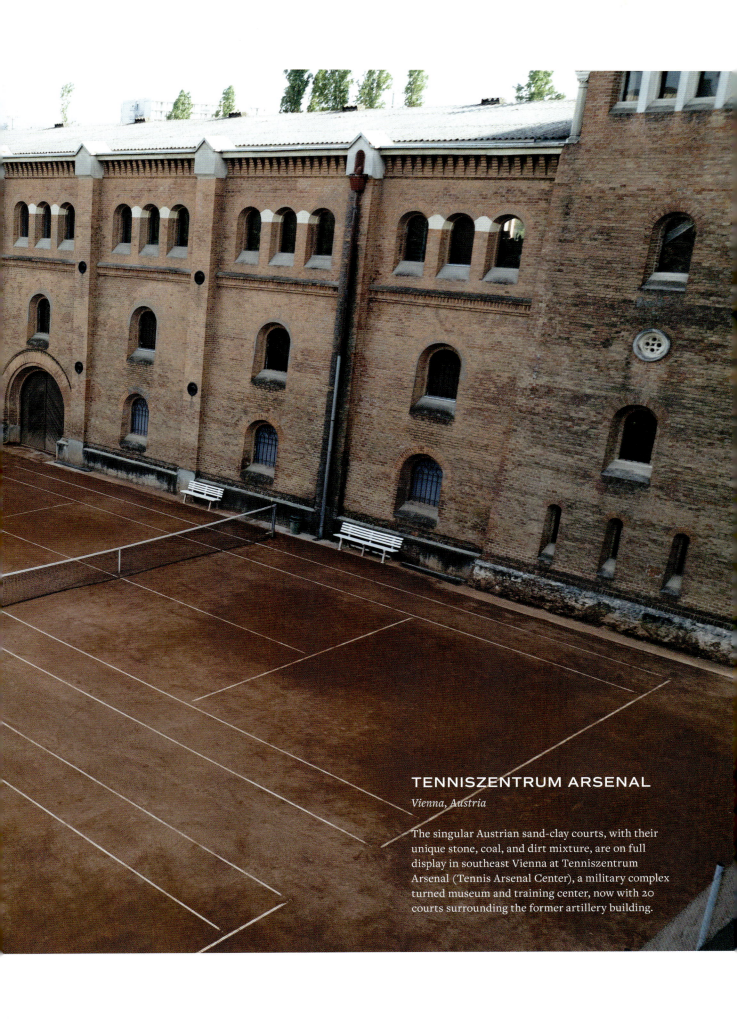

TENNISZENTRUM ARSENAL
Vienna, Austria

The singular Austrian sand-clay courts, with their unique stone, coal, and dirt mixture, are on full display in southeast Vienna at Tenniszentrum Arsenal (Tennis Arsenal Center), a military complex turned museum and training center, now with 20 courts surrounding the former artillery building.

TENISKI TERENI KALIŠ

Belgrade, Serbia

What you know about this country, as far as tennis goes, probably revolves around one person. But walk around with a racquet on your back and Serbian tennis fans, who are everywhere, might take notice and urge you to head to the most important monument in Belgrade, embedded in a vast park where the Danube and the Sava Rivers meet. When you enter the park on Knez Mihailova Street, small sculptures and pavilions dot every block until you arrive at the center of Kalemegdan Park. Here is Belgrade Fortress, the foundations of which date to 279 BCE. Below the watch posts of the fortress, shaded clay courts flank the outer walls. The fort was originally built by the Romans, then taken over by the Ottomans in 1521. During Turkish occupation, they called the fortress Fikir-bayır, or "Hill of Contemplation."

Five hundred miles (805 km) north, in a similarly tennis-obsessed country with an even richer pedigree, a sister club sits above the Vltava River. Attached to the ramparts of the tenth-century Czech castle, TENIS CLUB VYŠEHRAD draws local players to the baroque fortress. And keeping to the Czech form of courts appearing just about everywhere, neighboring Hřiště courts catch those who want to play on isolated courts in the woods.

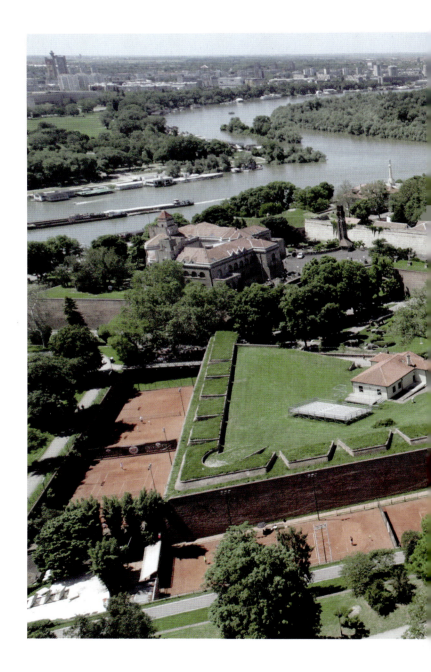

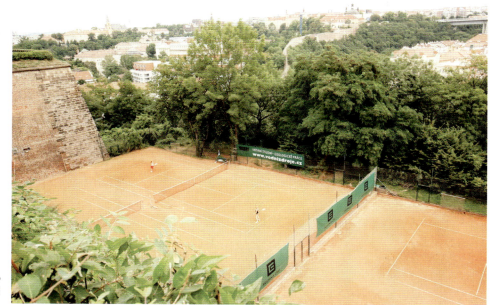

Tennis Club
Vyšehrad

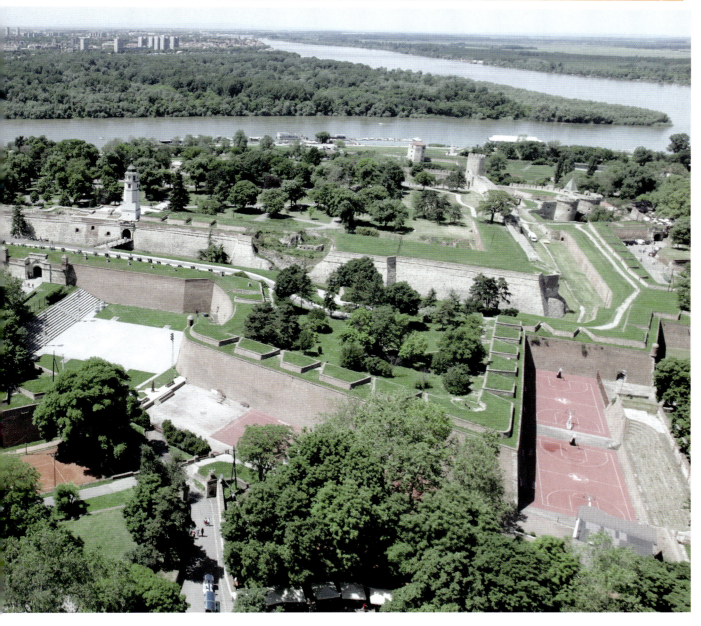

IL SAN PIETRO DI POSITANO

Positano, Italy

Were it not for a large-scale rockslide, this stark green hard court in the cove outside Positano would never have been made.

It was winter 1974, several years after workers drilled into the cliffside to make the luxury resort property Il San Pietro di Positano, when the cliff face near the hotel fell during heavy winter rains. No one was particularly surprised. The Amalfi Coast has long been ripe for rockslides. With the rocks removed, the cliffside stabilized, and the beachfront area leveled, the founders looked around and realized a tennis court would fit perfectly in the clearance.

It might be the only court in the world standing alone in a natural cove. The sounds of every ball strike ricochet off and up the cliffside, so even travelers standing on the lookout above can hear.

And as with all the best tennis courts in the world, there is a resident pet overseeing the grounds. Here she is a boxer by the name of Zarina. (Note: The property does not allow pets, only Zarina.)

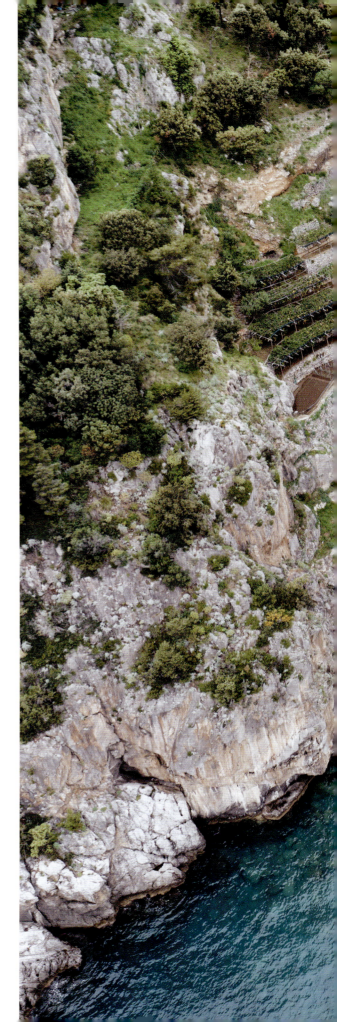

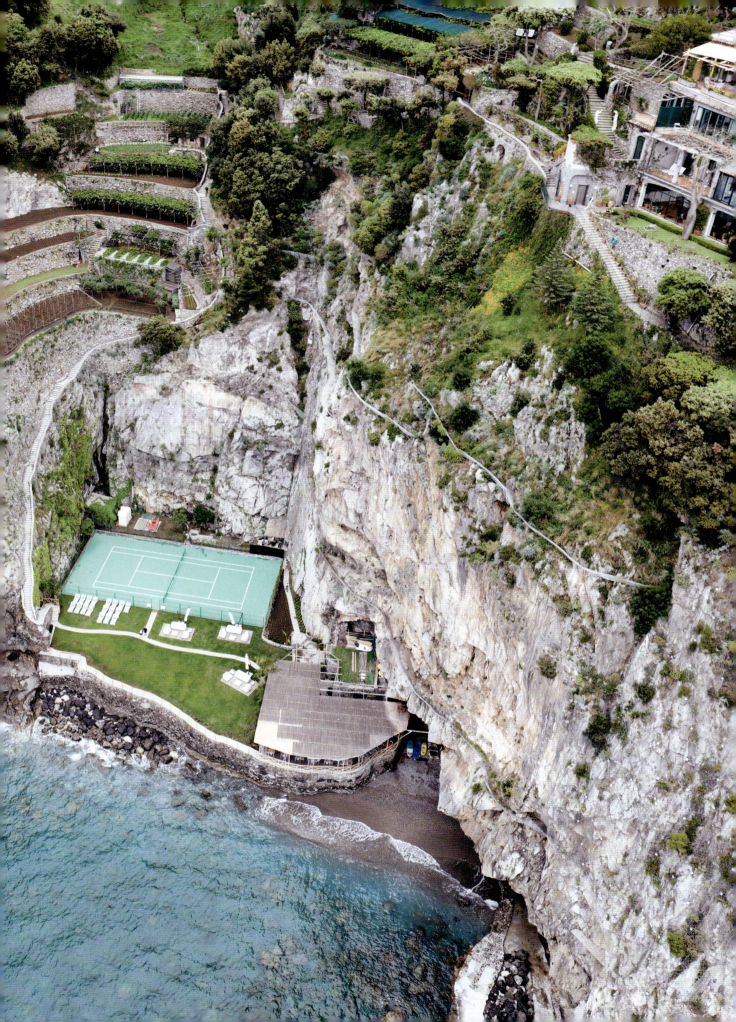

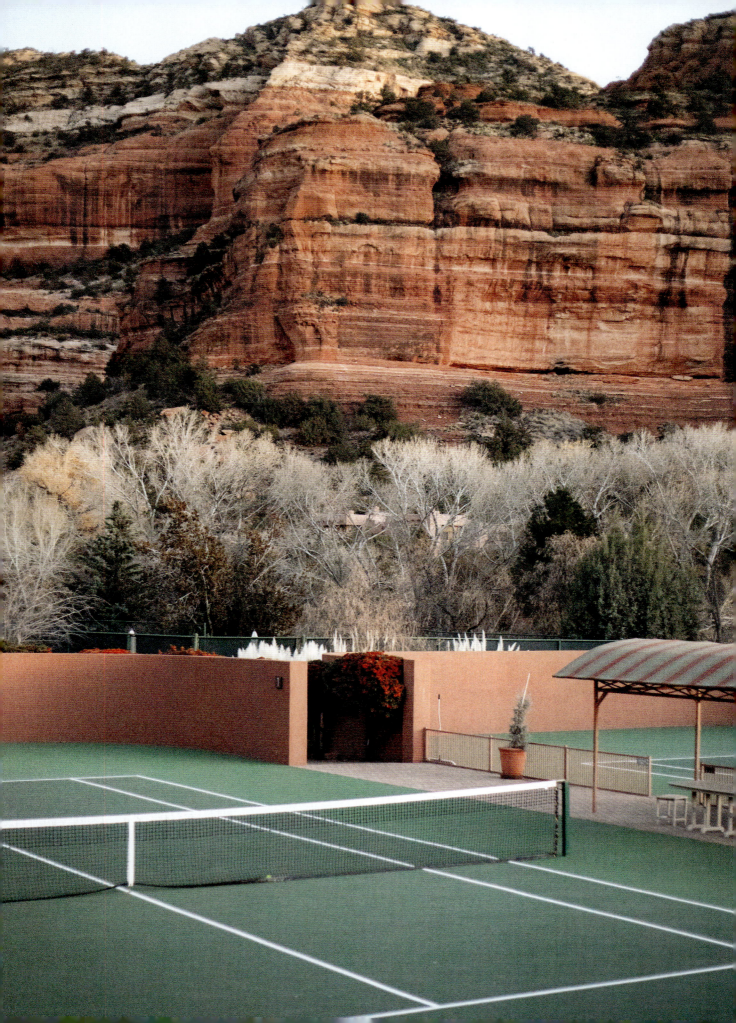

ENCHANTMENT RESORT

Sedona, Arizona, USA

Arrive in Sedona, and you'll hear all about vortexes, centers of energy crucial to self-exploration and healing. Technically the whole city is considered a vortex, and the pockets in canyons or on high mesas are thought to be the most powerful. One such spot is not far from the two hard courts below the red rocks at Enchantment. So, too, can this place be alive with healing energy.

REAL CLUB DE TENIS BETIS

Sevilla, Spain

One might notice the golden dirt scattered around Sevilla, Spain. It's in the parks, lining the walking paths. It's used in the bullfighting rings. But it's most vibrantly and artfully utilized for tennis. The world's only golden courts.

Trucks carry tons of this thick, dark yellow sand from the town of Alcalá de Guadaíra to Sevilla every month, and the team at RCT Betis studiously attends to the sand for the surface of their five courts. Before the material is spread out over the court in a mud or top-surface form, it's thrust through a sieve to make the sand even finer. Sand makes play trickier, more slippery, but also more addictive. The powder sits in the air after points, and you leave the court with a thorough dusting.

The courts get a resurfacing every year, a process that takes about eight days. With the rainy season and the extremely high heat of the region, the courts need constant attention, making hitting here a singular experience, one steeped in a long commitment to the tradition of maintaining these courts with only rudimentary tools and minimal resources.

Spectators come to this historic club, where Rafael Nadal won his first ATP point as a professional at age 15, for the Copa Sevilla, which runs every year in September. Unfortunately, as many at RCT Betis lament, this surface will never make a surge to global tennis popularity, as the color makes it too difficult to see the ball on TV. This is a court that must be witnessed in person.

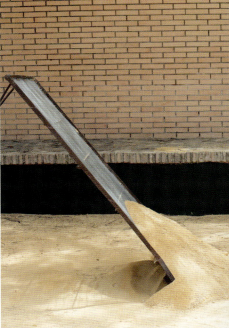

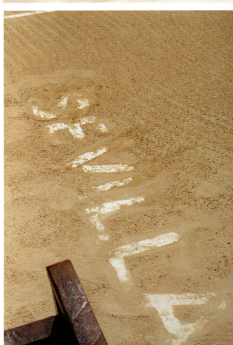

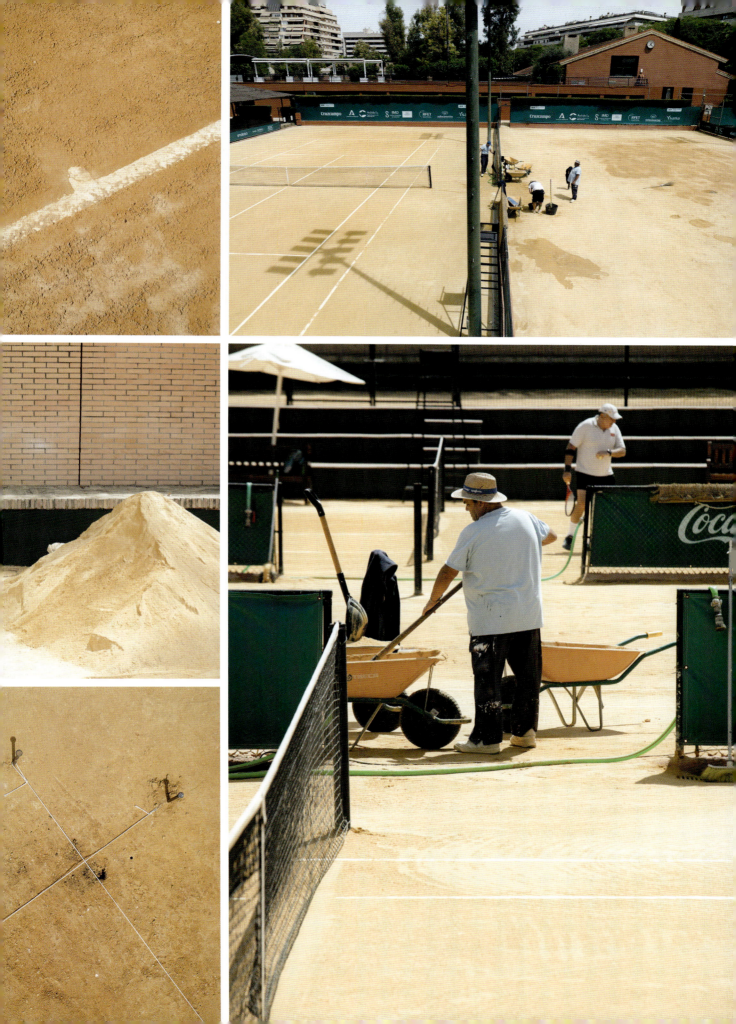

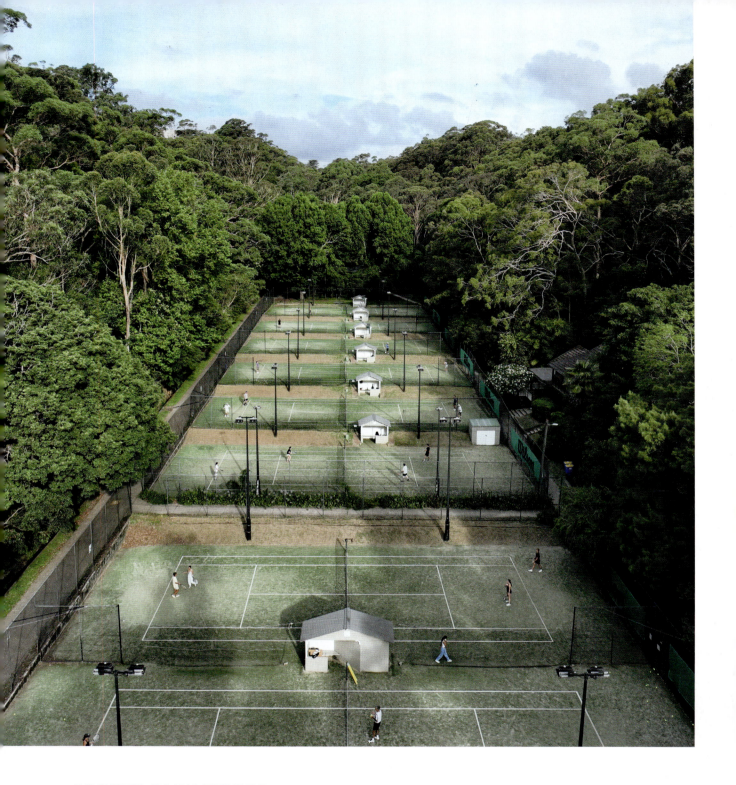

COOPER PARK TENNIS

Sydney, Australia

Cooper Park Tennis sits in a narrow gulch with leafy cliffsides. Enter the park from the east side and descend, taking the long route across the bridges and past the grottoes to reach the turf courts. You may never have played mixed doubles, a club favorite format, with so many types of very vocal, very large parrots and hawks flying overhead. The energy is relaxed and freewheeling—kids (and adults) practice obscure trick shots for no reason out here. The most notable, of course, is the tweener, the only shot in tennis where joy trumps all other things. It's the shot for the audience, for exuberance, for the comedic and crafty potential of the game. Cooper Park aligns with this sensibility, encouraging you to bend or defy convention, set your own lines, and enjoy.

AGIT ANALOGUE

Yangpyeong, South Korea

High atop up a lush, winding road in rural South Korea, a mountain nook holds the country's most unique courts. The Agit Analogue cultural space started as a rural home for owner Lee Dong-hyeok and his family. In 2021, after spending many years playing and working in tennis in California, he moved back to the region east of Seoul and decided he needed a court. He wanted to fashion it in the image of the Miami Open courts (when the tournament was held on the purple hard courts at Crandon Park). Everything would be purple, he decided. The two hard courts came first, then he expanded the home into a cultural space and opened it to the public. Many across Korea call it "the Hideout," owing to its location, although with its neon-purple exterior, it's easy to spot. The sheet metal contains zinc, so it becomes fluorescent in strong light. On the court level, white marble walls shield players from any glare or wind. The place has become an annual retreat for many, a tennis romance in the hills.

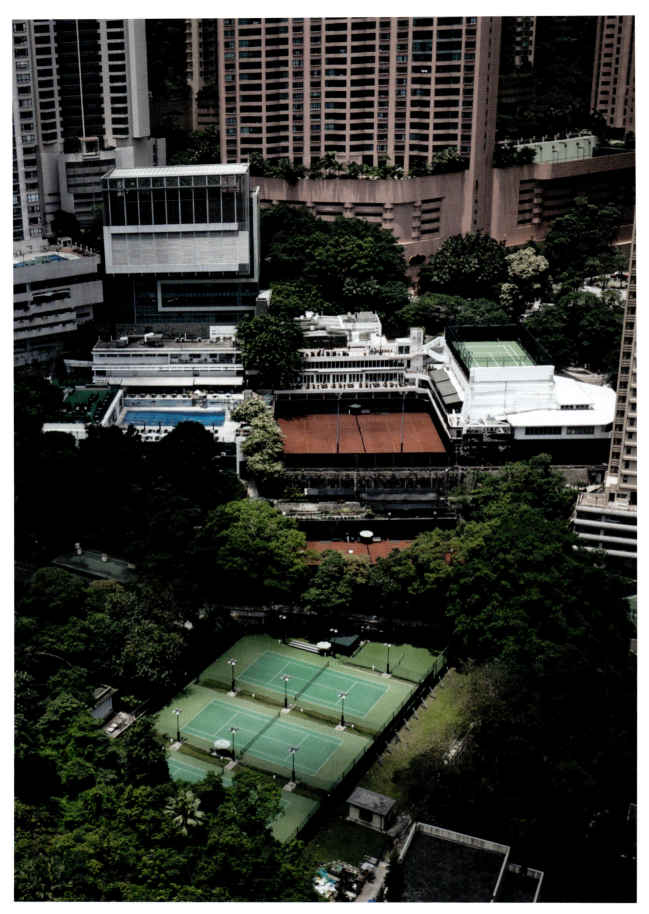

LADIES' RECREATION CLUB

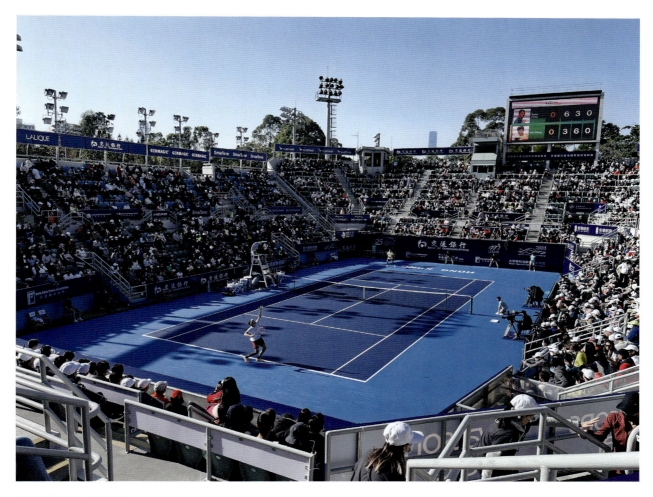

VICTORIA PARK

TENNIS UNDER THE TOWERS

Hong Kong, China

Here in Hong Kong, China, they play in tiny pockets at the base of the towers. The city offers no flat, wide spaces, so to play or watch tennis in one of the most densely populated places in the world, you must squeeze between the skyscrapers. There is, however, one open space for hitting, and every October the women's professional tour enters VICTORIA PARK, set among the largest green spaces in the city. The 3,500-seat hard-court stadium is open year-round for anyone who wants to play. Consider hitting at night during the autumn lantern festivals when the entire park is lit by massive displays.

The rest of the local tennis community plays at residential courts, and they liken it to playing on a court planted in downtown Manhattan, just with taller skyscrapers. The members at the LADIES' RECREATION CLUB also receive such an experience. The clay and synthetic grass courts sit on a steep hillside terrace overlooking the south side of the city, with towering residential complexes behind each flank of the courts.

SANDY STREAKS OF PUNE

India

On these courts, kids waiting their turn to play make paintings outside the lines, the lighter hue of the top surface giving way to wetter sand underneath. This isn't clay but fine beach sand. The courts around Pune, India, from the seven lively courts at FERGUSSON COLLEGE to the DECCAN GYMKHANA CLUB and the POONA CLUB, are topped with sand from the country's western wetlands and beaches. Sliding on the surface is easy, but the ball is tougher to reach—it stays lower than it would on a traditional clay court. Drop shots and slice serves are lethal. The longer you play or watch, the more the lines that get painted on every morning scuff and smudge away. If you train here, fill a cup with the wetter sand from the court's edge, wet it, plop it on the court, and blast away at your self-made targets.

DECCAN GYMKHANA CLUB

FERGUSSON COLLEGE

POONA CLUB

TENNIS CLUB GRINDELWALD

Grindelwald, Switzerland

This club in the Grindelwald valley, which is open to anyone and operates on an honor system for chipping in for your time on-court, runs out of a ski chalet with around 100 regular members, most of whom live in town on the other side of the creek. The club was founded in 1915 by a group of alpine skiing friends who needed something to do in the summer. What lives on is a tennis retreat hidden below the vast meadows.

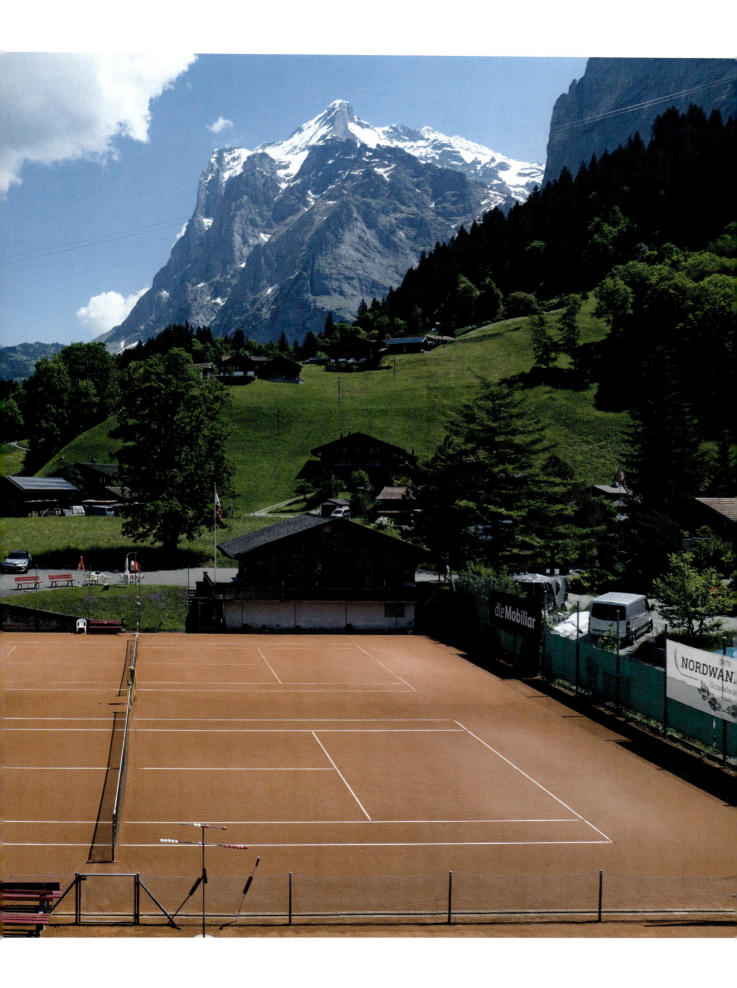

05

DRILL, GRIND, REST, REPEAT.

———

Places where tennis is played feverishly never cease
in showing the game's profound damage and delight.

Regardless of whether one is in Seoul or Brooklyn or Cairo or South Florida, the tennis grounds where the ravenous and most deeply committed come to drill, compete, and play day in and day out are all the same. And they are all reminders that life on the courts is one of the most sensorial lives one can lead.

There are the sweat-baked hats, blistered feet, and callused hands. Jump ropes and bands and Advil. Racquets lie around and form a macramé-like pattern; bags overflow with gear, trash, and reels of string. Coaches, mostly men, mill about, studying.

Two-ball cans, three-ball cans, four-ball cans pop open with that fuel-like scent. There's brief chatter about the merits of a Wilson ball, a Diadem ball, a Dunlop ball, a brand of ball that won't be named.

There are rapid conversations in the specialized tennis lexicon: Penko and Petko, Challengers, Bollettieri, Futures, 250s and 500s. There are comments exchanged on college tennis. Comments on coaches on Instagram. Comments on commentators.

There also seems to be an agreed-upon maxim: Tennis is a callous grind, a series of formulaic, brute extensions and awkward-footed jabs drizzled with narrow, caramelly strokes of beauty.

These grounds are never empty save for deep hours of the night. These are places where tennis functions as occupation, or as a deep personal obsession, for large swathes of diverse groups. And while mundane to some, they can also be surprising in their own minidramas.

Out here, styles of play consistently relay as well as rebuke layers of a player's identity and persona, no matter their age. In Prague, a local doubles specialist glides toward the net in a

three-times-a-week match against their friend-rival. The doubles guy keeps getting caught in no man's land—he'd rather be playing doubles instead of missing shots off his shoelaces. In Los Angeles, a self-proclaimed moonballer waits for an error from their hitting partner, the mercurial, impatient, aggressive player from New York. The moonballer grins with every slapped and missed shot. At the community tournament in the high desert, a 50-something regular who grew up idolizing Pete Sampras leans too hard into his serve against the bigger-serving, and much younger, Northern California college grad who moves with the cocky self-assuredness of someone who almost won The Ojai. In Spain, at a Gay & Lesbian Tennis Alliance world tour event, a Singaporean man dips sharp angles against the heavy-topspin shots of an Argentine woman who grew up a few paces behind the baseline. At a tennis academy in France, two 11-year-old upstarts who have no common language rally for the first time in front of an audience of coaches, each kid hesitantly rolling topspin balls high, refusing to miss in the net.

 On tennis grounds like these, the most varied of the tennis dedicated show up with persistence and verve. They watch their opponents past and future—stalking is a love language. Strategies emerge. But every plan can easily wash away when the toss ascends with ticklish anticipation at the beginning of a point. There's very little lip service to tennis as a form of grace. No one uses the word *balletic*. •

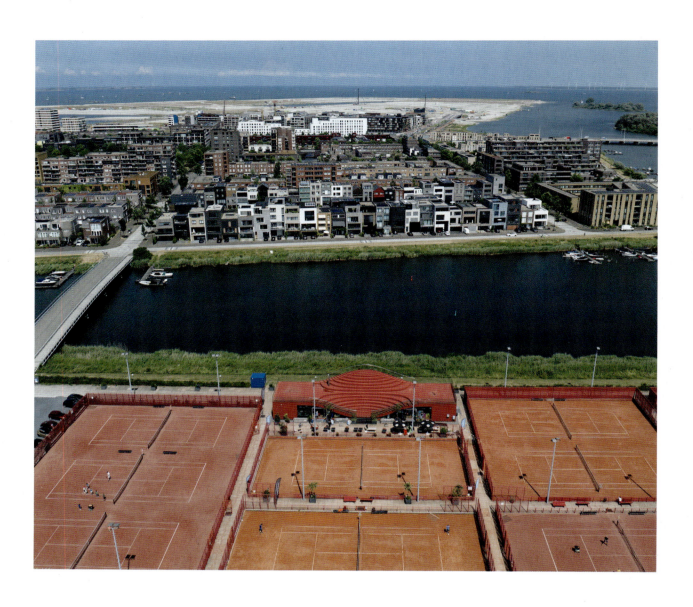

TENNISCLUB IJBURG

Amsterdam, Netherlands

Built in 2013, the architects called the seating-clubhouse hybrid "the Couch." In a newish housing development east of Amsterdam, on one of six man-made islands, the public facility does its job of attracting residents from the city. Players, viewers, and wanderers come here and hang out on the Couch like it's a piece of tennis street furniture.

The roof dips down toward the south and up toward the north; there are clay courts to the east, canals and ocean to the west. The structure isn't high enough for shadows to splay onto the court, so players need not worry about the light. The clay is a crisp, crushed red shale, dusty and not too sticky in the humid Amsterdam summers. The grounds epitomize a community tennis ideal—an open-expanse living room that's open all day and night.

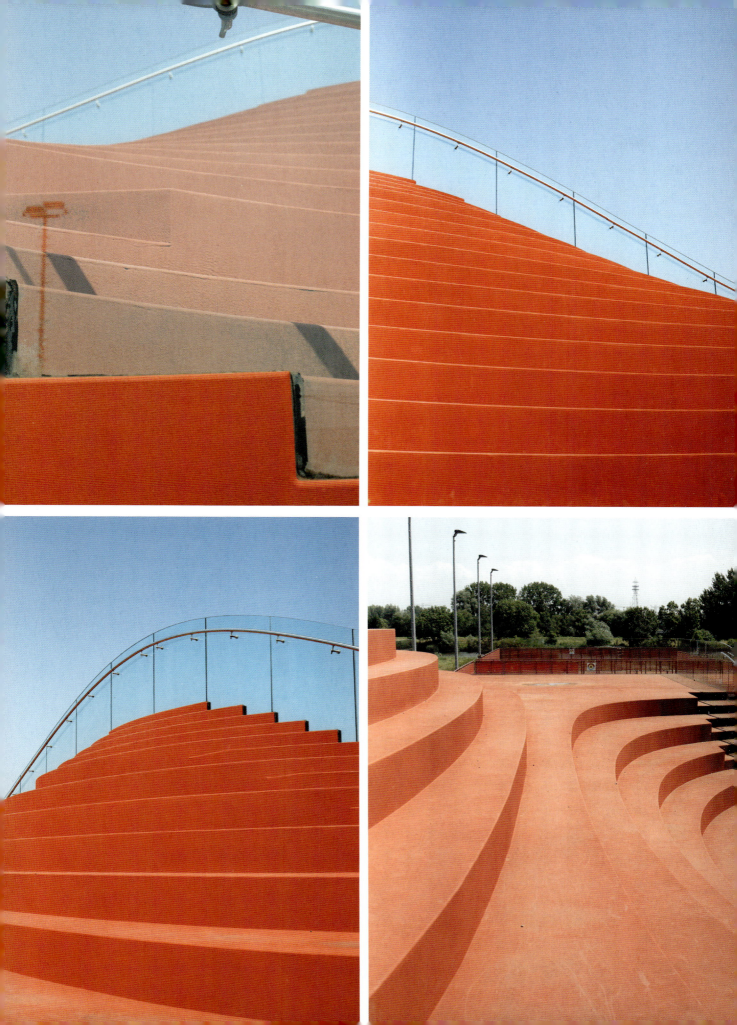

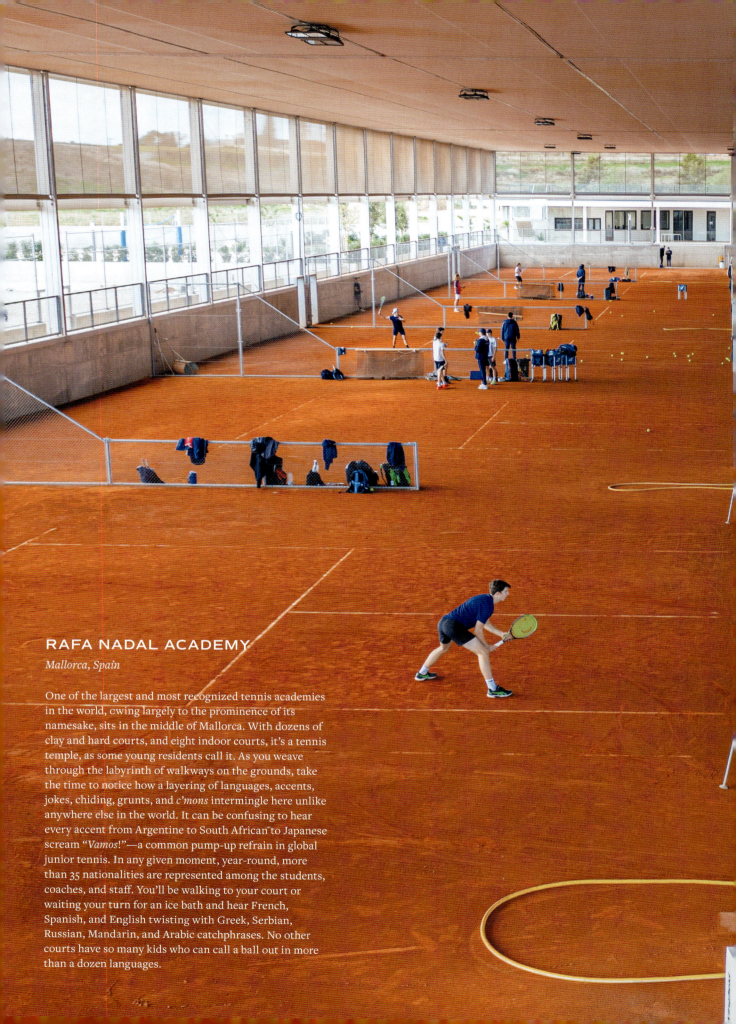

RAFA NADAL ACADEMY
Mallorca, Spain

One of the largest and most recognized tennis academies in the world, owing largely to the prominence of its namesake, sits in the middle of Mallorca. With dozens of clay and hard courts, and eight indoor courts, it's a tennis temple, as some young residents call it. As you weave through the labyrinth of walkways on the grounds, take the time to notice how a layering of languages, accents, jokes, chiding, grunts, and *c'mons* intermingle here unlike anywhere else in the world. It can be confusing to hear every accent from Argentine to South African to Japanese scream "*Vamos!*"—a common pump-up refrain in global junior tennis. In any given moment, year-round, more than 35 nationalities are represented among the students, coaches, and staff. You'll be walking to your court or waiting your turn for an ice bath and hear French, Spanish, and English twisting with Greek, Serbian, Russian, Mandarin, and Arabic catchphrases. No other courts have so many kids who can call a ball out in more than a dozen languages.

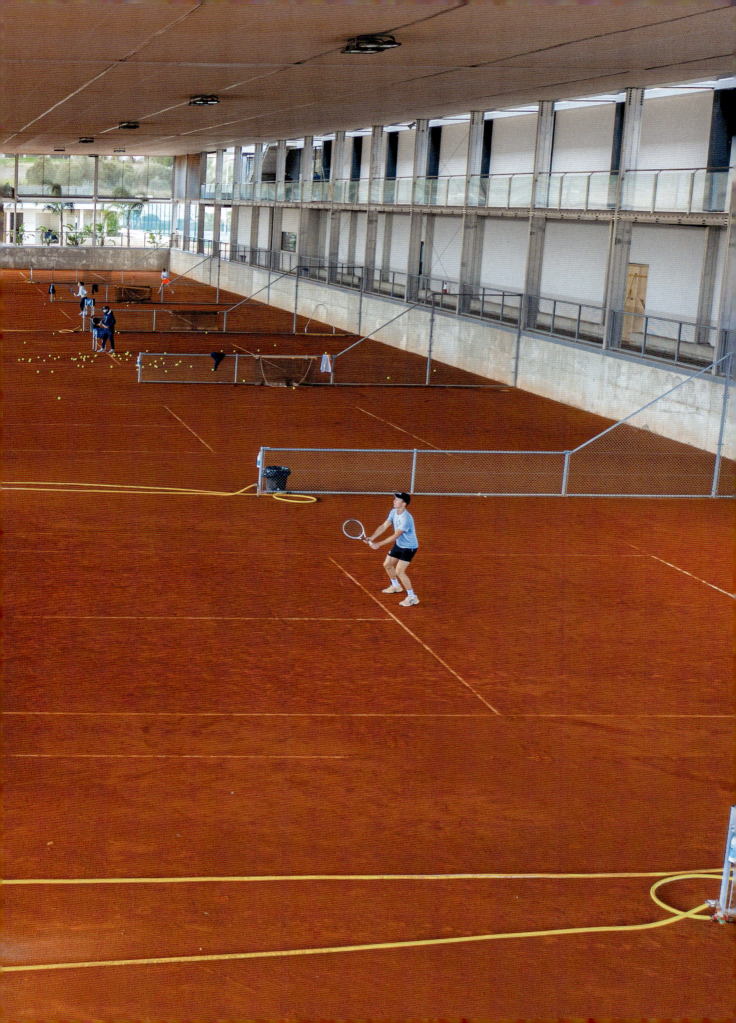

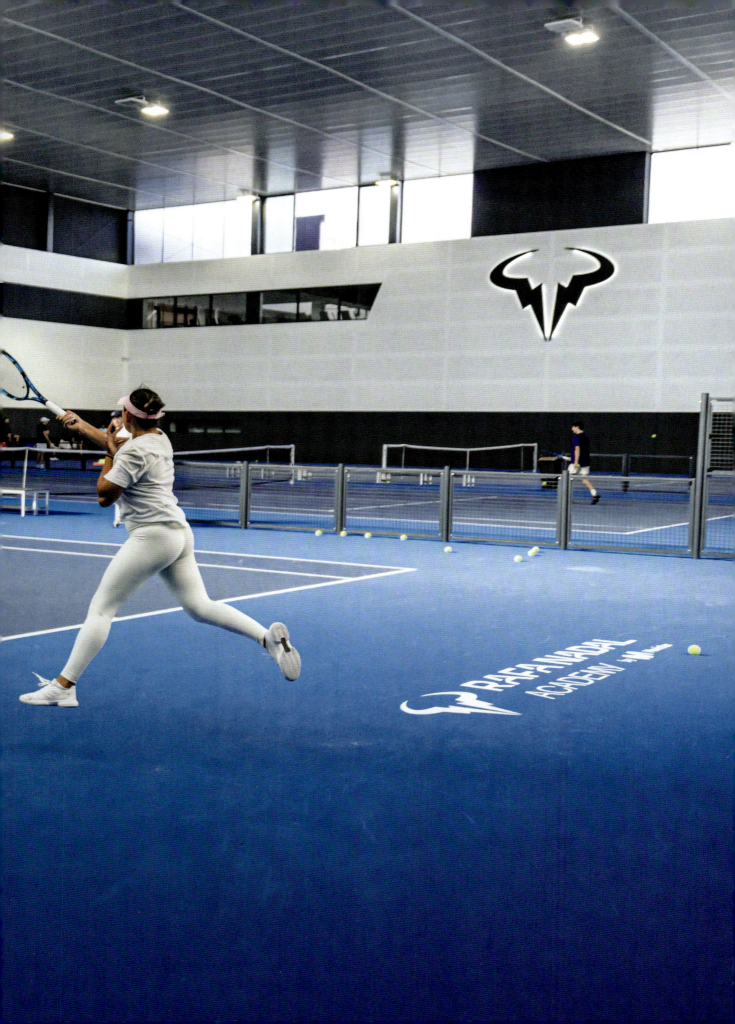

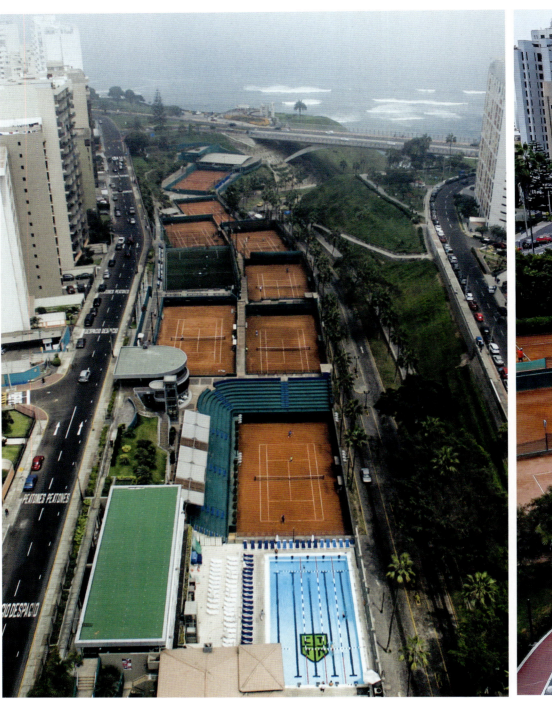
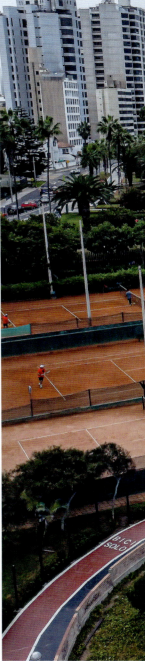

CLUB TERRAZAS

Lima, Peru

Every clay court on the grounds at CLUB TERRAZAS is wedged between two of Lima's major thoroughfares. In this tennis cove, each court has its own teal enclosure leading down toward the rugged coast, only a 10-minute walk downhill. The club has a beachside facility, too, but maybe the best coastal spot for drilling is at MIRAFLORES PUBLIC COURTS atop the cliff. These eight courts were built alongside the historic Paseo Ruta del Sol, a cliffside trail perched above the sea, with one court in particular jutting out toward the edge, creating an infinity-court effect on the western edge of the continent.

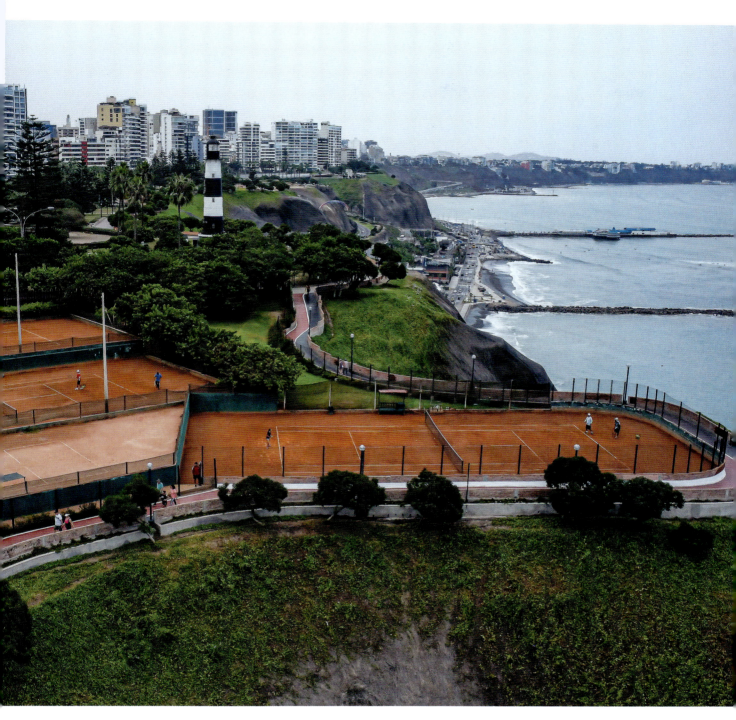

MIRAFLORES PUBLIC COURTS

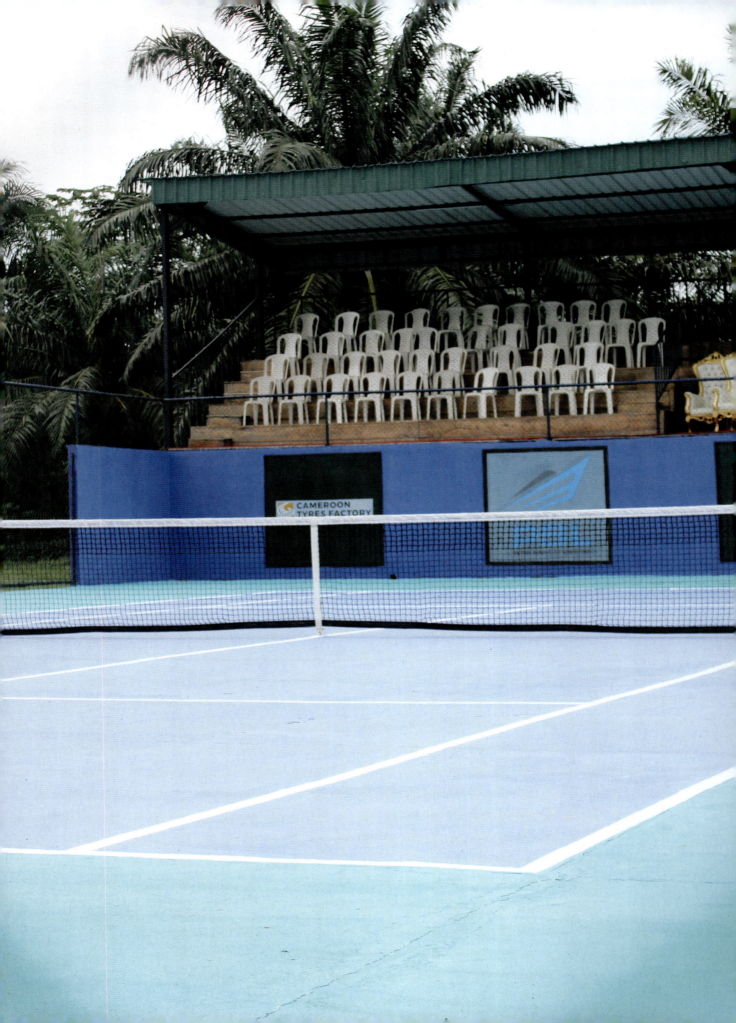

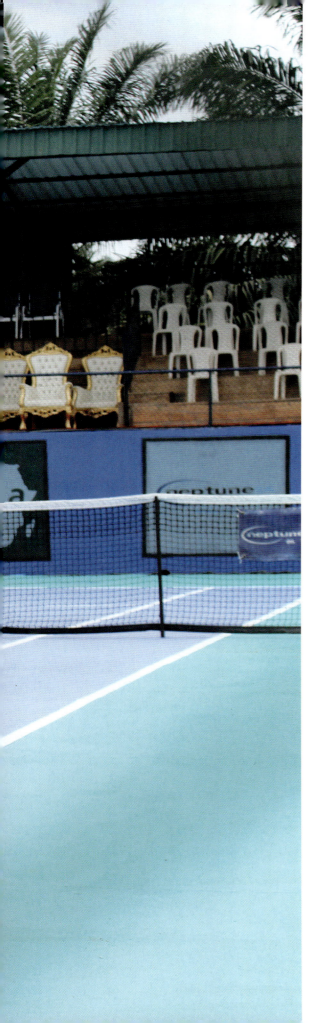
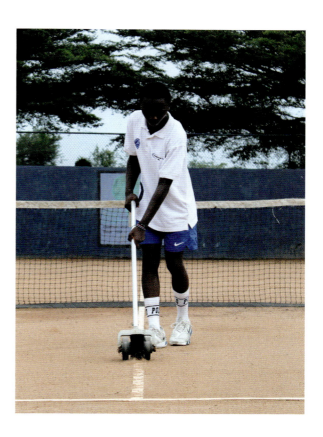

OYEBOG TENNIS ACADEMY

Souza, Cameroon

Few tennis grounds can claim a home in the middle of a pineapple plantation with nothing but flatlands on the horizon in every direction. Out here in Souza, former ATP pro and Davis Cup player Joseph Oyebog expanded his tennis initiative that started on a wall in nearby Douala into an academy complete with international tournaments, room and board for players, and regularly resurfaced hard courts and clay courts. On a daily basis, players grind through about a thousand cross-court drills before starting any match play.

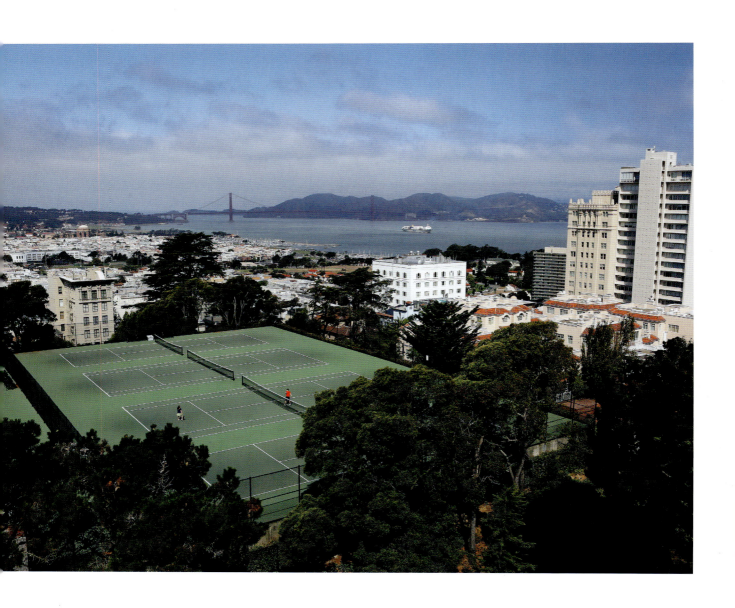

ALICE MARBLE TENNIS COURTS

San Francisco, California, USA

In the Russian Hill neighborhood of San Francisco, atop Lombard Street, regulars from across the seven-by-seven city come to play on the hard courts with views over Golden Gate Park. Few today recognize the courts' namesake, but before the advent of the Open era, Marble won 18 Grand Slam titles across singles, doubles, and mixed doubles events. She fine-tuned her aggressive playing style from a young age on the public courts in Golden Gate Park in the 1920s and '30s, the same courts where Rosie Casals would later learn to play. Marble would go on to coach none other than Billie Jean King.

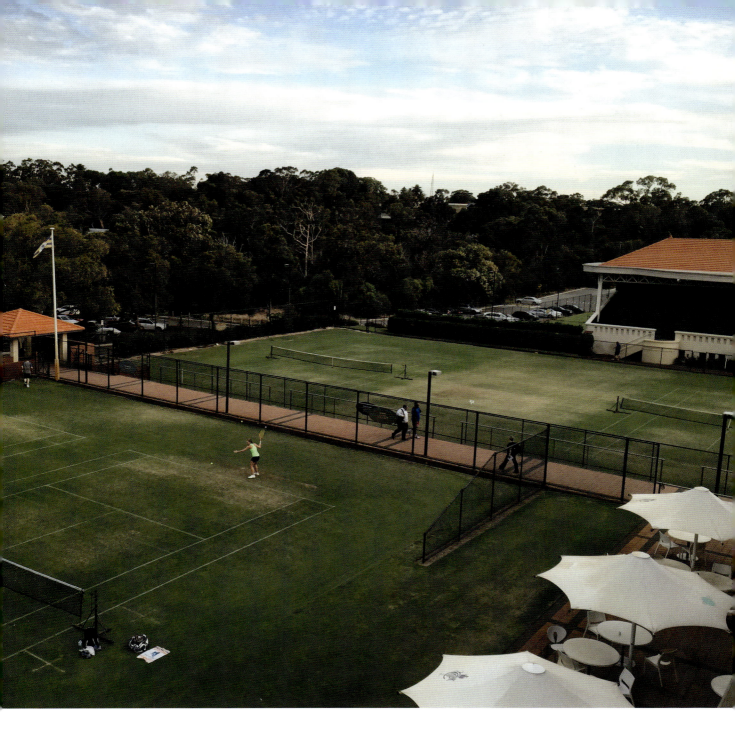

ROYAL KING'S PARK TENNIS CLUB

Perth, Australia

Five hours by plane from Australia's eastern cities, the pristine facilities of Perth draw the lively western tennis community in droves. What started as two asphalt courts in 1899 is now a sprawling 22-grass-court Eden at the Royal King's Park. The original viewing pavilion, built in 1926, remains the main seating area when the club hosts Davis Cup ties, among other events. The pavilion itself is a national heritage site.

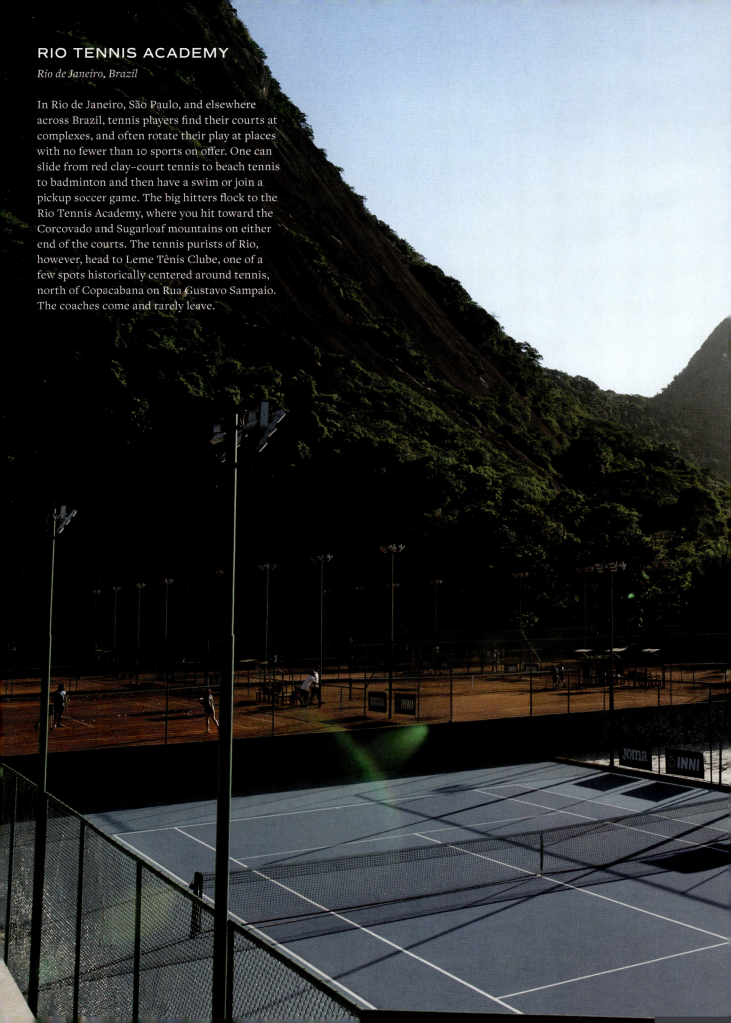

RIO TENNIS ACADEMY
Rio de Janeiro, Brazil

In Rio de Janeiro, São Paulo, and elsewhere across Brazil, tennis players find their courts at complexes, and often rotate their play at places with no fewer than 10 sports on offer. One can slide from red clay–court tennis to beach tennis to badminton and then have a swim or join a pickup soccer game. The big hitters flock to the Rio Tennis Academy, where you hit toward the Corcovado and Sugarloaf mountains on either end of the courts. The tennis purists of Rio, however, head to Leme Tênis Clube, one of a few spots historically centered around tennis, north of Copacabana on Rua Gustavo Sampaio. The coaches come and rarely leave.

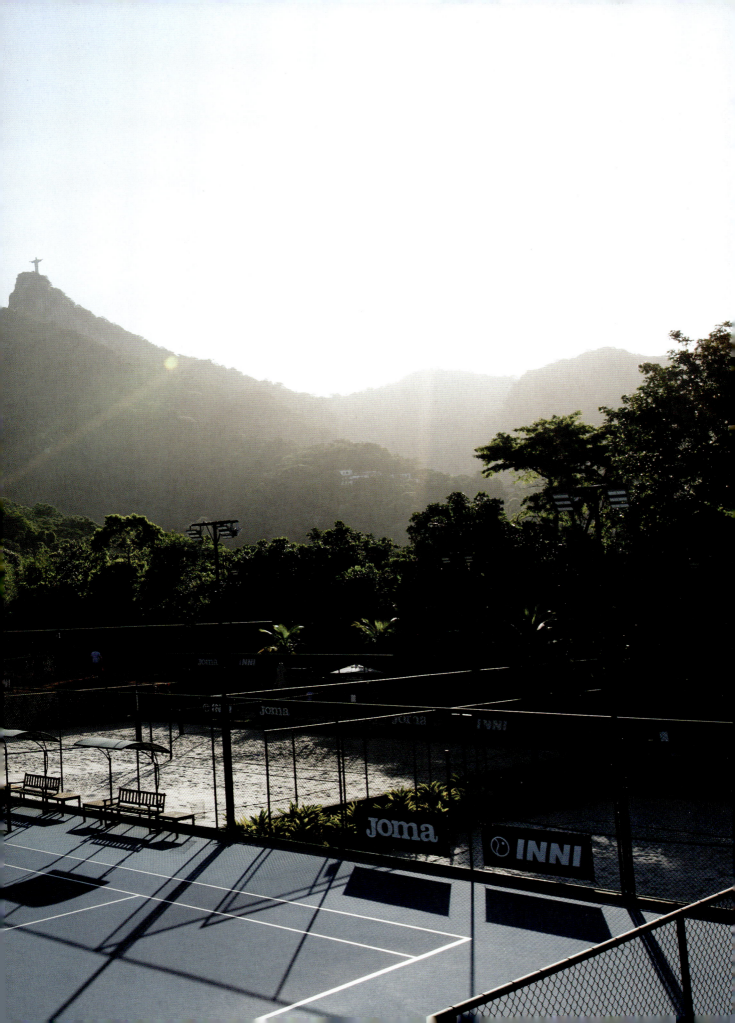

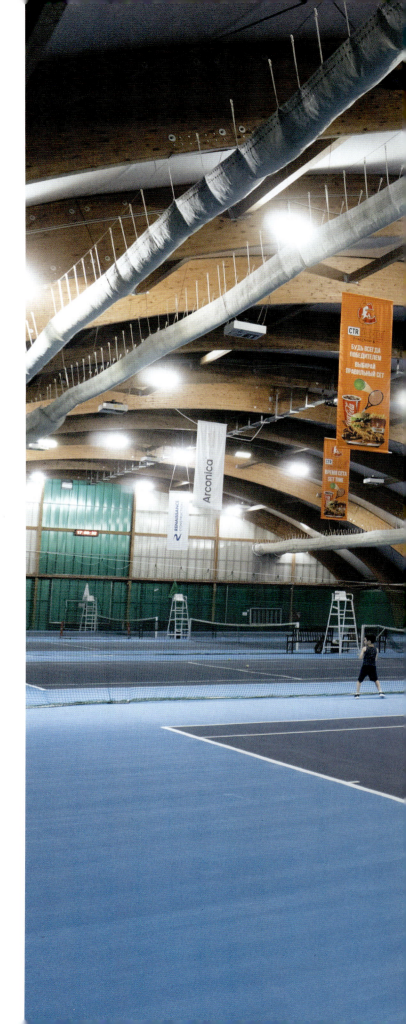

GORKY TENNIS PARK

Almaty, Kazakhstan

The sports park in western Almaty holds an array of staid Soviet-era structures shrouded behind the trees. And while tennis was frowned upon in the Soviet era as an opulent, privileged engagement, somehow Gorky Tennis Park has persisted since the late 1920s. In fact, these indoor and outdoor clay and hard courts have been the backbone of tennis in southern Kazakhstan for two generations, and the park now hosts its own men's Challenger tournament every year. While the nation itself has invested heavily in tennis since the 2000s (with the help of one megadonor billionaire obsessed with tennis), many in the local tennis scene point to Gorky as where the true grinders show up en masse. They also get decent weather to play outside for several months more than their compatriots 800 miles (1,287 km) north in Astana.

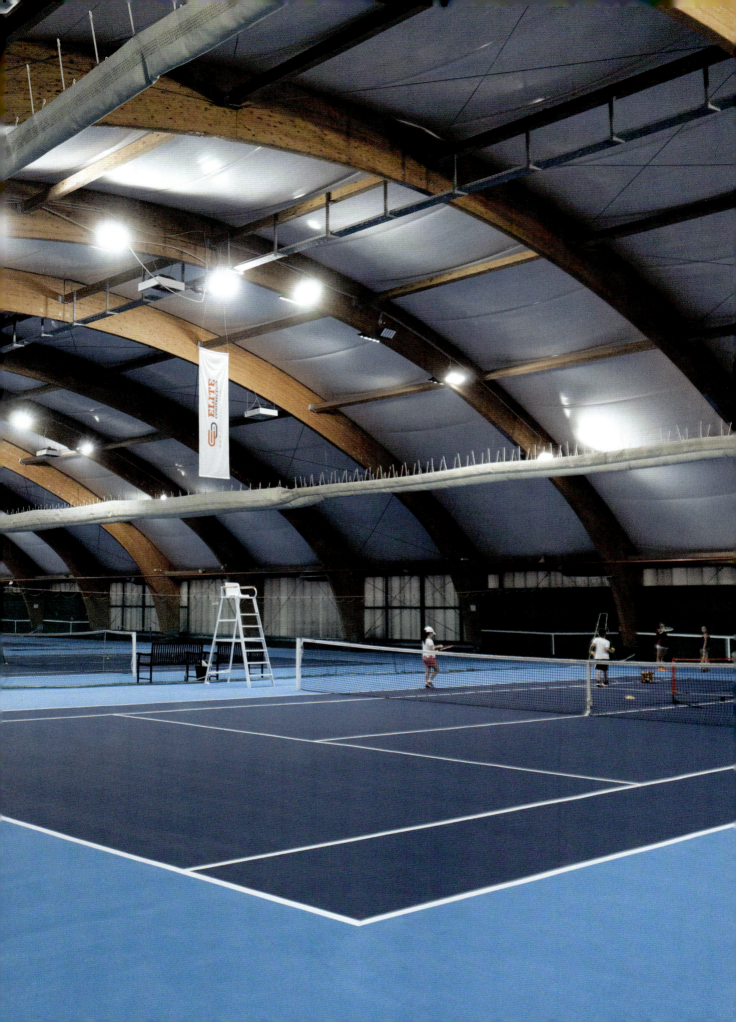

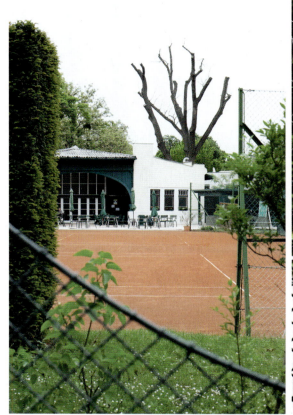

SCHWARZ-BLAU TENNIS CLUB

THE VIENNA NEIGHBORS

Austria

A short morning stroll down Rustenschacherallee takes you past Austria's most historic tennis clubs: WIENER ATHLETIKSPORT CLUB (VIENNA ATHLETIC CLUB), TENNISCLUB SPORTVEREIN SCHWARZ-BLAU (SCHWARZ-BLAU TENNIS CLUB), and WIENER PARK CLUB (VIENNA PARK CLUB). They're neighbors, each no more than 50 paces apart, in a leafy pocket east of central Vienna.

All three clubs have their own similarly styled sand courts—technically still clay courts, but picture something more along the lines of a coarse, heavy dirt. The surface comes from excess piles at retired Austrian coal mines, sandy coal-clay heaps that get processed into smaller granules. Moving around the courts sounds more crumbly than slick, and the ball bounce is even slower than on most clay courts, especially as the climate keeps the courts damp most of the year.

Go to any of the three and you might hear some banter about whose club is indeed the oldest. Their histories are all intertwined with other sporting departments founded in the late 1800s, originally cycling clubs or football clubs, with tennis added several years later. Who is truly the elder statesperson? Probably Vienna Athletic Club, which also has the largest membership in Austria with a fiercely competitive club team in Vienna's Tennis Bundesliga.

Schwarz-Blau, the sibling wedged in the middle, is arguably the most idyllic, with a piece of European history for a clubhouse. The Art Nouveau structure made entirely of green-painted wood was built in 1898 by Joseph Maria Olbrich, a founding member of the Vienna Secession and former employee of Otto Wagner. The structure maintains most of its original touches. These days, most members and visitors still use a wooden peg board to reserve their court time, then wait on the patio reading *Tweener Tennismagazin*, the local tennis magazine, until their court opens up.

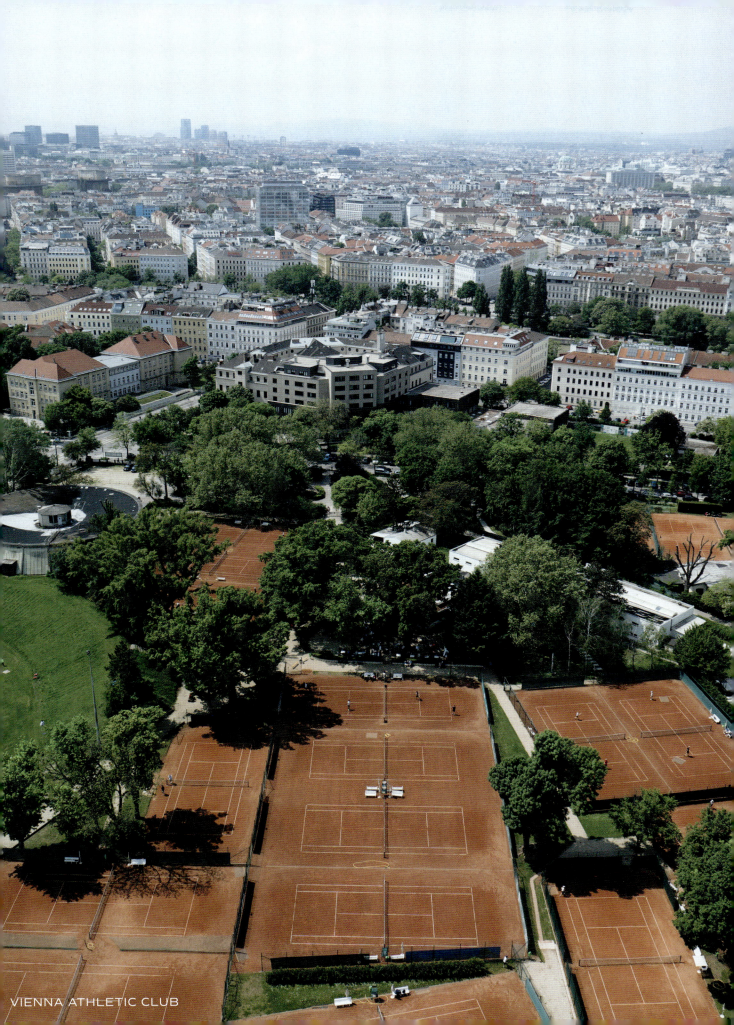
VIENNA ATHLETIC CLUB

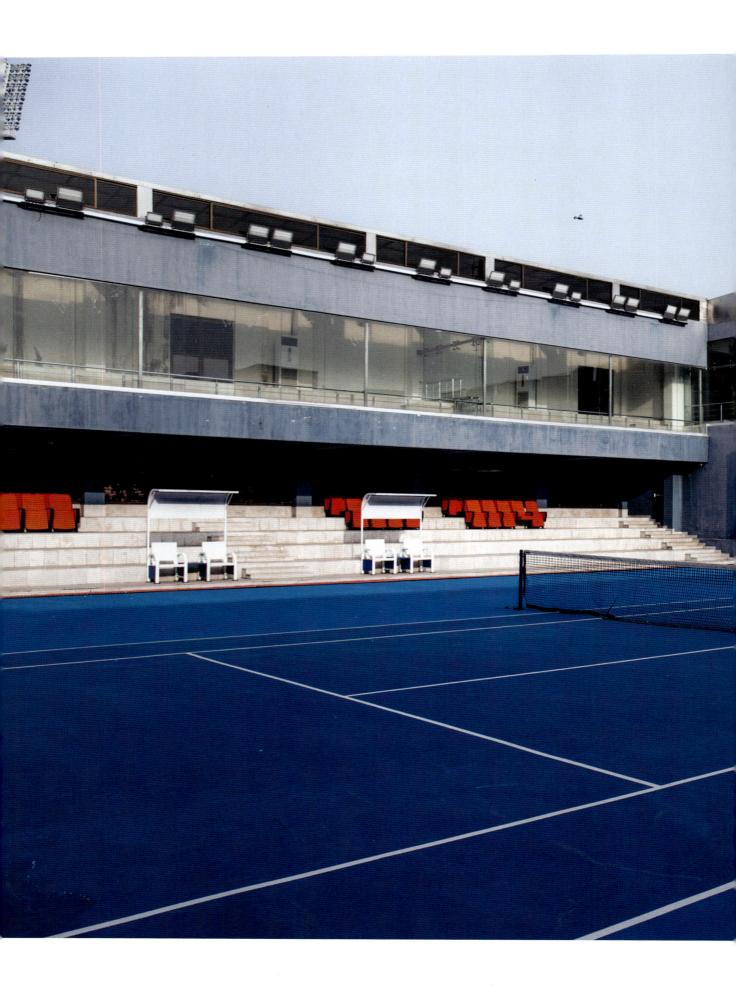

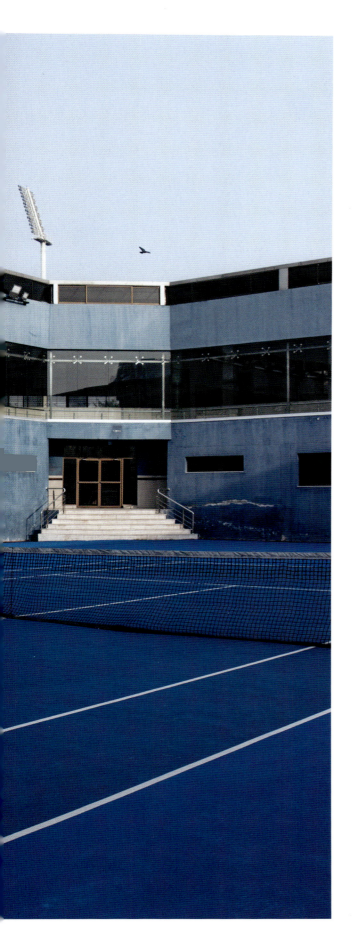

NISHTAR PARK SPORTS COMPLEX

Lahore, Pakistan

For a decade, the Nishtar complex in central Lahore had only one hard court, not enough for one of the few public facilities in the province and definitely insufficient to host any sort of tournaments. The only options were exclusive clubs for the wealthy. But as interest in tennis has grown in recent years, so has the demand for a national tournament. Four more blue hard courts emerged on the Nishtar grounds, and the Punjab Open Tennis Championship quickly followed, the first event of its kind hosting juniors, female and male, ages 6 to 18. This, one of the newest cohorts of national juniors, now has a place to call home on these deep-blue grounds.

Philippines

USA

India

Netherlands

Remembering (or Forgetting) the Score

Once, in a stadium in Montreal, some fans asked their seatmates a typical question before the start of match: "Who are you rooting for?" The group responded with their player of choice. Then someone else asked, "What's your ideal score line?"

It's a peculiar and a worthy question. Someone's desire for a 7–5, 6–4 score might show their proclivity for a stable, predictable match with a few tight moments. That day in Montreal, the first answer was, "I want a 6–0, 0–6, 7–6." Some of us yearn for chaotic entertainment, too.

New Zealand

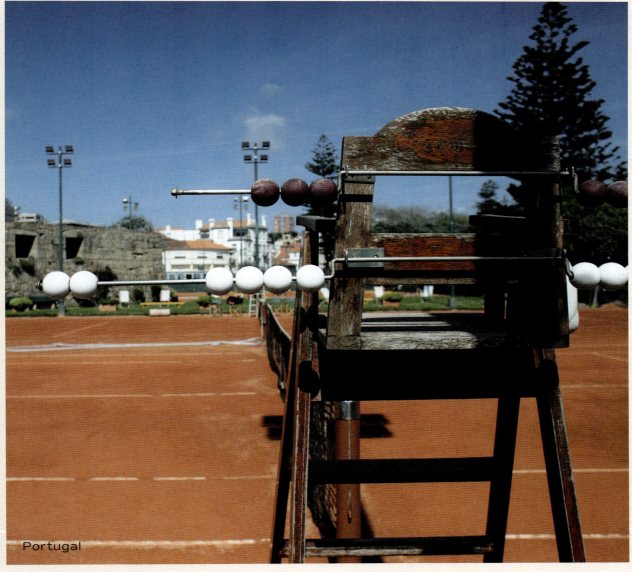
Portugal

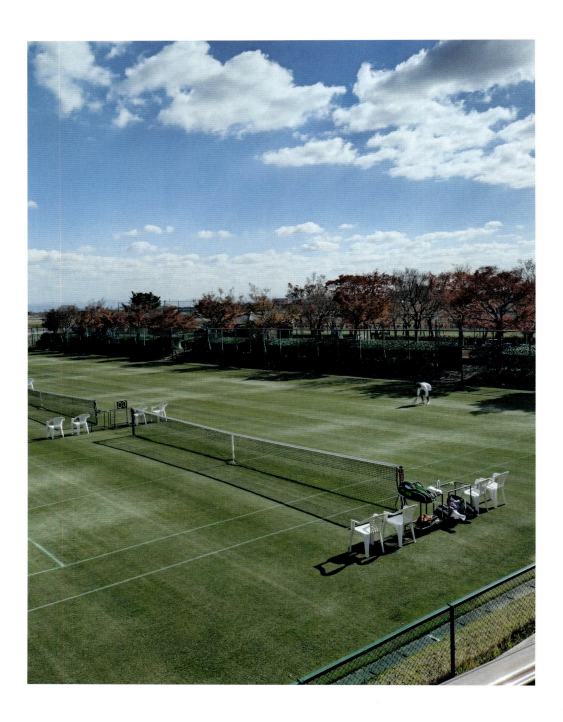

GRASS COURT SAGA TENNIS CLUB

Saga, Japan

Many locals, players or not, tend to linger here for hours. They dot the maple groves behind Courts 1, 2, and 3. The menu is always the same: the closest thing to a Wimbledon grass court one can find outside of SW19 thanks to three master groundskeepers, two of whom have held their posts for more than 20 years. In the north of Kyushu, the southernmost of the four major Japanese islands, the country's very first modern grass courts sprawl out among the open farmlands of the prefecture. The manicured lawns opened in 1975 as Wimbledon Kyushu, but later took on the Saga name and began hosting national grass-court tournaments in addition to a women's semiprofessional event on the 14 grass courts.

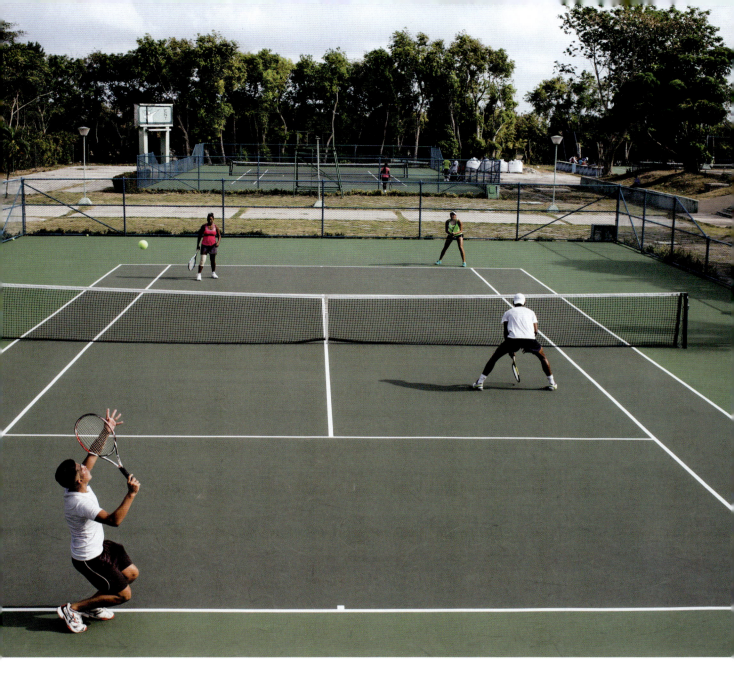

CUBAN NATIONAL TENNIS CENTER

Havana, Cuba

There's a ubiquitous feeling in Cuba that if you plant a seed, or bring people together, something will grow. This holds true for the revitalized courts at the Cuban National Tennis Center, east of Havana. Out here in the shadow of the derelict Estadio Panamericano, the hard courts were revitalized in 2018 thanks to a partnership between Cuba and the United States.

Tennis hasn't always thrived amid regime changes in Cuba. It was seen, not unfairly, as a sport for the elite and was cast out and underfunded during the Castro administration, which favored baseball and boxing. Tennis didn't align with the values of the revolution. But with the help of the US-based nonprofit Kids on the Ball, the national tennis center courts were rebuilt and resurfaced, and the seed was planted for a new generation of Cuban players.

There's little time spent here just standing around holding a racquet. Someone is always shouting for idlers to join them on-court. And during play, footwork on these courts is held to the highest standard—Cubans aren't quick to lose their boxing legacy. If you're not moving your feet or you're looking sluggish, someone, probably a kid, has no qualms about telling you to pick up the intensity.

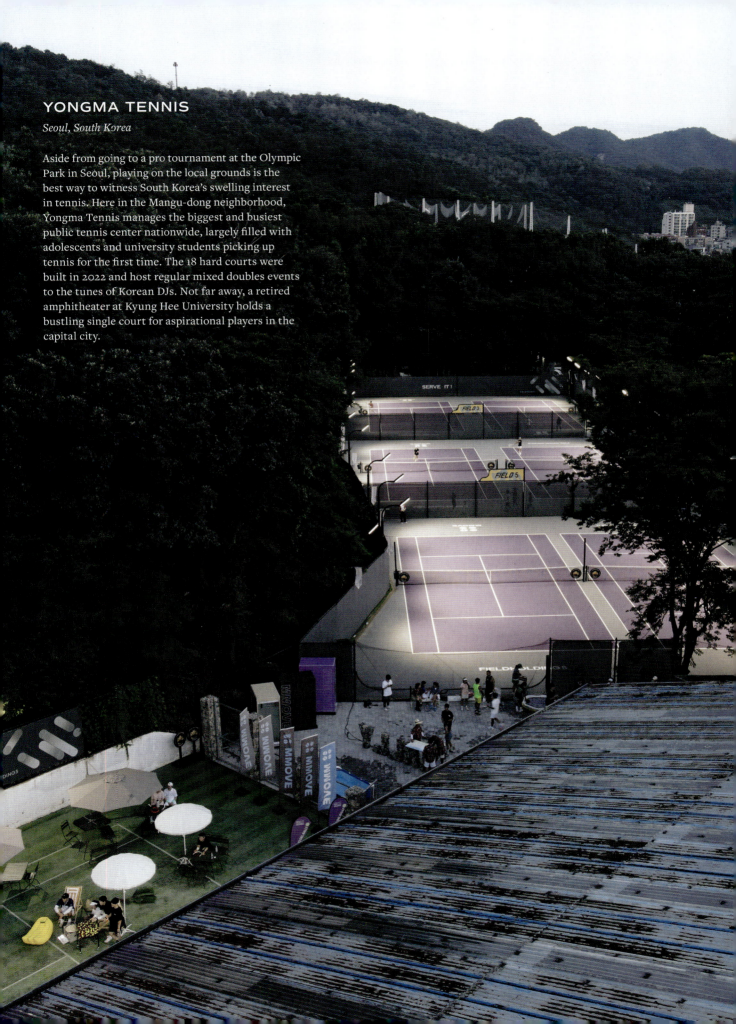

YONGMA TENNIS
Seoul, South Korea

Aside from going to a pro tournament at the Olympic Park in Seoul, playing on the local grounds is the best way to witness South Korea's swelling interest in tennis. Here in the Mangu-dong neighborhood, Yongma Tennis manages the biggest and busiest public tennis center nationwide, largely filled with adolescents and university students picking up tennis for the first time. The 18 hard courts were built in 2022 and host regular mixed doubles events to the tunes of Korean DJs. Not far away, a retired amphitheater at Kyung Hee University holds a bustling single court for aspirational players in the capital city.

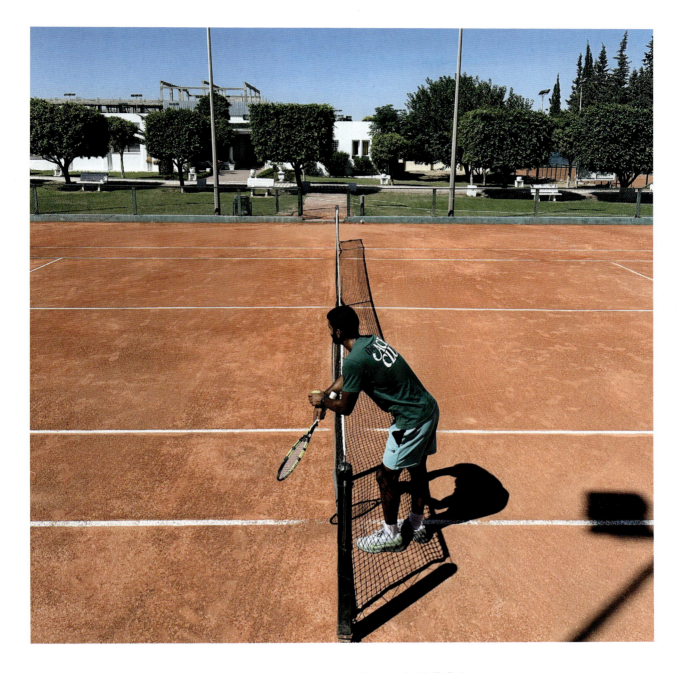

TENNIS CLUB DE L'AVENIR SPORTIF DE LA MARSA

Tunis, Tunisia

Every young tennis player is a map unto other players—whether they be former professionals or adept students of the game. Now, in young, emerging tennis nations, some coaches are getting the opportunity—or stress—of mapping their own tennis onto hundreds if not thousands of next-generation players.

One prime example can be found on the courts of Tunis and the surrounding areas, where a confection of oranges from clay court and burnt sky fill everything in sight. Here they've had a good problem in the past two years. Aligned with the rise of Ons Jabeur on the women's professional tour, the number of young women and men wanting to learn tennis has skyrocketed. On the coastal outskirts of the Tunisian capital city, Tennis Club de l'Avenir Sportif de la Marsa has witnessed this surge up close. With scant infrastructure and no billionaire benefactor to grow the sport, they've somehow attended to a groundswell of kids on-court and, with the help of the national federation, also provided those kids with events to attend in their own country. The club hosted one of only two ITF Masters tournaments in Africa in 2023 and 2024 (the other being in Morocco), and had players attend from India, Australia, Japan, and much of Europe.

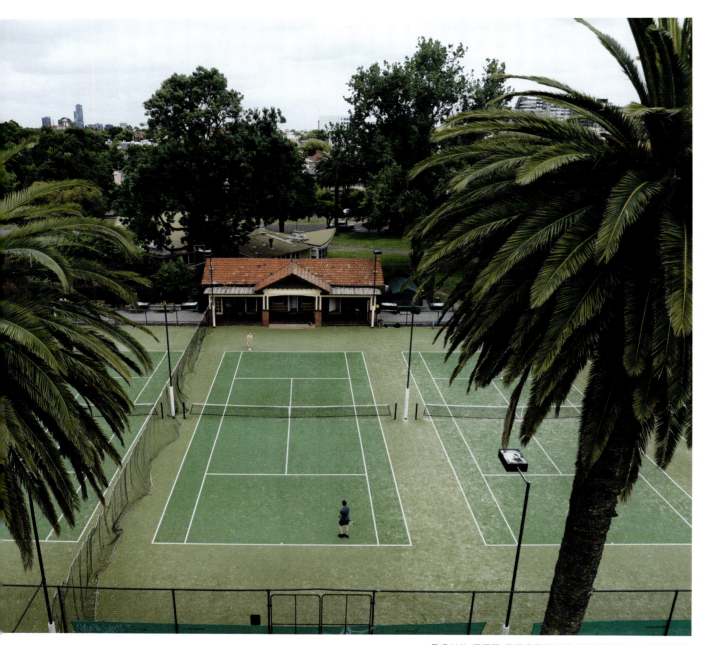

POWLETT RESERVE TENNIS CENTRE

SKIDDING ON MELBOURNE'S TURF

Australia

If playing with an acrylic-mixed blue surface underfoot is an important consideration, most Aussies will book some time at Melbourne Park or neighboring Albert Reserve most any time of year. But a truer entryway to the game as it is played by most around the country can be found at FAWKNER PARK or POWLETT RESERVE TENNIS CENTRE. There's an appreciation out here for the synthetic grass surface, used almost everywhere because it's easy to maintain and dries quickly after rainfall. The lines can be a bit trickier to call, especially for those who already struggle to call lines with any accuracy. Farther into the Melbourne suburbs, ELSTERNWICK PARK TENNIS CENTRE is one of the busiest and most competitive hitting spots on the striking blue turf.

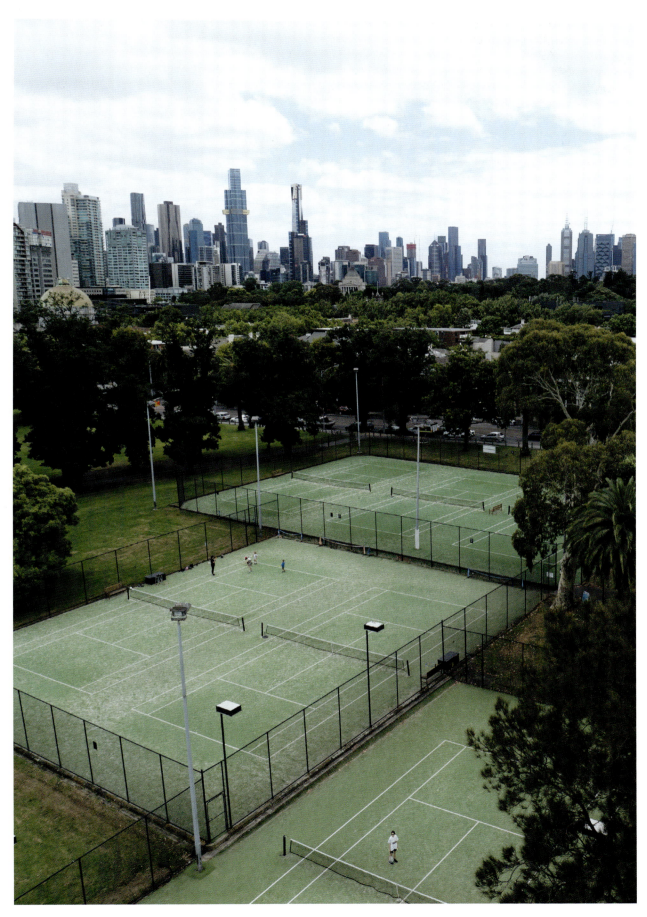

FAWKNER PARK

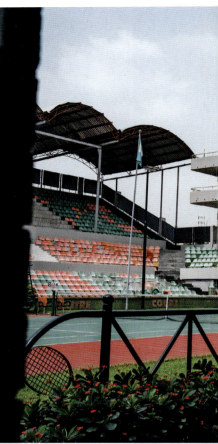

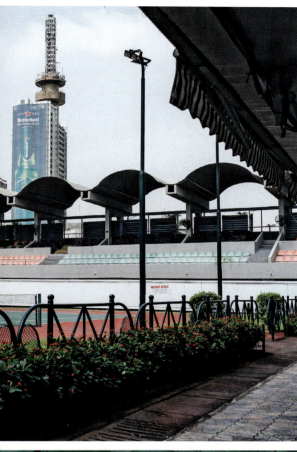

LAGOS LAWN TENNIS CLUB

Lagos, Nigeria

The nine hard courts at Lagos Lawn Tennis Club sit at the heart of all tennis in Central Africa. The club can lay claim to the title of oldest recreational club in Nigeria—likely the oldest in sub-Saharan Africa, in fact. Center Court, with its iconic pink-and-green seating, is also a centerpiece of tennis's geopolitical history. In 1971, Arthur Ashe and Stan Smith played here as part of an 18-day tennis tour of Kenya, Tanzania, Zambia, Uganda, Ghana, and Nigeria. It was an educational pursuit for Ashe, who was barred from entering South Africa at the time, and of course the tour carried political stakes as a pursuit funded by the US State Department. Ashe and Smith coached clinics and played in exhibitions with a gaggle of reporters and cameras in tow across each country. Years later, in 1976, soldiers attempting a military coup stormed center court during Ashe's semifinal match at the Lagos Open.

Today, the hard courts mostly play host to longtime coaches and their pupils. One such senior coach, Romanus Nwazu, started playing at the club at age nine and never left. Fifty-nine years later, he's still there, coaching, overseeing junior events such as the Allison Ayida Tournament, and running initiatives to drive more junior involvement in tennis.

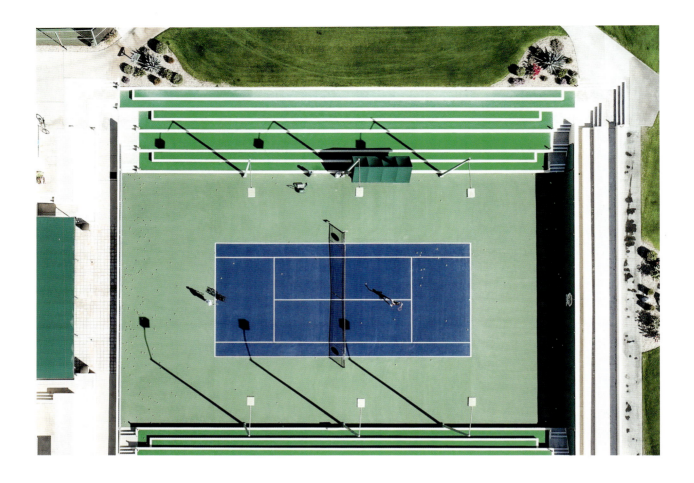

THE DESERT'S GREAT ABUNDANCE

USA

Tennis in the California desert in the summer months is an unviable, ruthless ambition. But every other month of the year, it's the sweet spot for hundreds of thousands yearning for dry morning heat. Greater Palm Springs offers a classic mini tennis escape where every court is its own little island to savor. When the tournament at Indian Wells Tennis Garden (page 72) is not in session, anyone can book a court on the deep-blue-and-green hard courts. But there are dozens of other options for playing, or spectating, in the storied desert.

MISSION HILLS COUNTRY CLUB, one of the original homes of the pro event at Indian Wells, has the trifecta: 17 hard courts, 10 grass courts, and 4 clay courts. A challenge: Play on all three surfaces in one day and still maintain your sanity.

Wait for night, when the winds have calmed and the temperature begins to dip under the lights. The blue hard courts at LA QUINTA RESORT & CLUB live up to the local fanfare.

The most lively local scenes, where you'll find people who play and then just want to sit and cheer on a stranger, are at RANCHO MIRAGE COMMUNITY PARK and FRITZ BURNS PARK.

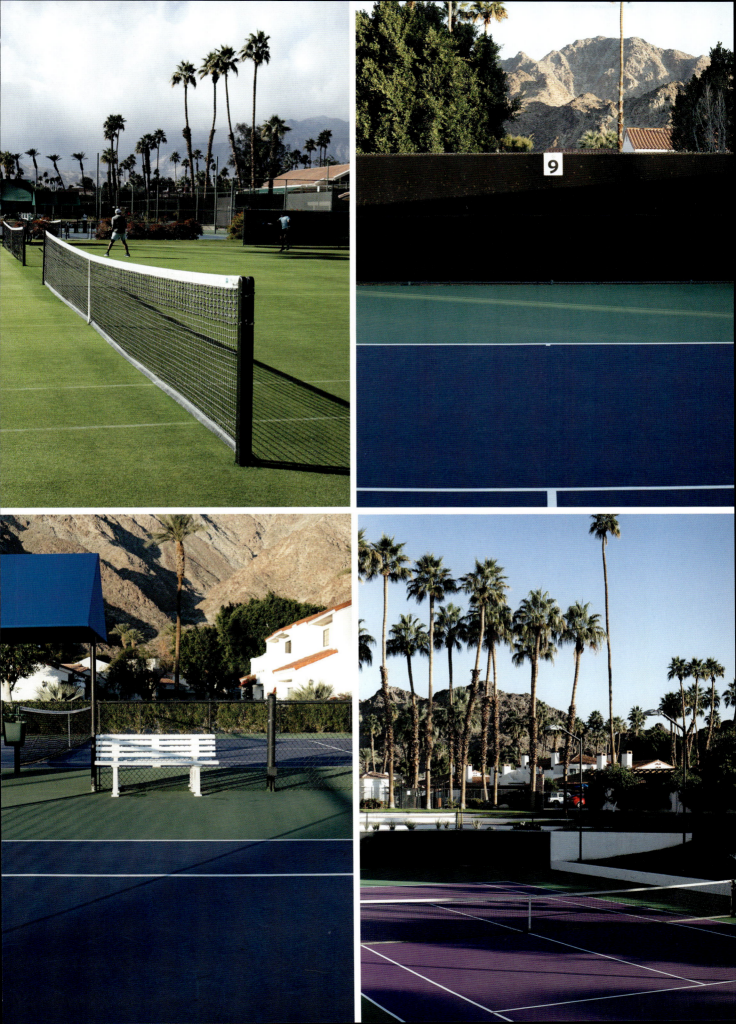

CANNES GARDEN TENNIS CLUB

Cannes, France

At these public courts, local juniors play alongside regulars who have hit daily on this Cannes hillside for over 40 years. They hit on either the hard or clay courts, outside or in the open-air shed structure. Server's choice. Don't be surprised if one of the elder regulars comes on-court to call your lines from the perch of the wooden umpire's chairs.

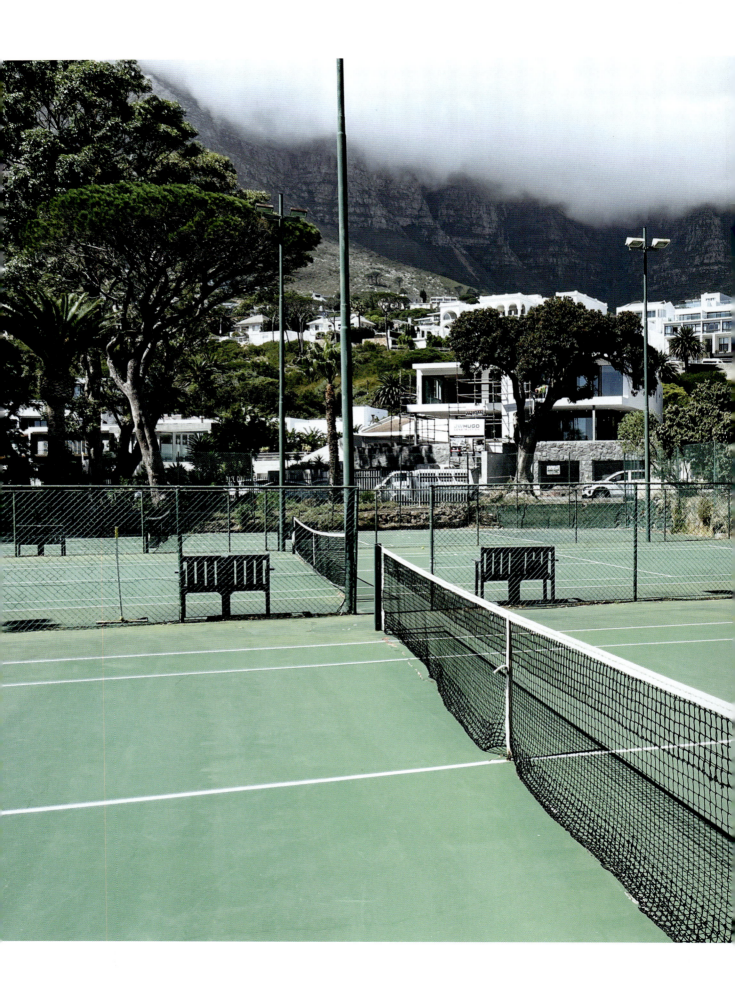

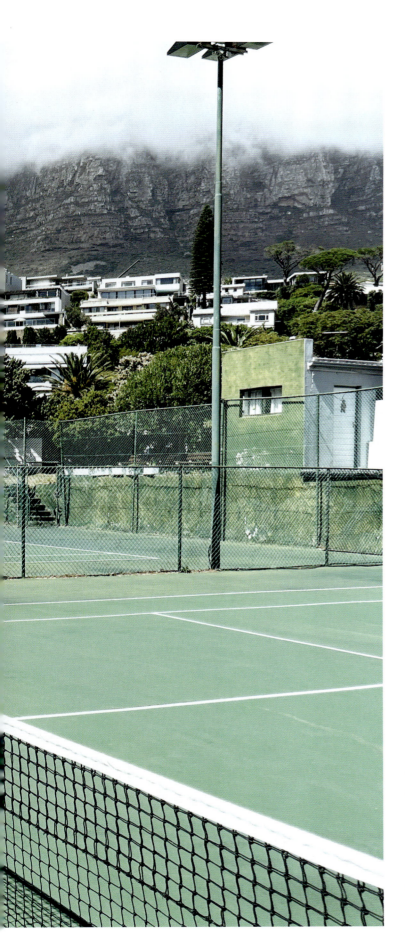

CAMPS BAY TENNIS CLUB

Cape Town, South Africa

Along Cape Town's rugged coast, shaped by whipping winds and harsh seas, every cove and peninsula has its own set of courts. You stand with Lion's Head mountain at your back, hitting into the Atlantic Ocean on fast hard courts. Camps Bay Tennis Club has long established itself as a small powerhouse by winning national club championships several times over. Its rivals on other coves: Fresnaye Sports Club and Glen Country Club, both with terraced courts embedded in steep valleys.

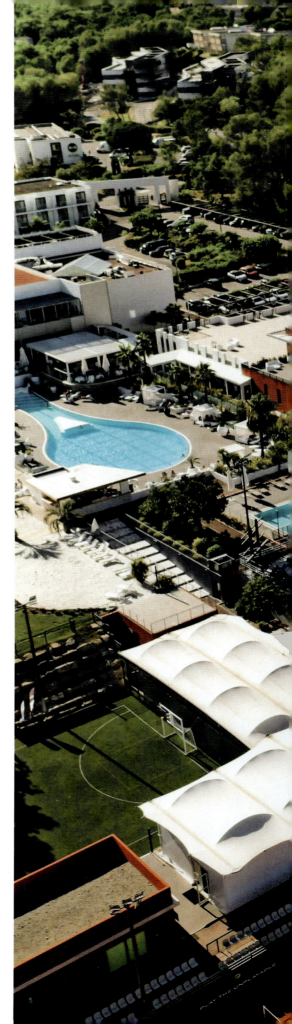

MOURATOGLOU TENNIS ACADEMY

Biot, France

Tennis academies can get a bad rap. There are countless anecdotes of emotional turmoil and burnout for thousands of juniors trying to make that top 1 percent of talent. They have a price tag to the tune of hundreds of thousands of dollars for one kid's development program and education. Kids arrive at a young age to live in dorms and spend most of their days on-court and inside their own heads. They can be tumultuous places, but there's no denying that these are the homes of the future of tennis. The vast majority of household names in professional tennis passed through these waters at some point.

These busy hives are the only places you can find a touring junior casually hitting on a court next to a professional ranked among the top 10 in the world. Watching or partaking in a camp for recreational players at an academy, suddenly visions of your next matches start to look different. Inspiration from the court next door is a powerful tool. Some of these academies have found a way to foster that inspired energy and create small tennis cities that feel more like hopeful kingdoms than boarding schools.

The Mouratoglou Tennis Academy is one such place. Juniors and adults alike can spend long night hours finding the shapes that will long live in their game. The familial energy here attracts many players chasing a less frenetic feeling than what you'll find at elite junior tournaments.

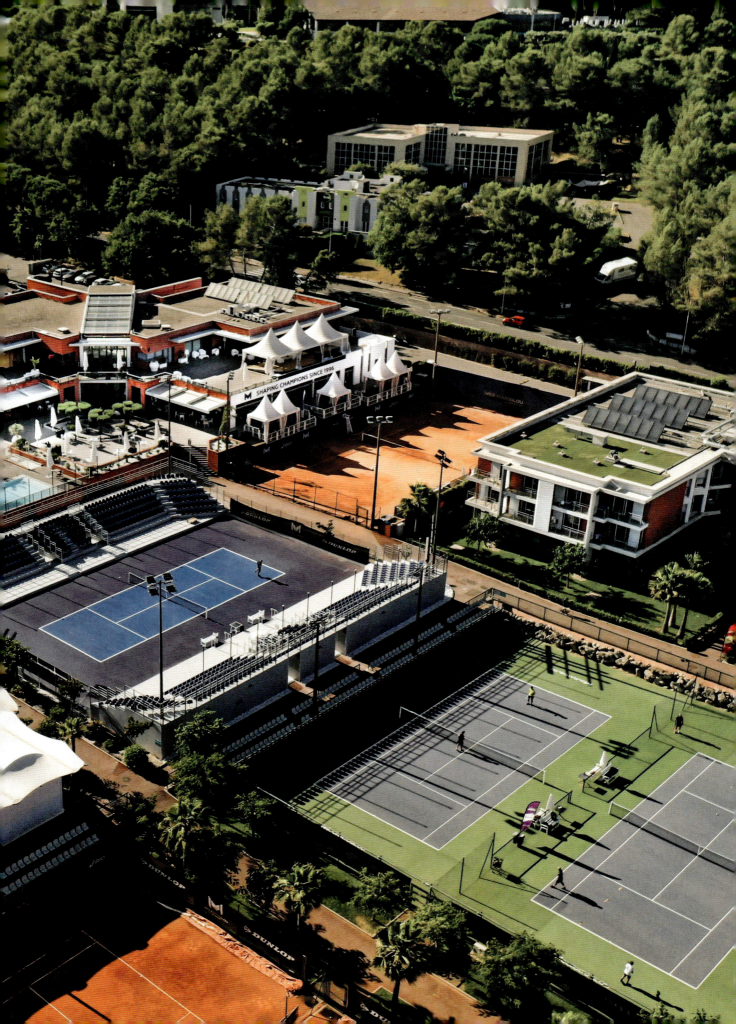

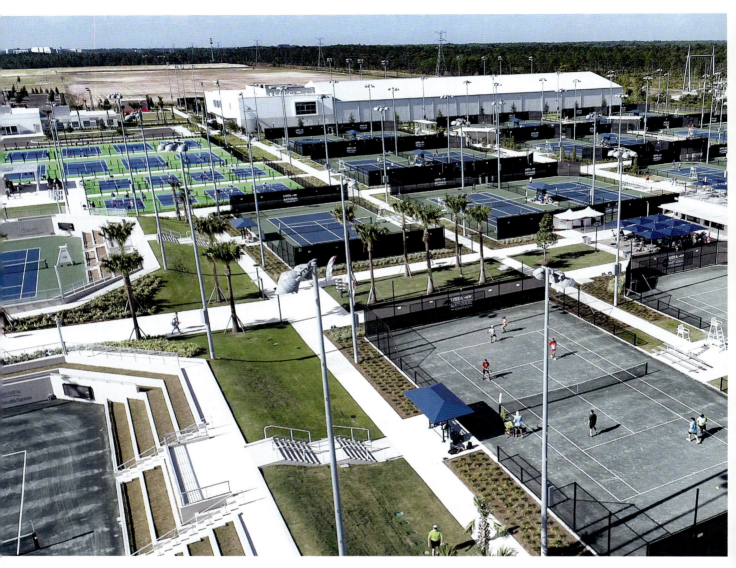

USTA NATIONAL CAMPUS

THE TENNIS COMPOUND STATE

USA

Playing tennis in Florida can be the easiest pursuit, albeit one with overwhelming abundance. There are clusters of courts everywhere, from retirement communities to elementary schools to correctional facilities (seriously). It's the global home of the tennis compound, whether it be a tennis academy or a public complex. The UNITED STATES TENNIS ASSOCIATION NATIONAL CAMPUS close to Orlando has nearly 100 courts and uses all of the Slam surfaces except for grass. IMG ACADEMY in Bradenton (formerly the Nick Bollettieri Tennis Academy) has more than 50 courts.

These courts are beehives: the busy screeches of rapid footwork, the snap of flat serves, the grunts and screams of focused gameplay. Some might call these courts great for this symphony of intensity. Imagine for a moment living on these courts, every day, indentured to a masterclass of regulating emotions and details.

These grounds are all equipped with cameras and lasers, tools to analyze every movement the players and the balls take. Even beginners can review tape and data in between each point to see exactly how much spin they hit on their serves today compared to yesterday, last week, or last year.

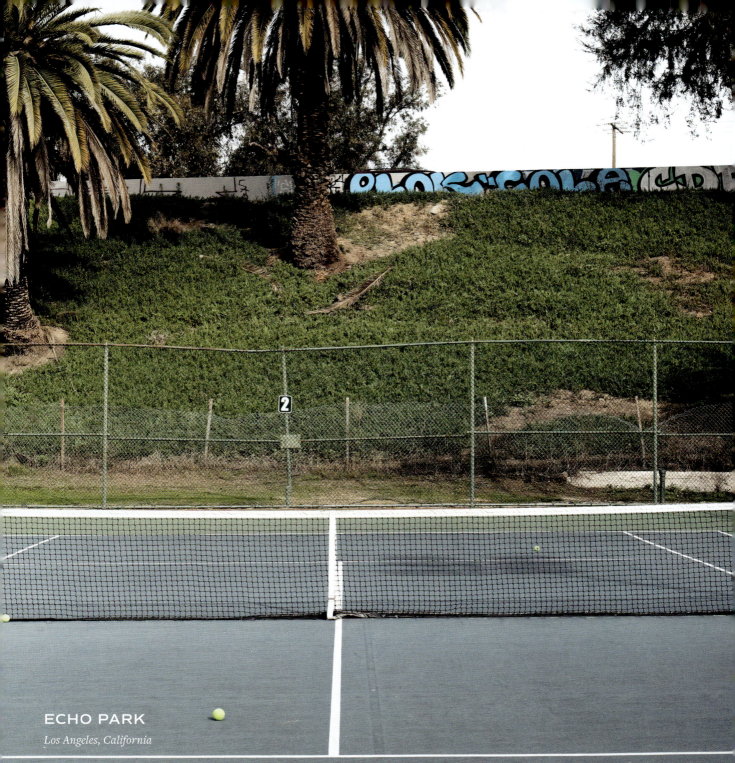

ECHO PARK
Los Angeles, California

Los Angeles. America's tennis megacity. A most energetic expression of a free-ranging sporting community. Connect, find your courts, hustle (drive), hit, hit, hit, and hit. You make your own way with an endless number of options to find hitting partners, and a never-ending stream of courts to discover.

The histories of LA courts both private and public are littered with Hollywood rivalries, loves, and fallen tears. Today, the real vibrancy of tennis in LA lives on the courts where play gets extended because more people show up, or where your singles match turns into two extra hours of rotating doubles, with someone's dog watching the action. Tennis is one of the few things in LA for which people show up on time, or even early.

With traffic on the 101 Freeway puttering along behind the courts, a top scene for players unfolds at the Echo Park tennis courts. As with all the best places in LA, communities merge around the passion. The "club" here consists of a largely Filipino player base, most of them in their sixties, who rip balls and serve-and-volley with any challenger who shows up and buys a can of balls from the gas station across the street. Another crew organized by the organization LVBL hosts fast-paced drop-in drills and games on these hard courts as the sun glares off the skyscrapers of downtown LA.

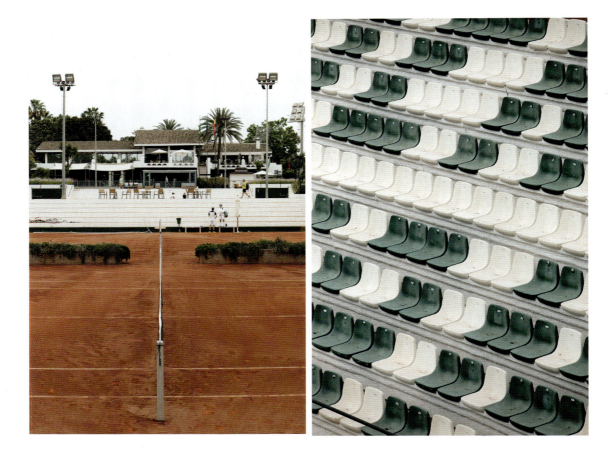

PUENTE ROMANO TENNIS CLUB

Marbella, Spain

Even with the green-and-white stadium nearby, the favored space here is Court 1, with low amphitheater seating, a deep backcourt, and towering palm trees on either side. Björn Borg opened this club in 1979, and the place has since been a mainstay for annual visitors from overseas and events like the Billie Jean King Cup and the Davis Cup.

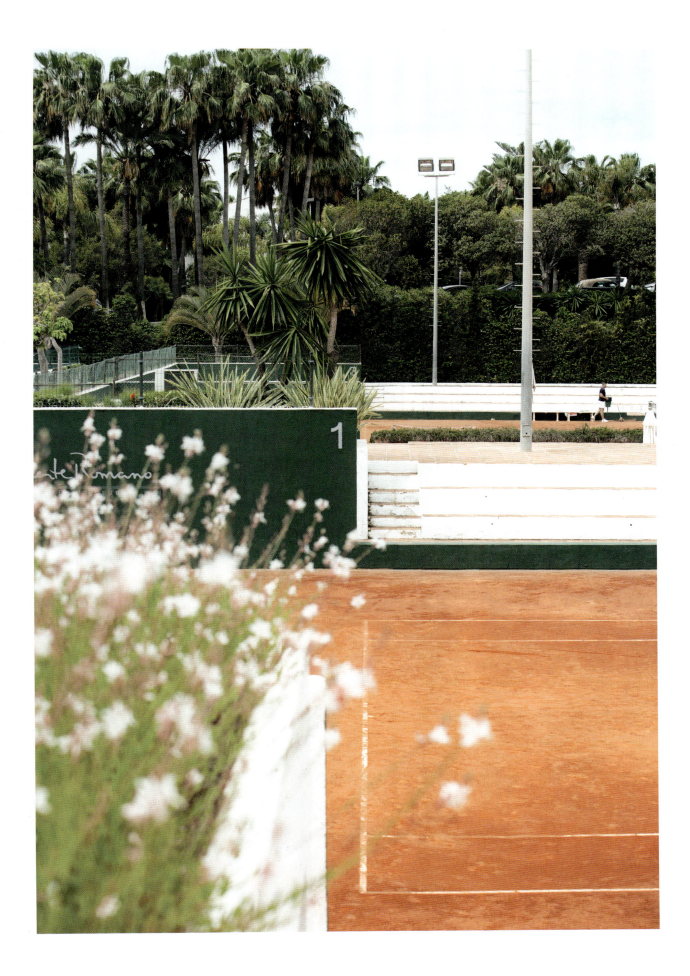

TENNIS CLUB PARIOLI

Rome, Italy

Stadio Nicola Pietrangeli (the one with the marble statues; see page 95) and the greater Foro Italico sits at the center of Rome's tennis row. Following the horseshoe bend north or south along the Tiber River from Foro Italico, Italian players get a tour through an esplanade of clay courts, each with their avid swell of daily players. This clay-court spine of Rome tennis connects more than 75 courts, from the mostly small and tranquil public clubs like Tennis Roma Duca d'Aosta all the way to the historic Tennis Club Parioli, a club over 100 years old where many of the professionals prepare for clay court tournaments.

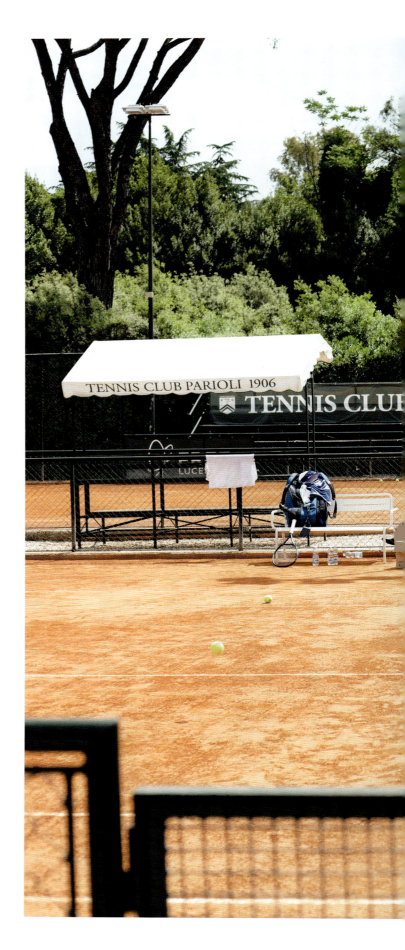

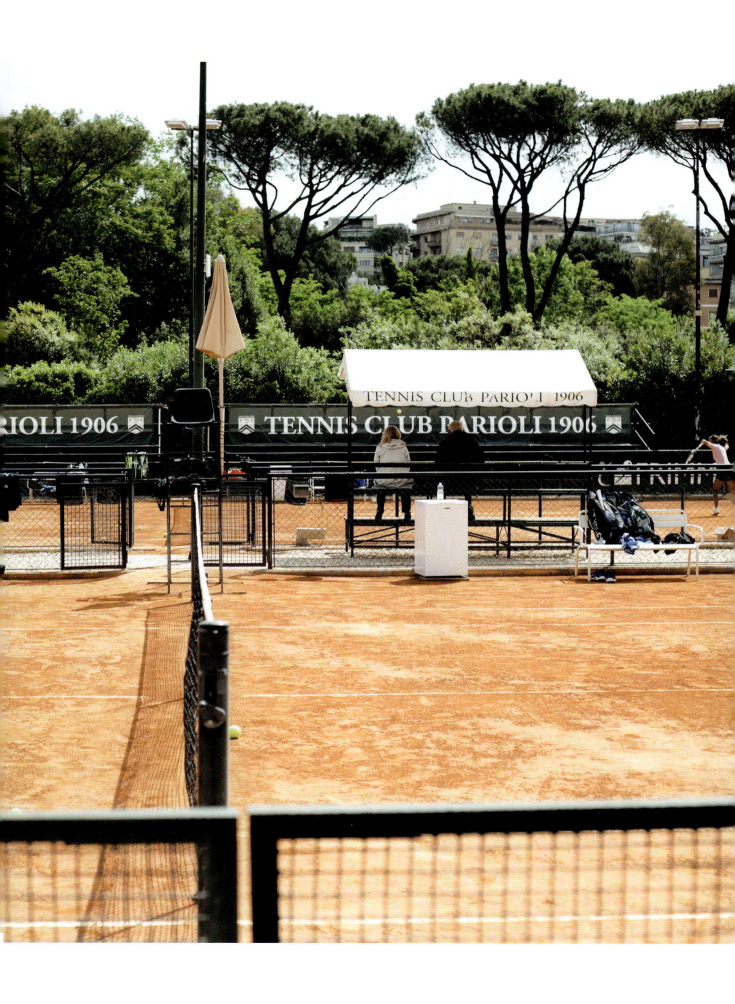

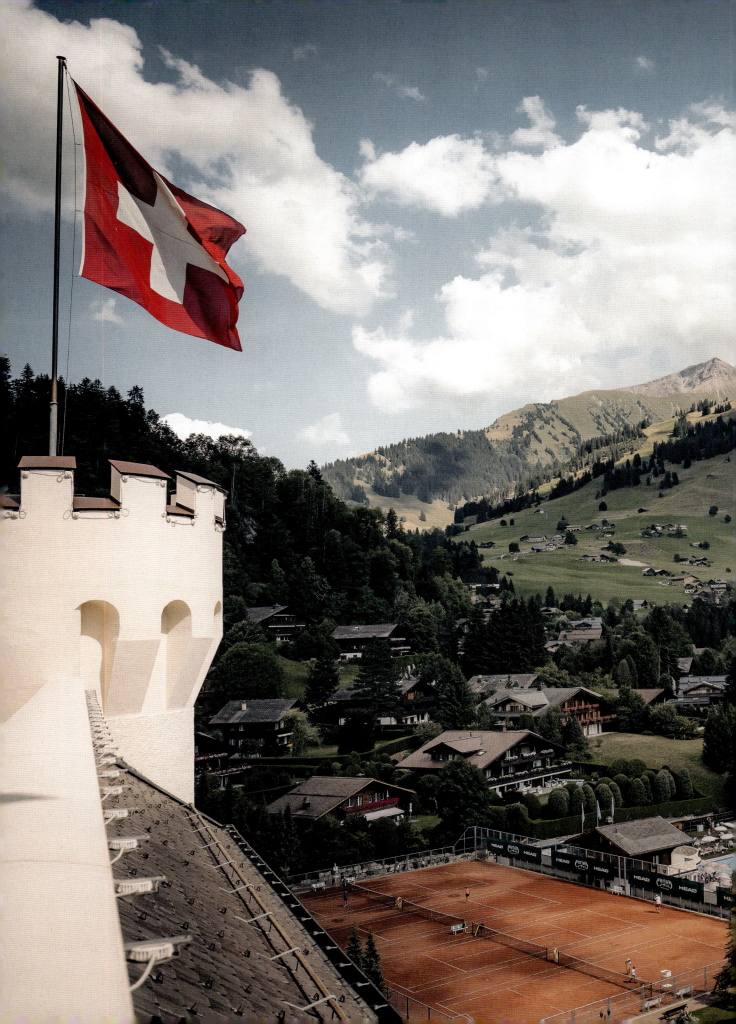

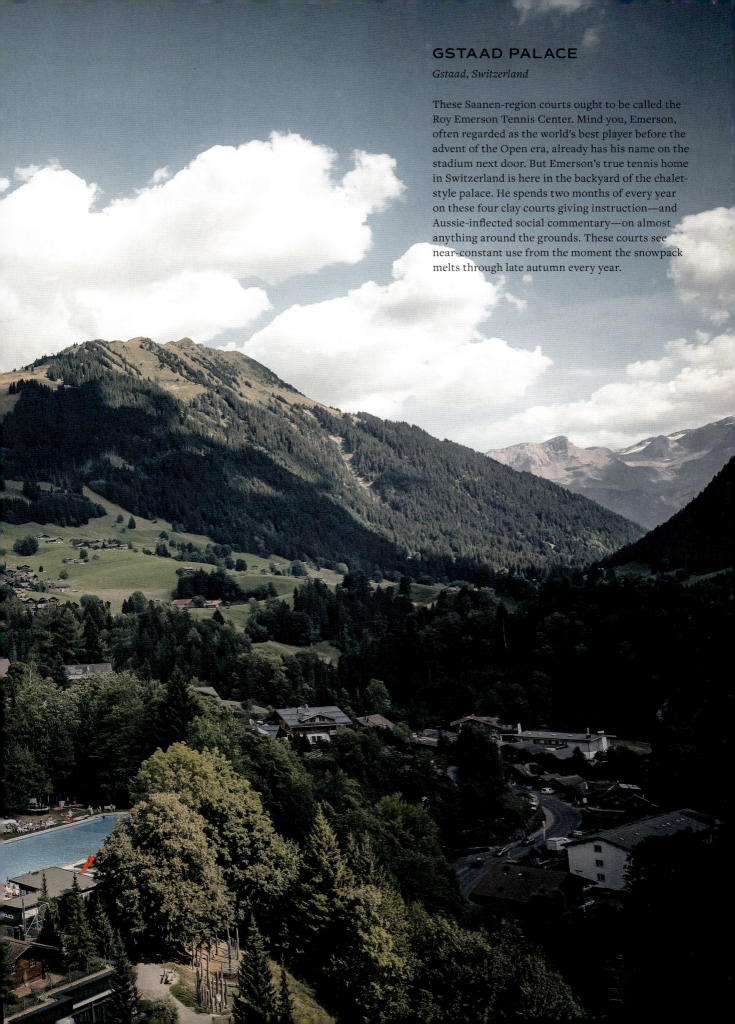

GSTAAD PALACE

Gstaad, Switzerland

These Saanen-region courts ought to be called the Roy Emerson Tennis Center. Mind you, Emerson, often regarded as the world's best player before the advent of the Open era, already has his name on the stadium next door. But Emerson's true tennis home in Switzerland is here in the backyard of the chalet-style palace. He spends two months of every year on these four clay courts giving instruction—and Aussie-inflected social commentary—on almost anything around the grounds. These courts see near-constant use from the moment the snowpack melts through late autumn every year.

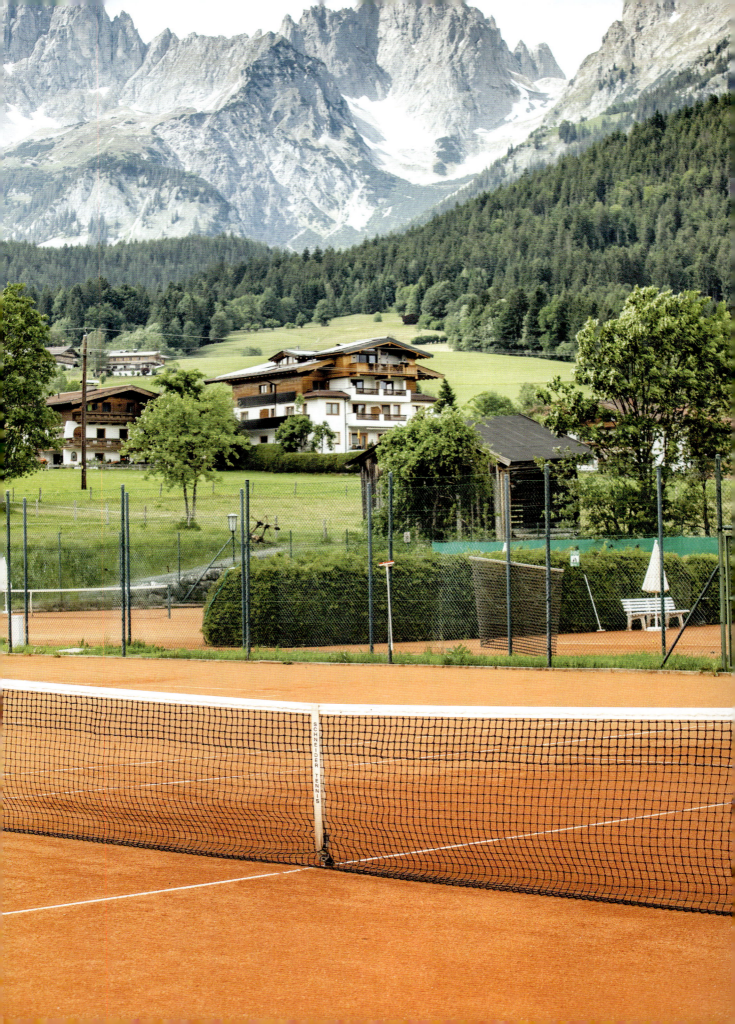

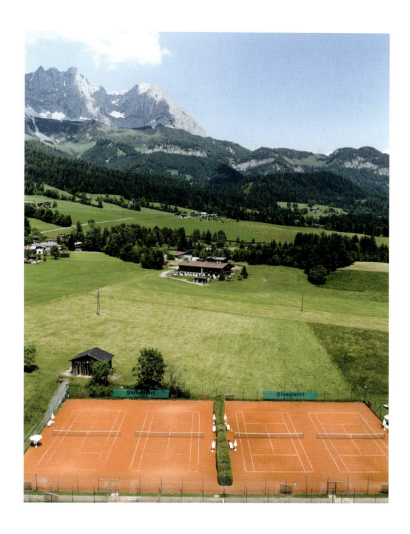

STANGLWIRT

Going am Wilden Kaiser, Austria

In western Austria, about an hour from Munich, the tennis program at Stanglwirt surged in popularity in the 1980s. Steffi Graf and Boris Becker were on the front page of every newspaper every time they won. Even when they weren't playing, their faces, their service motions, were everywhere in Germany. Everyone wanted Graf's Dunlop racquet in their hands, and they all needed a retreat to hybridize their vacation with their new obsession.

Off to Stanglwirt they went, along with hordes of celebrities who also wanted to perfect their swing. Nowadays, a full-service tennis coaching and camp program is run out of the property year-round through PBI (Peter Burwash International). Play takes place on the clay courts at the base of the Kaiser mountains in summer and on indoor synthetic-grass courts in winter.

QUICK HANDS ON CZECH CLAY COURTS

Czech Republic

Entire books could be written about Czech tennis, in particular Czech doubles in Prague. It can be a mystery as to how a nation of only about 10 million people has produced such a swell of champions going back to Martina Navratilova. That is, until one arrives at the clay courts around the country, of which there are hundreds, and sees the exchange volleys.

Most kids that pick and develop their games in the Czech Republic live and train four to a court. Leagues, interclub championships, and individual tournaments all lend a high priority to doubles. It's a country of junior doubles maestros, all with deft touch, rapid hands, adaptive movement, and sly trick shots at the ready. The impetus for doubles also takes some of the early-life pressure off young minds who might not be ready to handle the demands of constant, sometimes tortuous singles play. The line of title-owning professionals, especially doubles players, produced by this system is too long to list.

Wander the courts of Prague and see this crafty collective of tennis lifers. The oldest and most prestigious club sits on Štvanice Island. The I. ČESKÝ LAWN TENNIS KLUB (CZECH LAWN TENNIS CLUB) holds 17 outdoor courts, an 8,000-seat center court, and the Czech tennis federation's headquarters. Other regular hitters congregate at LAWN TENNIS CLUB PRAHA, an institution founded by local law students in 1904. As the juniors move from their competitive local circles to national levels, they can typically be found running close-range drills at TENISOVÝ KLUB SPARTA PRAHA (TK SPARTA PRAHA) or Štvanice.

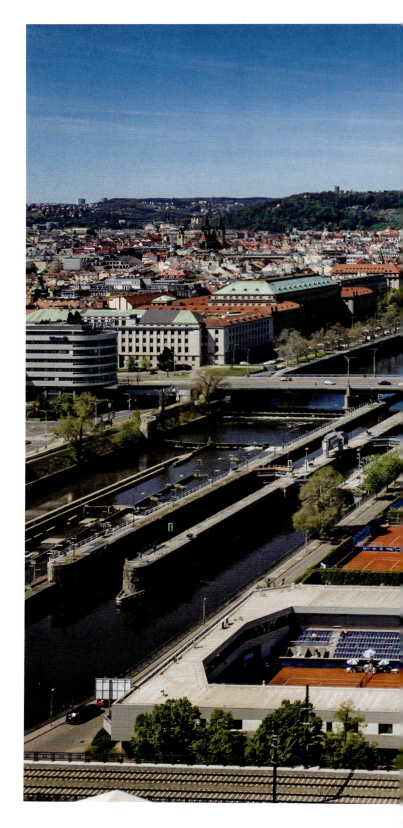

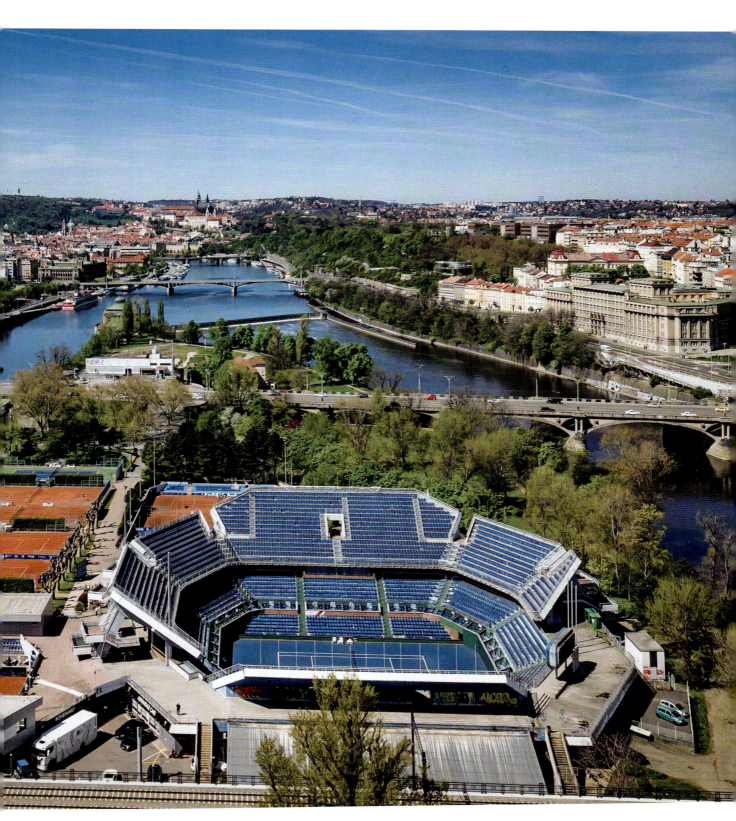

CZECH LAWN TENNIS CLUB

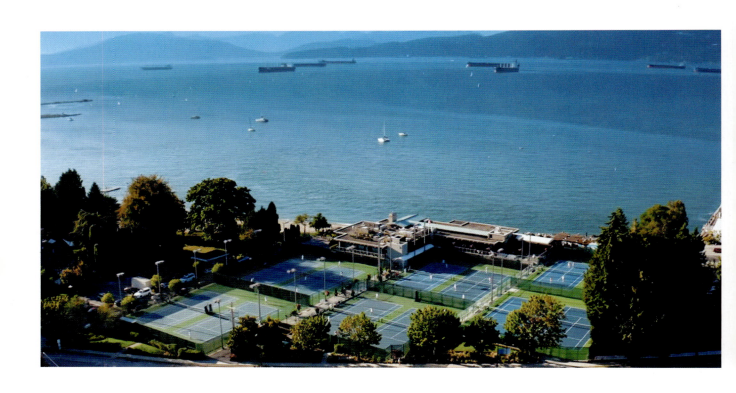

JERICHO TENNIS CLUB

Vancouver, British Columbia, Canada

Stately courts of British Columbia reside at the 100-year-old Jericho Tennis Club, just west of Vancouver. What started as a swimming club on the waterfront of Jericho Beach quickly turned into a rabid community for racquet sports. Swimming (namely, cold-plunging in the sea) after hitting is highly encouraged.

TATOÏ CLUB

Acharnes, Greece

A garden tennis variety sits north of Athens, in the foothills of Mount Parnitha. The holistic wellness club fashions itself as something of a hybrid tennis gathering place. An herb garden weaves through the nine outdoor clay courts, and the only sound you'll hear while playing are cicadas high up in the pine trees. The outdoor red clay here comes from Germany, the indoor clay comes from France, and often professionals will come to play on both in the brief breaks leading up to the clay court season. Others arrive here in late spring and see a select group of 11- and 12-year-old kids compete for the attention of sponsors and agents at the Future Stars event, dedicated to spotting and nurturing exceptional young talent. There's something both comedic and intriguing about seeing all the fixings of a professional tournament—umpires, ball kids, interviews—for kids who've been playing only for roughly six years (but already have agents betting they'll be lifting trophies within the decade).

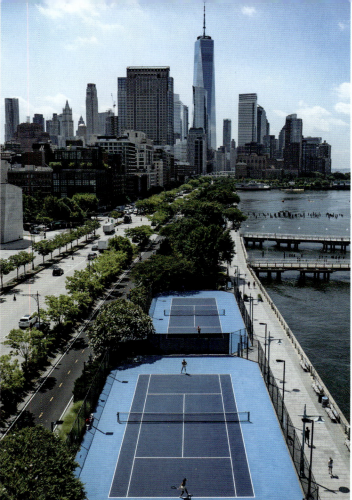

HUDSON
RIVER PARK

RIVERSIDE CLAY
TENNIS ASSOCIATION

THE MOST RUTHLESS PURSUIT IN NEW YORK CITY

USA

Many might flock to the 26 Har-Tru courts in CENTRAL PARK to play in the city-defining greenspace. But those steeped in the peculiar and at times ruthless pursuit of finding time on a court in New York City might opt to play elsewhere. The most committed might partake in two hits in one day: one session on hard courts and the next on clay, connected by an easy bike ride along the Hudson River. The recently refurbished courts on the Hudson have you hitting toward the Freedom Tower in Manhattan, and to the north, on 96th Street and Riverside Drive, 10 red clay courts await at the RIVERSIDE CLAY TENNIS ASSOCIATION, the most quiet and picturesque New York has to offer.

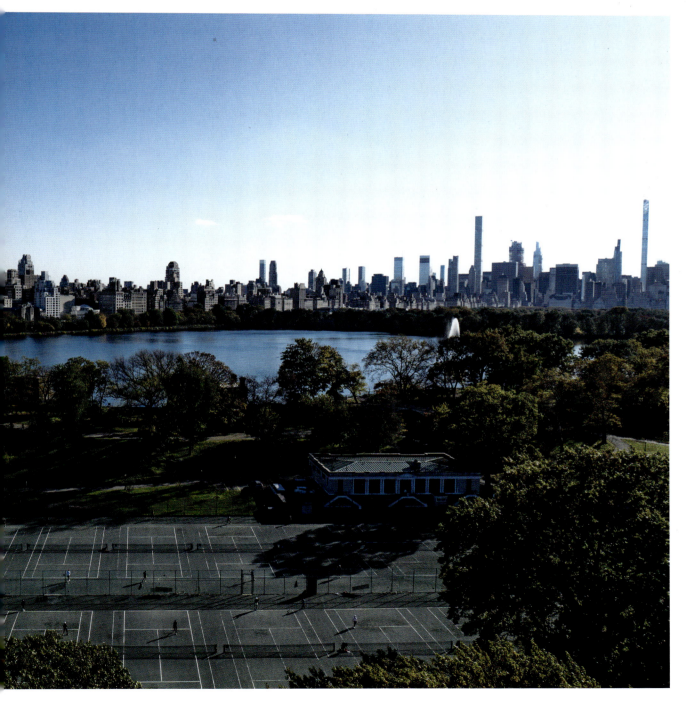

CENTRAL PARK TENNIS CENTER

DRILL, GRIND, REST, REPEAT.

FORT GREENE PARK

Brooklyn, New York, USA

Playing in Fort Greene Park, the term "tennis cult" comes to mind—but like a genial, prideful cult. No mal intent or injury. To be part of the community at these public courts means arriving at 6:30 in the dim morning light to wait in line with your fellow tennis mates and rivals just to sign a sheet of paper and reserve a one-hour slot to play later in the day. At the base of the hill, this is the busiest and the most committed hive of recreational tennis in New York City—down to the local stringer, Pierre, whose raging business led him to convert a Sprinter van into a mobile racquet stringing service. Community ladders and tournaments spanning levels unfold here every summer—singles, doubles, dingles, and mixed doubles. Don't mind the dead spots and how the north side of every court is certifiably several inches higher than the south side—everyone has to overcome some site-specific challenges.

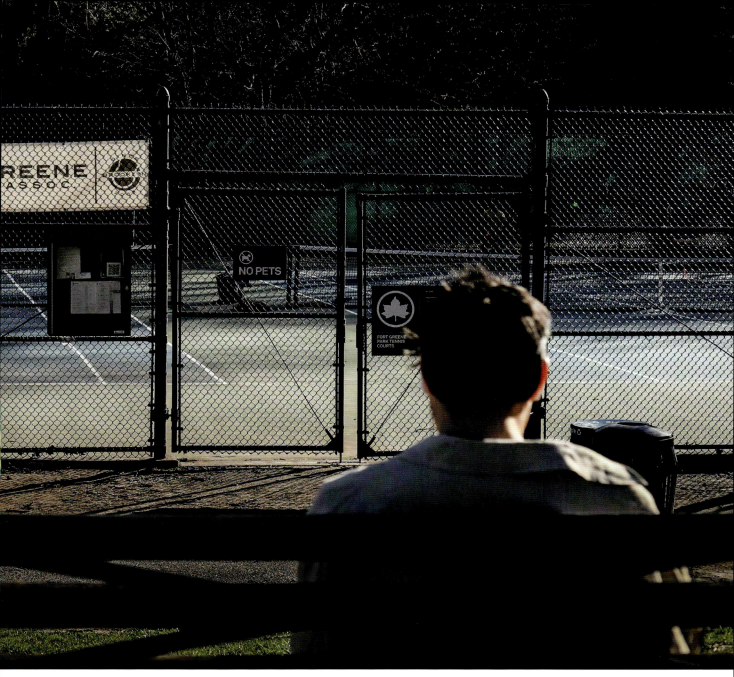

RANCHO CIENEGA PUBLIC COURTS

Los Angeles, California, USA

The Rancho Cienega public courts hold a rarefied commitment to grassroots tennis, perhaps more than anywhere else in the West. The courts are home base for the Rancho Cienega Tennis Club (RCTC), a community of avid players that has promoted wider inclusion for people of color in tennis since 1957. Come here during one of their team tennis tournaments or for summer Friday doubles mixers, and the keeper of the sign-up sheet can chat with you about the generations of tennis players these courts have seen and the sister clubs Rancho regularly competes against. RCTC is part of a network originally called the Western Federation of Tennis Clubs that, together with the American Tennis Association (the first all-black national organization in any sport), helped produce legends like Althea Gibson and Arthur Ashe. This was at a time when Black Americans created their own clubs and sanctioned their own tournaments. The courts in South LA were initially part of the Rancho Cienega Sports Complex. These courts were among the few spots where Venus and Serena Williams first learned to play.

A similarly illustrious tennis home can be found in Chicago. Long before tennis was desegregated, Black communities, and Black women in particular, made their own spaces for competitive play. In 1912, four women cofounded the Chicago Prairie Tennis Club on Chicago's South Side. Originally four clay courts, the club moved locations and became the first Black-owned tennis club on private grounds. The club still stands today, all hard courts, and continues cultivating young local talent.

THE VILLAGE AT CAMELBACK

Phoenix, Arizona, USA

Arizona tennis can be a bit of a comedy. Somehow, the juniors play and compete here almost every month of the year. Walk the grounds at the sprawling complexes of Phoenix and Tucson, and you'll hear players and parents comparing play in Arizona to running around a toaster oven or a frying pan. It's melt-your-shoes hot out there. Match schedules can start as early as 5 a.m., and there will still be kids carting massive coolers of ice on-court to sit in on changeovers. Unsustainable, maybe. Unhealthy, sure. But one can't help but respect the relentless endurance.

Arizona tennis is also ravenous. There are thousands of players in every kind of league imaginable, with one swarming community hot spot in the foothills of Camelback Mountain. You can find players of every level by the dozens, visiting pros, and an illustrious carousel of coaches. Out here near the red rocks you come to expect of the region, playing in the toaster oven is worth it.

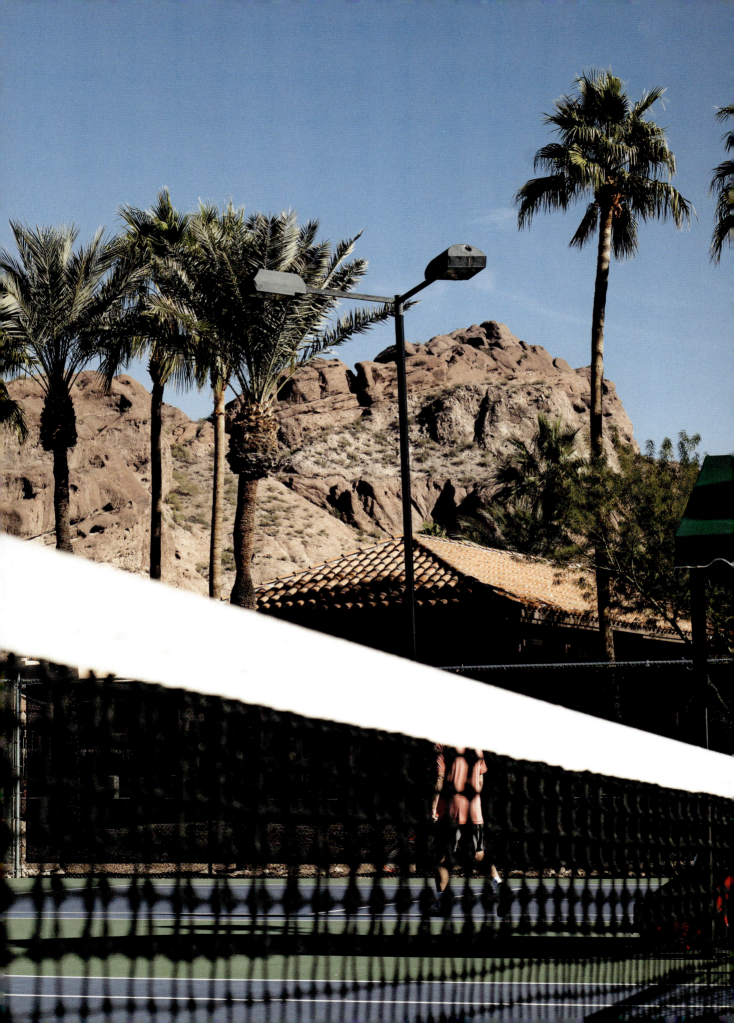

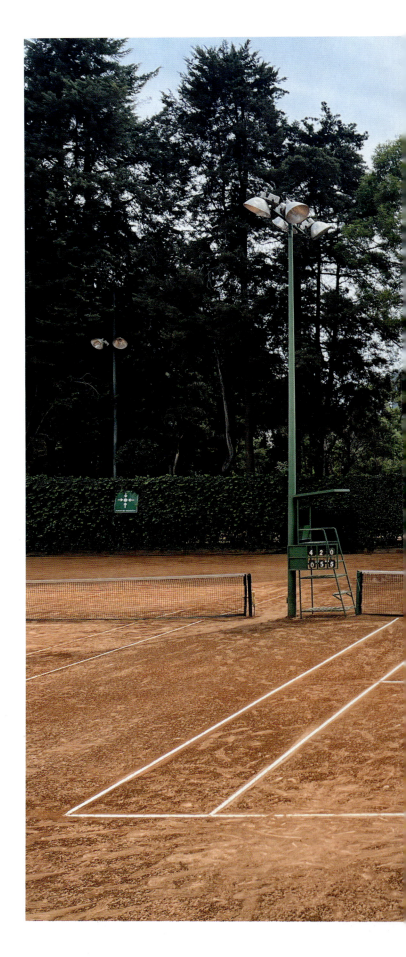

JUNIOR CLUB

Mexico City, Mexico

A hub for competitors in the Mexican capital, the Junior Club's 19 clay courts are nestled behind walls of vines on all sides, with long shadows across the courts most hours of the day. If the dedicated hitters aren't at Junior Club, they're 2 miles (3.2 km) up the road at Centro Deportivo Chapultepec, home of Osuna Stadium and some of the brightest orange clay on tour. The arena's namesake, Rafael "Pelón" Osuna, carried the dreams of a nascent national tennis community for over a decade, leading the Davis Cup team and climbing the rankings to become the number one player in the world.

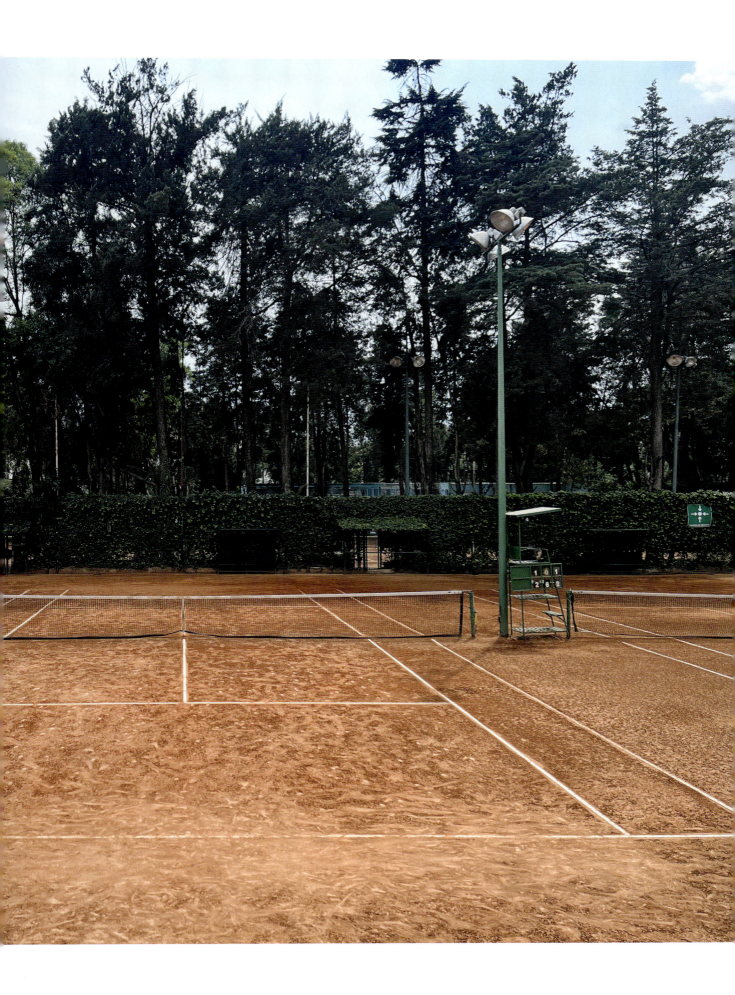

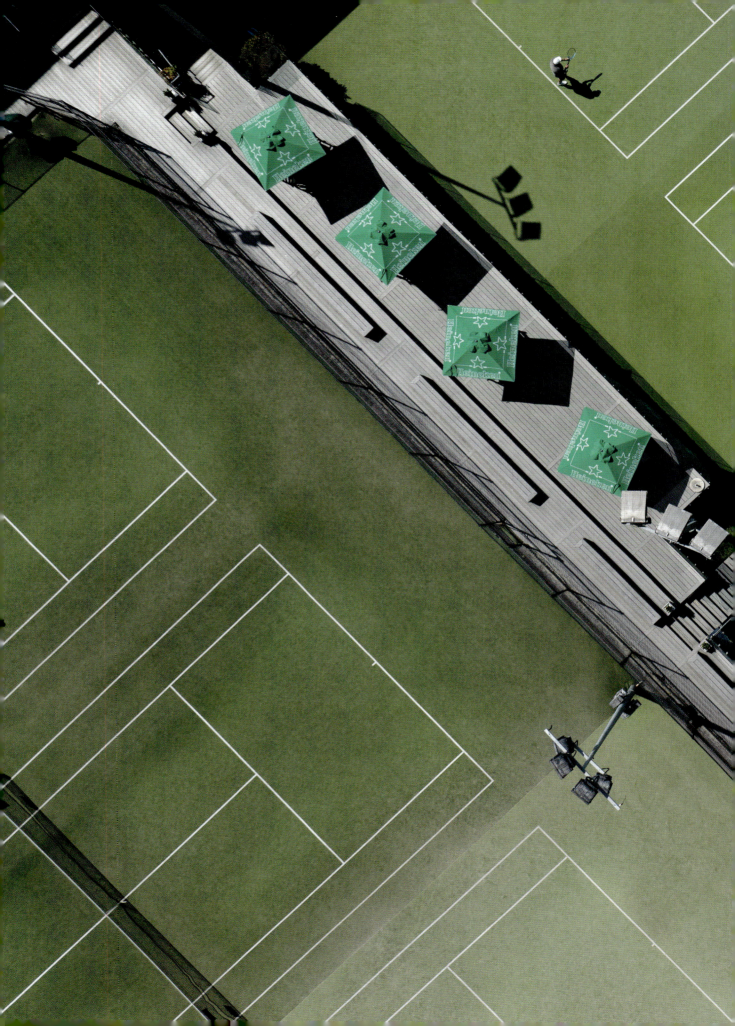

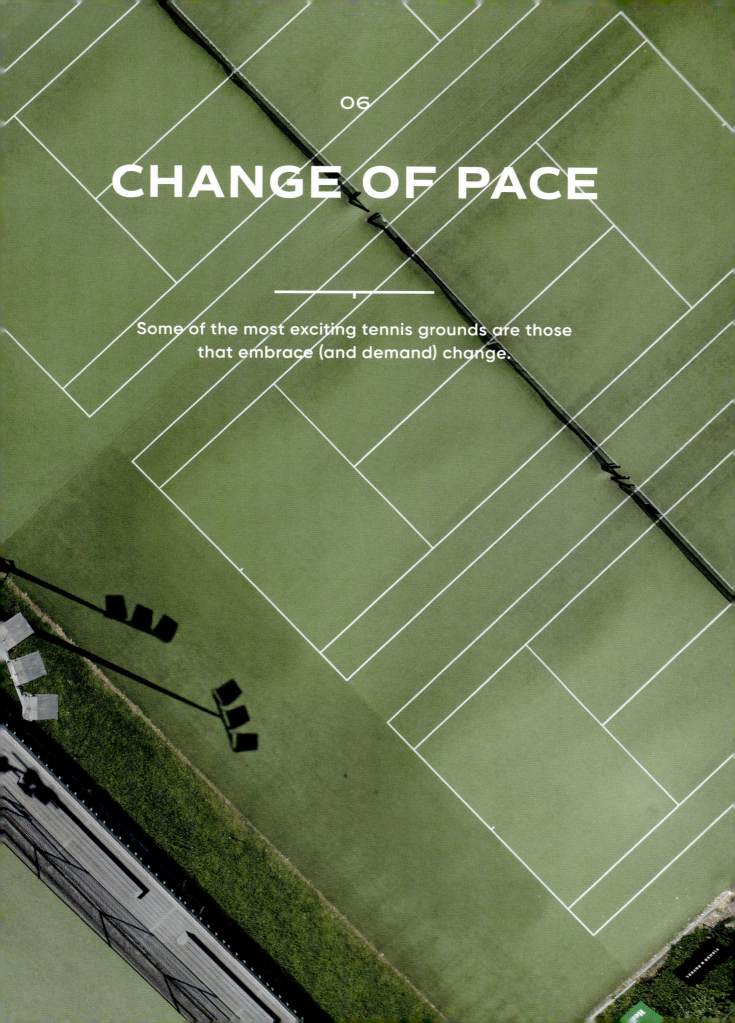

CHANGE OF PACE

06

Some of the most exciting tennis grounds are those that embrace (and demand) change.

Before setting out to travel for this book, I spoke with Professor Anne Osborne, an expert in sports and fandom culture and someone who, like me, is intensely curious about the mind games of sports. While she studies all sports, her favorite is, yes, tennis.

We talked about two matches—a recent US Open final and a match I'd played at a local prize-money tournament just outside Manhattan. She asked if I took notes on either match (I did not). She asked about my headspace during play: if I'm outwardly calm or expressive (calm), if I'm internally screaming or measured (screaming), if I'm optimistic or cynical when I'm winning (cynical, begrudgingly). Then she wanted to know about my thoughts while watching the US Open, but all I could really remember was hoping for a close contest.

"No one really remembers any match, watching or playing," she said. Regardless of the level, we do not remember a play-by-play tape. We take away a fractured, incorrectly ordered set of blips, she said. "But we do remember moments of change."

This can help explain the massive appeal of tennis. A beautiful thing about this artful, dynamic, violent sport is that change is so pronounced and pervasive. No other game can quite compare. The professional tour calendars change surface, thus tweaking game style, every few months. Pros could switch surfaces every week of their year if they really desire torment. Within matches, whether recreational or professional, change occurs unexpectedly, and momentum swirls every few minutes. It takes one shank winner or one silly error to alter a result. Surprise and luck have the power to delight our brains and stick around as vivid memories, as sports psychologists have found.

Beyond the professional circuit, some of the most memorable tennis grounds are the ones that have embraced change. One of the quintessential tensions in tennis globally today rests between change in the name of tradition—often being along lines of class and race—and embracing a more egalitarian presence that the sport is moving toward. Some of the same clubs that started a century ago as colonial outposts have since reshaped themselves into clubs that welcome anyone from their cities who want to play. Such clubs in Portugal, Colombia, and India have broken with their predecessors in this way. At the same time, new tennis communities emerge in pockets of the world that will expand what tennis represents and who gets to speak for it.

On an individual level, many of us active tennis players, regardless of our age or skill level, prefer to fend off changes to our game. Some are utterly allergic to it. But we ought to embrace the new perspective and vivid memory that comes with it. It's the change in the game and on the courts that we'll take with us. •

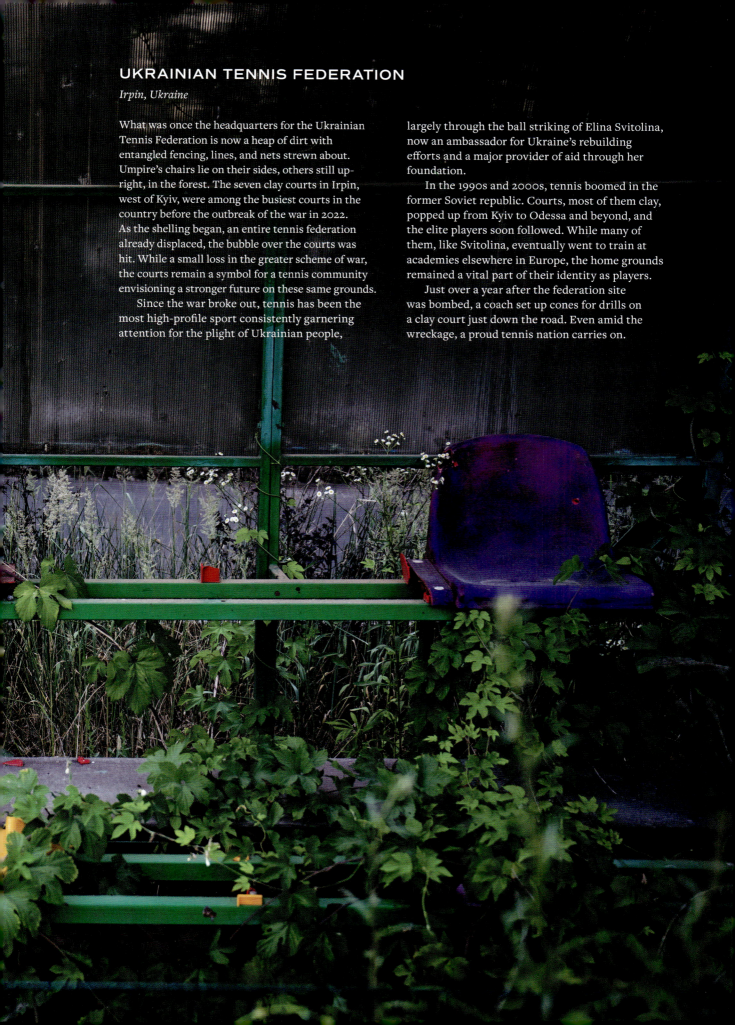

UKRAINIAN TENNIS FEDERATION
Irpin, Ukraine

What was once the headquarters for the Ukrainian Tennis Federation is now a heap of dirt with entangled fencing, lines, and nets strewn about. Umpire's chairs lie on their sides, others still upright, in the forest. The seven clay courts in Irpin, west of Kyiv, were among the busiest courts in the country before the outbreak of the war in 2022. As the shelling began, an entire tennis federation already displaced, the bubble over the courts was hit. While a small loss in the greater scheme of war, the courts remain a symbol for a tennis community envisioning a stronger future on these same grounds.

Since the war broke out, tennis has been the most high-profile sport consistently garnering attention for the plight of Ukrainian people, largely through the ball striking of Elina Svitolina, now an ambassador for Ukraine's rebuilding efforts and a major provider of aid through her foundation.

In the 1990s and 2000s, tennis boomed in the former Soviet republic. Courts, most of them clay, popped up from Kyiv to Odessa and beyond, and the elite players soon followed. While many of them, like Svitolina, eventually went to train at academies elsewhere in Europe, the home grounds remained a vital part of their identity as players.

Just over a year after the federation site was bombed, a coach set up cones for drills on a clay court just down the road. Even amid the wreckage, a proud tennis nation carries on.

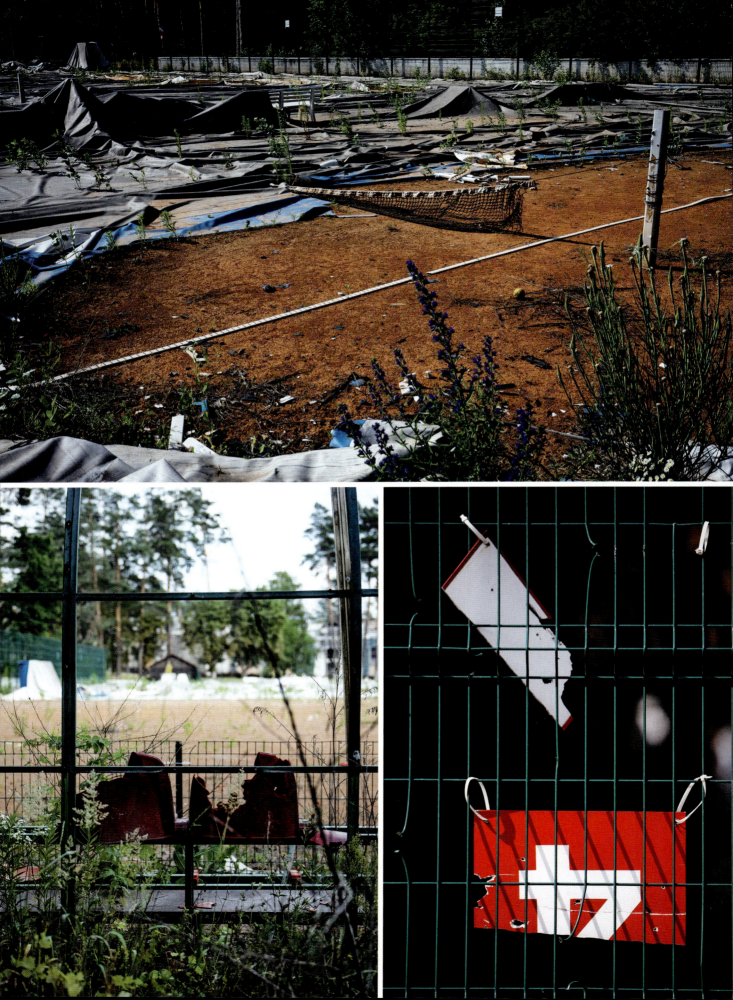

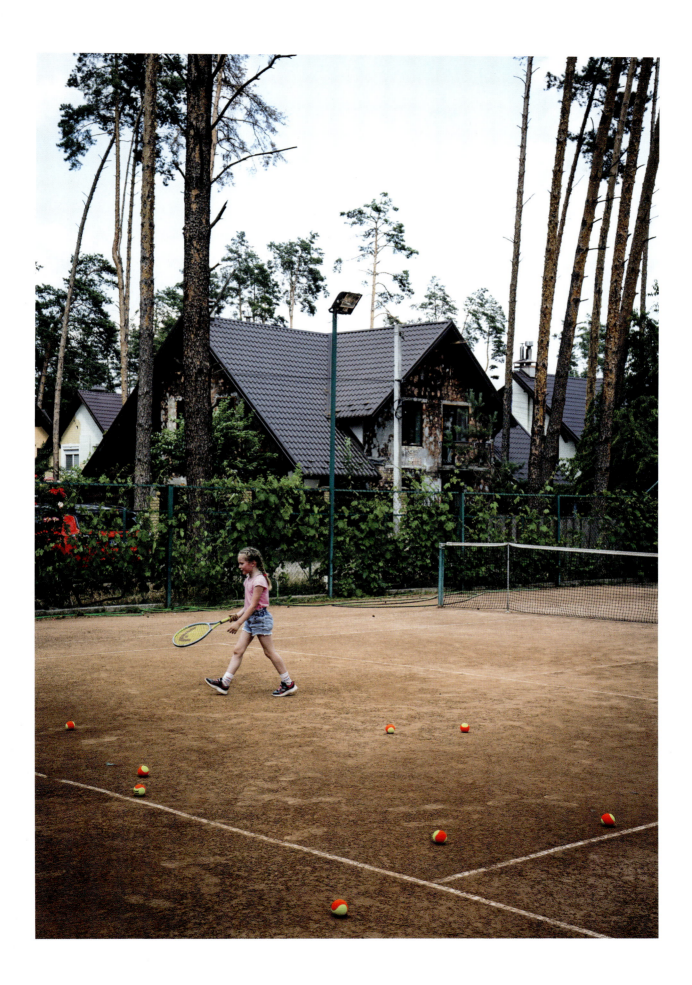

TOKYO LAWN TENNIS CLUB

Tokyo, Japan

Arakida-tsuchi, the soft brown clay used for modern Japanese clay courts, comes from a sticky soil found in riverbeds around Tokyo. It's kept cool and damp in large vats before groundstaff at the Tokyo Lawn Tennis Club (TLTC) cart it out onto their 10 courts for a sweeping local and international community to play on. It's the one thing that's stayed the same since this club was founded.

Organized in 1900, TLTC placed three courts in Nagatachō. In its early years, owing in large part to an internationally minded chairperson who worked as a foreign correspondent and local newspaper editor, the club took pride in having a membership that was majority Japanese while also including tennis enthusiasts from Brazil, Norway, Mexico, Russia, Germany, America, and elsewhere.

At the outbreak of World War II, the courts at TLTC were largely converted for farming potatoes and corn; the club ceased functioning, but two courts remained. Since reemerging at its present location in Minami-Azabu, Central Tokyo, TLTC has been the anchor of Japan's tennis hub. Courts span everywhere from schools to public sports fields. The TLTC courts share a back fence with the neighboring, and equally busy, public courts at the Azabu Sports Field.

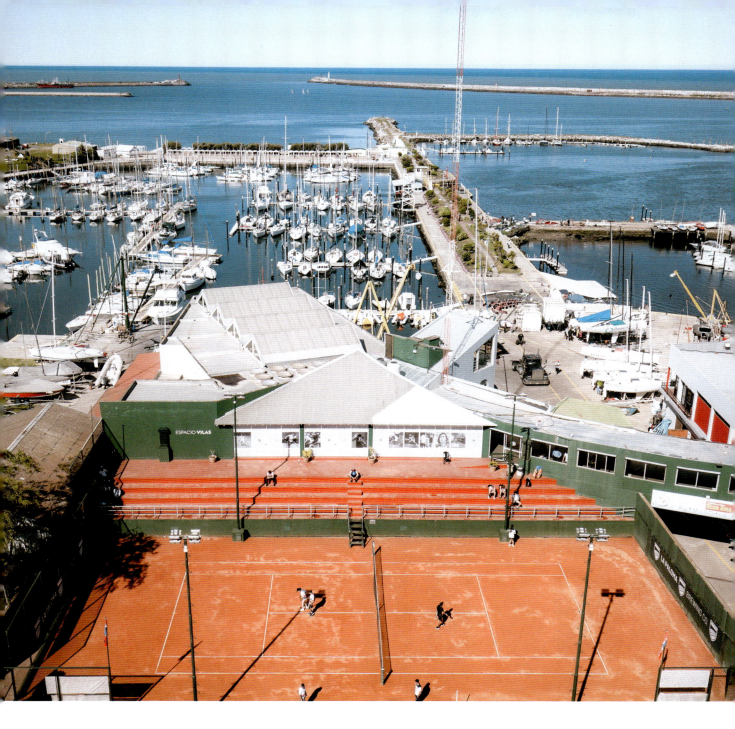

CLUB NÁUTICO

Mar del Plata, Argentina

Many an Argentine will make the trip to the clay courts of Club Náutico, a hybrid sailing and sporting club, to play on the same courts where Guillermo Vilas was raised and developed his game. The place has embraced the changing tides of the game since the days when Vilas played here but keeps to some tried-and-true Argentine traditions (like a heavy topspin forehand from deep behind the baseline).

Playing here with the sailboats nearby might compel us to change our tennis lexicon and adopt some sailing terminology, an unexpected but not entirely misplaced alignment, as one of the Náutico coaches will attest. Both athletes must constantly think of the wind and their angle of attack. For the English-speaking players, although it works for different Spanish terms, too, we talk of a "chip and charge," though they could just as easily use a sailor's term, "dip and tack." For "court positioning," they could say "bearing gained or lost." And when competing against a lower-level player, sailors might call them marshmallows. Maybe that's a new term for a pusher in tennis.

KIDS CLOSER TO SPORT

Kyegegwa, Uganda

In a sport dictated by confines, there's something to be said for finding your own flat space, drawing your own lines, whether for a miniature court or one cut to specifications, and playing on your own surface of choice. One could argue that you've never really embraced the game of tennis, or truly felt your place in the sport, if you haven't made your own court.

Several leaders in far-off pockets of the world have found the joy of creating new grounds, embracing the imperfections that come, in the name of growing and providing access to wide and diverse communities.

In the Wekomire village in western Uganda, Ben Nteza of Kids Closer to Sport used spades and shovels to dig out a flat space in the wet soil for a court. He and some friends then took ash from burnt wood to draw lines. The result: a tennis camp for kids from the local village and surrounding refugee camps.

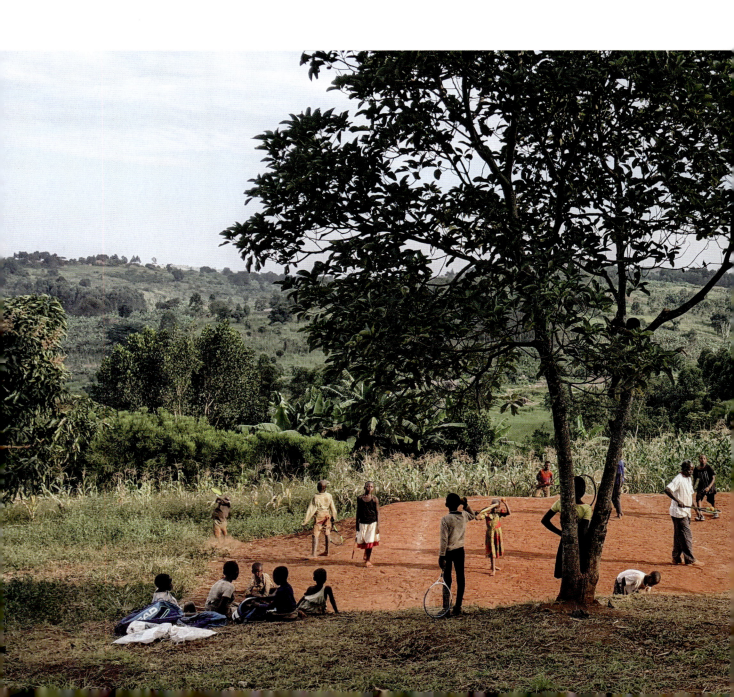

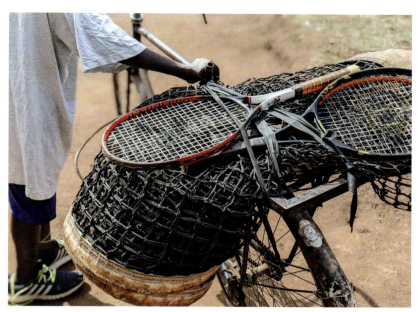
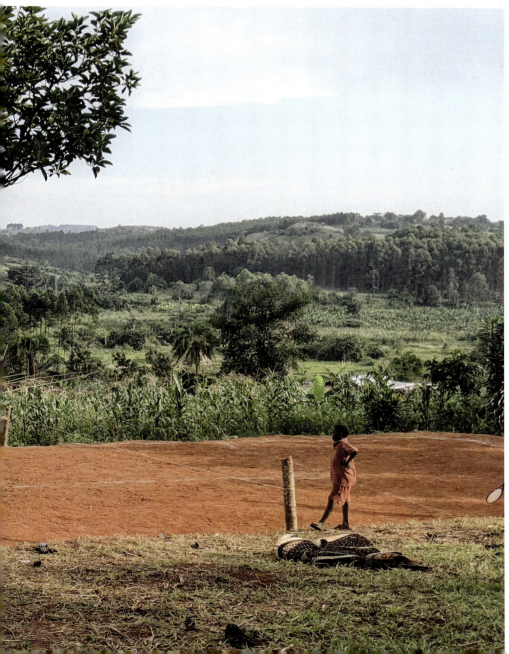

LOTON PARK TENNIS CLUB

Perth, Australia

While Loton Park Tennis Club has been around for more than 100 years, since 1995 the club has stood as the only one in the world whose constitution designates it as an LGBTQ+-managed club. And on these grounds of dedication to diversity and inclusion, they host one of the most popular tournament stops on the Gay and Lesbian Tennis Alliance (GLTA) world tour every January.

PARNELL LAWN TENNIS CLUB

Auckland, New Zealand

Though this club's origins date back to the 1870s, everything around it has changed. But despite its grass courts being swapped for turf in the 1980s, Parnell Lawn Tennis Club kept the name. The courts under the pōhutukawa trees sit on the border of the Auckland Domain in the shadow of the Auckland War Memorial Museum.

CLUB DE TENIS LA PAZ

La Paz, Bolivia

Adapting to a new surface can be arduous. Few tennis players of any level savor stark change. But a change in surface pales in comparison to adapting to playing at high altitude. All your usual calculations about pace and timing—forget them. You catch everything late. Hit everything long. The sheer velocity of the ball off the court and off your strings feels hyperactive, just as your breathlessness worsens. But when you *do* wrangle your timing, the change of playing up here is doubly satisfying.

One of the highest courts in the world, at double or triple the altitudes of cities like Albuquerque and Mexico City, is in the highest capital city in the world: La Paz, Bolivia. The thin-air clay courts at Club de Tenis La Paz sit at 11,000 feet (3,353 m) above sea level in the quiet residential area of La Florida, south of central La Paz. It's been a seminal gathering place of Bolivian tennis since its founding when waves of migration in the early twentieth century brought not only English and German players but also a surge of Chileans and Argentines.

Playing on these courts requires high-altitude balls that are customized with a more dense rubber core to prevent such a high rebound. But the still-high bounce might not be the main problem; it's more likely that fatigue and lightheadedness will cut a hit short. A common joke on these grounds is that if you simply run out of air, you can visit their leafy sister club, Huajchilla, on a property about 15 minutes away. But that will bring you down only to about 10,000 feet (3,048 m).

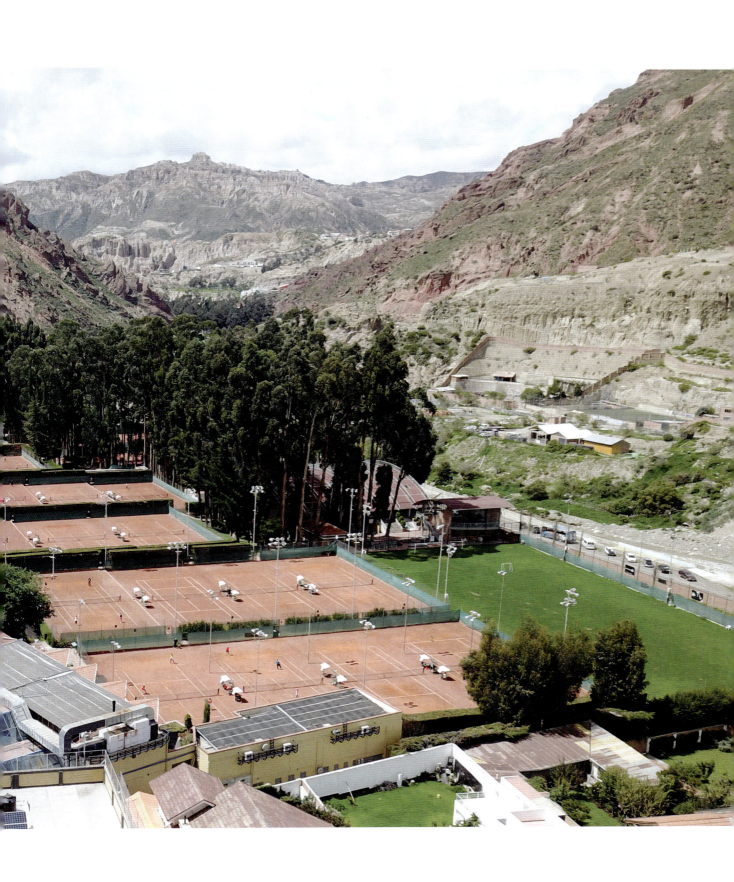

NICE LAWN TENNIS CLUB

Nice, France

There's an old poster in the entryway of the Nice Lawn Tennis Club that reads *Le tennis était-il pour les filles une danse ou un sport? Les deux peut-être.* ("For girls, was tennis a dance or a sport? Both, perhaps.")

Like most memorabilia in the pink clubhouse, the poster nods to the most famous player to come out of Nice Lawn Tennis. In its early days, these courts shaped the talents of Suzanne Lenglen, France's iconic sportswoman. Lenglen got her first racquet from her father at age 11 and learned on these courts throughout most French winters. The family owned a villa across the street from the club. Many remember Lenglen for her play style, which ditched formulaic poise for freestyle aggression. Some might say she was tired of people equating women's tennis to a childish dance for girls. She also did away with the typical playing corset of the time for a short-sleeved blouse. And during difficult moments in matches, she was known to take a sip or two of cognac.

You could say many members and visitors to the club nowadays, all of whom play on red clay, channel that same energy as they take in their surroundings on the hill above Nice.

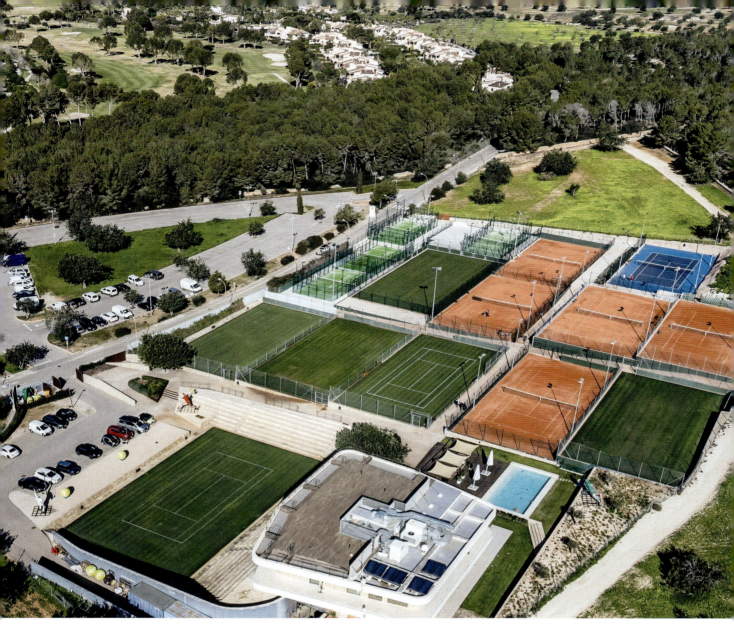

MALLORCA COUNTRY CLUB

Mallorca, Spain

These are the tennis grounds we all aspired to grow up with: grass, clay, hard, repeat. No crisis of settling for one.

The team at Mallorca Country Club set out to establish itself as the only place in Europe where one could play on each of the three main surfaces, aiming to offer a playing experience like that at the Grand Slams themselves. The most difficult to cultivate were, of course, the six grass courts. The team here on windy and dry Mallorca sought help from none other than the All England Lawn Tennis Club groundstaff. They now have plots as close to Wimbledon as an island grass court can get. The five clay courts cull their clay from the Spanish mainland. And the one hard court plays very much like the courts at the USTA Billie Jean King National Tennis Center in New York City.

The Mallorca club represents the culmination of the sport's evolution: 100-plus years of playing across dozens of surfaces in every climate imaginable, and all those years reckoning with making the sport accessible, entertaining, and true to tradition. The place fields all those generations of thought and molds itself into a multifaceted tennis experiment, to great success.

One can easily stop by to play here or see these courts at the annual men's professional tournament held at the club. Or you can become a member and pick your surface every visit, or play on all three, perhaps just in different shoes to suit each.

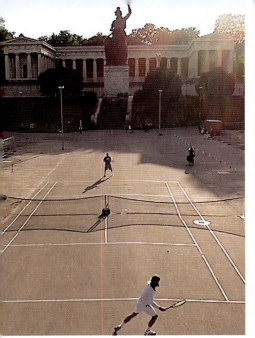

WORLD CLUB TENNIS

Germany and Around Europe

The individuals behind World Club Tennis, founded in 2015 in Germany, took an anticlub approach to create social pop-ups and brought the court to wherever the group wanted to play that week, which led to some fascinating endeavors. Decoupling the game of tennis from the club freed them, in many ways, and brought in a new fold of intrepid players and spectators. People like tennis in unusual spaces. The mentality took the group to the Munich Olympic Stadium with tape for lines and a net they unfurled and strung up themselves. Then they went to the port of Hamburg, a bridge over the Seine, and even to the top of the Zugspitze, Germany's tallest peak.

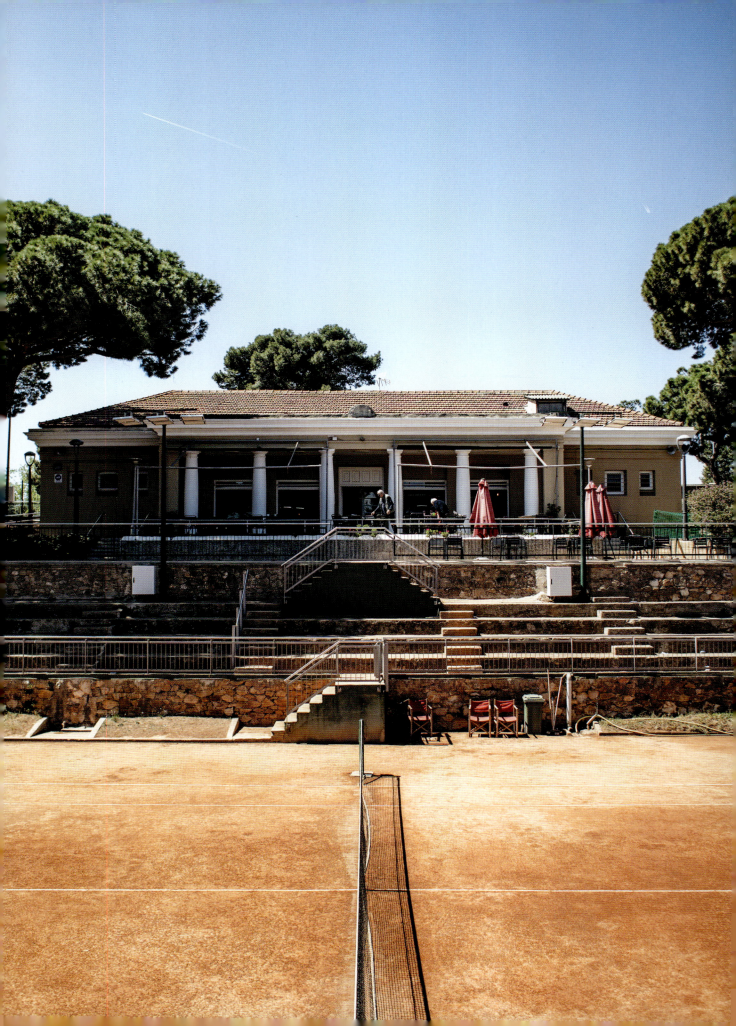

REIAL SOCIETAT DE TENNIS POMPEIA

Barcelona, Spain

Playing on center court at RST Pompeia imparts a sense of a gladiator-like battle. On this sunken center court, large stones enclose the clay on all four flanks. Anyone watching from the clubhouse terrace does so from atop the walls with a green curtain of pine trees surrounding everything.

Of the three royal clubs of Barcelona, this is the only one that's dispensed with its vestiges of exclusivity and now allows anyone to visit and play on center court in historic Montjuïc, not far from Plaça España.

For much of the club's early history, it only had one court, built in 1929 at this very spot. More courts eventually appeared in the 1950s, shortly before the club hosted the first Davis Cup bout ever held in Spain. Now a terraced array of clay courts dot the area overlooking the Olympic center nearby.

It's one of the most central tennis clubs in Barcelona, with around 600 members. The rest of Barcelona's clubs form a ring around the northwestern outskirts of the city. RST Pompeia stands alone, overlooking fantastical Barcelona.

LAWN TENNIS CLUBE DA FOZ

Porto, Portugal

The story you'll hear at this historic club will concern the wind. Upon arriving at the club, you'll be asked if you parked to the south and if you care about your car getting an orange dusting. Then the conversation will shift to playing in wind—its temperament consistently restless but sometimes helpful. Everyone watching the rallies on Court 1 in front of the clubhouse looks for erratic bounces and gusts that ferry a floating ball far away. If the wind catches a player wrong-footed, the senior members on the patio might let out a *tsk-tsk*, or *pobrezinho*, "poor thing" in Portuguese. The wind is the third player in all points played here.

It almost always comes from the north, stealing the clay away. But the club has adapted. A sprinkler system is synced to several members' phones, and when the winds increase, even in the middle of the night, the sprinklers come on in an effort to keep the clay from swirling.

The club sits at the mouth of the Douro River and is attached to the ramparts of Castelo de São João da Foz, a sixteenth-century fort. The fort's stone walls function as backboards for each of the red clay courts.

This club was the first club in Portugal to dedicate itself exclusively to tennis, around the turn of the nineteenth century, but it wasn't until the 1930s that the club gained momentum. Then and now, the club has been a headquarters for growing the sport in northern Portugal. And as most prestigious clubs maintain practices, and too often auras, of exclusivity, the leadership at Clube da Foz rebukes that tradition. There are more than 800 members, many of them families that have been members for generations, but the club gives free lessons to any youth in the Porto area who can't afford to play, and anyone can play here, provided they communicate with the club ahead of time.

You'll just have to contend with the Atlantic winds.

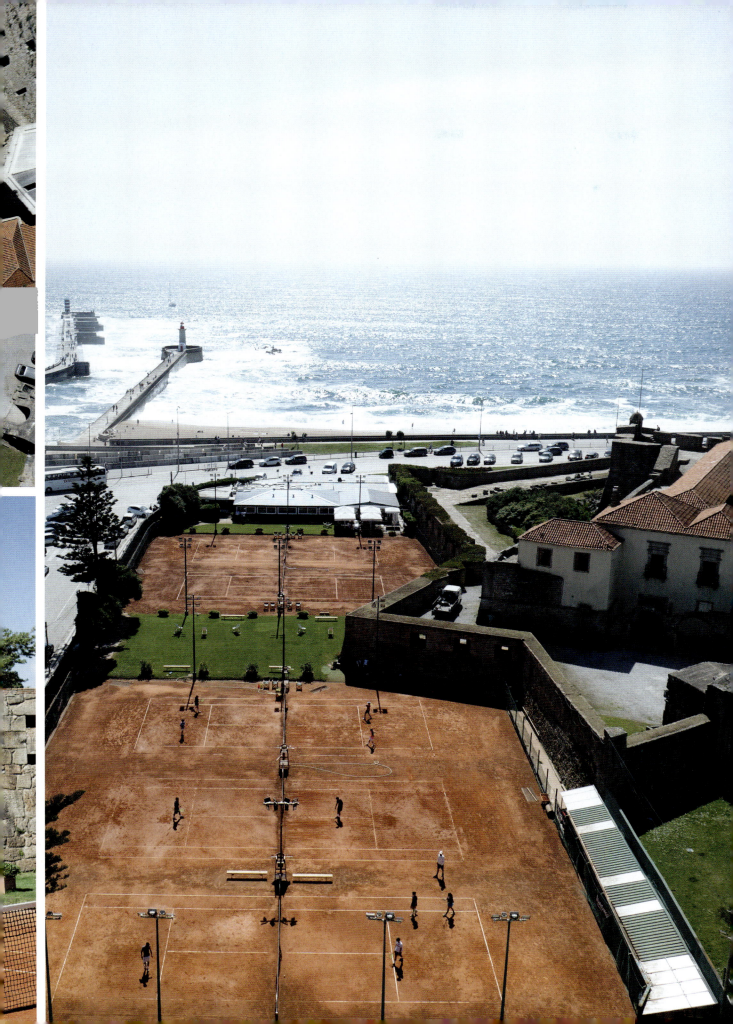

YOKOHAMA INTERNATIONAL TENNIS COMMUNITY

Yokohama, Japan

In most countries, the birthplace of tennis is usually a reflection of foreign influence. Typically, British colonial influence. Many of these grounds are relics of their former selves, if they still exist at all. But atop a bluff overlooking Yokohama Bay, in Yamate Park, the first tennis grounds in Japan maintains its late-nineteenth-century stature and traditions while also embracing a global, open sensibility.

Yokohama International Tennis Community (YITC) began as the Ladies Lawn Tennis and Croquet Club, a grass-court club exclusively for British settlers. Over time, the club welcomed a wider array of players. Records from 1936 state that Bill Tilden hit a 163-mile-per-hour (262 km/h) serve on these courts—unlikely, but not entirely impossible. The club admitted its first Japanese members in 1958, and later opened to visitors in the late 1980s, when it officially adopted its current club name. YITC's leadership, much of them Japanese women, thought that the best future for the organization would be one that is open to anyone who wants to savor the space atop Yamate Park. In 1986, the club inaugurated an annual doubles tournament where every team must pair partners of different nationalities. Many of the players in the early years represented various embassies, but the tournament has grown to include a wider array of players, many of whom travel from other historic clubs to play.

The surface at YITC is no longer grass; today, the six courts boast a thick clay made from the same sand base used in the professional sumo rings throughout Japan.

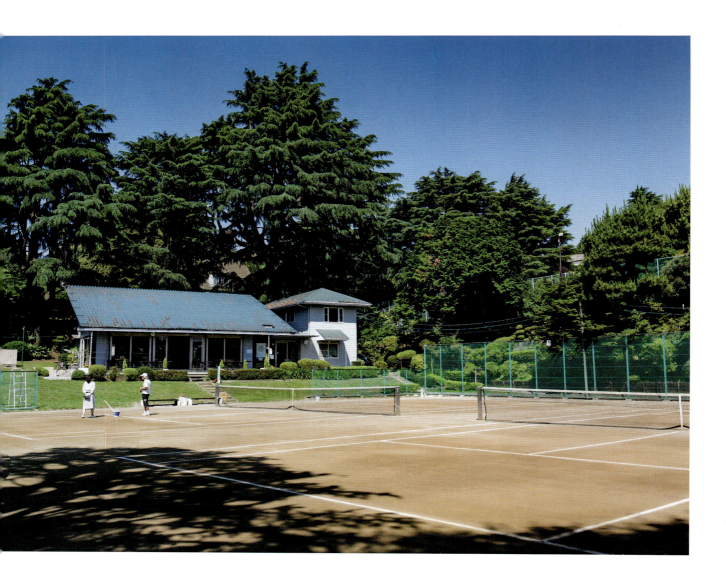

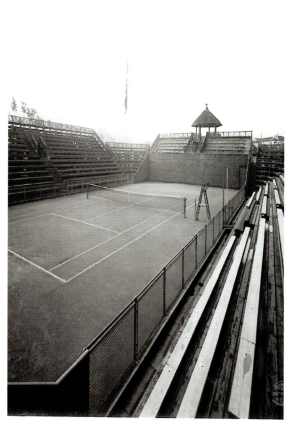
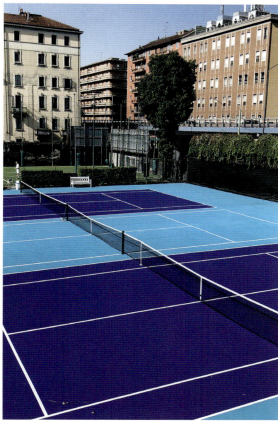

TENNIS CLUB MILANO ALBERTO BONACOSSA

Milan, Italy

As one of the founding members of the Centenary Tennis Clubs organization, and one of the oldest clubs in Italy, dating back to the late nineteenth century, Tennis Club Milano Alberto Bonacossa keeps up a historic club's juggling act. While keeping the sporting tradition alive predominantly on clay courts, the club has, in recent years, aimed to become a cultural gathering place beyond the sport. So while tennis may be on offer on most courts, there may be an opera event, book signing, gallery opening, or concert on the grounds as well. Of course, to experience the club at its finest, most visitors will arrive for a professional exhibition or event, like the Billie Jean King Cup or Davis Cup bouts.

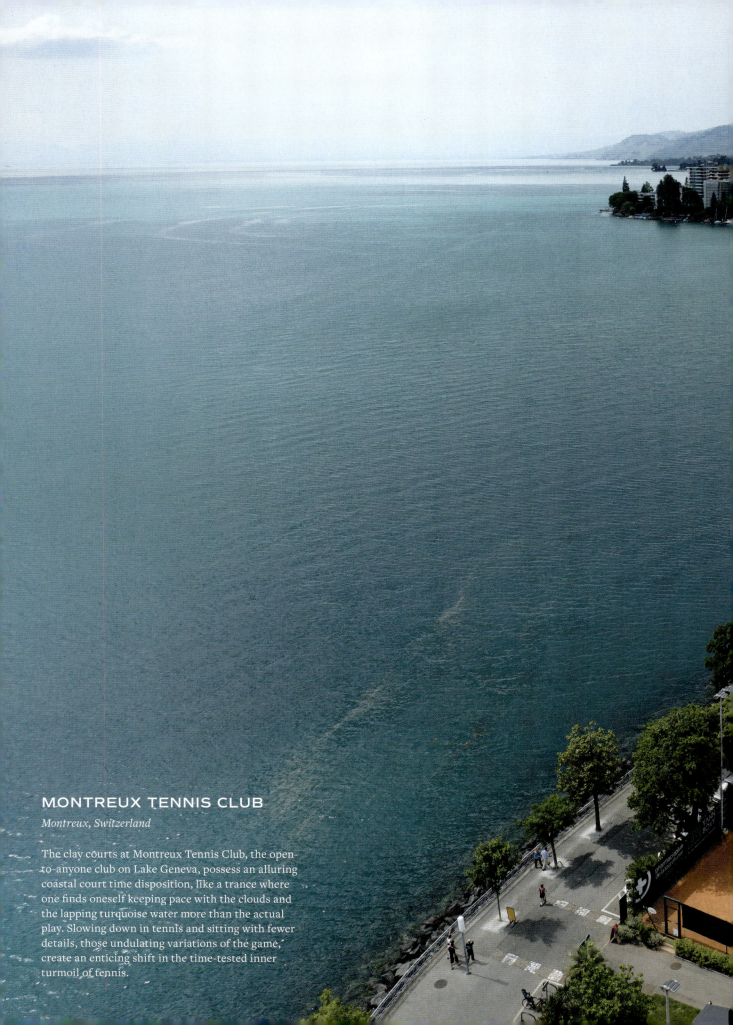

MONTREUX TENNIS CLUB

Montreux, Switzerland

The clay courts at Montreux Tennis Club, the open-to-anyone club on Lake Geneva, possess an alluring coastal court time disposition, like a trance where one finds oneself keeping pace with the clouds and the lapping turquoise water more than the actual play. Slowing down in tennis and sitting with fewer details, those undulating variations of the game, create an enticing shift in the time-tested inner turmoil of tennis.

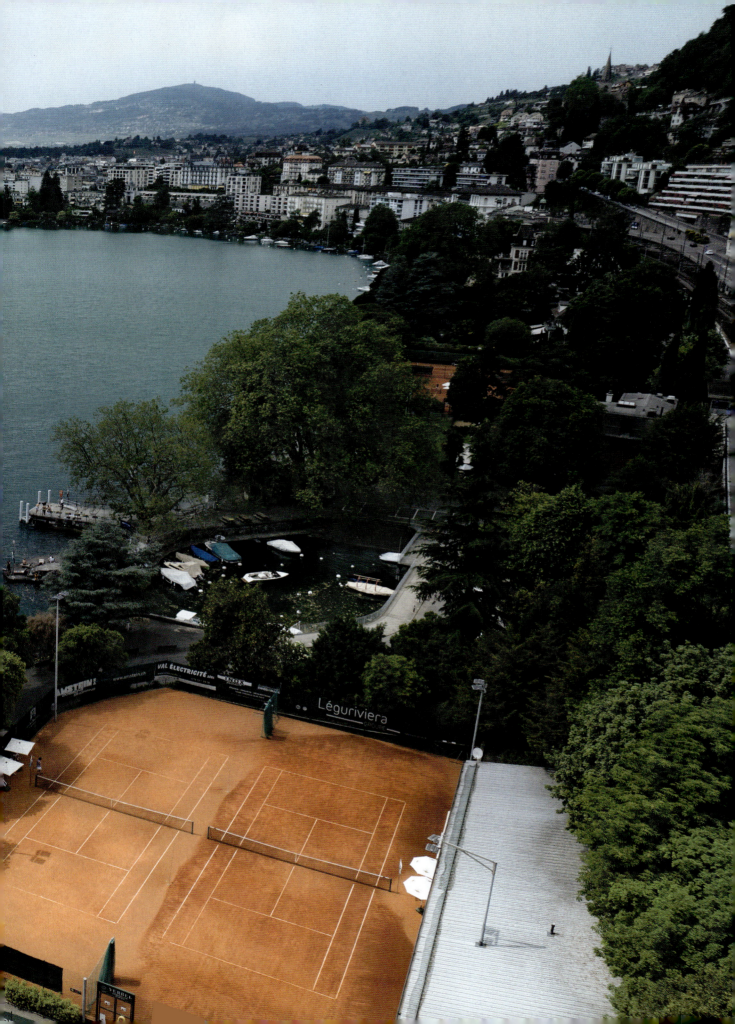

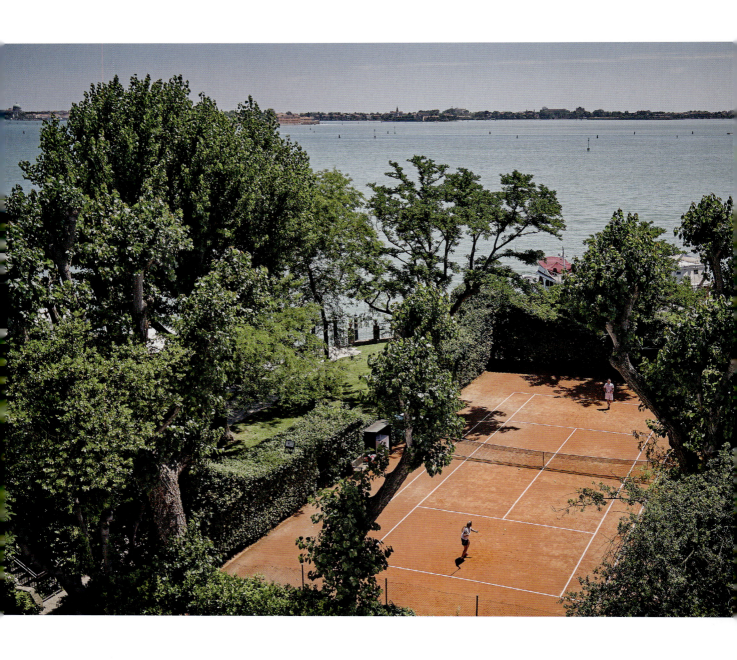

HOTEL CIPRIANI

Venice, Italy

On the Venetian Lagoon, with its briny scent and frequent boat traffic, the clay court has been a staple for more than 45 years. For a true tour of the neighborhoods, and no less than eight water taxi trips across the rollicking channels, some locals will venture out for a day of hitting starting at the Cipriani then walk the length of Giudecca to the courts near Mercato Sacca Fisola. From there, on to the courts at the edge of Murano before finishing on Lido at the city's oldest club (see page 325 for Tennis Club Venezia).

Brushstrokes Beyond the Baseline

In the last decade, artists have disrupted the uniformity of the court with their own creations. Dissolving the lines with splashy and vibrant works, while meant more for marketing than actual tennis, can make for a new kind of game.

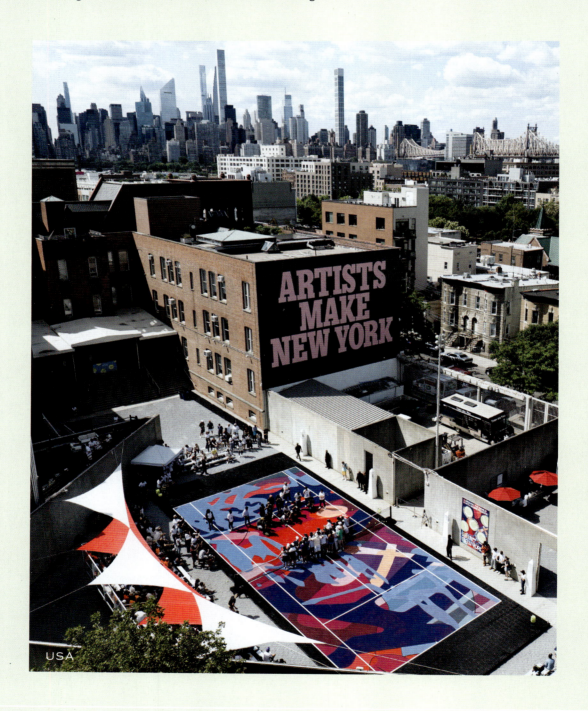

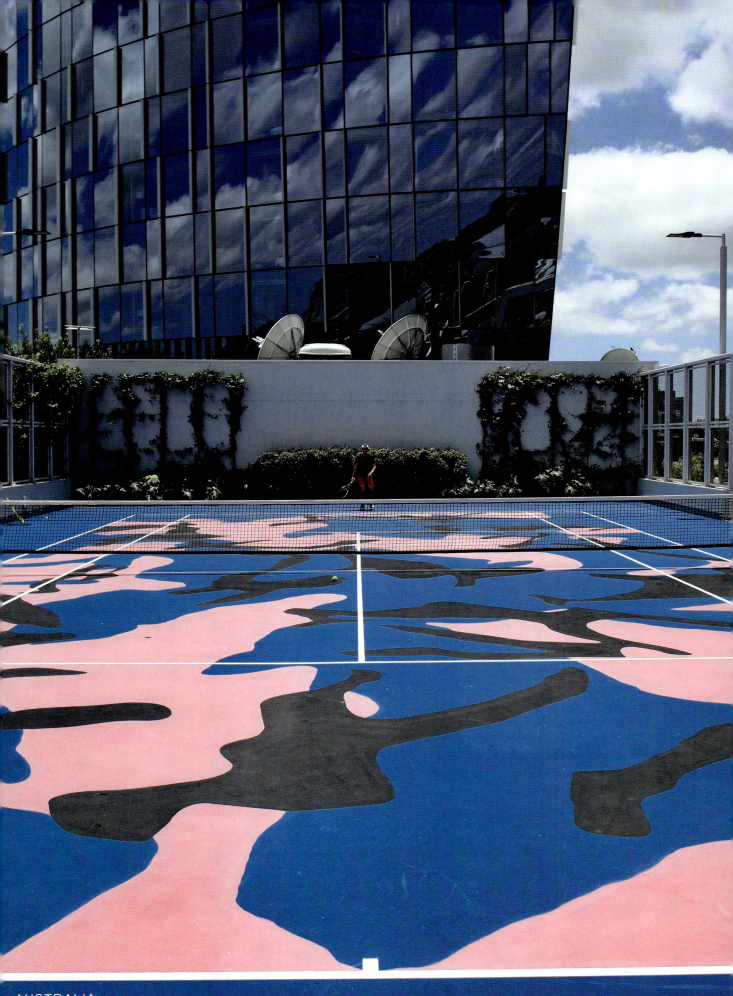
AUSTRALIA

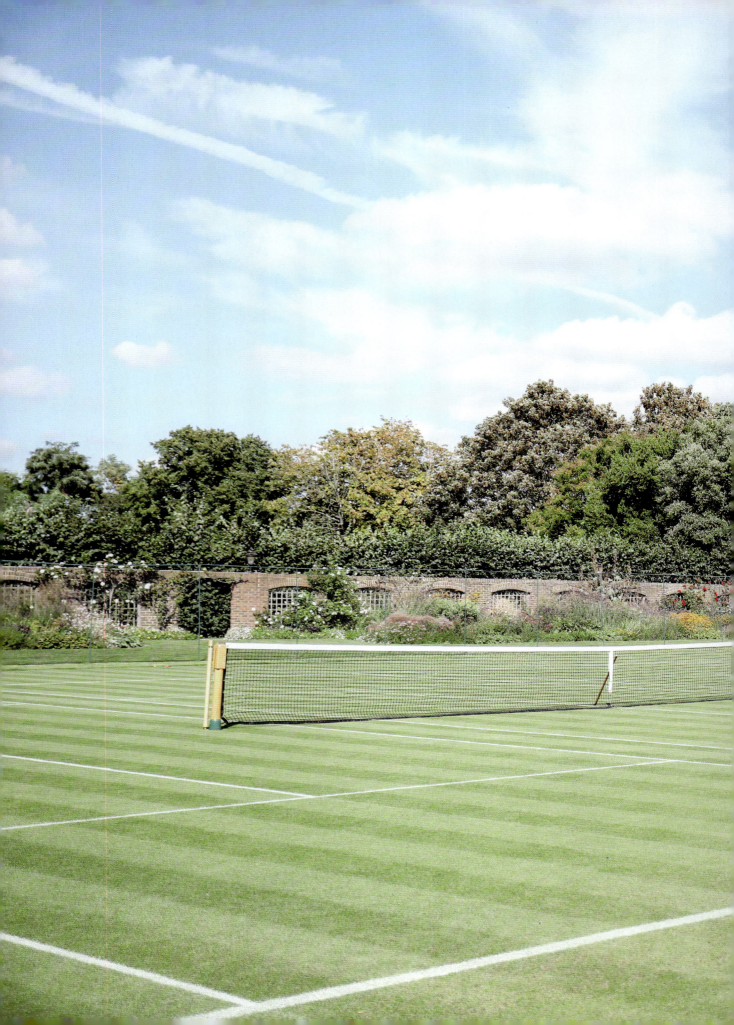

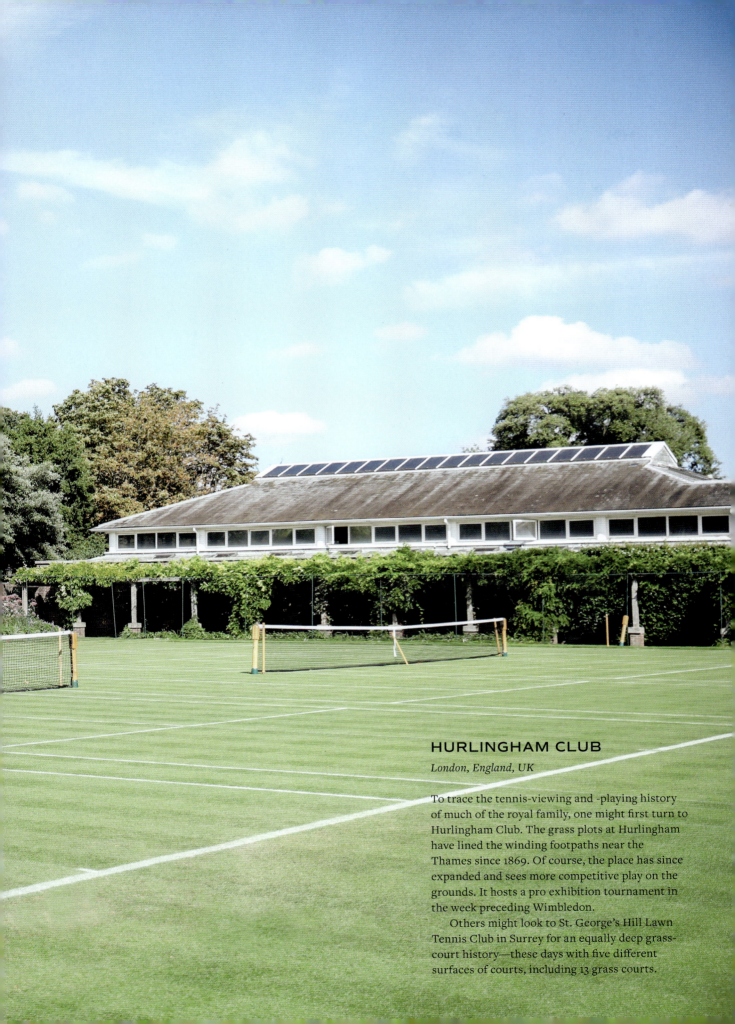

HURLINGHAM CLUB

London, England, UK

To trace the tennis-viewing and -playing history of much of the royal family, one might first turn to Hurlingham Club. The grass plots at Hurlingham have lined the winding footpaths near the Thames since 1869. Of course, the place has since expanded and sees more competitive play on the grounds. It hosts a pro exhibition tournament in the week preceding Wimbledon.

Others might look to St. George's Hill Lawn Tennis Club in Surrey for an equally deep grass-court history—these days with five different surfaces of courts, including 13 grass courts.

LE TIR

Paris, France

There are abundant preconceptions about the Parisians, their clay, and their affection for tennis, perhaps more than most any other city. Coming here, many visitors might align the tennis with stereotypes around a curt and regimented, but still arty, Paris society. And some of that holds up on the courts. But stay awhile, and some will also take from the experience a sweeping propensity for an indulgent, freewheeling, utterly casual long-session-style tennis vocation. Clubs and public tennis grounds around Paris impart a lesson in doing very little. Play tennis. Lounge. Drink coffee. Sit with a book. Read the first chapter. Drink again. Walk around. Say hello. Play tennis again. Repeat.

Tennis Club de Paris is one such rendezvous, a favorite among pros, veterans, and tennis families alike. Eighteen courts, nine of them the storied brick-red clay, same as at Roland-Garros, stretch toward the Seine in western Paris. Similarly, and maybe even more rarefied, is Le Tir, a spot defining slow tennis life in the heart of the Bois de Boulogne. You might find some reading a book on-court here.

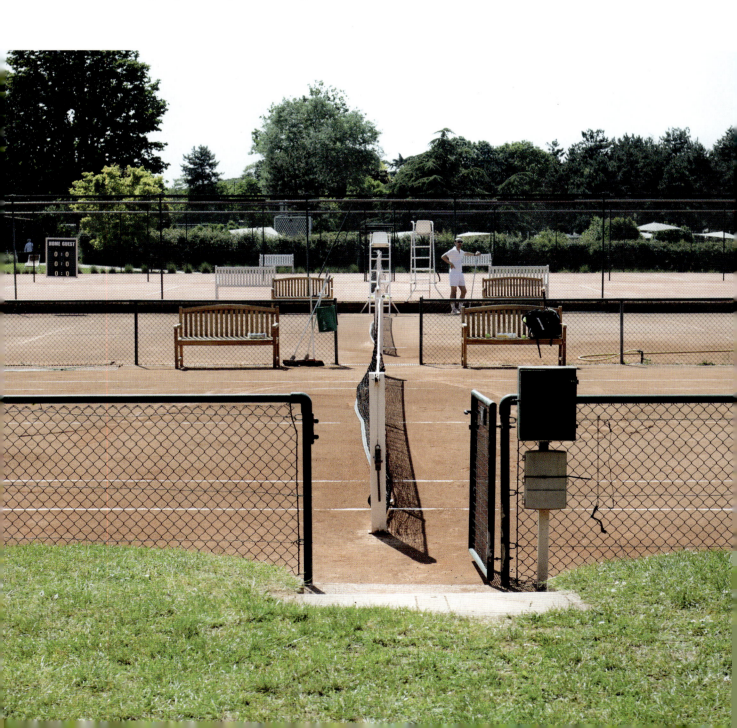

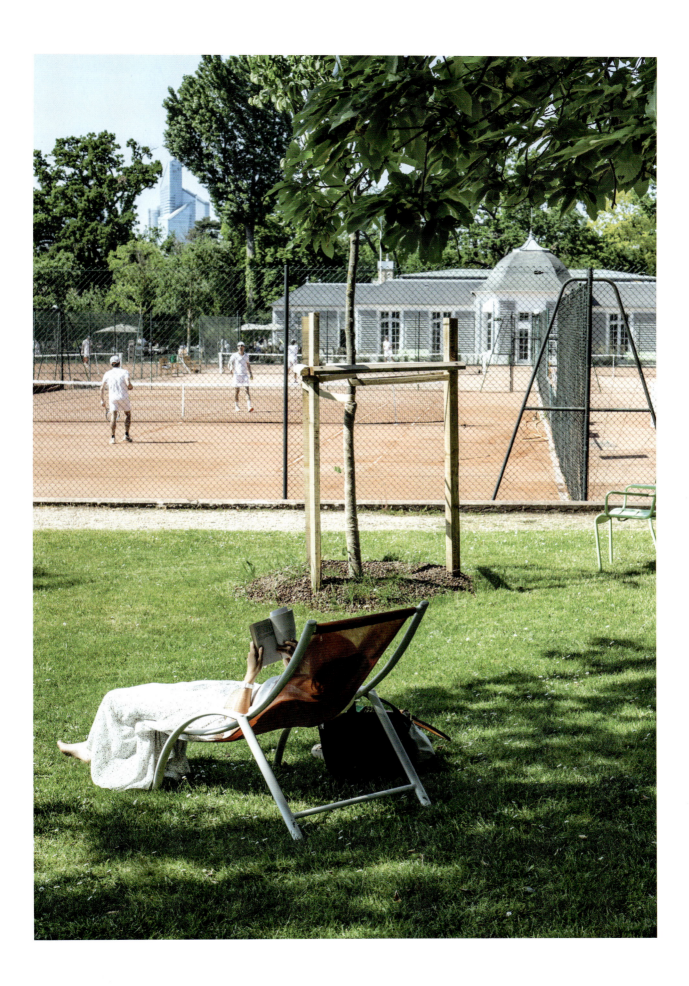

AMPHITHEATER COURTS

Germany

The Germans have refined the natural amphitheater court for over a century, from Stuttgart to Munich, Düsseldorf, Frankfurt, Berlin, and beyond. The simplistic style with grassy berms rising on all four flanks has helped them endure through generations of wars, local politics, and changes in demand for the sport.

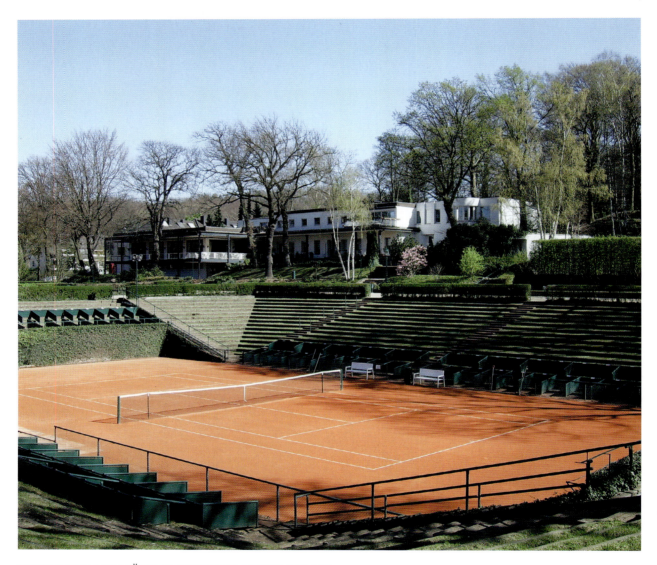

ROCHUSCLUB DÜSSELDORFER TENNISCLUB
Düsseldorf, Germany

In the Grafenberg Forest, the Rochusclub has held its championship matches on the amphitheater clay court since the late 1800s. Their most popular tournament: a doubles competition where every team consists of a parent and their child (minimum age: 10), now in its forty-fourth edition.

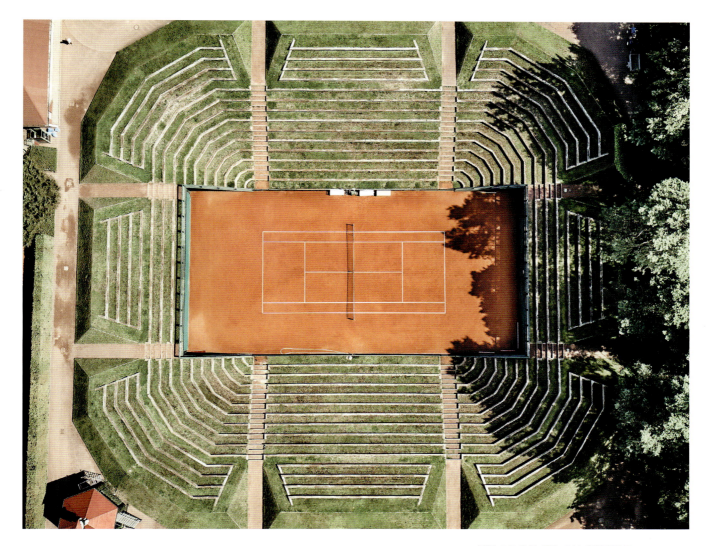

TC 1899 BLAU-WEISS

Berlin, Germany

Built in 1926, this natural amphitheater clay court is kept busy as the largest membership club in Berlin.

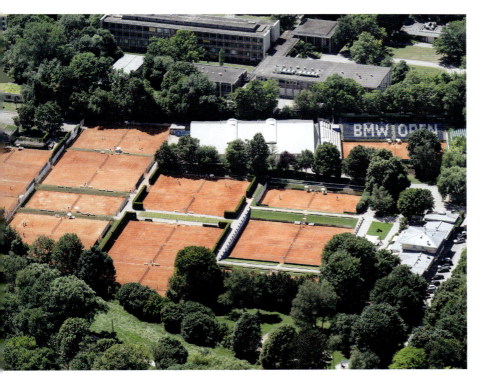

IPHITOS CLUB

Munich, Germany

Situated at the north edge of the English Garden in Munich, Iphitos plays host to the men's professional tour every summer clay season. But the best time to come might be during a German Bundesliga match, when the stands are gone and the grassy berms fill with spectators and players from around Bavaria.

DEEP HISTORY, NOW ON GREEN CLAY

Canada

If you've been around tennis anywhere on the eastern side of North America, you've likely come across the grayish-green (or bluish-green, if it's overcast) surface called Har-Tru. It occupies the space between hard courts and clay courts. The material is made in the US from quarried metabasalt; the rock is crushed, sifted, and processed with a proprietary formula just for tennis. It's what most of the recreational tennis population east of the Great Lakes and the Mississippi River learn on. Where people fall in love with tennis, or out of it. (And if you think this surface is dull or boring, don't mention it to the greatest Har-Tru players, like Chris Evert and Jimmy Connors.) And while it is everywhere, the easy-on-the-body surface is most cherished in the tennis hubs of Canada—it's the only court surface on the outdoor courts at Canada's two most historic clubs. Here there's a long-standing, ongoing romance with the chalky, friendly surface.

In the early days of the MOUNT ROYAL TENNIS CLUB, six courts and a clubhouse were built to the tune of about 700 Canadian dollars. The grass courts were among the most coveted in Quebec, and the club was poised to become a mainstay of Canadian tennis. Throughout the early decades, these grounds saw more Davis Cup matches than anywhere else in Canada: Japan vs. Canada, 1923; USA vs. Canada, 1931; Cuba vs. Canada, 1951. The courts then were all grass, with one show court used for events. But as tennis boomed later in the twentieth century, the decision was made to keep the club on Grey Avenue local, community-based, and small, resisting the top-dollar expansions and corporate partnerships. Enter the brick clubhouse today and you see photos of all those Davis Cup ties. As a summer-only club, the main event takes the form of Wednesday exhibition matches on Courts 1 and 2.

The Royal's counterpart in Canada's largest city is TORONTO LAWN TENNIS CLUB, dubbed simply the Lawn by those who play here. The all-weather Har-Tru courts thrive here as the Canadians stretch the outdoor season as long as they can before heading inside. A larger facility than Mount Royal, these courts hold the keystones to today's Rogers Cup. In 1881, the club hosted its first tournament, which was later run by the newly formed Canadian Lawn Tennis Association and became the Canadian National Championships. The tournament roamed locations through the years, but what started here now remains the third-oldest continuing tournament in the world, after Wimbledon and the US Open.

At both these grounds, there is a palpable pride in the Har-Tru collective, a surface with no Grand Slam and only one major tournament played on it.

TORONTO LAWN TENNIS CLUB
Toronto, Ontario, Canada

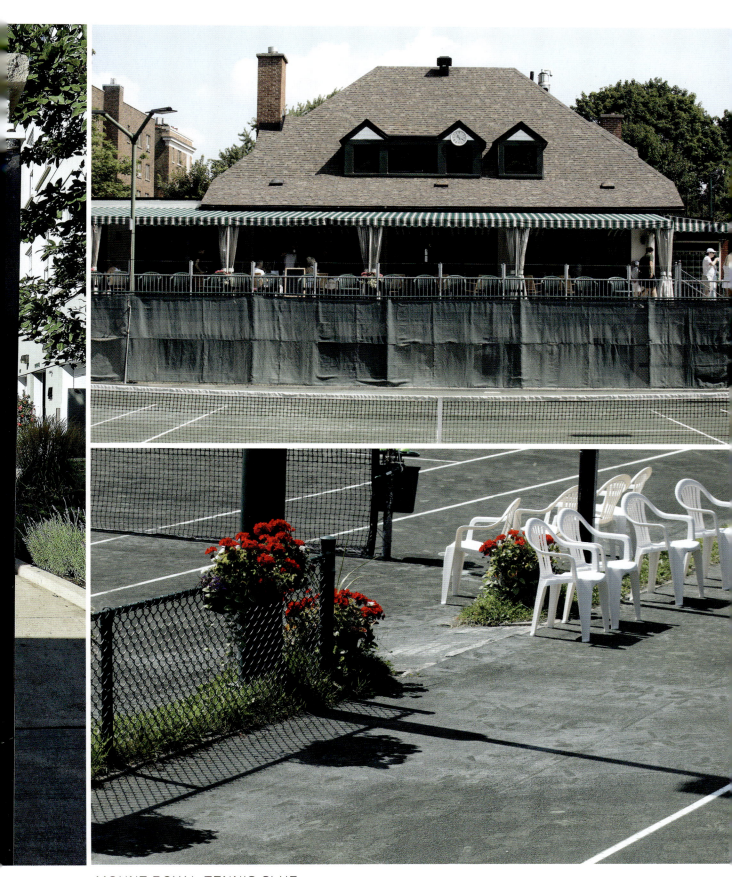

MOUNT ROYAL TENNIS CLUB

Montreal, Quebec, Canada

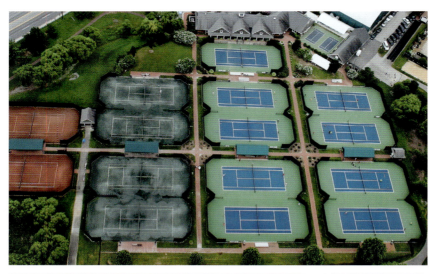

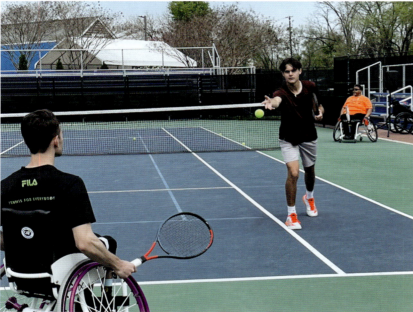

JUNIOR TENNIS CHAMPIONS CENTER

College Park, Maryland, USA

The courts at the Junior Tennis Champions Center (JTCC) in College Park, Maryland, are set up like a pyramid. You can go from red clay to Har-Tru to hard courts in linear succession and back—and the majority of junior players do, all year round.

Spend enough time at JTCC, and you'll find that this tennis academy and community center is among the most forward-thinking, progressive tennis grounds in the world. An odd reality of tennis, specifically junior development programs at tennis academies large and small, is that there are very few female coaches. It's a long-standing (albeit unsurprising) practice that the coaches, those who shape the players who will come to symbolize the game, are almost always men. The team at JTCC seeks to change that by striving for parity on their coaching staff and in their programming. The courts here are also host to some of the most inclusive hitting in the country, with frequent free community tennis festivals, weekly wheelchair tennis clinics, and a para-standing tennis program.

If you can envision a future for tennis led by voices that have long been marginalized by the institutional leaders of the game, and one that celebrates the game in its multitudes, it's here in College Park.

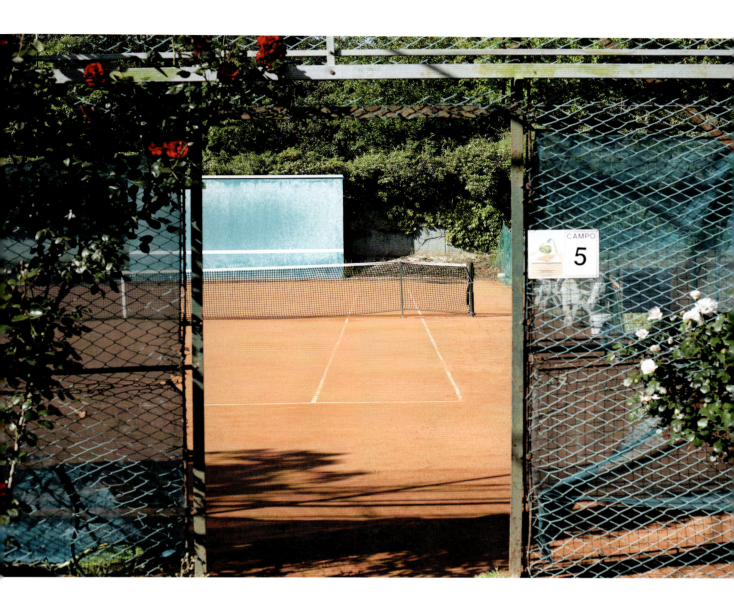

TENNIS CLUB VENEZIA

Lido di Venezia, Italy

The six clay courts of Tennis Club Venezia lie hidden in a rose garden, several steps below the main promenade on the Lido, a barrier island in the lagoon.

One of the oldest clubs in Italy, dating back to the 1920s, the club has long been a cornerstone of Venetian tennis. Much of the club's early success can be attributed to Giuseppe Volpi, a foundational business figure for the Lido and Venice, who organized events for some of the world's leading tennis names: Pietrangeli, Santana, Emerson. Until the early 2000s, Nicola Pietrangeli, regarded as the most successful Italian tennis player ever, gave clinics on these courts.

The club has since opened itself up to the local and global tennis community. Rousing exhibitions, along with drop-in celebrity tournaments, take place every year in September during the Venice Film Festival. All are welcome to arrive at this club and book a court—you just might need to compete with some juniors (most of them styling forehands like Jannik Sinner) for court time.

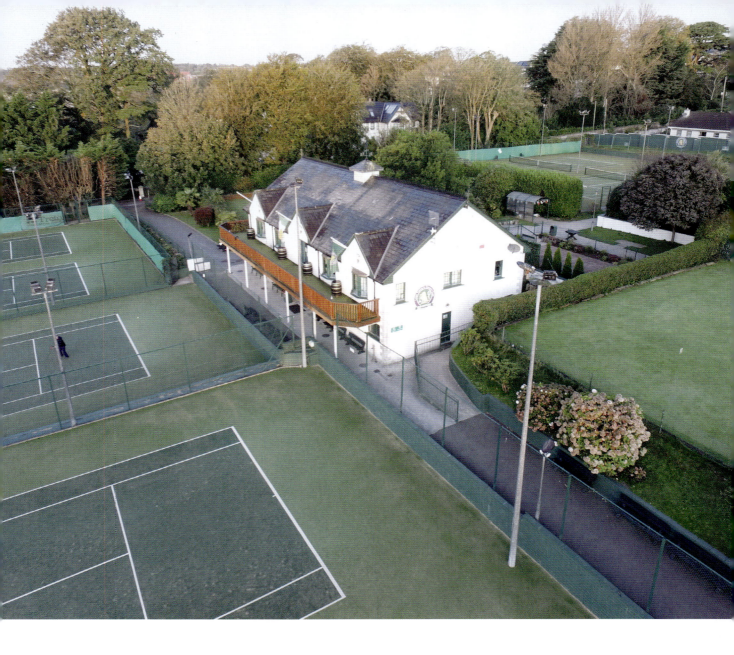

RUSHBROOKE LAWN TENNIS & CROQUET CLUB

Cobh, Ireland

In Ireland, many of your tennis counterparts celebrate the written word on the game as much as the play itself. Each of the historic clubs across Dublin and the countryside seems to have players who double as armchair historians, and some have taken the time to dissect local archives (and their rivals' basements) to write their own books on the history and aesthetics of the game at their home clubs. These books run around 150 pages, and one most prideful example is from arguably the oldest tennis club in Ireland—Rushbrooke Lawn Tennis & Croquet Club. Outside Cork, in Cobh, club member Frank McDonnell took more than 10 years to craft his tome on the club's history, documenting the pivotal first day when lawn tennis was played here—a bright July day in 1880—and other memorable dates through the club's generations. The club has always been a bit of a bullish alternative player itself, starting with its largely female leadership going back to its founding and its lineage of top Irish players who grew up on Rushbrooke's remote courts. Today, those 11 courts, two of which are grass, get almost constant use. Rain permitting.

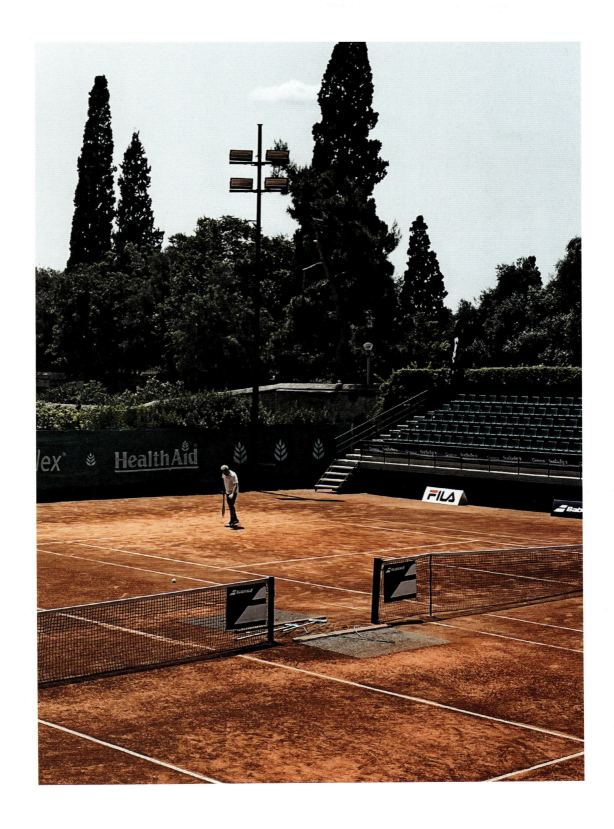

ATHENS LAWN TENNIS CLUB

Athens, Greece

In the earliest days of the Athens Lawn Tennis Club, only a dozen Athenians played the game on one grass plot. They were viewed as renegades, oddballs, and some other profane names of the 1800s. But soon, after tennis was included in the Olympic program in 1896, and played on these very grounds, their numbers grew. Now the grass court is gone but six clay courts and several hard courts remain in the same spot, in the shadow of the Temple of Zeus.

SEASIDE TENNIS CLUB

Waimea, Hawai'i, USA

In competitive tennis circles, players frequently mention and discuss training blocks. Think of them as periods for change—time dedicated to working on your game with a regimented plan in place. Usually these blocks are preceded by a strength-training program to make sure you don't holistically break your body during the training block. (But can anyone really get their body ready *enough* to handle heavy tennis wear? Still, we try.) A training block often calls for two-a-day sessions on-court, so you need a place that can appease or fully distract you from the rigor—chronic tennis-caused soreness and strain—of the program.

Seaside Tennis Club, located on the Big Island of Hawai'i, is one such place. A two-a-day hitting schedule on oceanfront Court 11 means you'll see skipper dolphins on their morning commute and (in winter) a pod of whales passing by in the evening. The pristine green-on-green hard courts sit in sweet juxtaposition with the surrounding palms, kupukupu ferns, and plumeria. If you get too hot during a session, soak your hat in the cool salt water of the tide pools 20 steps away.

AFTERWORD

When I finished the travel for this book, I returned to the hard court in New Mexico that I grew up on.

I have played with hundreds of people on this court, but it sits in my memory more as a solitary, introspective space. I used to bring my yellow Labrador out here and practice serves until I ran out of light or my left forearm went numb. Back then, just as today, the tennis court was the place where I could prod the seemingly impenetrable thoughts about almost anything in my life. Tennis either made things make sense or distracted me enough not to care.

Standing on the court in Albuquerque, I studied the cracks meandering from end to end. Give it a decade, and the roots of the nearby cottonwood trees will take over. I'll still come here to play.

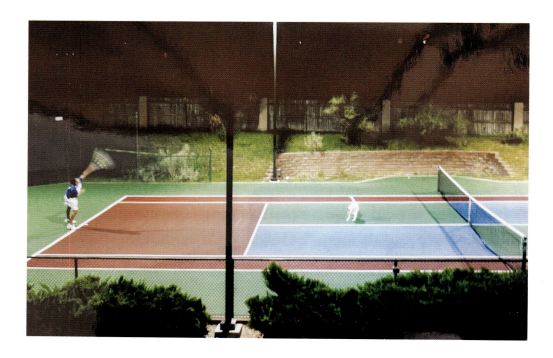

ACKNOWLEDGMENTS

There are so, so, so many people who have touched and shaped this book in a very big way, but before I talk about them and their tennis skills, or lack thereof, an enormous thank-you to every player, coach, clubhouse manager, groundskeeper, colleague, friend, or family member who has ever spent time with me on and around the courts. You all shaped my tennis world by making it full of surprise, laughter, vulnerability, and beauty. And to all of you who took the time to hit with me and talk about tennis and life over the past two years, especially those of you outside the US—your thoughts, musings, and jokes fill these pages, and I can't thank you enough.

To everyone at Artisan, who believed in me and my endless wanderings to make this book happen. Especially to my editor, Shoshana, for your patience in helping me create something much bigger than we ever imagined. And to Zach, for guiding me into the space for this little tennis dream to come true. To Suet, you made my erratic visual tennis odyssey a cohesive reality. To Hillary, for keeping the sharpest eye on all of this—let's go to the Australian Open next year. And to the rest of the Artisan team, Abby, Donna, Brittany, Alana, and Allison, thank you for all your work.

To Maia, Chris, Pete, Sima, Jenna, Melanie, Rachael, Ebony, Gabby, Brock, and Betsy, thank you for joining me around and above the courts. Your photography is unmatched and your perspectives remain invaluable. And to Melissa and Menelik, thank you for focusing my own photographic pursuit.

To my agent, Leah, thank you for sticking with me through this five-set match and for your soothing touch when I was lost and overwhelmed on deadline somewhere in Hungary—and then again in Paris.

To Spenser, for the gabbing and the surfing and for helping me find the voice of this book that sounds far more like me than my own voice alone. Thank you for getting it and for being perhaps the only person who knows exactly what's going through my head while I'm playing a match.

To my parents, T&T, for letting me be a wild head case with zero fashion sense on-court since day one. To Ally, Dave, Lori, George, and the rest of the fam, thank you for caring so much about my work and the making of this book. And to Luca, thank you for agreeing to play and love tennis even though you're only two years old—FYI, this book is dedicated to your great-grandma Louise, who was the most die-hard tennis fan. She'd come to watch my matches and rip me from behind the fence for hitting a double fault, but she did it with so much love.

To Jacob, for taking a ride through so much of this bonanza. And to Abby, Jack, Max, Sam, and the entire Aplaca-Casem clan, few things have brought me more joy than seeing you all during this journey.

Finally, to all the generous, loving, bighearted, and supportive friends who came on sections of the big tennis tour with me, read parts of this book, looked at proofs, or held me when I laugh-cried during the making of this, thank you for always reminding me that this book is important and that I am loved. If you ever want to go walkabout in pursuit of courts again, I'm ready.

INDEX

Agit Analogue, 211
Alice Marble Tennis Courts, 232
All Iowa Lawn Tennis Club, 46
Argideen Vale Lawn Tennis & Croquet Club, 36
Ariake Ccliseum, 108
Arthur Ashe Stadium (US Open), 114, 116
Athens Lawn Tennis Club, 327

Båstad Tennis Stadium, 79
Beachcourt Villa, 174
Bourbon Beans Dome, 110
Buenos Aires Lawn Tennis Club, 16, 70
Bunabhainneadar Tennis Court, 35
Bürgenstock Resort, 181
Burgh Island, 145

Cabo Sports Complex, 109
La Caja Mágica, 105
Camps Bay Tennis Club, 257
Cannes Garden Tennis Club, 255
Le Cap Estel, 157
Casa de Campo Racquet Center, 175
Central Park, 275
Centre Court (The Championships, Wimbledon), 96, 98
Centre Sportif Jules Ladoumègue, 190
I. Český Lawn Tennis Klub (Czech Lawn Tennis Club), 270, 271
Charleston Open at LTP Tennis Daniel Island, 77
Cheval Blanc, 171
Circolo Sportivo Tennis Emilia De Vialar, 27
Club Campestre de Cali, 140
Club del Sol, 162
Club de Tenis La Paz, 298
Club Náutico, 293
Club Terrazas, 228
Cooper Park Tennis, 210
Court 2 (The Championships, Wimbledon), 98, 100
Court 17 (US Open), 114
Court Philippe-Chatrier (French Open), 82, 84
The Courts, 131
Court Simonne-Mathieu (French Open), 82, 87
Crandon Park Tennis Center, 182
Cromlix, 142

Cuban National Tennis Center, 245

Dansk Tennis Club, 38
Deccan Gymkhana Club, 214
Diamond Head Tennis Center, 128
Dubai Duty Free Tennis Centre, 112

Echo Park, 261
Elsternwick Park Tennis Centre, 248
Enchantment Resort, 207

Fawkner Park, 248, 249
Fergusson College, 214, 215
Foro Italico, 95
Fort Greene Park, 276
Four Seasons Resort Nevis, 175
Fritz Burns Park, 252

Garden Tennis De Royan, 156
Gezira Sporting Club, 28
Gorky Tennis Park, 236
Government House, 164
Grand Hotel Tremezzo, 152
Grandstand (US Open), 114
Grass Court Saga Tennis Club, 244
Gstaad Palace, 267

Havnar Tennisfelag, 147
Heldman House, 49
Hotel Cipriani, 312
Hotel du Cap-Eden-Roc, 158
Hotel Splendido, 155
Hudson River Park, 274
Hurlingham Club, 317

Ilkley Lawn Tennis Club, 89
IMG Academy, 260
Indian Wells Tennis Garden, 72
International Tennis Hall of Fame, 43
Iphitos Club, 321

Jamor Tennis Training Center, 88
Jericho Tennis Club, 272
Junior Club, 282
Junior Tennis Champions Center, 324

Kailua Racquet Club, 20
Karuizawa Tennis Courts, 19
Kia Arena (Australian Open), 68
Kids Closer to Sport, 294
Knickerbocker Field Club, 44

Kooyong Lawn Tennis Club, 54
Kunglia Tennishallen, 78

Ladies' Recreation Club, 212, 213
Lagos Lawn Tennis Club, 251
Laikipia Court, 58
La Quinta Resort & Club, 252
Lawn Tennis Clube da Foz, 306
Lawn Tennis Club Praha, 270
Libbey Park, 50
Ljubicic Tennis Academy, 149
Longwood Cricket Club, 53
Loton Park Tennis Club, 296
Lotte Hotel Jeju, 168
Luanco Tennis Club, 22

Mallorca Country Club, 301
La Mamounia, 195
Miraflores Public Courts, 228, 229
Mission Hills Country Club, 252
Monte-Carlo Country Club, 91
Montreaux Tennis Club, 310
Mount Royal Tennis Club, 322, 323
Mouratoglou Tennis Academy, 258

The Nare Hotel, 144
Nice Lawn Tennis Club, 300
Nishtar Park Sports Complex, 241
Niyama Private Islands Maldives, 170

Olive Farm Tenis Kubülü, 167
Oyebog Tennis Academy, 231

Parnell Lawn Tennis Club, 297
Passalacqua, 154
Poona Club, 214, 215
Powlett Reserve Tennis Centre, 248
Puente Romano Tennis Club, 262

Qizhong Forest Sports City Arena, 102
The Queen's Club, 107
Queenstown Tennis Club, 127
Quinta da Marinha Racket Club, 163

Rafa Nadal Academy, 224
Rancho Cienega Public Courts, 278
Rancho Mirage Community Park, 252

Real Club de Tenis Betis, 208
Real Club de Tenis de San Sebastián, 163
Reial Club De Tenis Barcelona 1899, 94
Reial Societat de Tennis Pompeia, 305
Rio Tennis Academy, 234
Riverside Clay Tennis Association, 274, 275
Rochusclub Düsseldorfer Tennisclub, 320
Rod Laver Arena (Australian Open), 64, 68, 108
Royal King's Park Tennis Club, 233
Royal South Yarra Lawn Tennis Club, 25, 54
Royal Tennis Club de Marrakech, 120
Roy Emerson Arena, 106
Rushbrooke Lawn Tennis & Croquet Club, 326

St. George's Hill Lawn Tennis Club, 317
Il San Pietro Di Positano, 204
Schwarz-Blau Tennis Club, 238
Seaside Tennis Club, 328
Soneva Fushi, 170
South Cowichan Lawn Tennis Club, 137
Sportchalet Mürren, 150
Stade IGA, 76
Stanglwirt, 269
Steffi Graf Stadium at Tennis Club Rot-Weiss, 80, 81
Sunset Beach Park, 128, 129

Tatoï Club, 273
TC 1899 Blau-Weiss, 321
Tenis Club Argentino, 16
Teniski Tereni Kališ, 202
Tenisový Klub Sparta Praha, 270
Tennis Club de Belgique, 40
Tennis Club de l'Avenir Sportif de la Marsa, 247
Tennis Club de Paris, 318
Tennis Club du Rosaire, 134
Tennis Club Grindelwald, 216
Tennisclub Ijburg, 222
Tennis Club Malcesine, 153
Tennis Club Milano Alberto Bonacossa, 309
Tennis Club Parioli, 264
Tennis Club Rot-Weiss, 80, 81
Tennis Club San Stin, 32

Tennisclub Sportverein Schwarz-Blau, 238
Tennis Club Venezia, 325
Tennis Club Vyšehrad, 202, 203
Tennisclub Weissenhof, 80
Tennis De La Cavalerie, 193
Tennis La Rosière, 136
Tennis Michelangelo, 26
Tennis Park Lommerrijk, 139
Tennispaviljongen/C-Hallen, 189
Tenniszentrum Arsenal, 201
Le Tir, 318

Tokyo Lawn Tennis Club, 292
Toronto Lawn Tennis Club, 322
Turtle Bay, 129

Ukrainian Tennis Federation, 289
United States Tennis Association National Campus, 260

Vakkaru, 171
Valle Verde Country Club, 184
Vanderbilt Tennis Club, 186

Victoria Park, 213
Vienna Athletic Club (Weiner Athletiksport Club), 238, 239
Vienna Park Club (Wiener Park Club), 238
The Village at Camelback, 280

Waiheke Tennis Club, 161
Weiner Athletiksport Club (Vienna Athletic Club), 238, 239

Weiner Park Club, 238
West Side Tennis Club, 57
Wildflower Hall, 172
Wodonga Tennis Centre, 166
World Club Tennis, 302

Yokohama International Tennis Community, 308
Yongma Tennis, 246

Zayed Sports City, 112, 113

PHOTO CREDITS

Cover: Moosa Haleem for Soneva Fushi; **Case**: Cheval Blanc; **1**: Moon Hough; **2–3**: Cheval Blanc; **4–5**: Melanie Black; **6–7**: Cheval Blanc; **12–13**: Thomas Lindie; **24–25**: Club Tennis Luanco; **28–29**: Sima Diab; **30** (**bottom left**): Moon Hough; **31**: Melanie Black; **34–35**: Thomas Lindie; **36–37**: Melanie Black; **39** (**top left**): Brock de Haven; **40–41**: Tennis Club de Belgique; **42**: Courtesy of the International Tennis Hall of Fame / Mark Higgins; **43** (**top**): Courtesy of the International Tennis Hall of Fame / Kate Whitney Lucey; **46–47**: Rachael Wright; **50–51**: Holly Roberts, Kadaya Photography; **52–53**: Longwood Cricket Club; **55**: Kooyong Lawn Tennis Club; **56–57**: Noah Wolfe; **58–59**: Moon Hough; **64–65**: Julian Finney / Staff Photographer; **67** (**bottom**): Chris Caporaso; **74**: Indian Wells Tennis Garden; **78**: KLTK; **79**: Johan Lilja / Arena Bastad; **80**: imageBROKER.com GmbH & Co. KG / Alamy Stock Photo; **82–85**: Pete Kiehart; **88**: Josh Meiseles / ATP; **89**: Ilkley Lawn Tennis Club; **93** (**middle**): AELTC / Ben Solomon; **94** (**top**): RTC Barcelona; **96–97**: AELTC / Ben Solomon; **98**: AELTC / Joe Toth; **101**: AELTC / Edward Whitaker; **102–103**: Hugo Hu / Contributor; **103** (**top**): Xinhua / Alamy Stock Photo; **106**: Prisma by Dukas Presseagentur GmbH / Alamy Stock Photo; **107**: Riccardo Russo; **108**: Alfo Co. Ltd. / Alamy Stock Photo; **109**: Carlos Perez Gallardo; **110–111**: Josh Meiseles / ATP; **112**: Dubai Tennis Championships; **113**: Christopher Pike / Stringer; **114–115**: Darren Carroll / USTA; **116**: Jennifer Pottheiser / USTA; **118–119**: Brian Friedman / USTA; **121**: Ebony Siovhan; **126–127**: Josh Wallace; **131**: Samson Casem; **136**: Courtesy La Rosière; **140–141**: Christian Melgarejo; **142–143**: Cromlix; **144**: The Nare; **145**: Burgh Island Hotel; **146–147**: Havnar Tennisfelag; **148–149**: Hrvoje Petek, Ljubicic Tennis Academy; **152**: Grand Hotel Tremezzo; **153**: TC Malcesine; **154**: Passalacqua; **155**: Splendido Mare; **156**: Garden Tennis de Royan; **158–159**: Hotel du Cap-Eden-Roc; **164–165**: Pen Tayler; **166**: Wodonga TC; **167**: Olive Farm Tennis Kulubua; **168–169**: Lotte Hotel Jeju; **170** (**top**): Moosa Haleem for Soneva; **170** (**bottom**): Niyama; **171** (**top**); Vakkaru; **171** (**bottom**): Cheval Blanc; **172–173**: Wildflower Hall; **174**: Beachcourt Villa; **175** (**top**): Casa de Campo Tennis Center; **175** (**bottom**): Four Seasons Nevis; **184–185**: Valle Verde; **188–189**: Courtesy AIX/SCIF; **190–193**: Maia Flore; **197**: Betsy Joles; **198** (**bottom right**): Sanyuy Stephan; **202–203**: Dragan Trifunovic; **203** (**top**): Mindaugas Gelunas; **211**: Agit Analog; **212**: Oliver Lun; **213**: *South China Morning Post* / Alamy Stock Photo; **214–215**: Ashvita Singh; **218–219**: Tatoi Club, Elias Joidos; **224–227**: Nadal Academy; **228–229**: Club Terrazas; **230–231**: Sanyuy Stephan; **232**: Mark Kegans / The *New York Times* / Redux; **234–235**: Gabriel Nascimento; **236–237**: Gorky Tennis; **240–241**: Betsy Joles; **244**: Grass Courts Saga Tennis Club; **245**: Lisette Poole / The *New York Times* / Redux; **246**: Dongmyung Lim; **247**: Hirmane / The Ace Club; **250–251**: Oluka Levi; **256–257**: Camps Bay Tennis Club; **260**: USTA / Nicholas Shookla; **266–267**: Gstaad Palace; **270–271**: Jan Zirovnicky; **272**: Jericho Tennis Club; **273**: Tatoi Club, Elias Joidos; **282–283**: Alfred Marroquín; **288–291**: Pete Kiehart; **292**: Tokyo Lawn Tennis Club; **293**: Omar Erre; **294–295**: Ben Nteza; **296**: Brian Russak; **298–299**: Club de Tenis La Paz; **301**: Album / Alamy Stock Photo; **302–303**: World Club Tennis; **308**: Yokohama International Tennis Community; **309**: Tennis Club Alberto Bonacossa; **316–317**: Hurlingham Club; **320**: Rochus Club; **321** (**bottom**): dpa picture alliance / Alamy Stock Photo; **324**: Junior Tennis Champions Center; **326**: Rushbrooke Lawn Tennis & Croquet Club; **327**: Boyd Creative.